THE AUTOBIOGRAPHY

LOOK AGAIN
DAVID BAILEY

WITH JAMES FOX

PAN BOOKS

First published 2020 by Macmillan

This paperback edition first published 2021 by Pan Books
an imprint of Pan Macmillan
The Smithson, 6 Briset Street, London EC1M 5NR
EU representative: Macmillan Publishers Ireland Ltd, 1st Floor,
The Liffey Trust Centre, 117–126 Sheriff Street Upper,
Dublin 1, D01 YC43
Associated companies throughout the world
www.panmacmillan.com

ISBN 978-1-5098-9686-8

1 3 5 7 9 8 6 4 2

A CIP catalogue record for this book is available from the British Library.

Typeset in Sabon by Jouve (UK), Milton Keynes
Printed and bound by CPI Group (UK) Ltd, Croydon, CR0 4YY

Visit **www.panmacmillan.com** to read more about all our books
and to buy them. You will also find features, author interviews and
news of any author events, and you can sign up for e-newsletters
so that you're always first to hear about our new releases.

Dedicated to my wife Catherine Bailey and all the guys and girls who have helped me at the studio over the years.

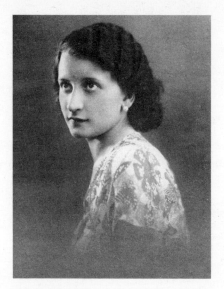

My mother Glad.

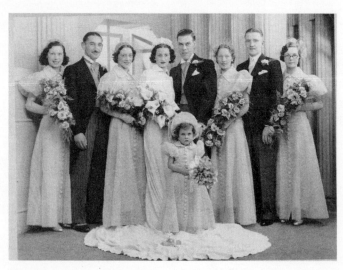

Glad and Bert's wedding day.

Table of Contents

Chapter 1

War

The two toughest women I ever met in my life were my aunt Dolly and my mother, Gladys, and it was they who brought me up. Dolly was the complete opposite of my mother, always laughing and up for a joke, whereas my mother didn't like jokes. She was more angry, mostly at her situation. She always seemed old, Glad, whereas Dolly always seemed young.

Dolly used to say funny things to me as I got older too. When I was married to Catherine Deneuve she used to call me up and say, 'How's your French floozy?' She'd say, 'You can't keep sharpening a pencil, David.' Later when I was with Marie Helvin, she'd say, 'Here, Dave, you married a chink?' I'd say, 'She's not a chink, she's a gook.' She was full of all that East End philosophy, such as, 'If you're fucking and it hurts you're doing it wrong.'

It's a shame Dolly's not alive. She always wore a white scarf – nylon probably – with those big curlers. I'd say, 'When you going to take your curlers out, Doll?' She'd say, 'For the party.' Then she'd come to the party in her curlers. She never took them off. I think she was a lazy bitch. Couldn't be bothered. She was nice, she was my friend. I loved Dolly. I wouldn't have grown up so close to her if we hadn't been bombed out of

our house in Leytonstone when I was four and we'd all moved in together.

Leytonstone is where I was born. One of my earliest memories is of the magnolia tree in our street, in somebody's front garden. It's still there. I'd never seen a tree like that in my life, the pink flowers almost glowing in all the greyness and rubble that was the East End in wartime. It was such a fantastic thing to see. I didn't know it was a magnolia tree, but at the time it was just the most beautiful thing I'd ever seen. It was also the first time I'd seen *anything* beautiful. It seemed like something tropical, as exotic as that, though I wouldn't have known to call it that. When I started working on this book I took my son Fenton and my collaborator, James Fox, on many travels into the East End, looking for the places where I grew up. Wallwood Road in Leytonstone, on the edge of Epping Forest, was the house where we first lived – me and my sister, Thelma, and our parents, Bert and Gladys. I was born in January 1938, my sister Thelma in November 1939, a few months after war broke out. I hadn't been back for a while, not since they put up a blue plaque saying I was born there. It's one of those Victorian houses, built around 1850, big bay windows on the front. We only had two rooms: my mother's bedroom, then down some stairs a long narrow kitchen you couldn't swing a cat in. There were loads of families living in the house. You shared a toilet; there was a bathroom on every floor.

When I got there that day with Fenton and James, we saw the door open; there was a police cordon at the top of those stairs, and a policewoman guarding it, saying it was a crime scene and she couldn't disclose what had happened. I could imagine our old room, not much different, where the crime had taken place. From the street, the curtains still looked the same. It looked really shitty. Same broken low wall, probably the original fence.

The privet hedge had been trimmed; back then they grew so far out over the pavement you had to tiptoe around them not to walk in the gutter.

The war was no problem for me. When you're a little kid you don't know it's a war, you just think it's normal. It's not scary. You hear the bombs but you don't think you're going to die. I was two when the Blitz started, and the wailing air-raid sirens and the 'ack-ack' of the anti-aircraft guns were the soundtrack of my life; going to the brick shelter in the garden every night was routine. From September 1940 they bombed London for fifty-six nights without stopping, mostly in the East End. Stepney got the worst of it. Lord Haw-Haw, I read since then, had promised to 'smash Stepney'. The theory was that Stepney got so bombed by the Germans because Hitler thought all the Jews were there. There were lots of Jews in the East End then. Everyone was Jewish or Irish, there was nobody else.

Almost my first visual image was of sides of houses gone, the inside outside. There'd be paintings hanging, and mirrors, and a fridge hanging on a ledge, or a bed there. It was like opening a doll's house. The other soundtrack, along with the sirens, was the crunch of broken glass. I remember coming into the hallway and everything was covered in glass, the windows blown in. They always had brown tape stuck over them so that the glass stuck together when they broke, but this time the force of the nearby explosion must have been too great. I was fascinated by the noise made when you walked on glass, the sound of that *crunch-crunch*. Later, playing on bombsites, I liked smashing it.

I still jump when I hear a bang. Once when there was a bang I dragged my sister underneath the table, because that's what I had been told to do, and I was a hero for about two weeks. But they soon forgot.

Myself as a baby.

We were living at Wallwood Road when my father brought home a Tonka toy that was being passed around all his East End mates. My dad said I must be restrained with my playing and not damage or scratch it as the next day it was going to another little boy to play with for one evening. Or to a girl, I suppose. I imagine boys because boys counted more than girls in those days. It was red and maybe yellow, strongly made of tin with a small crane on the back. I had never seen anything like it; it almost seemed like a holy relic. Toys were scarce in the war, even on the black market.

I also remember finding a little lead soldier or sailor in a pea jacket. I loved this thing so much. One day my mother was doing the ironing and I stood him on top of the iron to see what would happen, and it melted into a blob. There goes my sledge, my Rosebud, like in *Citizen Kane*. It turned into a ball and rolled onto the floor. The first tragic thing I really remember. Much worse than Hitler's bombs. Did I cry? No, I didn't cry. Boys didn't cry in the East End. They'd think you were a fucking wimp. That was sad, though, my Rosebud. I didn't realize it was Rosebud until much later.

One day in 1942, when I was four, we climbed out of the shelter to find the house next door bombed out. If you look now to the right of our house you'll see the council house that replaced it. We were moved to East Ham. My mother's sister Dolly and Uncle Tom, her husband, who was a pub pianist and worked in a wood factory, moved in with us in Heigham Road, a smallish house, later Victorian style, built about 1880, with bay windows framed with decorative stucco pilasters. They had their two kids, so there was eight of us living in this one flat, four babies. It must have been like the fucking Yellow Submarine. They had three rooms upstairs, and we had two rooms

below but you could make them three by pulling those wooden doors across the front room to make two rooms.

The front room was normally where nobody ever went. My mum used to have plastic over all the furniture. There were only two reasons to use the front room: you put flowers there; and when the doctor came round, no matter how cold you were, you were put in the front room, which wasn't heated, for him to examine you. But until the war ended I slept in the front room because there was nowhere else. In the East End lots of people lived really close together. We were used to it.

Uncle Arty, my mother's brother, who was gay, used to come home from the Navy and stay with us as well. I shared a room with him, which my father didn't like – not understanding the difference between a paedophile and a homosexual.

In the backyard at Heigham Road we had an outside toilet (the inside one didn't work) and a chicken shed, home to four Rhode Island hens and a cock. One of the hens was my favourite and my mum told me it was mine. I could look from the front room through the kitchen and see into the scullery, the little room where they had the cookers. And that's how I discovered that my dad had killed my chicken on Christmas morning. I saw it hanging up in the scullery with its throat cut. That's probably why I became a vegetarian, after that. When I was a bit older, about twelve or thirteen, I announced it. I don't know where I got it from because I didn't know anybody who was a vegetarian. I think it was the murdering of my chicken that did it.

After the Blitz ended there was a bit of a lull in the bombing but it started up again in early 1944, when I was six, and lasted a

few months. They called it the Baby Blitz. Every night we used to go down the coal cellar, always about six o'clock when *Toytown* started on the radio. Sometimes we'd stand at the top of the stairs so we could still listen to it, coming from the kitchen while the bombs were going off. The coal cellar was probably the worst place to go because it was full of gas pipes. We used to sleep down there in a big brass bed, surrounded by coal. All of us – Aunt Dolly too – except for my dad. He used to do so-called wardening. He'd vaguely tell us he was off watching for bombs or something, but I'm not sure my mum believed him. He was really off with women. He wasn't conscripted because he had varicose veins. Didn't pass the medical. His legs looked like a fucking cork oak. I suppose lots of tailors had it because they're standing up all day.

When the ack-ack guns went off, the house would shake and all the distemper, the white paint, used to flake off the cellar walls and float down, covering us. I always felt it was like being in one of those snowglobes at Christmas. There was one bare light bulb down there and I used to play airplanes, make shadows on the walls and shoot them down. I'd get smacked for that. 'Shut up, stop doing that, you're irritating me.' I took two wooden angel wings from a bombed church and brought them back but I didn't tell my mum because she would have said you shouldn't nick from a church. I hid them in the cellar and they're probably still there because I shoved them right back inside where the poles go under the ceiling. That would be a good bit of filming, bringing the angel wings back. It's too good to be true. The wings were such a bizarre thing to bring back.

The Germans bombed East Ham because it was near the Royal Albert Docks. I remember sitting on my dad's shoulder, watching the dog fights. My mother used to get angry,

screaming at my dad, 'It's dangerous, come in.' He'd say, 'He'll never see anything like this ever again.' I watched it all, the searchlights sending white beams across the night sky, planes fighting, everything. I loved it.

It eased up in 1944 when the Germans started using the V1, the doodlebug, which looked like a small plane. I remember the first one crashing, in Mile End, and listening to my parents talking about it, saying, 'There's no pilot.' They didn't realize it was a flying bomb. It used to run out of fuel over the target – that's how they got it to stop, crash and explode. It was a clever way of guiding them, in a way. We used to have to count the seconds between the engine cutting off and the explosion, like you do with lightning and thunder, and that was supposed to tell us how far away the doodlebugs were. Which I think is a load of bollocks.

Every day you saw V1s come over and the Spitfires in the sky, trying to shoot them down. I once watched a doodlebug knock off a chimney.

My parents must have thought it was getting too dangerous when the Germans started using the V1 bombs, because that's when my mum took Thelma and me to the country – not evacuated like other kids but taken to stay with a friend of my dad's near Bristol. The locals hated you being from London. One day two older kids gave me a blackberry and said, 'Would you like this?' I thought, why not? And I ate it.

'Do you want another one?' they said.

'Yeah, all right.'

'We're glad you liked those,' they said, 'because we pissed on them.'

So that night I took a box of Swan matches and set fire to the fucking field, which I assumed was theirs. The fire brigade

and police turned up. My mum was really angry with me. I climbed over the roof of the house we were staying in to get away, and the next day we had to move back to London.

By now I'd started going to Plashet Grove school, which always smelt of wet sand from two big sandpits in the playground. If the sirens went off, we'd go outside into the playground where we were all put into columns and marched over to a big brick shelter with a concrete roof. We had two Anderson shelters in the backyard at home, made from corrugated iron and dug into the ground. They were both full of water because there was no drainage. People never mention that. East Ham is pretty low, it used to get swamped by the Thames until they built the docks. That's why we used the cellar instead. Some people kept pigs and ducks in the shelters that were full of water. There wasn't too much RSPCA around. Sometimes, when Mum went shopping, she'd dump me with her aunt Mercy, who lived up the road. Aunt Mercy had a wonderful shelter – perfectly dry, lined with green felt, with cushions decorated with robins and flowers. It was like a country cottage!

There used to be packs of dogs, all different shapes, running together; they'd gone feral. Their owners might have been killed in the war or they'd been let go by people who were evacuated and weren't allowed to take their pets with them. There were still lots of dogs living on the street after the war, one of which I was pretty scared of. I used to have to walk around the block to not see it every morning. Horrible dog. A mongrel. It used to attack me all the time.

We never came straight home from school. We'd play on bombsites, which were fascinating if sometimes dangerous

places. A couple of kids got killed – one, I remember, in a cement mixer, another falling into a building. I used to collect shrapnel. I've got some still. It's hard to pick up because it cuts you like razors. We were warned not to pick up anything that looked like a toy or a fountain pen because they thought Hitler had dropped booby traps, so we were quite streetwise about picking up things. I brought an incendiary bomb home once, unexploded. I don't remember bringing it home, all I remember is the air-raid warden – with his armband and round tin hat – running down the road with it in a bucket.

I made little museums to house the items I picked up, which would be labelled things like 'Stone from Wanstead Flats' or 'Piece of Wood from Bombed Building'. My father had one of those record players with the radio underneath, all in one, so I took out the radio and the speakers and made it into a little museum. I got into trouble for that. My dad said I'd ruined his radiogram. But he didn't use it anyway.

We'd look for lead on the bombsites – bits of flashing or melted pipes from bombed churches or roofs. A lump was worth sixpence, and sixpence was a lot of money. When I had a bit of lead to sell, I'd go to the rag-and-bone man who'd come round the streets on a horse and cart. Horses were a common sight back then. Coal would be delivered on carts pulled by great big shire horses. The milkman, George, had a horse called George as well. And the horse just used to take its own time walking the float around; it knew where to go, it was always the same route.

Towards the end of the war, V1s were replaced by V2s – they were the first ballistic missiles, a rocket. That's when the Germans bombed the cinema in Upton Park and I thought they'd killed Mickey Mouse and Donald Duck and Bambi. It was one

of those great cinemas, an Egyptian cinema and a V2 got it. I was really pissed off with Hitler.

Everything was scarce so Glad was often out shopping and we were by ourselves a lot. It must have been awful for my mother. Now you think about it, it must have been awful for all of them. They'd go out shopping, come back and the house would be gone. If my mother saw a queue she'd just go on the end. She'd queue for hours. She didn't know what she was queueing for but she knew it must be something. It's a bizarre surrealistic act, just to get in a queue and not know what you're queuing for. Sometimes we were chucked out, when the sirens went, from a bank or post office – doors closed, into the streets, my mother furious.

Everyone was on the fiddle, buying on the black market. The soldiers were better fed than the civilians. Rationing meant you got a certain amount of food a month for one person, including meat. We used to have pig trotters because they were cheap. And my mother taught me how you tell a cat from a rabbit when it's skinned. When they split open, in a cat the kidneys are one above the other, and in a rabbit they're side by side, or it might be the other way around. But that's how you would tell if the butcher had sold you a cat instead of a rabbit. Because there were plenty of rabbits hopping around and quite a lot of cats.

Everybody grew something in their garden, especially during the war. My grandmother's kitchen opened straight onto the backyard, which was always full of beautiful rhubarb. We grew tomatoes and had chickens. The tomatoes would be put in the window when they were yellow, to get them to go red. In the East End you always saw loads of tomatoes in windows when you walked down the street and, growing through the fences,

blue lupins and buddleia. That's from China. Everything inter-
esting seems to be from China.

I remember our street having a big party when Germany
surrendered in May 1945, mainly because I hated it, all those
people making small talk. I was not sociable as a kid. Actually,
I'm not sociable now. And then the streets were full of bon-
fires, as people burned rubbish from bombed-out houses. It felt
wrong, now we had peace, to see fires still burning. They were
so hot they left big black marks on the roads.

When the war ended, Dolly and her family left and got their
own place. I shared a room upstairs with my uncle Arty when
he was home on leave, my sister had a room, my mother and
father had a room, and the front room went back to being used
only for flowers and doctors' visits.

I think about death every day, all the time. It started with
the war. I've had nightmares on and off ever since of buildings
falling down on top of me.

Chapter 2

Gladys and Bert

The area where I grew up – Forest Gate, between West Ham and Wanstead – was really rough back then. East Ham and Barking were the roughest, and they're still the last of the East End really. It's all becoming very middle-class. Stratford is completely middle-class. Wanstead's the next place that's going to go because there are quite nice houses there. All the houses along Wanstead Flats were the poshest houses I remember seeing as a kid. Now they just look like quite big, regular houses. Everyone wanted to move to Wanstead. All the taxi drivers moved to Wanstead. The park itself is the garden of a former house – one of the biggest houses in Britain, almost as big as Versailles – that was pulled down in 1780 or something.

I remember walking across Wanstead Flats with my mum when I was quite small. She was pushing a pram, with my sister, I suppose. I have an image of her; she had a flowery dress on and I remember thinking how pretty she was walking through the brown grass with the wind blowing. My mother was quite beautiful when she was young, and that was my first image of her.

My mum and Dolly used to go out for one day a year to the West End, to Selfridges. That outing was like your holidays. They just went to look at the clothes, but not to buy them. They couldn't

afford them. They were machinists so they knocked them off at home on sewing machines. My aunt Dolly used to make white flare parachutes at home – tons and tons of them, which I used to play with. My mum tried on this dress and I watched her twirling around in the light, backlit in the big plate-glass windows they had upstairs in Selfridges. That was the moment that changed my life. I thought it was magic. I just thought she looked beautiful. I didn't know what backlit was in those days. I didn't know who Avedon or anyone was then. I was about nine. It must have been a Dior copy of the New Look, which came out in 1947; it took probably a year to reach the shops here. That image has always stuck with me. It was my first fashion photograph in a way, though I didn't associate it with photography. She was quite slim when she was younger, my mum. She had big tits, I think. People had bigger tits in those days – or they're just disguised better now, because they must be the same tits.

Glad was fierce. You knew what mood she was in by how black her eyes were. She had the most scary eyes. Very black. Her mother was probably a Huguenot – they were all settled in the East End around Spitalfields from the eighteenth century, refugees. Even the gypsies were scared of Glad. They used to come to the door and try to get money out of me as a kid and she'd come down the hallway, yelling at them like a banshee, and they'd be running down the road with her shouting curses back at them. The gypsies in those days dressed like gypsies and they sold lucky heather with a bit of silver around it. They used to camp out on Wanstead Flats with their caravans. They made a big mistake when they picked on me.

If I was in a gang fight or something – gang fighting started when you were about eight – I was more scared of her than I was of getting a black eye because she'd give me a slap for it.

Once I was on the top of the stairs when she hit me and I fell down the flight. But I think that behaviour was normal then. I know she liked me a lot but Glad had a temper. She was just East End tough, like my daughter is. Paloma's tough. She's East End. They're always tough on the surface but deep down they're a bit soft.

I wasn't really a fighter. I was always getting hit back. A big bloke called Keith beat me up. Keiths are always dodgy guys. There were a few farmers that moved to the East End, a lot of people came from the country. That's why you got so many Greens; you were called Green if you were a Jew or if you were from the green of Ilford. I think he was a farm boy, big Keith. I came home with a black eye and Glad said, 'What happened to you?'

'Keith beat me up,' I told her.

'He did that to you?'

'Yeah.'

'Go and hit him back!' she said.

So I went back and I got beaten up again. I wasn't going to listen to my mum any more after that. I learned early on to use humour instead. Make a joke of everything. Say, oh, I like your shoes. Anything that throws them off what they're thinking. I've used it all my life, that. Making them laugh is better than making them cry.

My mother would clean our front step every day. If you walked out on the street about 7.30 in the morning, you'd see a row of women cleaning their steps. Glad used to clean it white with a great big lump of chalk and she looked down on the people who used red because they only had to do it once a week and she thought they were rather common. She was so proud of her step being clean. We had to step over it and if

we trod on it, it was, 'Oh my god, don't tell her.' We'd try to rub the marks away with our hand. She'd be furious. She was fanatical about it being clean.

The only person my mum was scared of was Mercy, her aunt, who lived about six houses along the same street and who was always out the front, talking. She was very intelligent and Mum looked up to her. Mum always insisted I behaved well for Aunt Mercy, to the point that I ended up scared of her too. Her husband was a merchant seaman and full of stories from his travels. I remember shaking his hand and him saying, 'You've shook the hand that shook the hand of Buffalo Bill.' My lesbian aunt Alice lived close by too. She was a troop leader in the girl guides – used to wear the girl guide uniform all the time. They had the boy scout hats, the girls in those days. Alice was very manly – tall, short hair, no make-up. (Glad would never admit anything. She'd never admit uncle Arty or Alice were gay. She almost made out she didn't know what gay meant. Maybe she didn't know what it meant. She was quite naive.)

Glad was scared of what Aunt Mercy thought. If there was a footprint on the white step outside the house and Mercy saw it, she'd be upset. You could write a whole Alan Bennett movie around the white fucking doorstep. I was as scared of that white doorstep as I was of her eyes. The only two swearwords she said were sod and bugger. 'I just cleaned that ten minutes ago and you stepped on it, you little bugger!' It was never real swearing – fuck or cunt or anything like that. Cunt was used more with your mates. But cunt was a nice word. I like single words. Like 'moonglow'. It's such a nice word. It's like a poem in itself. You don't have to say anything else. Tells you every-thing. Or 'cunt'. Perfect word. In fact, I've done some paintings called the Cunt Paintings. They're just black and if you really

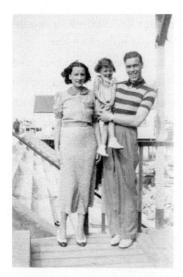

*Glad and Bert looking happy,
holding my cousin Maureen.*

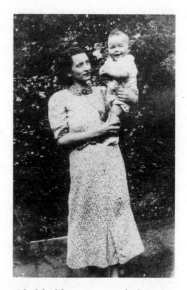

Glad holding me as a baby.

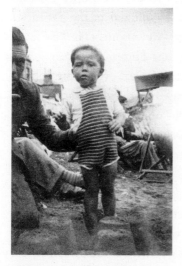

With Bert at the seaside.

look at them you can see the word cunt or rainbow or moon-glow. Magical words.

I always wondered what the white doorstep was about and why Glad looked down on people with red ones. It's funny, the snobbery in the East End. We looked down on people from across the river. They weren't East End enough. People who went to the Co-op were common to my mother. She wouldn't use cockney slang and she wouldn't use Jewish words. In the East End everyone used 'schmuck' and 'schnorrer', all those Jewish words, but she never did. My dad did.

She really wanted to be middle-class, my mum. Her heroine was Barbara Stanwyck because she thought she looked a bit like her. She used to take me to see Barbara Stanwyck movies when I was seven and a half or eight. She took me to the cinema a lot. We used to go four or five times a week, so I'd see ten films a week because there was always two films each time. The cinema was only 9 pence each so it was cheaper going to the movies than putting a couple of shillings in the gas meter for two hours of warmth at home. We used to take jam sand-wiches and orange juice to have our dinner. (Everything was called dinner. Lunchtime was called dinner; every time you ate it was called dinner.) My mum used to decide what films we saw. She had a preference for film noir, for drama. After that her choice was based on the actors she liked, whether the film was in colour or black and white, and where it was showing. We had to get a bus to the ABC in Manor Park, so that was always the last one on the list.

The film my mother liked best was *The Best Years of Our Lives*, starring Myrna Loy and directed by William Wyler in 1946 – a war film, made about a guy with a hook hand who'd lost it in the war. That was also the film I remember more than

anything, partly because such a big fuss was made of it but also because it was so long it had an interval in it. That made a big – and bad – impression on me. Usually you'd sit in the cinema and see the A film and then the B film and then the cartoons. I wasn't happy that with *The Best Years of Our Lives* you only got one film.

Glad was quite intellectual for the East End. She used to read books. There was a man who'd come door-to-door carrying this suitcase, a globetrotter case. He'd open it and I thought it was perfect, the way the books fitted inside. Now the globetrotter cases are poncey, like Louis Vuitton, but then they were the cheapest – they probably cost 10 shillings or something. Mum would hand back the book she'd just read and pick another one. I guess it must have cost a small fee but less than buying a book. She never stopped reading. She read as much as she went to the cinema. The two things she did most. Probably fucked a lot, I later found out. She had lovers.

My mum had pretensions. I think that's why she was angry. She became like that because of my father. Her favourite song was 'Try a Little Tenderness'. Bing Crosby sang it: 'She may get weary, women do get weary, wearing the same shabby dress.'

Women had it shitty in the East End then. Most families were a bit dysfunctional, though it wasn't dysfunctional, it's just the way it was for everybody. They used to fight all the time, my parents. I don't really know who was the worst, because she was probably a bitch, my mum, looking back. My dad was just an OK East End geezer with a pocketful of fivers. Everyone liked him. That used to make me think – maybe he's nicer than my mum says. Because my mum did everything to turn me against him and my grandma. He wasn't perfect, that's for sure.

Glad didn't have much of a life. My parents had to get married because she was pregnant. She was twenty-five, he was about thirty. In those days if you slept with someone in the East End you were supposed to marry them. But for my parents it certainly wasn't good to be married a year before war broke out. They had a bad time, in their sexually very active lives, right in the middle of the war. You could see why everyone was up for it: go to bed and you might not wake up in the morning.

And then my sister Thelma developed rheumatic fever around the age of six or seven. She was sick for about three years. She was at Stratford Hospital for nearly a year. Glad used to go and see her every day. She had a weak heart and she had nearly died, so my father was crazy about her. When she had the rheumatic fever, if you touched her she used to scream, and my father thought I did it on purpose. Because of Thelma's weak heart, when she went to school she had to go on what we called the silly bus. Then it wasn't politically incorrect. Nothing was politically incorrect then. It was the bus for the raspberry ripples, the cripples. Bertie Lemon was the most famous, he was a cripple and he had a big head, encephalitis. He used to walk like Dracula. And we'd say, 'silly boy Bertie Lemon' and he'd run away even though he was much older.

There wasn't much empathy in the East End. People said it like it was, or like they thought it was. What you have now is a kind of media-fed empathy that people think is empathy but is actually sentimentality. It's selective empathy, which makes people feel better. There wasn't much of that. People were tough but they looked after each other. Total strangers would take their hat off when a funeral went by and they'd clip you round the earhole if you didn't stand still until the hearse had

gone by. I remember someone taking off my cap and smacking me round the head. 'Keep still, you little bugger.'

I didn't know my father Bert at all really. I used to wait for him sometimes at the front door and I'd know he was coming because he used to slap the newspaper on his leg as he walked. He always wore an Anthony Eden hat and a Crombie overcoat. So sometimes I waited but I also kept out of his way. I was frightened of him. I'd hide from him, in the backyard behind a broken fence between us and the neighbours, I remember. He never beat me, though he threatened to all the time. If he was going to slap me on the legs or something – always just behind the knees – my mum would say, 'You touch him, I'll swing for him.' She meant she'd get done for murder. He was a bit of an arsehole like that. She liked me a lot, my mum, I think to compensate for the fact my father was mad about my sister because she was so ill.

I think my father was born in Hackney, his father was born in Bethnal Green, and then the rest of the family seems to be Whitechapel. I took one of those DNA tests that check for your ancestry and I am 47 per cent British and Irish, strongest in London, 30 per cent French and German and the rest is all northern Europe, plus a very small sub-Saharan percentage. So somewhere in the back I've got a touch of the tar brush. I don't know where that comes from. Probably soldiers because Baileys were usually soldiers; historically they guarded the bailey, the courtyard defence in a castle. In Scotland the name's derived from Bailiff, which is completely different. I think it's different in France too; it doesn't mean the bailey yard. Catherine Deneuve used to say, 'Why are you called Belly?' Because the French can't pronounce Bailey. She'd say, 'What a funny name, Belly, to have.'

My father was a cutter, which was the most important job in tailoring. He worked at Polikoff, the tailoring factory in Mare Street, Hackney, owned by a Polish Jew, Alfred Polikoff, who later opened a big factory in the Rhondda Valley that became Burberry. They made uniforms all through the war. All my family on my dad's side went into the tailoring business. Horne Brothers was a well-known tailor's and his sister Doris worked there as a machinist. His two brothers, Roy and Ernie, also worked in tailoring. That's why they all look good in photographs – because their clothes were tailored. Boris Bennett was the high-street photographer who took their picture with my parents at their wedding. I've got the original picture in the original frame. He was really famous – the David Bailey of the East End, known just as 'Boris'.

I went to a football match with my father once, which I hated, in 1948 when I was ten. It was the Olympics between the Indians and the British and the thing I remember most was the Indian players didn't wear boots, they just played with a bandage around their feet. Otherwise I didn't see much of him after I was about ten. Once in a while we'd talk about music. He liked a trumpet player called Whispering Smith or something. He never had any records but we had a radio with a bit of string you pulled along until you got a station. That would be on the whole time. *Music While You Work* was always on in the mornings, made for the factory workers. They used to play that right through the Fifties too.

If we went on holiday it was an East End holiday – a day trip to Margate, Southend, Clacton-on-Sea. It was awful. The adults all got drunk on the coach, stopped at every fucking pub; there was sick going up and down the aisle, bottles rolling down. They'd all be singing 'Knees Up Mother Brown' or some other

stupid song like the 'Hokey Cokey', while I was choking on the smell of sick and beer. And if you didn't go away they used to take you to the pub. Kids would be left on the doorstep. I'd sit outside The Green Man all the time, for hours. Sometimes with my sister. You might get a lemonade and a packet of crisps. It was miserable. Fucking cold as well.

My parents didn't talk to each other. It was kind of like a comedy. They never liked each other as far as I can remember, although I did hear them fucking once, which was disgusting. They would communicate through me. We'd be sitting in the kitchen and Mum would bring the food in from the scullery – the very small scullery, wouldn't even be the size of a toilet now. She'd put the food on the table and say, 'Tell your dad his dinner's ready.'

'Tell her I don't want sausages,' he'd say.

'He doesn't want sausages.'

'Tell him he'll have to lump it,' she'd snap.

I couldn't bear to eat with him because he used to chew with his mouth open. He was much more of a peasant than my mother.

One Sunday my mother said, 'Go and wait for your father at the top of the road.' I was standing there, playing with my penknife, when two boys stopped and said, 'What you got? What's that knife? We'll have that.' And they pinched it.

My dad didn't turn up and after a while Mum came down to find me. I was a bit pissed off about the penknife and told her.

'We'll go and get your father,' she said.

He was at the Duke of Fife pub, and I remember walking in the door and there he was, necking with the barmaid behind the bar. My mum was screaming and then we were dashing back. I couldn't keep up with her, she walked so quick, dragging

me along because she was pissed off because they'd stolen my knife, and then doubly pissed off because my father was with the barmaid. I just remember thinking how quick grown-ups walk. That incident was typical. They never seemed that happy.

He was always in his club, my father, if he wasn't at work. He did take me there sometimes. It was a sort of a dodgy snooker club in Hackney. It was above the Polikoff factory, a club for the staff but you could go if you didn't work there. My dad just ran it. On Fridays, when he took me down, they used to have people come in and do little turns: juggling acts, performances, people would draw things. I can still draw one of those performing characters from memory. Everyone played pool or billiards and they'd let me win. It was a nice atmosphere. I remember two women telling me, 'God, with your eyes you're going to make some women unhappy,' and for years I wondered what they were talking about.

I would see the CID come into the club on their Friday visit.

'What do those guys want?' I asked my father.

'They've come for their tea money,' he said, which was the name for protection money.

My father had lots of schemes going like loan clubs and Christmas clubs. When he died I had to pay off everybody. When I was about thirteen, he got slashed by a knife at the club, leaving him with a scar down his face. I cycled to see him in Stratford hospital, where they were sewing him up. He told me to go away. He was embarrassed, I think. I didn't know who had done this to him at the time, but my aunt Peggy, who married Dad's brother Ernie, told me it was the Kray twins. The irony is that I got to know the Krays and photographed them, photographed Reggie Kray's wedding, never knowing that they'd scarred my father. It was a very closely kept family

secret – a dangerous piece of information. I had this interview with my aunt Peggy shortly before she died in 2015. It was one I'd been wanting to do for many years for the archives. I started the interview by asking her to tell me about Glad, telling her I knew nothing about my family.

'I met you when you were three years old,' she said, 'and that was 1941. Ernie [later her husband] was in the Air Force and we were courting, and we came round to meet your mum and dad. I know you're going to laugh at this, David, but you were the loveliest little boy anybody could know. You were quiet, polite, a pretty little boy. And I remember the first thing you said to your mum: "Is Uncle Ernie an ossiser?" You couldn't say officer. We used to come over quite a bit. You were always very close to your mum when you were little.'

She told me how my father got his face scarred by the Kray brothers.

'Well, your dad was the head cutter of Polikoff's and he ran the dances and things. This particular time, they had a dance at York Hall in Bethnal Green and your dad was running it. A gang of lads came and they started to cause havoc, throwing the beer about and making themselves a nuisance. Your dad's friend was a copper and he happened to come in to see your dad and between them, they threw them out. But when the dance finished, this other friend had gone home. Your dad had to clear the place and lock it up, and they must have got back in. York Hall has got a balcony and they'd got up there and hidden themselves on the balcony. So your dad's locking up and all of a sudden they jumped out when he was on his own and they said, "Get him." They jumped down and smashed a pint glass in his face, cut his face right the way down. He had a terrible scar for the rest of his life, sixty-eight stitches. It was on the front page of

the *Hackney Gazette* and what it said was two brothers, Ronald and Reginald Kray from Whitechapel somewhere, had been sent down for it. They were boxers and they were nineteen years old, so they weren't really well known then. But they were getting to be a nuisance. And I think they got two months or something, inside. So I know your dad was frightened and said, "Look, I've got to forget it." He told Gladys off because she was having a go to people about them. Your mum was saying they ought to do something and he said, "Gladys, shut your mouth, nobody's to know of this." And I thought that's Ernie and I as well. You couldn't, because everybody sort of knew them. I never told my daughter for years. And you, David, being well known, I thought I won't say anything because I'd never believe in letting the press know things that are going to alter your life. And of course eventually I read their life story and it said Reginald Kray had their wedding pictures taken by David Bailey and I went berserk. I said, "David doesn't know that they caused the scar on his dad's face."'

It was when I got a bit older that I started to realize things were really pretty unbearable between my parents. I didn't see a lot of my father; he was always in the pub, always chasing women, as far as I could make out. That's what my mother told me. I came to think of him – much later on, though – as an all right bloke in a funny sort of way. But it's not what I heard later from women in the family, when we were working on this book.

Ernie was a wireless operator in Lancaster bombers, and he and Peggy were married at the end of the war.

'Your dad did like other women,' Peggy told me. 'When Ernie first got demobbed in 1946 we had a holiday. We were going up to the Rising Sun pub on Woodford New Road to have a drink, and this car pulled up, and who should step out but your

dad with a woman and another couple. He says, "Oh, this is my brother Ernie, he just got demobbed, come with us and have a drink," and he was trying to make out that this woman was with the other couple, but she kept going up to him and putting her arm around him. She was older than your father as well, and she kept saying, "Oh Bert, have you got my costume made yet?" and all that. He was trying to brush her off so that we wouldn't know he was with her. And that's when I realized what a philanderer he was, because you were still young children. And Grandma Bailey was all for her sons, whatever they did. There was no one like them, they couldn't do wrong. She never ever stuck up for your mum and she didn't like it when I used to stick up for Gladys and say what I thought of Bert. She fell out with me once because I used to call him her prodigal son. Bert only went to see Maud, his mother, once a year, but when he had a new woman he'd take the new woman around to her. Do you remember when he had that Jaguar car? And Ernie and I felt so sorry for your mum. I said to Grandma Bailey once, "Why do you encourage Bert?" "Well, he's my son and I don't turn any of them away. And *she* (your mum) should go out with him." I said, "How can she? She's got two young children." So she was a bit naughty with me after that. Bert had so many different girls and Maud, your grandmother, egged him on.'

Maud, who lived in Leyton near Hackney Marshes, was a bit Winnie the Witch. She was a rent-a-cockney; she had a bull terrier and a parrot, an African grey. Everybody in the East End had an African grey and a bulldog because they lived near the docks and they wanted protection. I tried it on once with the Inland Revenue. I had dog food down as tax-deductible. They said, 'What's this dog food?' I said, 'They're protection, they're guard dogs.' So she said, 'That's all right. What's this parrot

food?' I said, 'They're guard parrots.' It cost me three grand for the joke. Shit, no humour, this woman. They *were* guards in a way, they'd screech if someone came in, like geese.

There was always a parrot shop at the top of the road. I suppose that's how I started to like parrots. But Grandma's bull terrier bit my sister badly in the eye – she still has the scars – and that did finally cause a rift between her and my father.

If Maud the witch didn't like the girl her son was courting she'd put buttons in their food – an old tradition. Nip a button off a bloke they liked and put it in the girl's food, so they'd never marry. She did it to Peggy when she was courting Ernie.

'Ernie was in the Air Force so he wasn't there at Christmas to get his slice of pudding,' Peggy told me. 'So I'd be round there and she'd say, "I've made my Christmas pudding. Ernie won't be here but perhaps you might get the bachelor's button, you might not get married." I thought, we'll see about that! So she's put it on the table and I've looked at it and I thought, I swear she knows where that bloody button is. And she said, "Wait a minute, I've left the knife outside." I thought right, so I turned the plate round – and I never got it. She was so surprised I didn't get the bachelor's button! Mind you, if I did get it, it wouldn't have worried me as long as I didn't swallow it.

'Maud was so against Gladys, gave her a very hard time. I liked Glad. We got on like that, Glad and I. She could get fiery. Your dad was always out drinking every night. You were left in bed. One night he hadn't come home, he fell asleep in the British Queen pub in Wanstead. He went to the toilet and fell asleep on the throne and they had locked the door, not knowing he was in there, and he was in there all night. Another time he came home drunk one night and she was in bed, and it was very late and he's got in bed and wants to start performing. And

she said no, she wouldn't have it, which she wouldn't. Anyway, he blacked her eye, he gave her a good hiding. So she thought, "Right, Maud thinks he's so . . ." So she went round to Maud's and when she opened the door Maud said, "Oh Glad, what have you done to your eye?" She said, "Take a good look at it, Mother, this is what your son's done." Do you know what the old girl said? "Well, you must have deserved it." She was always nasty to Glad. But your mum couldn't answer back.'

I don't think my father was very violent. I mean, he might have slapped her, but everyone got a slap. Women used to say, he doesn't like me any more, he doesn't hit me any more. They thought it was a sign of love. The trouble is, he was an East End bloke and you have to take into account time and place. That's the way blokes acted in those days. I'm not saying it was right, but that's the way it was. That's why people don't quite understand the Krays and what they got up to. They don't get it, but you didn't have much choice in life unless you went into trade, like a plumber or something. My choice was to be a car thief or a hairdresser. The idea of being a photographer was so middle-class, it wasn't even on the horizon.

I did know my mother hated my grandmother and wanted to turn me against her. She was always saying, 'You don't want to go over there, she's a witch.' It looks like my mother was right. When I was about six or seven she said to me, 'Oh I hate her. You hate her, don't you? Tell me you hate her.' So I said, 'All right, I hate her.' It was my first big lie because I liked her. She encouraged me to breed budgies and secretly gave me the money to build a birdcage, where I kept cockatiels, in the kitchen. She used to clean the pub on the edge of Hackney Marshes. She was a pub cleaner until she was ninety-two, I think. She lived to ninety-six.

Instead of my father being at home, I saw my mother's boy-friend George there a lot. At least, I sort of suspected he was her boyfriend, because I'd come home from school and George would be there. I thought, 'What's my dad's best friend doing round our house at four o'clock in the afternoon?' When you're a kid you know those things, but you don't really know. I never thought at the time they were having it off, but they obviously were. She thought he was posh. She told me to watch the way he eats, puts the knife and fork down in between mouthfuls, whereas in the East End they slap it all in in one go. He used to say dreadful things, used RAF terms like 'off like a flash, old boy.' It was all fake. I think he worked in a pub in Wanstead, where all the taxi drivers wanted to move to. I always knew he was a cunt with his badge on his blazer. Didn't tell her I thought he was a cunt, but I did.

Madame Maud of Hackney

My mother asked me, when I was about eight, if I would I like to go and live with Maud, my father's sister. In fact, Maud had suggested it because she could see that my dad didn't like me. And my mum recognized that, and thought I might be better off. I wouldn't have minded really because she had a daughter called Maureen who was twelve. To an eight-year-old she looked rather sexy. They're always tasty when they're a bit older when you're that age. Aunt Maud was a bit posh. She lived in Wanstead in a house with a garden backing onto Wanstead Flats, whereas we just had a backyard. Her husband was in the wholesale rag trade and was the first person I knew to get his clothes made in Hong Kong. Maud wanted to adopt me, but I said no because I didn't want my mum to be upset.

Peggy told me, 'Now, Maud was a very clever dressmaker and she had her own business in Hackney. She was known as Madame Maud of Hackney and she had a showroom where the girls worked on machines. She used to do wedding wear and evening wear. And then she had a shop next door where all the things were on show.'

Seventy-five years after Maud offered to adopt me, I travelled up to Norfolk to meet her daughter Maureen, now in her

eighties – the one I'd nearly left home for. I hadn't seen her since we were kids but she'd been sending me Christmas cards. The other purpose of the journey was to check out the Sainsbury Centre for Visual Arts, in the Norman Foster building on the campus of the University of East Anglia, where I was going to have an exhibition of my pictures. I took along my eldest son, Fenton, also my assistant, to film the interview.

We'd agreed to meet Maureen in the cafe of the museum. She wasn't difficult to spot. She was tall, dressed in a scarlet, full-length coat, her silver hair pulled back tightly into a bun on top. She carried a walking stick: she looked elegant, white-faced, imposing. It was lucky I hadn't been adopted by her mother in the end. I might have been given elocution lessons, though that was the least of what I might have suffered at the hands of Madame Maud of Hackney, according to what Maureen told us of her childhood. Madame Maud sounded like a very cruel woman.

JAMES FOX: *Lunch is ordered. A whisky for Maureen. She starts by showing Bailey old photographs of the family.*

MAUREEN: These photographs were taken in Jaywick Sands. We used to go there on holiday. That's your mother. That's you . . . You know, David, I've been wanting to meet you for such a long time. I wanted to meet you once before I died, just to talk to you. Look, there's Grandma playing cricket.

BAILEY: Is that my father? Good-looking, wasn't he?

MAUREEN: But he was a scallywag. I'm afraid so. I probably shouldn't say that. Are you sorry you didn't meet me earlier? I did send you Christmas cards.

BAILEY: Did you? I never saw them.

MAUREEN: How did you manage to see the last one, that I sent this Christmas?

BAILEY: I just happened to see it.

MAUREEN: I sent you Christmas cards every Christmas for about five or six years. It would have been nice to meet you when I had my decent clothes and I could walk properly.

BAILEY: I like what you're wearing now. When you walked in I knew it was you. It's nice to meet now, it's kind of exciting, like a bad David Lean movie . . . I remember you in the garden once, there was a red rose in that garden.

MAUREEN: Why were you frightened of me?

BAILEY: I wasn't frightened of you, I fancied you.

MAUREEN: I was always well dressed.

BAILEY: Can I say something? I think you're wonderful.

MAUREEN: Why?

BAILEY: You just are. Take my fucking word for it.

MAUREEN: Your mother gave you your first camera, didn't she?

BAILEY: Yeah, a box Brownie.

MAUREEN: Richard, my son, has got Daddy's box Brownie. It still takes photographs, apparently.

BAILEY: Is he a keen photographer?

MAUREEN: He's been to college to learn.

BAILEY: But he doesn't work in photography?

MAUREEN: No, he'd love to but he's got to get known. He's done weddings and, as I say, he takes things of stones and dead flowers. He put flowers in ice and takes photographs. Very strange.

BAILEY: No, it sounds good.

MAUREEN: Your hands are shaking, David.

33

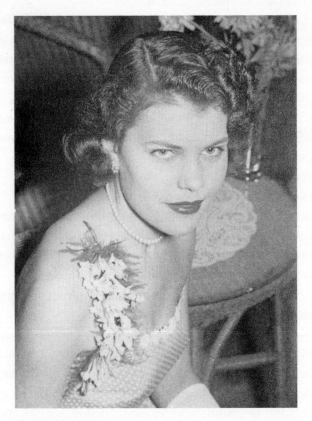

Cousin Maureen.

BAILEY: Masturbator's colic.

MAUREEN: It's no good telling jokes because I've got no sense of humour.

Lunch arrives.

MAUREEN: I've got to tell you I don't eat very much. This will be all I eat today. I don't eat a lot at all. I never have done. I don't have any breakfast or lunch. Sometimes I wonder how I've managed to live so long. Because I drink like a fish, I smoke like a chimney.

BAILEY: *[looking at a photograph of Maureen as a young woman]* You were quite beautiful in a way, weren't you? Nice bone structure.

MAUREEN: I was terrified of men, you know.

BAILEY: Why?

MAUREEN: I don't know, but I was terrified of men when I was young. They frightened the life out of me. If I had my life over again I wouldn't change it, I'd do exactly the same as I've done. But I would learn to drive.

Now, that's Glad. Your mother was very glamorous.

BAILEY: Do you think Glad was beautiful?

MAUREEN: Yes. Very attractive. She played the piano beautifully, by ear too. She used to play Mummy's baby grand. She would never talk about you. She'd never say how you were doing or what you were doing, which used to annoy me at times. I suppose she didn't want to boast about you because you were, let's face it, when you were younger, very successful.

BAILEY: Are you sure Glad used to play the piano?

MAUREEN: Yes. I'll tell you how I was absolutely certain she played, because I was learning to play the piano and I had to read the music and was finding it very difficult. And she

used to come over and sit down on that damn seat and play away and I thought, how can she do that, she's got no music! Of course, I learned afterwards she played by ear. She used to play 'Jealous' a lot.

BAILEY: She had a piano at home but never played it.

Glad didn't like the Bailey family much. The only ones she liked was you and Aunt Maud.

MAUREEN: That's because they didn't like her.

BAILEY: Why didn't they like her?

MAUREEN: I'm not telling you why they didn't like her. It's a secret. *[whispers to James Fox]* Because his father had to marry his mother.

BAILEY: Oh, I knew that. Because when they got married, I was born six months later or something.

MAUREEN: Oh, you knew that? I thought that was a secret.

BAILEY: So they didn't like her because she got pregnant?

MAUREEN: Oh yes. As far as they were concerned it didn't take two to tango. Which it does. I didn't want to upset you.

Your father worked in Polikoff's. He drank a lot, didn't he? And he didn't go home a lot. I don't quite know what to say. He wasn't a very nice person. I used to go there for tea a lot in East Ham and one day, things were on ration, he brought out this bar of chocolate and gave me a piece and Thelma a piece and he wouldn't give you a piece. So I gave you mine. I always knew he didn't like you.

BAILEY: I don't give a monkey's. I didn't like him much anyway.

MAUREEN: Well, I knew that, David. You didn't like him when you were a child – why should you like him now you're grown-up?

BAILEY: Your mother, Maud, liked me. My mother asked me
if I wanted to go and live with her. She'd said she'd adopt
me.

MAUREEN: You wouldn't want to live with her.

BAILEY: At first I said I didn't care. I didn't like my mother
much, to be honest.

MAUREEN: God, I had to live with Mummy for nineteen
years. I never saw any of my relations when I was growing
up because Mummy didn't want anything to do with them.
Except for Auntie Gladys, your mother. I don't know why.
Gladys used to come a lot to tea at our house, but she
was always very glamorous. When my father went into
business on his own and we got more affluent I wasn't
allowed to mix with my family. My uncles and aunties
were below me. And I wasn't to mix with people like that,
I was to mix with a higher society. And when I had my
twenty-fifth wedding anniversary I invited all my uncles
and aunties. My mother was furious!

BAILEY: But did you know she had a shop called Madame
Maud of Hackney? Peggy my cousin said she was known
as 'stuck-up Maud'.

MAUREEN: I don't know anything about that. But my mother
was quite rich too. She had two businesses. I went to
private school and I had elocution lessons, dancing lessons,
horse-riding, piano lessons – you name it, I did it. I went
to a school to learn to be a model; make your face up and
everything. I used to do ballroom dancing. I got a bronze,
silver and gold medal for ballroom dancing. But I haven't
got that any more, the burglars took it.

 She had the boy she wanted me to marry mapped out,
and I was going to marry well and I was going to be rich,

and that would have been the end of the subject, her job would have been done. She'd brought up a girl, educated her, she'd been to elocution lessons, and all this. When I got married, every other word was 'actually'. I'm not like that any more, am I, David? Totally different.

My mother hit me all the time. I remember once I bled into her baby grand piano, good God. She left me bleeding and saw to her baby grand piano. She hit me across the face because I was playing 'Chopsticks' on her baby grand piano. Oh, she was terrible. I never really liked her because of the way she was with me. You'd get up in the morning and she'd say, 'You've got to take your Shakespeare to school,' and I'd say, 'It's Tuesday today, I don't need the Shakespeare.' She'd say, 'It's Wednesday today, you do need it today, take it.' And it was no good arguing with her, and you knew very well it was Tuesday. So you used to have to do it. This is what it was like all my life. She bullied me all my life. And I could never do anything, I was stupid.

BAILEY: Who told you that, your mother?

MAUREEN: Yes. And when I won my first cup for flower arranging, she looked at it and said, 'This is no good,' and started pulling it apart! And this woman came along and said, 'What are you doing, Maud?' She said, 'This is no good.' She said, 'Leave that alone, she's just won the cup for it!'

JAMES FOX: It must leave you with some scars.

MAUREEN: I had Daddy. She suffered very much from migraines and she'd phone up the school and say, 'I'm going to commit suicide,' so the school used to send me home. So I'd go to the phone box – Daddy always gave me money in case I needed it – and I'd phone Daddy at his

place of work and say, 'Daddy, Mummy's going to commit suicide, you better come home.' He'd say, 'Don't take any notice, go and get yourself an ice cream and walk home slowly.' So that's what I used to do.

She was horrible. Nobody liked her, it wasn't just me. Daddy didn't like her either, not much. I told him to divorce her. I said, 'Get rid of her!' He said, 'No, I can't do that because of the boys,' – he meant my two children. I said, 'I can't see it will make any difference.' But he said, 'I can't do that.' But he didn't like her. I didn't love my husband when I married him. I liked him but I didn't love him. I married him to get away from my mother. Also I married him because Mummy hated the sight of him.

BAILEY: So did you have other lovers?

MAUREEN: No. I've only ever had one man and I don't intend to have another one.

BAILEY: Didn't you get frustrated?

MAUREEN: Why?

BAILEY: Because you didn't love him and you had to sleep with him.

MAUREEN: That was all right. Very nice actually. I haven't had the whisky yet, don't make me say things I shouldn't. My sex life was very good, if you want to know. I liked him. I had him doctored in the end because I didn't want any more babies. I had all my men doctored, had the dogs doctored as well.

I didn't go out to work until I was fifty. My husband Philip was made redundant; he worked for Thorne Electrical. So I went to work in Dickins & Jones in Regent Street. I started off as a shop assistant and ended up as the under-manager of the model hat department. I made

myself some really beautiful clothes for that. You had to wear black and grey. But I came down here and nobody dresses up. So I threw them all away. And now when I came here to meet you, David, I've got nothing to wear, have I?

I've got a picture of you with the Queen at London Fashion Week. And you had on a scruffy old jacket. I said, 'Hasn't he got anything decent to wear? He must have plenty of money.' Did you get an OBE or something?

BAILEY: CBE.

MAUREEN: What did you wear to get that?

BAILEY: I put a jacket on.

FENTON BAILEY: It was the bare minimum.

MAUREEN: Why do you look scruffy like that?

BAILEY: I'm not scruffy, I'm just comfortable.

MAUREEN: You went to the Rolling Stones' wedding?

BAILEY: Well, Mick was a mate.

MAUREEN: It said you wore a pale-blue velvet suit and you had a Rolls-Royce to match. I've got that on a piece of paper somewhere.

Chapter 4

Silly Class

My mother used to say. 'You'll end up like all of us, driving the
101 bus.' I thought, I fucking won't. I always felt sorry for 101
buses because they were always used in the negative. It wasn't
very encouraging, but encouragement was in short supply, from
anybody.

I was seven and a half when the war ended, and things didn't
really get back to normal until I was ten. I don't think I had
much schooling at all in that period. I don't remember learning
anything. Even without my dyslexia, it wouldn't have been dif-
ferent. But dyslexia added humiliation, although I didn't know
it was humiliation. Nobody knew about dyslexia or dyspraxia.
They just told me I was an idiot. I was told I was stupid every
day of my life. I just thought I was a stupid cunt. It wasn't until
I was thirty that they discovered what dyslexia was and I was
all right. I got tested by Mary Lobascher, the guru of dyslexia
who put me in the top 5 per cent of intelligence in the UK.
From one day being an idiot to next day being Einstein, it was
ridiculous. But I also began to realize that dyslexia was the best
thing that had ever happened to me.

I wasn't good at anything at my school, but I did get one
thing right. One of the teachers asked who built the Suez Canal,

and I said the French and they said, you're absolutely right. But I wasn't right. I just thought every foreigner was French! All I knew was that whoever built it wasn't English. Eventually, I was put in the silly class. I thought it was better to be top of the silly class than bottom of the smart class. They were all raspberry ripples in the silly class.

The fact is I didn't go to school much at all. One year I counted I'd been about fifty days in all. I always used to fuck off. Nobody really checked up on you. There was a school board man but you never saw him. I used to go to Wanstead Flats with a pair of ex-army binoculars I'd borrowed from my father so I could birdwatch. I wanted to be an ornithologist, but then I realized I'd never be able to learn the Latin names, so I swapped the binoculars for a bike. My father was furious.

My mother knew I was intelligent and she knew the school thought I was an idiot, so when I was eleven she sent me to Clark's College in Ilford, which I think cost about £8 a year, which was quite a lot. Ilford was quite posh, though still a bike ride away from Wanstead Flats on the east side. My mother thought I'd have a better chance at the new school. She was like that, Glad, she always wanted things to be better. I think she liked the word 'college' – she thought it made me different. She also thought the council school was rough and she didn't want me there. But, in a way, where I went was even worse.

This so-called private school was for lower-middle-class kids. Their fathers had tobacconist shops or they owned off licences or they were builders – there was a big building boom after the war. It was an awful school. Much worse than the council school. They didn't teach me anything either. And they hated me there. The headmaster used to embarrass me, make me stand up in front of the school and ask me to spell a word like 'was'

or something and I couldn't spell it. I spelt it w-o-z. Which to me still makes sense because that's how I see it. Then he used to give me the cane because he thought I was doing it on purpose. Because you can have a conversation and be intelligent about something but can't spell 'was', they think you're taking the mickey. You're not, obviously. Sometimes I would even spell David wrong; I'd put the 'v' and the 'i' in the wrong place.

The headmaster's name was Skellon and he was a real sadist. He'd become headmaster soon after the war. He used to have a cupboard about six feet high and full of canes stacked horizontally, graded by thickness, and you had to choose which cane he was going to cane you with – on your arse, not on your hands. I'd always go roughly in the middle. On sports day he took my shoes and socks away to make sure I didn't run away. I used to get into trouble because we couldn't afford the right uniform. Mine was made at Polikoff's by my father and it was the wrong colour brown. I didn't know I was being humiliated, I just thought they were real fucking arseholes at that school. But dyslexia taught me at least not to care what people thought. I did recognize that there was something wrong with me mentally, but I didn't feel stupid, I thought the teachers were stupid. The only one who liked me was the art teacher, a pretty blonde woman. I saw her necking once, with one of the other teachers in the toilet. I was envious of him. She was nice.

James found a biography of Skellon on the college old boys' website and it's a classic of that time:

> From the beginning it was clear that [Squadron Leader J.T.C. Skellon] was not to be trifled with and was not a man to suffer fools gladly. He imposed a discipline upon the boys which was wholly good. The visible evidence of this was in

the way the entire School [note capital 'S'] leapt to attention to receive the Head and any visitors who chose to visit. As is always true, the discipline gave birth to respect . . . Never slow to say what he thought, Mr Skellon's report on the occasion of successive Speech Days was noteworthy for its criticism of the slackness of modern youth and thought provoking in its remedial suggestions.

I wasn't there on speech day to hear it. I was probably slacking. But while all this discipline was going on, one of his masters was trying to put his tongue down my throat. He used to grab me in the corridor and say, 'Can you keep a secret?' I suppose I was twelve or thirteen. When his face came close I'd see all these tiny veins around his mouth and nose. I just used to get away from him. Until I was about twenty-three, I thought homosexuals always had broken veins around their nose. I was quite stupid then. To be fair to him, he also recognized that there was a mismatch between my intelligence or logic and my writing and spelling that didn't make sense. He thought I was different from the others. He was gay, he was an outsider. If you were dyslexic you were definitely an outsider too. He came to see my parents and said, 'I'd like to give your son private lessons because he's got potential and he's bright.' I didn't want them because I knew what he was after so I just said no to my parents. I couldn't tell my parents or the headmaster what was going on. My mother would have killed the teacher, even though I could never have told her he wanted to get his cock up my arse. Not that I understood this was what he wanted at that age, but I knew something was wrong. The headmaster wouldn't have believed me. You're between a rock and a hard place. You can't do anything about it. Eventually he just went away.

Up until I was thirty I had to keep my disability a secret. I was always trying to hide it. In fact, it would have barely been noticed in the places I started working, given the prevailing idea people had that you couldn't be able or articulate without an education. Beatrix Miller, editor of *Vogue* in the Sixties, used to tell me that all the time. She'd say, 'If you'd had an education you could be anything you want.' I used to think, 'Well, I'll be anything I want anyway!' I think being dyslexic makes you arrogant in a way too because you know you can do it, it's just that you can't explain it. For me everything is related not to words, it's related to visuals. That's why I was good at commercials. I can read a script and see it straight away. If I wasn't dyslexic I'd be fucked. Because if you tell me something, I see it as pictures. I don't see it as words. I know the words and what they mean but I can't spell them. I can see it but I can't write it down a second later. It completely goes. It's a nightmare really. What often throws people is that you can read; at least 50 per cent of dyslexics can read. It takes me four times as long to read a book than my wife, Catherine. I have to mark it carefully or I'd never find the spot again.

I think I can tell dyslexic people straight away. After reading *One Hundred Years of Solitude*, I think Márquez might have been dyslexic because I understand the way he writes more than any other writer. The easiest writer for me is Graham Greene because he manages in a few words to visually set you up. But Márquez is something else. It's a struggle – I'll have to read a page twice or three times – but I know the way he thinks.

I started experimenting with my mother's box Brownie camera when I was twelve or thirteen. Everyone had a box Brownie; it was really cheap. I used a roll of film over the summer holidays, and processed it in the coal cellar where we spent the war,

using my mum's baking dish. I nicked the chemicals from the science teacher at school. Longest eight minutes of my life, processing that film in the bowl of developer, waiting for the alarm clock to go off when it was ready. I always wondered why the prints were so scratched; they had train lines up them, but it's where I used to scrape against the wall in the cellar in the dark. I learned it all out of science books the teacher had.

I used to try and photograph the sparrows but I didn't know there were things like telephoto lenses. I couldn't understand why the sparrow was so small. I was so sad when someone broke into my house in Primrose Hill in the early Sixties and nicked the box Brownie and all my old cameras, including the camera I had in the Air Force. I had only used the box Brownie and taken pictures that one summer – I didn't take up photography again until just before my national service about five years later. And I wasn't so interested in photography when I was thirteen, as much as I was fascinated by the coffee coloured liquid of the developer and the fact that a picture came out of it.

When I left school at fourteen I had a series of jobs. The worst was a gofer, a coffee boy for the *Yorkshire Post* in Fleet Street. I cycled to Fleet Street every day from East Ham, which was a long way. The *Post* was printed in Yorkshire so I had to take some print blocks, mostly for advertisements, to King's Cross station every night. I started out taking a taxi but they never gave me enough money for tips. One taxi driver slung the threepence I gave him as a tip back at me – he thought I was keeping the money for myself. So I thought, 'Fuck this, I'll run instead.'

I worked for a week for 20th Century Fox. I wanted to be in

the media – I knew there was something about movies or news-papers that was more exciting than tailoring – but my job in the film business turned out to be pushing cans of film around to different buildings in Soho so I left. They only paid me about £1 or 24 shillings a week. Living at home, I had to give my mum ten bob, but she used to give it back to me sometimes.

I worked in Polikoff's factory for a bit as a time and motion study assistant. After that I went to work for Isaac Wolfson's company, Great Universal Stores. One of my dad's best friends was David Brown, who was a director. I was at Wickhams, part of Wolfson's empire, which was like the Harrods of the East End, a big department store. There was a little jewellery shop right in the middle of this great building and the jeweller, a Jewish guy, wouldn't sell, so they had to build the building around his shop. It's still there! At least the facade is. I think one of my aunts worked there – Claire, I think she was called – she was head of the restaurant. I'd get a big discount when I had lunch. I did everything, sold carpets – I hated that because of the dust – shoes, bedsheets. Then they moved me to work with a guy who went round collecting money and then they put me on bad debts.

I used to go round with Mickey Fox, who was also a boxing referee (from an old Mile End family of boxing referees) and a villain. He was balding, a bit on the fat side, an ex-boxer him-self. He was my guv'nor and I was his gofer and we'd try to get money out of people who owed the store. It was totally illegal because debt collectors were supposed to be twenty-one and I was only seventeen. But nobody seemed to bother in those days. You'd knock on doors only to be told, 'I can't pay you this week. You can take it out my arse if you like.' Which didn't mean fuck her up the arse, it means you can fuck her. I drank

more milky tea than I ever drunk in my life on that job. And I hated tea anyway. But if you didn't drink tea you didn't get the two and six. Two and six – two shillings and sixpence, the tosheroon – was the basic unit of the never-never debt business that we were promoting. We used to leave behind sheets and nylons, saying we'd pick them up the following week, because those were the two things that women always used. The next week we'd say, 'Where're the sheets and the stockings I left last week?' And they'd say, 'Oh, we used them.' So they went on the bill. All the tally men were on the fiddle. They were the first real villains I met really. There were canvassers who went around before you – they'd get an account going, and then you'd go in and collect the money. If you didn't know the people, you'd drop a ten-shilling note on the floor when they weren't looking, and then you'd pick it up and say, 'Oh, this must be yours.' And they'd think you were honest.

If you saw 'DS' on a doorway you'd know not to use it – it meant 'don't serve'. They wouldn't open the door, so I'd stack milk bottles against it and hang around out of sight until I heard the bottles crash, so I'd know when they were coming out. Shitty jobs. We used to shout through the letterbox, 'Pay your fucking debts!' so the neighbours would hear and it'd embarrass them. I didn't know at the time but these people never had any money. I didn't have much myself. But I used to put two and six in sometimes when they said, 'We can't pay,' because I got fed up going round in the rain.

I'd cycle in the rain for miles, getting soaking wet, all for two and six. I remember thinking, 'Shit, this is what the future holds.'

Chapter 5

The Barking Boys
(Where the Fuck Is Danny O'Connor?)

'What you've got to remember is, we were a bit ahead
of the game in the Fifties. When they talk about the
Sixties, we were before that. The movement was already
happening then in the East End. In dress, attitude,
everything.' DANNY O'CONNOR.

At school there was no one to relate to in a funny sort of way.
It wasn't until just before I left, when I was fourteen, that I
became friends with Danny O'Connor – we met at a youth
club – and then, when I was working at Wickhams, I met Charlie
Papier, who was the window-dresser. Danny and Charlie
were really into music. It was music, especially jazz, that was
changing everyone's lives. There was a big teen world brewing,
long before the Sixties, and we were part of it; a bit like the
world of *Absolute Beginners*, the book by Colin MacInnes,
set in the mid- and late Fifties at the time of the Notting Hill
race riots in 1959. That was the real start of the Sixties. Colin
MacInnes had spotted that the teen kids were taking over when
everyone else was writing plays about class war. They were in

revolt. The hero of that book is, by chance, a working-class photographer, long before my time.

We'd meet in milk bars, which were around before coffee bars, and were really just cafes painted white, where you could get soft drinks and snacks and sit about. Glad used to think that if you wore yellow socks and met in milk bars, you were suspicious. We'd also go to Lyons tea shops and ABC, large-scale cafes. The only place I ever ate out in the East End – apart from pie and mash on the street or fish and chips – was Chan's Chinese restaurant in East Ham High Street. I first went to Chan's when I was about fifteen in the early Fifties. Danny and I were regulars there. I still go there. The menu hasn't changed. They're all Chinese, oldest in the area. Chan's opened in the war, in 1941. A few things have changed. They used to have terrible cockney accents; now the owner speaks as if he's been to university. They didn't have tablecloths; the art on the wall was pictures with lights that rotated the images; there was one of a waterfall where the water was always cascading to the sound of music, in an ornate frame. I'm sorry they've got rid of those. When I brought Jean Shrimpton here I'd say, 'Don't fucking talk,' because she was too posh. I said, 'If you fucking speak like that you'll get us into a punch-up.' It was the place a lot of villains used to go. Their framed pictures are still on the walls, all dressed in suits, East End style, though I don't remember the Krays in there. They used to go to a Chinese restaurant in the Edgware Road.

I came back with a BBC documentary crew, not long ago, and they got all uptight because I called Kevin, who runs the place, 'China'. They didn't realize that 'my old China' is cockney rhyming slang. China plate – mate. They thought I was being politically incorrect, bunch of fucking wankers.

Sixty-five years on, Danny O'Connor and I are still mates; he's my oldest friend. He lives in Upminster. He's the smartest plumber I've ever met – a plumber in the real sense of the word: working with lead for many years, on roofs, on churches, until it poisoned him and he had to retire.

He's got a wife and a family. He's so respectable, Danny. Real middle-class. But he wasn't then. He was always smart, though, slacks and a jumper. I called him Nature Boy because he liked going over to Wanstead Park, liked the trees. He was always very gentle with women, poetic, always dreaming. It came from a song by Doris Day. Danny was a regular East End guy. Charlie wasn't. He was quite educated – he'd been to art school, which is how I found out that such a place existed. He was the first artistic person I met. Charlie was a French Jew; his parents lived in Aldgate and they were very kosher – had to light a candle on a Friday night, all that. His brother was a tallyman and a wise guy. He was three or four years older than our little gang and he was a big influence, though Uncle Arty had been the first big influence in my life. Uncle Arty bought me my first pair of brogue shoes. He brought back Maori records, a New Zealand choir singing that strange music. He gave me my first record. It was Frank Sinatra singing 'Stormy Weather' and it was unusual because 78s were usually 10 inches and this was 12 inches, so it was very precious because it was so big. It was very early-Fifties Frank Sinatra. Arty had a wind-up record player that he eventually gave me. He used to buy shawls from Malta for my mother, embroidered and always black and white.

Arty used to change his clothes several times a day. No one did that down the East End, but he was a sailor so I assumed it was because on a boat you have to be clean because there's lots of other blokes in a confined space. When we shared a

Danny O'Connor in the East End in 1959.

room – which was on the first floor – he'd often come in late and pissed. I'd be asleep until he climbed over my bed to get to the window so he could piss out of it, onto the roof of the outside toilet. He went to live in San Francisco in the Fifties. I never saw him again. He died in the Eighties of AIDS.

Going back to Charlie Papier, I remember him saying to me as I was getting on the bus at Whitechapel, 'Read books, you punk.' Then he said I would find out about this magical person who seemed to own art, called Picasso. Discovering Picasso, aged sixteen, had a big impact on me. His pictures showed me there were no rules. Once I found out a wheel didn't have to be round, it changed everything for me. I'd never thought of a wheel not being round. It was a way of thinking about something that doesn't exist.

Danny and Charlie were my two close friends, although they didn't know each other at first, because Charlie was from Stepney. I had two lives really: the Stepney, Whitechapel life after I left school when I started working in Fleet Street for the *Yorkshire Post*, and the East Ham life. Then gradually they merged.

The other Jew I knew was Michael Holland – I was told that all Jews who came from Holland were called Holland. He was part of our gang; so was Bobby Harrison, a drummer and quite a good singer who was later drummer for Procol Harum in their 'Whiter Shade of Pale' days. All my life I've been around Jews and Irish. You couldn't be more Irish than Duffy and Donovan, my mates and fellow photographers later in the Sixties. Or more Jewish than the painter Julian Schnabel and the photographer Bruce Weber, both close friends of mine although Bruce is the only Wasp Jew I know. He's kind of a Wasp but he's a Jew.

Our gang would sometimes meet outside Whitechapel station and find out where the party would be, whose parents were away. We'd go to parties in the East End a lot, all around Stepney Green, Bethnal Green and Whitechapel. We'd meet sometimes in a pub in Wardour Street in Soho for a stout and mild, buy a marijuana cigarette called a reefer on the street. They came ready-rolled and they were a tosheroon, two and six.

I discovered jazz through that gang. Everybody liked music; we all played something. Bobby sang, though at first he was shy. We used to have to get him pissed and lock him in the toilet until he sung 'Up the Lazy River', Hoagy Carmichael style. Danny played guitar, Charlie played guitar. Their heroes were Barney Kessel and Charlie Christian. I tried to play trumpet but I was tone-deaf. I used to go to lessons at Dansey Place in Soho, at 10 shillings a lesson, but I was no good. And it was through jazz, through record covers, that I got into art – that was the only art available in the East End really. Ornette Coleman had Jackson Pollock on his cover, which was sensational. In fact, jazz introduced me to everything. And the blues a bit, but more jazz in the early days. Dizzy Gillespie and Charlie Parker, particularly. There was an American Forces Network show presented by the Baron of Bounce who used to play Charlie Parker. I suppose Charlie Parker became one of my heroes. Stan Kenton was the first big band I heard of. I liked Duke Ellington, Count Basie. He was a genius, Duke Ellington. He was up there with Stravinsky. People don't seem to have heroes any more. Everyone's a hero for a week.

I was in a taxi in the East End and the driver said, 'Do you remember Charlie Papier?' I said, 'He was my mate.' He said, 'He died four years ago.' Charlie used to tell everybody he told me to do photography. Well, he didn't in fact, but it's a good

story. It's funny, I hadn't seen him in all those years, and then to get in a taxi and be asked, 'Do you remember Charlie Papier?'

So the only one left of my close friends from those days is Danny. Before Danny and I graduated to the jazz clubs in the West End – still younger than anybody there – we had our initiation in the dance halls of the East End, particularly in West Ham where there was always violence. There was the Ilford Palais, the East Ham Winter Hall – where they'd cover over the swimming pools and turn it into a dance hall – and just down the road was East Ham Working Men's Club where we used to go all the time, and where you'd be likely to meet the Barking Boys. You went there for a punch-up. You'd get into a fight there every weekend. I remember somebody tried to do me with knuckle-dusters there and I kicked him in the bollocks. He had to go to the hospital. He had a knuckle-duster so it was valid. That was rough, East Ham Working Men's Club. I once went to Whitechapel Hospital after a fight there. Someone ducked and I hit the glass window rather than him and my hand went through the glass. I went to the hospital to have it fixed but then I heard them calling the police so I left. Still got the scar there.

I started a fight by mistake outside the Blind Beggar once, by the cockle stand. We were standing around outside, eating off plates, and I had a shrimp I didn't like the look of. I threw it behind my back and it landed in someone's plate and he turned round and hit the bloke next to him. I said, 'Let's get out of here.' It was a fucking street fight. Time to leave.

People didn't ask you a question, in those days. If you'd cut them up on the road, they'd get out the car and come over and smack you. They didn't talk.

*

The Krays and the Barking Boys were the two biggest gangs in the East End. The Krays were more sophisticated, they beat you up for business, whereas the Barking Boys were gratuitous. They beat you up because they *could* beat somebody up. They were just hooligans really. Also the Krays didn't come down to this part of the East End, to Barking and East Ham, they operated more in Stepney and Whitechapel. The Barking Boys used to wear sunglasses and had little teeny cigarette holders. In their sharp suits they looked chic, almost Savile Row. They'd come up and say, 'Who you fucking clocking?' Next minute you're on the floor. *Smack*. No good trying to argue. They were all lightermen, they worked in the docks. That was probably the job everybody wanted, lightermen, because they made the most money. When boats couldn't dock, they'd go and get the cargo in the lighter boats and lots of things went missing by the time the lighter got to shore. They used to earn £40 a week when the average wage was about £8. That was astronomical. They were a closed-shop union; membership was passed from father to son, no outsiders. So lightermen had more money than God as far as we knew. The Barking Boys had a car even, an old Vauxhall. If I heard a car coming late at night I used to hide in a doorway in case it was the Barking Boys because they'd stop and beat you. They were always tough guys. They beat me up really badly, but once they beat you up and you didn't go to the police (you never saw police anyway, no point going to them), they looked after you. I remember seeing a girl I knew quite well (we'd get the same train to work sometimes) using eyebrow tweezers to pick a bloke's teeth out of one of the Barking Boys' fists.

Danny and I were very young when we first went to the dance halls with their imitation Joe Loss or Ted Heath dance

bands. I was maybe fourteen. I'd already started drinking. And started dating girls. But I was older – sixteen or seventeen – when I got my beating from the Barking Boys. I made the mistake of dancing with one of their girlfriends in the Winter Hall. She was kind of the belle of the East End. She looked like Snow White – she had black hair and blue eyes, which was unusual. I thought she was the most fantastic-looking thing I'd ever seen. I never shagged her. I tried. Terry Stamp was in love with her too, couldn't fuck her either. Terry lived up the road in Plaistow. I didn't know him but I knew of him because he wore a brown suede jacket. Not many people wore those.

I knew dancing with the girl was probably a dodgy thing to do. I was scared of the Barking Boys, although I didn't know till afterwards that one of them was fucking her. But you just dive in. Don't ask, you don't get. Three of the Barking Boys found me outside the Winter Hall later that night and kicked the shit out of me. They didn't punch you, they kicked you across the road. Suddenly all my mates weren't with me. I remember thinking, 'Where the fuck is Danny O'Connor, my mate?' They left me and I was knocked out cold. I woke up about six in the morning, lying near a Times Furnishing store, with the blackbirds singing and someone picking me up. The next thing I knew he'd stuck his tongue down my throat. I shouted, 'Fuck off, I'm not like that.' I thought, 'Fuck this, talk about out of the fire and into the frying pan.' I was pissed off that Danny O'Connor and his mates had disappeared.

Stamp met the girl ten years later and she'd emigrated to Canada and married a bank clerk or something, and got very fat. So I was saved from that one by the Barking Boys beating me up.

★

JAMES FOX: *We met up with Danny for lunch at the Sorrento Restaurant, his favourite place to eat in Upminster, out eastwards from the East End towards the M25. Danny's house, where we went first, is kept immaculately clean by his wife, Jill. He showed us round the garden, where a prize-winning marrow was concealed under a large leaf. Danny moved here in his early twenties when he started his family, but he's still an East End boy.*

'I loved it. I absolutely loved it. I loved East Ham,' he says when we sit down. 'Loved the people. In fact when I moved up here, I pined for East Ham for two years. I kept saying to Jill, "Can we move back?" But of course this is a great place to live. Believe it or not, in my life, in the building sites and wherever I've been, I've met people I don't know, and I know they're from East Ham. It's uncanny. I don't know what it is, but there is definitely something.'

And so the lunch continued along these lines.

O'CONNOR: *[to Bailey]* It's great to see you. Nothing's changed.

BAILEY: My dick's got shorter.

O'CONNOR: Well, I can't comment on that. I was remembering the all-night parties we used to have round your place, when we were very young. I don't know what happened to your mum and dad – they used to go away?

BAILEY: I don't know. I never saw my father. He used to think I was queer because I wouldn't wear Brylcreem. Used to get quite angry about it. To me it was the other way around; he was the one who was a bit queer. And then when I became a vegetarian at thirteen, that was the end of our relationship, I think. You didn't like my father?

O'CONNOR: I didn't dislike him. He was a character. Bit of a bugger, wasn't he, with the floozies? I used to see him walking down the high street with a floozy and we'd shout out, "Wahey," very loud. I had the little Austin 7.

BAILEY: I remember that. People think it was an antique. It wasn't. It was your fucking working car. Would be worth about thirty grand now.

You do lose touch, but of our gang I saw you more than anybody else. Bobby Harrison just wrote to me after sixty years. I'm going to take his photograph. Michael Holland, never seen him. He wouldn't talk to me.

O'CONNOR: Well, we don't want to discuss why Michael wouldn't talk to you.

BAILEY: What, his wedding? I was supposed to be his best man, but I was giving Jean [Shrimpton] one down in a haystack in her house in Buckinghamshire. I said to him, 'Well, what would you do, would you be best man or do Jean? You fucking work it out.' So he never talked to me again.

O'CONNOR: Yeah, we were all there at his wedding and you were due to turn up, but you didn't and no one knew where you were. Including your wife Rosemary.

BAILEY: Was she there?

O'CONNOR: Well, I mean, a woman scorned really. She was phoning me up, 'Where's Bailey? Can we meet?' She wanted to see me to try and find out more. But you did turn up to my wedding – you were my best man in 1963. We got married at Ipswich and you brought along Jean, your new girlfriend. She was a lovely girl. Wouldn't have her picture taken. Didn't want to steal the limelight. That's the kind of girl she was.

BAILEY: She was very county, Jean. I'm called Bailey because of Jean. She went out with public schoolboys and they were all called by their surname and I got lumbered with it.

O'CONNOR: *[to James Fox]* I can't call him Bailey. I can't. I have to call him David.

BAILEY: But Bailey's become my name. If you say 'David', I wouldn't turn around.

O'CONNOR: There's no way in the world I could say it.

BAILEY: If you said, 'Oi, you cunt,' then I'd turn around.

O'CONNOR: In our day, that would be so rude to say someone's surname.

JAMES FOX: Back in the early days were any of you at school together, your gang?

O'CONNOR: No, we went to different schools. We were only a few streets away from each other. I met David when he was fourteen in Vicarage Lane youth club. But I remember David saying he wasn't going to do much more of it because it seemed to be leading to subjects like religion. All we were interested in was music, girls, the odd drink, and just getting out and enjoying it. But the next week they had a dance there, and it was our first introduction to a little bit of dancing with the opposite sex, and after the dance I remember us looking at each other and – without us saying anything – from that moment we were looking round East Ham for the dance halls. We thought this is the way to go, dancing with girls. You could hold a girl, couldn't you? And we were the youngest there, weren't we? Three or four years younger than anyone else. Sometimes our age was a little bit of a let-down, perhaps we looked a little bit young. I was only thirteen, David was fourteen. But we were quick off the mark, and that's when we went

to East Ham to the Working Men's Club down the Barking Road. Used to go there a lot and that's where we met the Barking Boys. The Winter Hall was fabulous on New Year's Eve – had a balcony, the silver glitter balls.

FOX: I was going to ask how you were dressed when you went to these dance halls.

BAILEY: Very smart. Bilgorri suits. Or we'd like to think. He made the suits for the gangsters. And ties.

O'CONNOR: Pin-sharp.

BAILEY: Even a stiff collar.

O'CONNOR: White stiff collars.

FOX: Where did you get your suits made?

O'CONNOR: I got mine in Manor Park. There used to be a really good tailor's in there.

BAILEY: I got it off my dad because he worked with Polikoff's.

O'CONNOR: Although our mate Michael was a tailor, I don't think we ever had anything done with him?

BAILEY: No, too expensive. They were quite good, the suits. If I remember, about ten quid each. It seems a lot now. It was the forerunner of the Mods. The Mods were trying to look like East Enders.

FOX: There's an interesting mixture between the elegant dress code and the violence. Everyone who hit anybody was always dressed in a nice suit, like the Krays.

BAILEY: You figure if someone was dressed well they wouldn't get into a fight because they would be scared of fucking up their clothes, but it wasn't true. They'd hit you anyway. The Barking Boys hit you for anything.

O'CONNOR: Waiting for somebody to take the mickey.

FOX: If you get beaten up by the Barking Boys, how great is the damage?

BAILEY: Well, I was out cold all night.

O'CONNOR: They'd knock you out. But we didn't consider it malicious.

FOX: But that's pretty dangerous. You can kill someone if you kick them in the head.

BAILEY: They kicked the shit out of me, three of them.

O'CONNOR: I met up with them years later, on a job. They were on the building sites and they said they outed some of them from their group because they were too rough. I knew them for quite a few years after that, working with them on jobs.

FOX: Had they changed at all?

O'CONNOR: Yeah, grown up. We were just kids.

[The conversation turns to Bailey's many girlfriends from this time.]

BAILEY: Molly Rodder. Martin Harrison interviewed her when we were doing one of the books, and she said I said to her when I was fourteen and she was fourteen, 'You better get my autograph now, because when I'm older I won't have time to sign.' She was good, Molly. She was still in East Ham thirty years ago. The one I really fancied was Helen from Wapping. Her father chased me down the street once with a kitchen knife when he caught me in her arms; might have had my dick out, I can't remember. I got away rather quick. 'You little bastard.' I liked her. Used to call her and her friends the Moon girls.

FOX: Why was that?

BAILEY: They all dressed the same in French Resistance raincoats and black berets and black stockings, very stylish. This was before Saint Laurent. And there was that crazy girl at The Lyceum who used to give me a blowjob.

O'CONNOR: I refuse to enter this conversation, I never knew her.

BAILEY: I did. I got a lot of blowjobs.

O'CONNOR: David hasn't got much of a filter. He says it as it is. And he's always been the same. This is him. We've been out and I've been next to him on the dance floor and I've heard his conversation to the girl he's dancing with, who he's just met, and I can't repeat what he says, but it's not the normal . . .

FOX: Fairly direct?

O'CONNOR: Oh, you can well imagine.

FOX: Did it work?

O'CONNOR: Yeah, a lot of the time. Because he kept doing it. I mean, it was out of order, barely believable. This is at a young age. I was spellbound. I wonder he didn't get bashed round with a handbag.

FOX: Could you give him a sample?

BAILEY: Don't remember.

O'CONNOR: So direct. Straight in.

BAILEY: Honest. Ask people what they want; if they don't want it, you know where you stand.

O'CONNOR: I'm going to have to whisper this. *[whispering]* That was your approach!

BAILEY: 'Do you want to fuck?' Well, yeah, then you don't get into trouble, do you? If they say no, move on.

FOX: What sort of success rate did you get with that question?

BAILEY: They all said yes.

O'CONNOR: Also he could scare a lot of the girls on the train. I know that first-hand because they told me. The girls in the early days, they thought he had a frightening stare. We all know it as 'the Bailey stare'. My wife, Jill, we've been

married about fifty-five years, and she remembers you on the train. She said, 'He used to frighten me. He used to stare.' But once again, I think the computer brain was going, you were seeing things as we were going along in your memory, up top somewhere. You were locked in on something. You probably didn't know you were staring. In our day that could be dangerous – a bloke comes along, 'What you looking at?'

BAILEY: Especially with the Barking Boys. We used to get smacked a lot, people saying, 'Who you fucking looking at?'

FOX: Danny, do you remember Bailey dancing with one of the Barking Boys' girlfriends?

O'CONNOR: Oh yeah. She was beautiful. Not that tall. David had a habit of flirting with other people's girlfriends at a young age.

BAILEY: I didn't know she was his girlfriend. Well, I thought he'd probably got his leg across. But I didn't know for sure.

O'CONNOR: No, but this was a recurring thing, it didn't just happen once. But nothing sinister or anything like that; it was just law of the jungle out there, of the East End. We were a bit of a target for the older blokes, I suppose, because we were so young. But we braved it out, stood firm.

BAILEY: Terence Stamp went out with her. He didn't get beaten up. I wondered what happened to you.

O'CONNOR: Well, I think I was probably out of it anyway because I was walking along the Barking Road and all of a sudden I ended up in the middle of the road. Somebody punched me on the side and then punched me right into the road.

We got out of the local dances. We very quickly moved uptown. So by the time we were fifteen we were up in the jazz clubs in London, the West End. Nobody else from East Ham was going up to the jazz clubs. We were progressing really quickly. We never met with the Barking Boys uptown, did we?

BAILEY: They didn't go to the jazz clubs. They were East End. I think they considered it a bit arty.

O'CONNOR: The Flamingo jazz club had just opened, in 1952. In the basement of Mapleton's Hotel in Coventry Street. It was opened by Jeff Kruger, and Billie Holiday sang there in 1954; then it moved to Wardour Street in 1957, when you were in the Air Force. We went to the Florida at the Café Anglais in Leicester Square on Saturday nights. We were by far the youngest people there, at least two years younger than anyone else. We were part of the furniture. We didn't cause any trouble because were out and out for the music. All the years afterwards we had wonderful musicians coming through; the diversity of it was incredible. So many different musicians, so much talent. Saturdays they had all-night jazz.

BAILEY: We used to walk home sometimes from the West End to East Ham. It was getting light by the time we got home.

O'CONNOR: I'm not quite sure whether the war years had anything to do with it, but it was a beautiful time, I thought it was, the Fifties, so beautiful. It was like electricity, tingling, stardust in the air. There was a certain sort of energy, a goodness in the world. You just met so many people. Because when you're young you haven't got any mud stuck on you, you don't judge, it all rolls over you.

[to Fox] I'm amazed in a way that Dave has never changed. Still the same person he was when I first met him. And I think that's remarkable, absolutely remarkable, and I take my hat off to him. I don't know many people like that. Absolutely amazing. *[to Bailey]* What I want to know is, how do you feel about success, how have you managed it? Because I couldn't.

BAILEY: Couldn't you? I'm still working on it, being successful.

O'CONNOR: That takes something, I would have thought, to be able to handle it.

BAILEY: I was lucky because I got successful really quick. I was twenty-three or something.

FOX: What did your father think of your success?

BAILEY: Never mentioned it really. Thought you were showing off if you said anything about it. You couldn't mention who you were photographing because the neighbours would think you were name-dropping. There was no idea of success. People from the East End didn't have success. Success was getting an off licence or a second-hand car business. People had no classifications for photography. My dad thought you only took pictures on holiday. Even ten years after I was at *Vogue* – so late Sixties – I'd bump into cockneys and they'd say, 'Still on the smudge, Dave?' If you did Brighton Pier or Southend, you were on the smudge, because all the pictures were always smudgy. I had a dog called Smudge. Lots of people went on the smudge on the boats because you could get laid a lot. Get lots of business, get fucked as well.

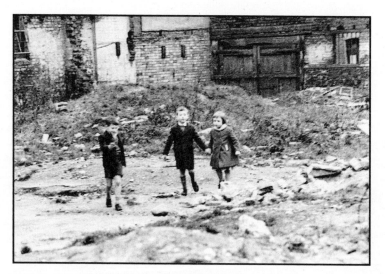

Children playing on an East End bomb site.

*Danny O'Connor (left), Charlie Papier
(centre) and me in 1959.*

Chapter 6

Silly Sods

Nobody did national service out of our mates. I was the only one. Danny got an exemption because he was an apprentice. When I was called up, at the age of eighteen, I went to Wanstead for the medical, hoping to fail. The doctor didn't care that I'd had measles as a kid. I wasn't flat-footed, which seemed to be the most important thing, so I tried to make out I was gay. He said, 'What's your favourite sport?' I said, 'Ping-pong.'

I didn't like sport, I always thought sport was stupid. They knew all the tricks, though, and I passed A1. I chose to go in the Air Force because I didn't want to be lumbered at sea or in the infantry in the Army. I'd heard that the basic training was tough, then afterwards it was easy. I was sent to Hereford on the River Wye and then West Kirby near Liverpool.

I was never any good at square-bashing. I remember a red-faced NCO screaming at me, hot smelly breath in my face: 'Does your mother know you're a cunt?'

'Yes, sergeant!'

'I'm not a fucking sergeant, I'm a corporal.'

A favourite punishment was to make you run three times round the parade ground, your rifle held up over your head. It sounds quite easy but I couldn't manage more than half a circuit.

At night, trying to sleep, you'd hear boys crying, and some people killed themselves. Every other day I'd be on night patrol, which was spooky. The worst bit was patrolling to the wash house, which was where people chose to hang themselves. I never saw a body but I was always scared I might. Training culminated in a 14-mile march over the Brecon Beacons in the dead of winter, just a cape to cover us and our rifle. Towards the end I kept seeing people in stretchers going the other way, back to camp.

After basic training I didn't want to be stuck at Northolt on 24 shillings a week, but to go abroad I had to volunteer and take another medical. After telling me to take my shirt off and sit on a chair, the doctor said, 'How do you feel?' I said, 'I feel fine.' He said, 'All right, you've passed.'

First we were told we were going to Suez. This was right at the time of the crisis, in 1956, when we invaded Egypt, along with the French, to regain control of the Suez Canal. When our plane landed in Tripoli our commanding officer told us, 'You're not going to Suez any more, you're going to the Far East,' but he didn't say where. The crisis was over. The Americans had ordered us to pull out. We've never really got over that humiliation of getting our wrists slapped by the Yanks.

It took six days to get to Singapore because you couldn't fly at night-time and you couldn't fly over foreign territories. When they make films about the military they never show how boring it is – the eighteen-hour train journeys, the sitting around in railway sidings or airports. We weren't popular abroad. We got booed in some of the places where we landed. In Karachi, in Pakistan, I was stoned by some youths aged about thirteen to twenty. We weren't supposed to leave the barracks but I walked out with a Welsh guy to take a look round the city. Suddenly

we were attacked but a Pakistani student said 'Follow me,' and
we ran through a cinema and climbed out the back through the
toilet windows. I was quite good friends with that Welsh boy.
I remember later on Bugis Street, which was out of bounds in
Singapore, he told me he wanted to have a whore, and asked,
'Will you pay for it?'

'Yeah, all right,' I said, 'but why don't you have any money?'

'Because I'm saving up to buy my girlfriend's engagement
ring,' he said.

So I did. I paid for it but I never went with a whore. I went
to brothels but I never fucked anyone.

Singapore was a British colony – an island at the tip of
Malaysia, which had been handed back by the Japanese in
1945 after their occupation. It has a causeway to the mainland.
It was invented by the British, Singapore. Before that it was
nothing, just little fishing places, not even a village. When the
English came in they drained it and set up a military base. It
was the nastiest place in the world – certainly then – and the
hottest. In 1956 they were getting their 'Merdeka', their free-
dom, and they used to have these terrible riots. In town people
used to get blown up. There were still lots of CTs there, com-
munist terrorists. They used big knives to hack people with – a
machete with a bit of cow hide around the handle. I bought
one from a market. I've still got it.

It was the end of everything, empire wise. It started in India
in 1947 and got to Singapore when I was there ten years later.
We were on stand-by for riots, but because the Army were
there too and had two jungle rescue units, we never had to do
anything.

I was based at Changi aerodrome, right on the tip of Singa-
pore, which had been built not long before by the POWs who

the Japs used as slave labour. Then we put the captured Japs to work on it, to finish it after the liberation, to put steel strips down on the runway.

I was called an AOG clerk – everything was initials, still is in the military – which means an aircraft-on-ground clerk, which sounds terrible but it was a great job to have because all you have to do is service the planes when they land so they can take off again. Make sure they refilled it, check the batteries, little things like that. LAC (Leading Aircraftsman) Bailey 5027034. They said you'll never forget your army number and I never have forgotten it.

I kept in the lowest rank I could. You started as an ACM then you became a leading aircraftsman. If you went up one more rank, you had to take responsibility for what you did and I didn't want that. 'What, me? No, sarge, I'm not responsible.' As soon as you get rank you're given responsibilities and then they've got you. I did as I liked, really, in the Air Force. I didn't really take national service that seriously. I had a great time. I had my own hut on the runway, didn't have to wear a full uniform, just shorts, and I could bypass the road and walk from my billet through Changi swamp to get there, which is now their main airport. It was full of mudskippers, the fish that use their flippers to walk. And monkeys, big ones.

I had six coolies working for me. Can't call them that now. I had a three-tonne truck I could drive. I didn't have a driving licence, but I drove, having learned on Danny O'Connor's old Austin. When we had an AOG, aircraft on ground, I could break the speed limit driving between the stores and airplanes to get more batteries or something. We had this form called 'surplus to requirement'. It was a magical form that made things disappear. Even Sergeant Bilko couldn't have invented it. Everything in the

Air Force has a form. Your fucking belt would have a form. A toothpick would have a form. So if you lost anything, you just wrote out a form that said 'surplus to requirement' and it was forgotten. We lost a Vampire jet once. It wasn't lost, strictly speaking, it had gone to another station but we didn't know which one, so we just wrote out a 'surplus to requirement' form. I think the planes were about £75,000 in those days. And a Sten gun was 17 shillings and sixpence – about £20 now.

As an aircraftman, you were government property and you got done for damaging government property – if, for example, you got sunburn. And people did get sunburn badly. If you got sunburned you got three days' jankers, we used to call it. You had to report to the guard room every hour in a different uniform, which was not good because it was about a mile away and you had to walk in the heat of the sun.

Singapore has probably got the worst climate in the world – so hot and humid it was hard to breathe. The monsoon season lasted three months. If you put a pair of shoes in your cupboard overnight, the next morning they'd be green with mould. After a week, they'd be unwearable. It was hard to sleep at night, with fifty men on my floor of the billet, open doors to let the air in (unless it was monsoon season, when they were closed), noisy fans going all night, men on night shift coming in and out. I woke up once with a weight on my chest and saw a big black rat sitting there staring at me. It's the biggest shock I've ever had. And only officers and sergeants had mosquito nets. I went to see the doctor about malaria, and the bloke said, 'Oh, if you haven't got it bad, take a day off and drink some quinine.' It seemed to come back every six or seven years after that. It didn't disappear until the late Eighties. You get a headache and you sweat like you can't believe.

I decided to do a parachute course. You don't really think about it when you're nineteen; it's just something you do, being young and fucking stupid. We trained for about a month before we made our first jump. They used to pull you behind a slowly moving Jeep while you learned to struggle out of the parachute. Get out quick. In Malaya, because it was too windy for balloons, we'd jump off the top of a hangar, attached to a propeller contraption that slowed our fall. That was scarier than jumping off a plane as the ground was so close. After doing that about ten or twenty times, they'd say you're fit to jump out of a plane. I roll automatically now when I fall over – I've saved myself a couple of times since. In Dartmoor recently I fell and just rolled over and didn't have a scratch. My wife, Catherine, was pretty impressed. They train it into you, they drum it in, just repeating it and repeating it.

Wartime jumping is from 800 feet and peacetime is 1,000 feet. We used to jump out of Valettas, which in America is a DC2. The worst were the first jumps, standing alone in a doorway. After that we did crocodile jumps, where you're all in a row and if you refused to jump they just slung you in the back where the toilets were and you went on the next round. They didn't waste time on someone panicking, they just yanked him aside and pushed you out. The red light used to go and a bell, and they'd shove you. I mean, we'd jump anyway because you'd done a month's training. It was a bit of a lark really.

It only took fifty seconds to reach the ground at 1,000 feet, so it's not too long to enjoy it. The thing you want to hear is the bang as the parachute opens. You had a little back-up parachute on the front that used to cause more accidents than not. People would pull it when they didn't need it, because they'd panic that the big one wouldn't open, then the two became tangled.

On the first jump we made, we arrived at the jump-off point at about four in the morning and at five o'clock they made us sign a will. That was the first time I'd signed a will! Nobody got killed or anything. One bloke broke his ankle, but that was normal. Doing the course meant I could wangle it to jump whenever I wanted. I didn't want it very often. I suppose I did about three or four jumps without permission. It was fun, especially with the Gurkhas. They used to throw up while parachuting, last night's curry coming out the hatch. They hated aeroplanes. It was less fun servicing the plane after they'd landed, vomit everywhere.

If you weighed just eight stone like the Gurkhas, you'd get the same sized parachute as the rest of us, but you'd come down a bit slower. Being light, the Gurkhas used to drift off, missing the landing zone and coming down in the jungle. We didn't like doing things with the Gurkhas because they were always so professional and so together. On parade we looked like Dad's Army whereas the Gurkhas looked so smart with lacquered boots. I used to call all the parades and marching 'playing silly sods'. 'Are we playing silly sods today?'

We were always playing silly sods. About ten of us would be sent to escort the ammunition train from Singapore to Kuala Lumpur. We'd be issued a fucking First World War rifle, a .303 with five bullets in a sick bag. You weren't allowed to put the clip in the rifle. You'd get three days on charge if you did. You could only put the bullets in if the officer told you to load up the rifle. The whole thing was so ridiculous. If we'd been attacked we wouldn't have stood a chance. We'd have to find an officer to tell us to put our bullets in the gun and we'd be well dead by then. We were more scared of losing the rifle than we were of being shot at by terrorists. If you lost the rifle it was

75

twenty-eight or thirty-eight days inside. We used to sleep with the rifle between our legs, the strap around our hand. That trip took eighteen hours on the train – small-gauge, Malayan and very bumpy.

I preferred doing escort duties with a mate of mine called Crazy Jones. There were a lot of different people doing national service, people I'd never have met in the East End. Some of them professionals – some musicians, photographers. The musicians formed a jazz club in Changi. I was friends with all the people in the band, I used to hang out with them. Crazy Jones was a bass player and the first kind of hippy I ever met. My mates in the East End were pretty cool but they weren't like hippies. The first cool white guy – there was lots of cool black guys – was Hoagy Carmichael as far as I was concerned. He was almost like Humphrey Bogart, had his hat on the back of his head, fag sticking out of his mouth, and he wrote 'Stardust'. He was fucking genius. Crazy Jones sort of had a hump, bent over from carrying his double bass, and used to do all that jazz talk, like 'cat' and 'cool' and 'yeah, man'. He was a lorry driver as well. I used to be his escort when we took ammunition by truck to Salito, meaning he drove and I sat next to him with a Sten gun. Again, I couldn't load it, I had to keep the bullets separate. It's the most primitive gun you've ever seen, the most inaccurate. It's really for close-up killing, that's why you had it in a truck – a three-tonne lorry full of shit. It wasn't always ammunition we were transporting; sometimes it was tubes of gas, which was very dangerous because they used to blow up. So you're talking *Wages of Fear*. We'd wear rubber shoes and they took away everything from us that could cause a spark. It was quite a long drive through the jungle, from Changi to the camp at Salito. We'd get the day off, stay over in Salito or come back that night.

We used to go up Fraser's Hill in Malaysia, do this thing called 'ambush' – supposedly training for jungle warfare. It was more playing silly sods, but lots of guys really got into it, crawling through the fucking jungle for three days, covered in leeches, pretending to be soldiers. And you knew if anything real happened you wouldn't stand a fucking chance. I'd be creeping through the undergrowth and someone would shout, 'Ambush' and from about 18 inches away a rifle would come out of the bushes and I'd think, 'Fuck this for a game of soldiers.' I learned very quickly: don't get wounded, get killed. If you got killed you were handed a red armband and you could go back to your billet and sleep for three days. If you got wounded they started putting bandages on you and hoisting you up in helicopters. There's no way at the end of training you were really going to be able to fight in the jungle. But it got you out of station duties.

The Air Force was my first encounter with the class system. Most of the officers were really snobby. They didn't talk to you. Coming from the East End, I had never met posh people before. It amazed me that in the Air Force there were three different toilets: one for the ranks like me, one for non-commissioned officers and another for commissioned officers. You weren't allowed to use the other toilets. When you're eighteen you're thinking, 'I don't get this – my arse must be a different size to an officer's arse.' The officers liked me, nonetheless. I charmed them. I'd done parachuting and they hadn't, and I used to read books by Steinbeck, Hemingway and Dostoevsky, and all the usual crap they all read. And Anthony Burgess. He was one of my favourites, him and Graham Greene. I read a great deal, especially in the Air Force because

DAVID BAILEY

I had fuck-all to do. Also I was lucky because my command-
ing officer was a kind of mate. He was quite young. He was
the only one I ever talked to. I used to get charged with dumb
insolence, which could be anything from pretending to salute
then scratching your head to looking at an officer like he was
a cunt. It was a hard charge to disprove when the evidence is
just your expression. After I'd been marched into his office, the
CO would ask, 'Guilty or not guilty?'

'Not guilty.'

'Why are you saying you're not guilty even though you're
clearly guilty?'

'Yeah, but if I say I'm not guilty I might get off.'

He'd often just say, 'Fuck off.'

I was very fond of playing the trumpet. I could knock out
'September Song' in C, I think, but that was about it. I lent my
trumpet to the art officer, who said he wanted to draw it. When
I asked for it back he said, 'Oh, it's been stolen.' There was noth-
ing I could do, with an officer and a gentleman. What are you
going to do? You're fucked. No one was going to take my word
for it. There was a lot of that in the Air Force, that class system.

I was no good at playing the trumpet, so I'm glad he
nicked it in a way – or lost it. It meant that I spent more time
doing photography. In Singapore, which was a free port, my
24-shillings-a-week wage was worth probably three times as
much as in England and I actually had enough cash to buy
things. That's why I was able to afford my first proper camera,
a second-hand cheap copy of the Rolleiflex. As well as my
cheap Rollei I had a second-hand Canon, which was a copy of
a Leica. I could tell which film came from the Rollei because
when you processed it, the line around the edge was all fluffy.
The camera had fluffy black velvet inside it to stop the light.

That one picture of me in my billet in Singapore with an almost shaved head, the Picasso print on the wall (which is in this book), was taken by me, by accident. That picture of Picasso was a provocation: 'you think you're better than us.' Most blokes were just waiting for Friday and Saturday night to get drunk, and spent the rest of their spare time lying in bed. They were country boys who shovelled food into their mouths with their knives and didn't like cockneys or Glaswegians because they assumed we were all villains. I remember the Glaswegians carrying little shivs – a bit like the East End gangs. I got into a few fights but, although the country boys were hampered by fighting clean, they were huge with punches that could knock you out. So I challenged them instead by putting up a fancy Picasso picture when they had photos of Bardot stuck up by their beds. I remember I read Henry James and Chekhov then. I read every day for at least an hour.

There were lots of anoraks in the Air Force who taught me about photography. Then I suddenly realized that there was a technical side to taking photographs that you could learn. I never thought I was capable of learning it before. They taught me how to take delayed action shots. The mechanism was clockwork in those days. You'd switch it on, and you'd sit there and let it take the picture. There's only one picture – one take – because a roll of film was expensive and I couldn't afford to take more. I used to go to the Chinese pawnbroker every two weeks and hock my cameras to pay for the processed film, then when I got paid I'd be able to get my cameras back. I'd take some pictures again, then hock my cameras again. They weren't worth much anyway. I still have my Chinese hock tickets.

In the Air Force I learned about photographers like Bert Stern, who photographed shoes. I later became great friends

The anoraks in the Air Force taught me about photography.

with him. The two images that changed my life were Picasso's portrait of Jacqueline Roque, which made me realize you could do anything, and Cartier-Bresson's four ladies of the Himalayas, which was such a magical image I couldn't believe it had been made with a camera. I saw Stern's and Cartier-Bresson's work in magazines, mostly American, which I borrowed from all those geeks there who were into photography. Photography was like computers are today. I suppose, in a way, you were a very modern man if you had a camera. But that didn't appeal to me. I just thought it was a nice way to make a living.

I loved it in Singapore. Bugis Street was out of bounds to all of us, but you'd go and dodge the military police. It's where I first saw transvestites, because all the good-looking girls were men. Afterwards in the Sixties I used to go to Singapore to do Singapore Airlines ads. 'Singapore girl, who are you?' I think that was the quote for the campaign. It was funny going back as a civilian. The air hostesses used to wear Band-Aids over their nipples, so when the wind blew they didn't show through the uniform.

I had a girlfriend, Delphine, the best-looking WAAF in the Far East. She had big tits. I'd never had a girlfriend with big tits. I've never had a girlfriend since with big tits. I never liked big tits. I liked girls that looked like boys. She had a Vidal Sassoon haircut long before Vidal Sassoon. The first time I saw her I was having breakfast when she walked by. I remember thinking, 'Oh, she's a bit of all right.' And somehow we got to know each other and she became my girlfriend there. She was a rarity. Most of the girls on Changi station were lesbians or they were all married within six months or pregnant and sent home. It was a way of getting a husband, I guess.

I used to get in a lot of fights over Delphine. There was a Kiwi in love with her too, a pilot who used to fly with the Kiwi Red Devils. He said, 'I'll take you up' because he wanted to show off and give me a fright. He was twenty-two, and I was nineteen. So I went up and did aerobatics – that was unbelievable. In a Vampire too! They're not very fast, but when you're going 450 miles an hour upside down over the coconut trees, you think, 'I hope he doesn't get fucking hiccups!' I threw up but I had to swallow it because I'd have had vomit all over me, and I remember thinking, 'Fuck this.' I didn't sleep for two weeks afterwards because I was having nightmares about flying upside down. It's the only thing in my life that's ever affected me that badly. I had a camera with me and I didn't take one picture. But it was worth it – she was worth the fuck, Delphy.

When we came back to England, I only saw her once, took her out. That's when I realized we had nothing in common and she seemed to think she was better than me. I've got a picture of her in one of my books. She's sitting by the Singapore Strait, boats going by in the background.

Chapter 7

John French

I moved quite quickly when I came out of the Air Force. If you wanted to work for a photographer, who could you work for? I didn't want to work for a high-street photographer, taking pictures of babies and weddings, so that only left fashion photographers. If you were a photojournalist, you did it alone. I wrote to about twenty photographers in longhand, which must have taken me a good while. I got replies only from John French, who was the hot fashion photographer of the time, very big on the *Daily Express*, and Tony Armstrong-Jones, who was soon to marry Princess Margaret and turn into Lord Snowdon. I'd seen some of Snowdon's photographs in Singapore including a self-portrait of him sitting on a stool. I went to meet him in Pimlico. He brought out the silver tea set and everything. He didn't look at my work. He just wanted to talk to me. Then he said, 'We do a lot of room sets. Are you any good at carpentry?' Fuck me, no.

Tony was the best in London at the time at what he did, which was street photography. He did all those pictures of nannies and actors and street characters. His street photography was really good in those days. Looking back, it was naive, but time and place is everything. Things look different later – some

of my fashion pictures look very naive to me, but that's because I've got sixty years' experience now. I used to call him Snowdrop when I got to know him. He didn't mind, he thought I was 'amusing'. He used to talk funny, Snowdon, didn't he? He'd use the wrong adjective: 'I think David is fun,' he used to say.

He offered me the job, but I wasn't going to do it because I didn't want to be a carpenter so I decided to go with John French, who was the only photographer I ever worked with. He'd been a Grenadier Guards officer in the war and looked like Fred Astaire, very skinny, about six foot two, I guess. He always wore a pink ties and light-coloured suits that made him look like a fucking ice-cream salesman. He was quite mannered, spoke almost in a whisper, and smoked in that affected way, his first two fingers in a V sign, cigarette held rigidly between them. My dad's cigarette was always stuck to his top lip and waggled when he talked.

John's photographs had a near perfection to them – he would pose them very carefully, and say 'Still' when he wanted the assistant to pull the shutter. But the pictures were awful. He only had three poses: full-length, cropped and headshot. He was a great man, John French, but I don't think he was a great photographer. Fashion was very staid then. Models wore gloves and pearls; they were supposed to look 'ladylike'. John's great innovation was that he'd developed a photographic technique to get pictures to look sharp and contrasted on absorbent, low-quality newsprint. He'd revolutionized fashion pictures for newspapers in the Fifties. He did it by a reflected-light technique. More contrast, no middle tone, almost black and white. I think he got it from John Rawlings in America. He worked on it with Harold Keeble, art director at the *Express*, who was to be a key figure in my career too. That's why I always made

things quite contrasty. John trained me, so it took me quite a long time to get rid of his way of taking pictures because I'd been doing the same thing every day for months; that's what newspapers wanted. He never worked for *Vogue* or *Harpers* or anything like that. He did everything for the *Express* – he was the people's photographer. I didn't learn a lot from his pictures. I learned less from John about photography than how to conduct myself and how to deal with clients.

When I first worked with John French he paid me £4 a week. That was in 1959. Then he put it up to £8 when he realized how brilliant I was. I was only with him for eleven months. He had three assistants and I was the middle one. It's always best to be second; never be first. Let them all fucking argue about being first. Just be second, sit back and let them fight among themselves. The third assistant was a Thai prince, son of the king of Siam – of course. A bit of *The King and I* in there somewhere. At the top was a person called Gerald Workman, who was tipped to be the super photographer of the future. I remember a magazine did an article on assistants and they had him at the top, and I didn't make it. They said Bailey will never make it because he's too all over the place. That was in 1959. But he never went anywhere, poor old Workman. He used to wear a tie and that, and the assistants would say to me, 'You've got to wear a tie.' And I wasn't being a rebel; it was just that I couldn't be bothered. Why would I want to put a ribbon around my neck? It was the idea that it was manly to wear a tie, which I thought was contradictory – like my father thinking it was queer not to wear Brylcreem.

One of my jobs was setting the camera up and framing it, which was easy to do. I had three notches on the tripod and I knew if it was a headshot it would be on the top notch; if it

was a quarter shot it would be halfway down the tripod; if it was full-length it would be at the bottom. I'd put up the backgrounds too – white, black or grey (it was all black and white photography). John used to get annoyed because I'd look at the clothes and know what background would work best. If it was a grey dress, I'd put up a dark grey background and I always got it right, which would make John angry and he would deliberately change the colour. 'Oh, I think we'll have a white background.'

So I really got the white background in my pictures from him. Everyone thinks it was from Avedon, but it wasn't. It was from John French. I did think it was sensible to have a white background. It was probably the hardest picture to take really because you've got no props. But I always thought props made the photograph look like a catalogue. I made it really white, and got in close. Common sense.

John was gay, and he was married. He married Vere because she got pregnant by Lord Norfolk or someone like that. She had twins and they were both born dead. Needn't have married her. Straight out of Somerset Maugham. He used all these gay models and put beards on them to make them look more masculine, and I'd say, 'You've made them look more gay, John.'

I once asked him why he gave me the job. He said, 'Well, David, of course I knew you were lying when you said you could operate strobe lights and take exposure readings – but I liked the way you dressed.'

I remember once I was in the darkroom, which was about the size of a toilet, processing eighteen rolls of film, when I suddenly realized I could see them. I thought, 'Shit, there's light in here.' There was a curtain that went across the door and as I pulled it I'd hit the light switch and lit up the whole fucking

lot! I thought, 'Right, I'm going to get the elbow now.' I went to see John and said, 'John, I've had an accident, all the films got fogged.'

'I'm shocked,' he said, understated as always, with his cigarette. 'Come and show me what you did.'

So I showed him and he said, 'It's not your fault, this switch shouldn't be there with the curtain. I guess we'll have to shoot it again.' He was very precise. I remember he had an awful white Rover.

'Why have you got a white car? It's so vulgar,' I said.

'You know, David,' he said, 'it always comes in handy as a reflector.'

He was great, John French. He allowed me time to do my own photographs, and he helped me with commissions. I did a model shoot for the *Sunday Pictorial* and I shot, in John French's studio, my first published portrait for *Today* magazine. It was a picture of Somerset Maugham. I'd read his books in the Air Force, very slowly over months. *The Moon and Sixpence* and *Of Human Bondage* – one of my favourite books – are the two best. But they're all interesting. I loved Maugham's completely gay view of women. But he sort of got their trickiness – because they're very tricky, women, much trickier than men. I loved him when I met him. He was so nice and kind. I had my Rollop, which was a copy of a Rolleiflex, on a piece of string because I couldn't afford a strap. But I spoke to him – more than anyone I ever spoke to – when I photographed him. I think he had a bad time emotionally because he stuttered. I remember him saying, 'Don't give it all away, Bailey. Keep some stuff back for yourself. Don't let them know everything.' He was the first famous person I'd ever photographed and I thought, 'If they're all going to be like that, it'll be great.' But of course they're

not. And they judged you by your accent too, writers, but Somerset Maugham spent an hour talking to me. And it wasn't sexual – he was too old for that, I think, he was about seventy-something. He did invite me for the weekend, though, in the South of France. Going to the South of France in those days was like going to Africa, quite a journey. He said, 'It'll be an amusing weekend; Jean Cocteau's coming as well.' I thought, 'Yeah, and guess who's not coming to dinner – me!' I could handle predatory gays in bars and things, but I'm not sure I could have handled Cocteau and Maugham.

It was while I was working for John that I met the two other photographers who would soon get linked with me, as the 'Black Trinity' of the Sixties – a nightmare cliché when it was invented by Norman Parkinson, the grand old dandified portrait photographer to the Royals. Terence Donovan, who was born in Mile End, had opened his studio in January 1959, in Clerkenwell. He worked for *Man About Town* from 1960. He mostly shot men, so he wasn't a rival in the fashion photography business. Importantly for him, he was great friends with Tom Wolsey at *Man About Town* – later just *Town* – who was probably the most influential art director at the time. Brian Duffy, contrary to the 'Trinity' narrative, was not an East End cockney like me and Donovan. He came from Kilburn and he was educated. He'd been to Saint Martin's School of Art, so he was a bit of an intellectual. He was also a Marxist. He'd joined *Vogue* in 1957, photographing fashion. He had tried and failed to work for John French. Trinity or not, they were my close mates already by the time I left John French after eleven months. He'd sort of fallen in love with me in a way, which was difficult. He said, 'Oh, come with me and we'll just travel around Europe, we'll go to Greece and photograph the

The last picture of Catherine's dark hair.

Self-portrait in Singapore during National Service on a delayed action camera.

Michael Caine.

My first professional portrait of Somerset Maugham for Today *magazine.*

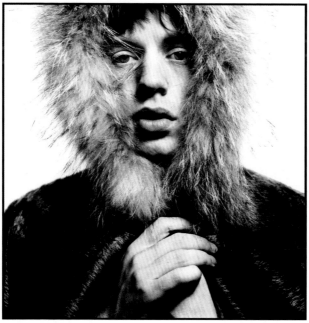

Mick Jagger.

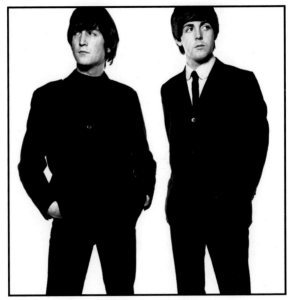

John Lennon and Paul McCartney.

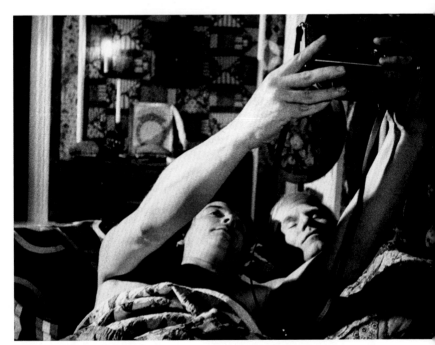

My first selfie with Andy Warhol.

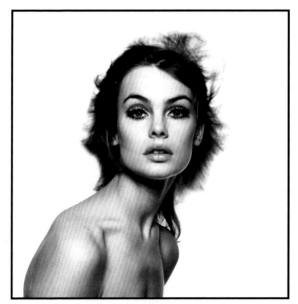

Jean Shrimpton.

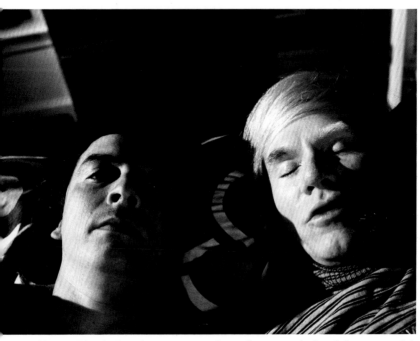

...dy said he would only do a documentary with me if I got into bed with him, so we did
...t the interviews in bed.

Anjelica Huston and Manolo Blahnik shot for Vogue.

Papua New Guinea.

Catherine Deneuve.

arie Helvin shot for Vogue.

Penelope Tree.

Making friends with the locals, Naga Hills.

ruins.' Oh fucking hell, no thanks. His first assistant had just left, which meant I was going to get the job – the middle one always took over – so I thought, 'Shit, I have to get out of this.' I went to John Cole who had a studio of young photographers like Norman Eales and Vic Singh. Cole took about 40 per cent of our earnings. I was there for three months.

John French died not so long after, in 1965. He was a sweet man. When he was dying I went to see him in hospital.

'Can I have your sunglasses?' he asked.

'No, I like my sunglasses,' I said.

'I'd like to be buried with them,' he said.

Funny old queen, John. Of course I gave them to him.

I did my first successful fashion picture – the one that maybe launched my career – for the *Daily Express* thanks to John French, in 1960. He sent my pictures to Harold Keeble and that's how I started really, working for the *Daily Express*, not *Vogue* as people believe. It was a picture of the model Paulene Stone kneeling over a squirrel, with autumn leaves scattered around her. Unconventional by the standards of the time, it was the picture Mary Quant later said inspired her – and she'd already been going for a while. Donovan said later he was 'disturbed' by it; he realized immediately that I'd done something. He rang me up, and said, 'You realize you've made a breakthrough? Did you do that on purpose?' I said, 'Yeah, of course I fucking did.' I always had girls talking to squirrels in the studio! But I'd been more interested at the time in street pictures – outside the studio. In 1959 I took a picture of the Jewish section of Aldgate where they had all the kosher butchers; almost at that same moment Don McCullin was taking his first black and white pictures of the Teddy boys across town in his home around Finsbury Park. I was influenced by Bill Brandt and his

My first successful fashion picture with Paulene Stone.

photographs of coal miners and wanted to do more reportage. Bill Brandt is a fantastic photographer. He was actually German but lived in England all his life. Nobody has been as good as him.

There were three gays that made my life, in a way: Arty, John French and John Parsons at *Vogue*. At the time *Vogue* was the only magazine you wanted to work for, and John Parsons was its powerful art director. He was a junkie but he was Chelsea posh. I think he'd seen my stuff in the *Daily Express*, and he recognized something in me and he asked me to a meeting with him. *Vogue* only had five photographers at a time and they were on a two-year contract. He offered me instead a staff job, which meant you got paid £25 a week, whereas if you were a contract photographer you got £25 a picture. I was already getting that, so I said no. *Vogue* was just another woman's magazine to me, albeit one full of gold frocks. I didn't really understand the fashion world. Three months later John phoned me up and said, 'All right, we'll give you a contract,' which annoyed Duffy because he'd already signed up as a staff photographer. But he couldn't give me a contract until Eugene Vernier's two years were up. They were only allowed to use people who actually had a contract at *Vogue*; it was quite elitist. So I had to wait a bit.

God knows how I got in there. Well, I got in there because of John Parsons. I think he saw something in me that I didn't even see. I was always helped by gays. I think we had an affinity. They didn't have that class resentment that I was an East Ender. I suppose we were all, in a way, outsiders.

I'd been living at home with Glad in East Ham after coming back from Singapore, then in 1960 after I left John French I

got married to Rosemary Bramble. I met her at the Flamingo, I think, the jazz club. She was quite something, always dressed in black. She wore lace-up boots right up to her knees that I had made for her at Anello and Davide, the theatrical and dance shoemakers that I was one of the first to popularize. She was a typist and she lived on Clapham Common.

In the East End when you first did it – when you slept with a girl – you were expected to marry her. It hadn't bothered me before, but when Rosemary said, 'You've ruined my life, now we've got to get married,' I said yes. We were married within six months. I thought it was normal. We were married in Battersea Registry Office in February 1960. Danny was best man. It was so cold he went to Boots to get a hot water bottle as a wedding present. I never met any of her family. I never took marriage that seriously – I'd seen what marriage was like between my mother and father. Maybe I got married to get away from the East End. You couldn't live with your parents, so you moved out. People didn't live with their parents, not like they do now. At eighteen you were expected to go, quite rightly so. The world's much more wimpy now; everyone's so much more spoilt. Or maybe getting married was also, instinctively, my need for protection from all these gays. I don't know. I didn't think about things that much in those days. We rented a one-room flat at The Oval, with a partition for the kitchen, no inside toilet, but I was sort of used to that, anyway.

She was quite a girl, Rosemary. She was good in bed. I remember her saying at first, 'I don't want to do it, I don't want to do it.'

'Why don't you want to do it?'

'I might like it too much.'

And she did. It's nothing to do with class or anything, being

good in bed. Some people are good in bed and some are not. Often girls that look sexy aren't sexy. There's that middle-class thing where girls are a bit prissy. Blowjobs were difficult in those days. People didn't like giving blowjobs. They soon changed.

I didn't really get on that well with Rosemary. She was always hysterical, angry, jealous of other girls as well as me. We weren't together very long.

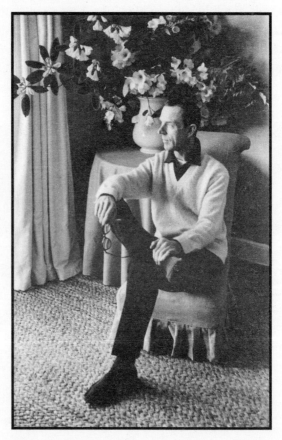

John French.

Chapter 8

Inventing the Sixties

Nicky Haslam claims I said once that he and I invented the Sixties together. Maybe I wasn't joking.

I've never slept with a man in my life, which is odd because I had the gays after me all the time. It was a bit of a nightmare really. And they always seemed to be old, but I suppose everyone was old then because I was so young. But Nicky, who I met in 1960, was never after me in a sexual way, and he was a year younger than me. Even so, he wrote in his memoirs, he fell in love with me at first sight. It didn't matter to me. I didn't know about it. He was good fun. Really intelligent. A fourth key person in my career who was gay.

After Danny O'Connor, at the time of writing, Nicky is my oldest living friend. It looked like an unlikely friendship: Nicky had left Eton only three years before he met me.

Nicky was very good-looking and he had a few very well-connected mentors in the gay world. He was part of a rarefied group that surrounded Bunny Roger, a rouged and exhibitionist clothes designer, famous for dressing-up parties that ended up in the *News of the World*, who had taken up Nicky when he was still at Eton. 'Sometimes I took my friends from school with the express purpose of showing Bunny off,' Nicky wrote

in his memoirs. 'They would gasp at his square shouldered suits; the corset like waistcoats over exaggeratedly skirted jackets and narrowest drainpipe trousers.' Nicky had another mentor called Simon Fleet, who I met – lanky, thigh-length boots, bejewelled, once a writer of musical reviews – who had had to change his name because of the acute shame he felt about his appearance after some failed plastic surgery. Nicky had wanted to introduce me – he said that Fleet's knowledge of the East End so far was visiting Hawksmoor churches and looking for trade in seamen's hostels. In these drawing rooms of Chelsea, Nicky seemed to have met everybody from Truman Capote to Cecil Beaton, by the age of twenty-one. His lover was Michael Wishart, who painted flowers and watercolours.

John French was a friend of Bunny Roger, which is how he met Nicky. He invited Nicky to the studio in Clerkenwell. Nicky remembered seeing a trio of assistants – Donovan, Duffy and me. Everyone gets that wrong. Duffy never did work for him, and Donovan worked for John French's other studio in Holborn.

Nicky's description of me in *Redeeming Features* is worth reprinting – at the risk of being immodest – for the prose style of an Etonian coming up against a bit of rough.

The third – stranger, more distant – looked at me from under his thick fringe, his eyes smudged with dark lashes, his look an impudent Mowgli. He was the most junior of the trio, and earning merely three pounds a week. I fell in love with David Bailey instantly. Within a few days we were inseparable.

David was like the Gypsies, or the boys I had noticed manning the carousels and bumper cars at Bertram Mills' Circus that my parents would take me to as a childhood

Christmas treat. There was nothing smooth or brought-up-proper about him. He was unruly, though he had wonderful, innate good manners and a sense of style. David Bailey crystallised for the first time exactly the way I wanted to look . . . He was so utterly different from any of my Etonian friends. The enchanting thing about my friendship with David was that we instantly accepted each other's vastly different backgrounds.

I saw him all the time after we met. He used to joke about coming down the East End with me for a bit of rough and taking me up west for a bit of posh. What Nicky wanted was a style. He'd got it from America, in his teens, and now he wanted an English look. He wanted to look like me, like a London pre-Mod. He cut his hair like mine. This was the Mod look before Mods proper – it was the East End look they later adopted. I had a Vespa GS, later the only model for a Mod to have. Nicky persuaded some relation to buy him one, a much more expensive one than mine. I used to come off mine all the time.

I used to take him to all sorts of places, like the Deuragon Arms, the drag pub in Hackney, where boys dressed up as Mae West and paraded in front of their mothers; there were drag acts like Rogers and Starr, who soon went mainstream and West End. I took him to Peckham Market, almost all black in those days, to get winkle-picker shoes on the stalls. I got him fitted out at Bilgorri in Liverpool Street to get his boxy suit with the short jacket. To me, it was normal to go to Bilgorri, but I suppose to Nicky it was something special because it wasn't Savile Row. I'm sure Nicky had only been to Savile Row before he went to Bilgorri. Then it became the fashionable Sixties tailor

for the rock and rollers. I turned Nicky (and Mick Jagger) on to these Spanish boots I'd discovered from Anello and Davide. They were a bit like cowboy boots but very delicate.

Years before The Beatles and the Stones, there was first a shift, a movement in styles and attitudes. We were listening more to jazz then, or American pop like Dion and the Belmonts, or crooners like Paul Anka, and the Beatles' first hit was two years away. Things happened really fast from 1960. I always thought the Sixties were over by 1965 when Swinging London had become just a fashionable idea.

I didn't know anyone else posh until I met Mark Boxer and Francis Wyndham, a bit later, at the *Sunday Times Magazine*. But Nicky was the only other one apart from those two who seemed to get the Sixties. Nicky understood what was going on – the working-class revolution – though I think he stumbled on it, in a way. He got it, but he couldn't really be part of it because I think it had to come from the working class really, in the end. If you're middle class or rich, you weren't gambling anything. You always had something to fall back on, so you weren't really taking a chance. If you were working class it didn't matter if you were gambling. You had nothing to lose. Some people got it without knowing it, like John Parsons at *Vogue*; he got the Sixties. It was an attitude. It had no foundation, it wasn't like a club or a university. I think the reason it got through is that there were so many working-class people on the loose after the war, coming out of the army all at once. And the middle class had to listen to them because they wanted to be heard after the war and there were too fucking many. If there had been fewer, the middle class wouldn't have listened. They hadn't been given anything, there was just an opportunity

there that was yours to take. Suddenly they had people like me at *Vogue*, whereas before me it was all ponces from Chelsea.

Nicky wasn't doing much then, workwise, but he became very soon – in a couple of years – assistant art director at *American Vogue* at a very young age. He became later on famous as an interior decorator, a columnist, a writer, a singer. He was always changing his look, his outward persona, becoming somebody else. He was me for a bit, then somebody else.

Actually the photographers invented the Sixties. In *Absolute Beginners* Colin MacInnes had picked up on something, which Danny and I were also aware of, or taking part in, as Danny has described. It was the book everyone talked about at the time. John French was into it. All the gays liked it; MacInnes himself was gay. I knew him; he was a friend of *Vogue* editor Bea Miller. He used to talk to me – and everyone else – about the world being divided into Greeks and the Romans – roughly art versus power. So did John French actually, he got it from *Absolute Beginners*. That's where you read about the real stirrings of change.

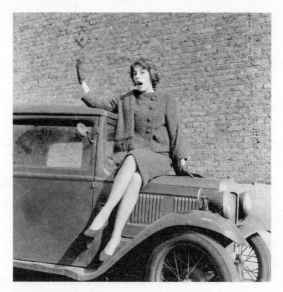

Thelma in the East End.

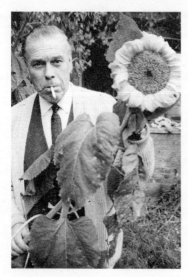

Bert in East Ham.

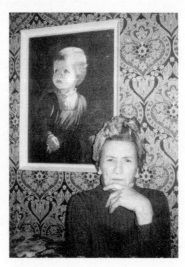

Glad in 1959.

Chapter 9

Jean

'New York broke the ground for fashion as it was
from then on. [Bailey and Shrimpton] turned the world
upside down. Fashion was no longer static and stiff,
posed in the studio: it became something that was
relevant, current – suddenly there was a place where
young people could live and exist.'

— MARIT ALLEN, *VOGUE*

I first saw Jean Shrimpton around the door in Duffy's studio
on the top floor of Vogue House. She was doing a Kellogg's ad
with him. I don't think Duffy had picked her out; I think she
was sent by the agency. Duffy was using a sky-blue background
and you could see the blue sky behind her eyes, as if you could
see through her head. When I saw her I just fell in love with her
eyes. It was the first thing I noticed. She had great legs as well.
She was exceptional, Jean. I said, 'Who's that girl?' Duffy said,
'Forget it, Bailey, she's too posh for you.' I said, 'I think she's
great,' and I booked her to do some tests, because she wasn't
yet a proper model.

I think we fell in love with each other straight away, although
I was an odd choice for her. She'd been used to people with

MGs called Ponsonby or something, and suddenly she met this bloke with a Morgan who couldn't spell Ponsonby. Her father was working class, very successful. He was a builder who also had quite a big farm, 200 acres in Buckinghamshire. She was posh, kind of county, she socialized with lots of public school-boys who were all known by their surnames. Up until then, I'd been Dave. It was Jean who started calling me Bailey and after that I was lumbered with it. It wasn't megalomania on my part, that I wanted to be known by my surname, it was accidental.

When I took the first pictures of her she was all arms and legs, like Bambi on the ice, but I realized her arms always went in the right place, her hands were always in the right place and she always knew where the light was. Everything about her was perfect. She was an exceptional model. It's something you can't put your finger on. I suppose it's a kind of visual intelligence. I didn't explain anything to her, she knew. I'd just nod. She'd understand the nod. You did half a roll on Jean, and you had it. In fact I don't know anyone better than her. All the models in the Sixties understood something about the dress designer. I tried to emulate what the designer meant to do. When you got a model who didn't know, it was a nightmare. Jean had instinct, she knew how to move in a dress. And she was interested in what I was doing. Now models come in and they're not really interested. You don't have to work a dress now because there's no design to dresses, they're just flowery or whatever the latest fashion is. But most photographers didn't know about fashion. I guess because my dad was a tailor, I did. To be a good fashion designer, you really have to be a good tailor. Now I don't think it matters.

Even now, I'd say Jean and Kate Moss are the two best I've ever worked with. You can't take a bad picture of either of them. They're the most peculiar women in the attraction they have

for people. I've never understood why everybody likes them so much. There are many more beautiful girls. But they've got this universal, democratic appeal. It's like Dietrich and Garbo in movies. They've just got this thing that makes them stand out, whereas some models you photograph and think it was fantastic and then you look at the contacts and it's shit. That's the most depressing moment in my life, still, seeing the contacts when they're dead.

I loved Jean. It took me three months to seduce her. I'm sure I got to the point straight away, I didn't beat about the bush. But she wasn't happy, to start with, that I was married. That was the period when I ended up in the haystack at her parents' house. We had nowhere to go – when I started seeing Jean I often had to go back to Rosemary at night. Jean was living at her parents' home, at first – she was barely eighteen.

JEAN SHRIMPTON: I was at a convent. I left school at sixteen. I didn't want to stay on the farm, I didn't want to go to university, I hated school. So I did this secretarial course and I was so bad, hopeless with my hands, so the electric machine ran away with me, and my fingers were so weak I couldn't press the keys on the manual typewriter. We were sent to do work experience at Polydor in Oxford Street, and I thought, 'I can't possibly live like this! And I don't want to stay at home.' I didn't know what I wanted to do. So when I was told by the director of *Zulu*, Cy Endfield, as I was walking on a zebra crossing that I should become a model, I thought, 'Oh well, I suppose so,' so I borrowed thirty quid from my dad to do a course at Lucie Clayton modelling agency. And it went from there. But it was all happenstance, I just couldn't have been a secretary. But it

seemed like I wasn't in control of my life, I just went along for the ride and I'm amazed how passive I was about it all.

Bailey did look around the door in that studio. I think his was instant attraction. He was something so different for me. My father didn't speak to me for a year because he was married, and I had to go and see my mum in the week when my father was working. Bailey kept pushing me and I didn't want to do it. I had guilt because he was married and I was out of my depth a bit. I was a convent girl. I wasn't a virgin, but I didn't want to not be a virgin and then have an affair with a married man, it went against convent principles. But I got over that quite quickly.

And I have an image in my memory that personified him very much at that time. Bailey was very attractive to men and women. He's not attracted to men, but the men like him – the Cecil Beatons and so on. In those days men didn't buy flowers and carry them very easily, obviously, and Bailey was in a Cecil Gee bum-freezer suit, pale grey, and he had the Cuban heel boots and the Beatle haircut, and it was long before The Beatles. I remember him coming across the bridge to me, where we were photographing, holding these flowers with this kind of walk, this Bailey kind of strut, and it encapsulated his complete disregard for what people thought. Men didn't do that much and it was attractive. And he could get away with it like with people like [Vogue editor] Lady Rendlesham – he could sort of put his hand on her knee and god knows what. I mean, today he'd be in trouble, but most people were quite happy to receive his attentions. Although he's mad about women, he's not macho at all. He's very tactile with both sexes.

The first *Vogue* cover I shot was published in February 1961, therefore shot the year before, soon after I got the contract. The model, holding a clutch bag to her face like the classic *Vogue* pose, was Enid Boulting, former wife of film-maker Roy Boulting, who went on to act in films. From the moment I met Jean I only wanted to work with her, but it wasn't easy. I had to fight for her. There was a lot of 'we can't book her just because she's your girlfriend'. Out of the studio Jean did look a little scruffy and unsmart and *Vogue* was very touchy about appearances. And suggestions from me. The editor was an awful woman called Ailsa Garland who just thought I was an East End yob. She liked all the gay photographers because they danced with her. Alex Liberman, the venerated editorial director of Condé Nast, used to send to English *Vogue* all the photographers that he didn't want in America. Henry Clarke is the one who sticks out the most, and Don Honeyman ('Catch a butterfly' was one of his poses; the other one was 'Taxi', people holding up the *Financial Times* waving for a taxi. I called them taxi shots. I used to do things like that if I did fashion advertising.), and Claude Virgin. He used to ship them over. Americans don't have that snobbery we have about class. It's about money in America now, though it wasn't then. Even with Parsons promoting me, I don't know how I got into English *Vogue*; it was a fucking miracle.

Roman Polanski, who came over around this time, loved London. He had a good view of it because he saw it as a foreigner. He said later that when he came to London he hardly spoke any English, but we became friends through his producer Gene Gutowski, who wanted me to photograph him; so we linked up. Being dyslexic, *I* hardly spoke English.

But I don't think he really understood the class system too

much, how awful it was. If you had an accent like mine, there was no way you got into *Vogue*. You were judged immediately, 'He's no good for the job.' If you were born in East Ham you stayed in East Ham, if you were born in Stepney you stayed in Stepney. Once you stepped out, they said, 'Oh we can't use him, have you heard his voice?' Paulene Stone, whose picture I took with the squirrel, was a working-class girl and a beauty and the newspapers like the *Daily Express* loved her. Sheila Wetton, the fashion editor at *Vogue* said, 'Oh darling, we couldn't use her, have you heard her accent?' This is the same woman who patted me on the head once and said, 'Doesn't he talk cute.' It wasn't until Twiggy came along that they accepted a working-class model. By then things had changed.

Sheila Wetton was great, very down to earth. I was newly arrived at *Vogue* when I met her and I still thought only posh people listened to classical music, or that if somebody had a posh accent they were clever. I was up a ladder doing the *Vogue* cover shot when she walked into the studio and said, 'What the fuck are you doing up that ladder?' I thought, 'Oh shit, posh people swear!'

Vogue was shooting a fourteen-page 'Young Idea' story – they needed a younger market – in July and August 1961. Ailsa Garland said I could use Jean, because she was tired of me going on at her, but under the threat of a reshoot by a different photographer if the pictures weren't right for them. In the end eight of the pages were of Jean. The feature was a success, and Jean – and the combination of me and Jean – was launched. Jean became a top model overnight. After that we worked every day together. A sense of style had been established. I didn't know it was a style, but looking back it came out of the East End. It came from the Moon girls with their

French Resistance raincoats and berets. They all seemed to come from Wapping or the East End. A key picture of Jean at that time was of her dressed very casually, almost shabbily in a raincoat, standing in the street. When we got together for this book Jean said, 'There is a photo of me which I've always quite liked in an old raincoat, looking the most dreadful mess, that's me. That's what I was like.'

I loved Jean's legs; she had fantastic legs, so I used to pull her skirt up for the photographs and *Vogue* used to airbrush it down because they'd get one letter from Scotland saying Jean was disgusting showing her legs. That was just the beginning of my skirmishes – or skirtishes – with *Vogue*. I was photographing women the way I saw them on the streets. People could identify with Jean because I didn't make her look like a stuffed shop mannequin. Suddenly she was someone you could touch, or maybe even take to bed.

I don't know where I first made love to Jean – I think in the countryside in Buckinghamshire, Littleworth Common or on Wimbledon Common. It was on a common, anyway, I remember that. We had nowhere to go for a while. Jean's father, who was an awful man, had threatened to shoot me. He didn't want his daughter with a married man. And he wasn't speaking to Jean. Jean could only go home to see her mother on weekdays when her father wasn't there. My story about choosing between being best man and seducing Jean Shrimpton in a haystack worked well as an excuse but it wasn't quite true. The night before the wedding, before our first time together on the common, I'd gone to visit her with Charlie Papier and we realized it was too late to drive back to London. Jean said we could sleep in the haystack at her house. Maybe she thought she could conceal us until her father went to work, but the pigs in the yard

Jean Shrimpton.

made a terrible noise and scared us; I went to get Jean, and the pigs with their piglets followed us and Charlie was shouting, 'Run, Dave , run.' Then Jean's father came out and shouted, 'Get out. Clear off.' That was what I was doing instead of being best man at Michael Holland's wedding. I wasn't in the arms of Jean Shrimpton, though I would have liked to have been.

I met Mick Jagger when he was about eighteen. He was going out with Jean's sister, Chrissie. It was before he was in any kind of band – or very early days, just at the time he'd met Keith on the train at Dartford, 1961. So imagine, poor Mr Shrimpton – his two daughters were going out with 'David Bailey makes love daily' on one side and 'would you want your daughter to marry a Rolling Stone' on the other – in fact the Stones hadn't been invented, though they soon were. One day Jean's mum, who I really liked, walked in and found Mick in Chrissie's bed – but I should get Jean to tell that story.

With Nicky Haslam, we all used to go to the Casserole on the King's Road. The first time I took Mick he'd said, 'Dave, take me to a posh restaurant, I've never been to a posh restaurant.' So I thought of the Casserole. I used to call it the Casa Arsehole because they were all gay in there. The bloke who owned it was a New Zealander, he collected Roman busts and things like that. After the meal, I said, 'Mick, you have to leave a tip.'

'What fucking for?' he wanted to know.

'Well, you leave a tip in a posh restaurant,' I said. 'Give them ten bob.'

He put ten bob on the plate, but as he put on his jacket I noticed he whipped the ten bob off and put it back in his pocket! Typical Mick. He was always mean with money. Still is. The first picture I took of Mick – which *Vogue* UK wouldn't use, and which came out in American *Vogue* when Diana Vreeland

was editor, in 1963 – was taken in Paris, before the Stones had even made a record. He'd come to Paris to be my assistant, as a laugh. Mick was quite rude to people, which I liked. When we were coming back through the airport, some bloke with a black double-breasted blazer with a fucking poncey badge on it and grey slacks, said, 'What do you think you look like, young man?' Mick said, 'At least I don't look like a cunt like you!' The guy just walked off, and I thought, 'God, that was good.' He was a tall guy as well.

These were great moments – one thing that got swept away at that time, and long overdue, was the old deference to authority, that reflex from the old shame culture. Same in the East End – you'd get clipped around the head if you were rude as a kid. I was too polite to say something like that. I'd been controlled by that kind of class thing, in the Air Force, so I was shocked that Mick could say it. The best, the most natural at that kind of confrontation who should have been the fifth Rolling Stone – he was more a Rolling Stone than the rest of them, more than Mick anyway, more like Keith – was Andrew Oldham. He became the Stones' manager later on, and pushed for the Stones to be as bad, rude, loudmouthed and long-haired as he could get them – a masterstroke that broke all showbiz rules, and which led to the national panic and shocked editorials in the papers. I remember he and I were in a Chinese restaurant, the Krays used to go to it, on the Edgware Road in 1963. As we were leaving, this group of guys went, 'Hello, girls,' blowing kisses at us. We were wearing boots from Anello and Davide, which looked like cowboy boots, but they were also Flamenco shoes so they had very tough heels – strong so you could stamp in them. Andrew went over to one of them and grabbed his tie, rammed his Cuban heel into the bloke's foot, and held him

there, demanding, 'What did you say?' And the bloke backed down. I thought, 'Fucking hell, I'll be careful of this one.' He looked like a skinny little bloke but he was vicious like an Irish fucking villain. He remembered the incident, writing fifty-seven years later from his home in Colombia: the restaurant, he said, was called The Lotus House, 'where the special on a Sunday night was half a bottle of Mateus Rosé, akin to Paco Rabanne aftershave.' More of Andrew's exploits later.

Jean and I lived for a while in Hampstead with Eric Swayne, quite a well-known photographer of the period, who was then with Pattie Boyd, later George Harrison's girlfriend. We had a single bed; I slept mostly on the floor. We were paying him more for the room than he was paying for the entire flat. He was a bit of a ducker and diver. He later went to prison for photographing underage girls. Then we had nowhere to live for a while so for us to get a gig outside London was the only way we could be together. And it was winter. Then came the trip – at that very moment, February 1962 – that changed everything in fashion photography, in a way: *Vogue* sent us to New York for a fashion shoot called 'Young Ideas Goes West', Young Ideas being the newly invented section to attract young readers. Jean and I went with Nicky Haslam, and with Lady Rendlesham – Clare – who was the new section's editor. Clare Rendlesham didn't like Jean, wasn't sure she wanted to use her, and I'm not sure she liked me very much; she was suspicious. There had been endless fights. Rendlesham was a real bitch, really tough. She was tiny, very thin. Grace Coddington told me that if anybody put on weight around her, Rendlesham would get furious. She even managed to conceal her own pregnancy in her tiny frame, said Grace. She could talk as well and I wasn't very good at dialogue. They had so much power, fashion editors, and most of

them had terribly old-fashioned ideas and knew nothing about photography. They only cared about the dress. She expected me to do what I was told. I never wanted to do what other people wanted, I wanted to do it the way I saw it, not the way they saw it. Later Rendlesham and I became friends and she was quite nice. She advised me to buy Francis Bacon paintings, though I could never afford them. She even asked to be my agent.

I'd been having fights too with Ailsa Garland before this trip to New York, over the *Vogue* way of doing things. Sometimes even Jean would be on their side because she couldn't always see it the way I did. Ailsa or Lady Rendlesham would say, 'This shot has to be full-length.' I'd say, 'No, it doesn't, it doesn't work full-length, it will look like a catalogue picture.' So I'd crop into it, and they hated that. They'd say, 'There's a foreign body in the photograph, there's somebody who shouldn't be there.' I'd say, 'No, that person should be there.' But they couldn't get that. They didn't understand what John Parsons understood. He had much more power; he was almost as powerful as the editor. So the only way to break through was to keep on doing it. The editors were always looking over their shoulders at the advertisers, which was always a problem because advertisers never understood fashion. They don't understand it's not the idea that sells fashion, it's the zeitgeist, it's the wind. But they need an idea otherwise they've got nothing to sell to the client.

The editors at *Vogue* UK before Bea Miller, who came in 1964, were all useless. I had to wrangle them. I had to make out it was their idea. If I wanted to do a clown cover, I'd say 'It would be good to do something about clowns, it would be really interesting.' I wouldn't say anything more and then six months or a year later, I'd ask, 'Do you remember that idea you

had about clowns?' I learned very quickly to be Machiavellian about the whole thing.

But things were changing fast in all the visual arts – in film, typography, painting, in the pop culture, in photography at the time we went to New York in 1962. Everything started to look different, and that changed attitudes. Partly it was the influence of French New Wave cinema, Godard with his hand-held camera and jump cuts, Truffaut's long tracking shots from the roof of a car, which had much to do with it just being a cheaper way to do it. A breakthrough, and a cheap one too. But it wasn't just the French; the Italians were doing it as well. And there was the 35mm camera that commercial photographers had learned about from people like Cartier-Bresson, who had used it right from the beginning, when the Leica appeared in about 1930. It wasn't invented for stills, it was invented to test movie film. That's why it was that shape and that format. Then suddenly people realized they could take pictures with it. Then when they invented the motor drive – I had an early one in the Sixties – it gave you total freedom. That was just a technical thing; the same thing was happening in movies, because suddenly you got a 16mm camera with built-in sound, which led to the Maysles brothers, people like that, and a new form of documentary. Everything came in at once, all the technology, I suppose after the Fifties really. The Fifties was America's only moment. What they did with the French New Wave you could do with stills as well. I think it was all happening at the same time. William Klein was the first person to exploit it. He was a reportage photographer. He did a fantastic book called *New York*, probably the best book ever on New York. Robert Frank is probably slightly better, but it's arguing over nothing, it's like

arguing whether you like Beethoven or Mozart. So it came at the right moment. And it was a complete breakthrough.

I started to use 35mm a bit like Klein used it to do reportage. The 35mm gave you freedom, instead of the slower setting-up of a plate camera. I think in a way I pushed it further, because I liked mistakes. I liked people walking through my picture, because I knew I couldn't get the accident artistically. My artistic thing was to rely on the accident, which I think is the definition of existentialism, in a way. Because you take the existential and then you kind of turn chaos into something that you can do. It's using the accidental nature of the universe, and making a story out of it. At least, that's what I think it is. I don't know. You'd have to ask an intellectual. You have to create your own values in a way, out of the chaotic mess of the universe. Many of mine came from Hollywood glamour, from those hours and hours with Glad in the cinema. I guess that's why I like black and white so much. Black and white is the colour of photography. It's the colour of dreams. Eighty per cent of people don't dream in colour, they only dream in black and white.

I remember the film Roman Polanski made in 1958 when he was twenty and at film school in Poland, *Two Men and a Wardrobe*. It starts with them taking the wardrobe out of the sea – something surreal, which started from irrational images in his imagination and became like a short story of random encounters, before they carried it back into the sea. It was funny, it was theatre of the absurd, but it had a freshness and wit about it. I really liked it. Bowie did the same, taking sentences and random lines and making them into songs. I like surrealism more than anything; to me everything's an accident so it fits into my life, and suits the camera. Often you don't see the accident until the contact sheet and you think, 'Shit, that's better than I

thought.' It's a surreal moment, but I think I can claim it because I spotted it, and most people wouldn't spot it.

I photographed Man Ray later, a major figure on the edge of the Dada and Surrrealist movements, for my *Box of Pin-Ups*. He did me some paintings in the studio. He would take two little canvases and he put some yellow acrylic paint on one, then some blue paint on the other – complementary colours, or colours that clash – and he rubbed them together and said, 'There you are, you've got a work of art.' He did about six of them and left them in the studio. The next morning I said to my Italian assistant, 'Where's Man Ray's pictures?' He said, 'Oh, I slung them in the dustbin.' So we went and looked and the dustmen had got them. So six Man Rays went in the dustbin. But what he was trying to say was, that's art. I agreed with him: I think everything is art. My pinnacle of art is somebody that makes gnome gardens. I miss gnome gardens, I used to love walking through Wanstead suburbia, and you came across gardens with gnomes in. Now you never get gnome gardens. I don't even see them in Devon much any more. They're gone. It's a great art form that's gone. That French designer Philippe Starck did gnomes. I think, that's completely surreal, people expressing themselves with fucking gnomes. I mean, how great can you get? Fuck sharks in formaldehyde, put a gnome in the tank instead.

The problem I had in New York – and before and after it – is that 35mm was unheard of for taking fashion shoots. They wanted me to use a plate camera. I was already at a disadvantage in America – Bert Stern was the hot photographer (the one I'd discovered in the Air Force), and Avedon and Penn were

always beyond everybody. You couldn't do things like Avedon in England because you didn't have the back-up. There was no stylist, no hairdresser, no production. You were the production. In Avedon's pictures, the girl's perfect before she gets on the set and you can only do that with money and the power to say this is how we're going to do it. In England it was a bit amateurish.

I couldn't compete with the Americans, they had so much production, I couldn't believe it. I never had an assistant that I travelled with. At the time I thought *Vogue* wouldn't pay for it, but now I realize they would have paid for it, I just didn't have the arrogance to say I wanted an assistant. Jean and I used to do it ourselves. Going straight from the airport to the studio with all the camera equipment. I could have done with some help. I'd arrive at the studio all sweaty, and down the road there's Avedon or Penn with fucking thirty people working for them. But don't get out the violins.

When we got to New York the immigration and customs people took one look at us and pulled us over. Jean was dressed all in leather – slightly kinky leather boots and a leather dress. I was dressed in a leather jacket and the pointed Cuban boots. They didn't like the look. When they searched us they found Jean's worming pills for her dogs, so we were there for two hours or so before they examined them and let us go, which didn't please Lady Rendlesham. When we got to the St Regis hotel we were put up in the maids' quarters at the top, which were fairly basic, and Lady Rendlesham had a suite below. There was also a telex or telegram for me from the managing director of *Vogue*, saying, 'Please don't wear your leather jacket and jeans in the St Regis hotel because you do represent British Condé Nast.' A year later they were begging me to wear a leather jacket. Awful man. Reginald Williams was his name and he

hated me. A year or so later I was getting messages from him, saying could I move my Rolls-Royce because it's blocking him in, and he had a Humber. He was ex-RAF and he expected me to treat him with a little more reverence, in the old style.

In the lift at the St Regis I got picked up by Salvador Dalí, although I wasn't sure who he was. He had a walking stick with a propeller and two naked dolls on the propeller.

'Have you met my sister and mother?' he said.

'No, I haven't even met you before,' I said.

And he pressed a little button on his walking stick and the propeller span round with these two naked dolls. I said, 'Oh, that's good.' He was all right, but his wife was a bit scary, Gala.

We went up to Harlem and saw Ella Fitzgerald. Everyone was so shocked we went to Harlem without any bodyguards, but everyone was really nice; they thought we were hilarious, for some reason.

Then we get to the shoot. A fashion shoot in New York. Lady Rendlesham introduced me to the photographer Frances McLaughlin-Gill, who was famous at the time and who did highly statuesque fashion pictures for *Vogue*, thinking she could give me some location tips. She suggested I photograph the lions outside the New York Public Library. I thought the lions we've got in Trafalgar Square aren't great but they're certainly better than the little ones outside the New York library. She was a nice woman but as I listened to her suggestions, feeling like a schoolboy, I thought, 'I'm going to do the opposite to what she wants.' People still ask me, 'Why have you got a teddy bear in that New York series?' *Vogue* said it was 'a young idea, we want something young,' and I didn't know what they meant so I thought, 'Well, fuck it, I'll put a teddy bear in every picture. Under Jean's arm, something like that.' She's still got that teddy bear.

DAVID BAILEY

I did a few things Frances McLaughlin-Gill suggested. She said I had to photograph the United Nations, so I did it behind wire, with a teddy bear stuck in the wire. Quite good. I just did street pictures really. Accidents. I photographed Jean on the pavement, in the traffic, at intersections in the New York street, next to flashing pedestrian signals, with passers-by. We took pictures on the Brooklyn Bridge, where Jean fainted from the February cold. But she stuck it out. They were the first kind of fashion street photography. I didn't plan it. It was just common sense – or uncommon sense, as my wife Catherine calls it. We'd go in the street and see what happened. Jean was nervous, thinking that we should do what Lady Rendlesham said. I'd argued with Rendlesham. We had terrible fights. I made her cry three times in New York and Jean tried to make peace between us. Lady Rendlesham didn't know what I was doing. A photograph of a girl standing next to a puddle had never been done in *Vogue* before. Nicky described the situation: '*Vogue* was doing ladies in gloves and pearls, sitting in Long Island country clubs. He was doing these pictures of Jean almost upside down on top of street cars. Of course they didn't like them.'

I didn't know those pictures had changed things. I didn't take any notice of what was said about them. It was just a style I could use. But people just raved about those New York pictures, and crucially John Parsons got it – and his assistant, who was also gay, but Duffy later told me he was in love with me, which I didn't know about, so maybe it didn't count. I just thought that was the right way to do it. And then everyone twigged and a year later everyone was doing it. There were already a few other photographers who were quite good at doing what I was doing too. Frank Horvat and Jeanloup Sieff were doing similar pictures. But they were in Paris.

The 'Young Ideas Goes West' pictures made fourteen pages in *Vogue* in the UK, but I also shot three pages for the US edition. It was on the strength of these pictures of Jean that Liberman gave me a contract for American *Vogue* when I went back that year in August. I went on a twelve-page fashion shoot for *Glamour* magazine – the sister publication – to Mexico in October that year, and Liberman told me to take some portraits as well, of interesting people like Luis Barragán, Dolores del Río and the muralist Juan O'Gorman. It wasn't a part of the shoot. It was Liberman who suggested I could sign prints, 'like Mr Penn' – he knew I wasn't being paid very much and he wanted to help me, even though this seemed to slightly undermine my contract. I was already doing portraits in England, but he encouraged me. I was getting the idea that would become my *Box of Pin-Ups*.

Other allies were gathering in New York. Nicky Haslam had, on our first trip together earlier that year, not only moved in almost immediately with the architect Philip Johnson, but had been given a job via Clare Rendlesham who persuaded Liberman to take on this unproved, jobless Englishman as assistant art director of *Vogue*. Nicky had moved to New York.

The art director of *Glamour* in New York, Miki Denhof, had been in New York for Condé Nast since 1945. She liked my work and, having been raised in Austria, she supported many European photographers who might not have been noticed in New York. Her striking layouts were stark and tightly cropped and suited the way I took pictures.

Vogue still didn't know I was using 35mm. I'd cheated and got away with it. I used to blow up the 35mm contacts in an enlarger to make them look bigger, like contacts from a plate camera. *Vogue* couldn't tell the difference and they'd publish them. My argument was that it wasn't a loss of quality, it was a

change in quality. Melanie Miller, a *Vogue* fashion editor, would say, 'I want to see the shoes,' which didn't often feature in my tightly cropped pictures. I'd say, 'Oh Melanie, you should have told me before. I haven't got a shoes camera with me.' She'd believe it because she didn't know technically anything about photography.

Later when I had one of the first Nikon motor drives, for 35mm, Liberman asked me to do Chanel, which everyone kind of wanted to avoid because Chanel was always done differently from the rest of the designers – insisting, for one thing, on using only Chanel models. Coco Chanel refused to work with Avedon after he took a picture of her that made her look like a lizard. I hated Chanel – to work with. She always had what I considered old models – they were at least twenty-five. They seemed like old dykes to me. So I said, 'All right, I'll do it on the motor drive, on the Paris quai, on the Seine.' I didn't quite know how to work the motor drive, with the speeds, so the pictures were all a bit blurred. I thought, 'Fuck it, I'll send it anyway, then they won't ask me to do Chanel again.' Liberman came up and said, 'Bailey, these are fantastic, they're enhanced reality.' I didn't tell him they were a fucking mistake. I love it, 'enhanced reality!' How can you have enhanced reality? Reality is reality. You silly old sod, I did them because I thought you'd fucking hate them. It was like *The Producers* – my sabotage had turned into a hit. He said, 'The motion, the blurs, they are wonderful, fantastic.' But then some editor at *Vogue* had had enough of these accidents and insisted, 'You've got to stop using single lens reflex 35mm because you don't have enough control.'

Chapter 10

Vreeland

Jean and I rented a grotty basement flat in Princess Road in Primrose Hill, which was a slum then. If you looked over our back wall you'd see the canal. It was there we were tracked down by private investigators working for Rosemary, my wife, to prove we were adulterers. The bloke sat outside in a car, and once came into the house. I felt sorry for him. I remember I'd go and give him a coffee, the poor fucker he'd been out there all night. So it was all over the *Daily Mail*: top model cited in divorce.

I didn't only photograph Jean. There was another model I used in London that year, 1962, called Jane Holzer, a blonde socialite from Florida and New York, who was doing modelling jobs in Europe. The following year we went back to New York, this time with Mick Jagger, who had just been on his first tour with the Stones – girls had started screaming at him despite the Everlys and Little Richard on the line-up. We visited Jane Holzer and her husband who had a big apartment on Park Avenue. I remember Jane ticking off Mick for putting his feet up on her Japanese lacquered coffee table.

Miki Denhof had suggested to me that I meet Andy Warhol, who she'd been using for years to do drawings of shoes for *Glamour* magazine. He was working on his first Elvis silkscreen.

She said, 'Meet this guy who does things like you do, who takes things and turns them into something else.' Warhol came to dinner, where he also met Mick for the first time and Jane Holzer. In Tom Wolfe's book *The Kandy-Kolored Tangerine-Flake Streamlined Baby*, he quotes Baby Jane Holzer, as she became in her persona as a Warhol superstar, as saying, 'Bailey is fantastic, [he] created four girls that summer. He created Jean Shrimpton, he created me, he created Angela Howard and Susan Murray. There's no photographer like that in America. Avedon hasn't done that for a girl, Penn hasn't, and Bailey created four girls in one summer. He did some pictures of me for the English *Vogue*, and that was all it took.'

At the risk of self-flattery but in the cause of social history, I'll add what Tony Shafrazi, the New York gallery owner, said in an introduction to a book of my photographs: 'Recently phoned my friend Jane Holzer to check out this story and she notably remembered that day with precise detail, and went on to elaborate with a delightful laugh, describing Bailey as a "great dish" asking me to tell him when I spoke with him next, "I hope he is as good a fuck now as he was then," which I did, and Bailey laughed on the phone and said, "Yeah, I am better now, with Viagra."'

She was great, Jane. It was just one of those things, it wasn't love or anything, she was married. It was just a fun romantic affair. Then I did a photograph of her for *Show* magazine, which caused a real political stir, in a bandmaster's hat, holding the American flag, with trinkets from tourist shops on 42nd Street. She did quite a few films for Warhol – she was his first superstar.

I'd become friendly with Mark Boxer around this time – smart guy, magazine editor, designer, cartoonist, who had worked on *Queen* magazine, with a lot of other talented people

like Francis Wyndham, the writer. Like Francis, Mark got the Sixties – very few of that lot did, the Chelsea 11 – as I call that poncey lot, the public schoolboy team – but they certainly did. Mark became the first editor of the *Sunday Times Magazine* in 1962, which later became the greatest colour magazine ever for photojournalism and photography. It was copied unsuccessfully across Fleet Street and it made so much money that it had its own independence editorially. That's where Don McCullin's career took off too. Mark put my picture of Jean on the very first cover, and it was quite revolutionary in a way – multiple poses of Jean in a blue dress, and one footballer in his own frame. Its title was 'A Sharp Glance at the Mood of Britain'. I couldn't have done that without the support of Mark Boxer. Mark was great and he got it, though he didn't always get it right. He was rude about me once. He said in *Campaign* magazine, 'Bailey was invented by Jean Shrimpton,' so I sent him a silver shovel, to shovel shit. Completely untrue, we discovered each other. But he was a nice guy and I loved his wife Arabella.

Meanwhile I was having more confrontations with Ailsa Garland, the editor of English *Vogue* – she was always rejecting ideas, including my idea to photograph a model with The Beatles, who had just had their first hit, or were about to. She turned that down. So at the end of 1963 when my *Vogue* contract expired I went across to *Queen* magazine, where Beatrix Miller was editor and Tom Wolsey had just arrived. Tom was the great art director who had created, at *Town* magazine, the revolutionary Sixties look – big type on closely cropped pictures – which had set the mood of the times.

Tom had used and promoted photographers like Donovan and McCullin and me. He liked sharp images. But as soon as I got there Bea Miller said to me, 'You've got to leave.'

'What are you fucking saying? I've just left *Vogue* and now you're chucking me out?' I said.

'No, I'm not chucking you out. I'm going to *Vogue* to be the editor, and I want you to come back to *Vogue* with me.'

Bea Miller was a talented editor at *Vogue*, but she didn't have the flair of Vreeland in New York or Vreeland's eye for what was going on. When Diana Vreeland left *Harper's Bazaar* and became editor of American *Vogue* in 1963, everything changed. I had American crews, rather than Jean and I doing it all ourselves. The production of American *Vogue* was enormous. Budgets were double in America what they were in England. England's always been a bit on the cheap side. But most of all there was Vreeland, probably one of the most extraordinary women I've ever met – along with Penelope Tree and Grace Coddington. I didn't know intellectuals, I never knew people like writers, who I'm sure I would have been fans of. Vreeland wasn't intellectual but she knew them all.

Jean and I went to see her when she first came to *Vogue*, to pay our respects. It was raining, and we were staying in someone's flat and we couldn't get a taxi, so we walked in the rain from Tudor Buildings to the Graybar Building. We were soaked and by the time we got to *Vogue* Jean was crying because she didn't want to meet Vreeland looking like a mess. As we walked into her office Vreeland shouted, 'Stop!' and Jean burst into more tears. Then Vreeland said, 'The English have arrived!' That's why I liked her. I thought when she arrived she'd get rid of us all and bring the *Harper's Bazaar* photographers with her. But for me it was the opposite.

Nicky had just started work at *Vogue* and he was dazzled by his first encounter.

Mrs Vreeland's appearance was breathtaking. She didn't merely enter a room, she exhilarated it, and all eyes immediately locked on her, hypnotised. Her onyx black hair, sleeked back from a sloping brow, revealed ears powdered terracotta red with a hare's-foot brush; her peony pink cheeks, the pronounced crimson lips below a long nose, her crane-like walk and pelvic-thrusting stance had all been described to me, but her actual presence was like a sock on the jaw. You knew you were seeing a supernova.

She had a really good eye. She could tell a good dress straight away – she was the first to spot Saint Laurent. She published the first picture of Mick in America, in *Vogue*. It was the first serious picture I ever took of him. He looks very young and he's wearing just a shirt. I gave it to English *Vogue* and Bea Miller turned it down, saying, 'I don't know who he is and I don't want to publish him.' I showed it to Vreeland, who said, 'I don't care who he is, I'm going to publish it because it's such a great picture.' That was the difference. It was the first one of my portraits to be published in America, the first significant picture.

Vreeland also loved Jean. I think she was on the cover of *Vogue* seventeen times in a year, because *Vogue* used to be fortnightly. I asked her why she used Jean so much. She said, 'People love a cover of somebody they're used to.' They used to put up potential cover shots from me, Bert Stern, Penn, then later Avedon when he came to *Vogue*. Then a psychologist, a professor we called Doc, would choose one.

Vreeland became my best mate in New York in the Sixties. I used to have dinner with her every Thursday when I was in town. I don't know why it was always Thursday. I used to go

to her house and she always had Cecil Beaton there. I became very good friends there with Bill Paley, the head of CBS. What fascinated me was that he believed in flying saucers – the head of a major news channel who was convinced of the existence of UFOs.

Vreeland was good at conversation. She was always interesting and she treated everyone equally. She used to call Cecil 'Sir Cecilia'. She asked me once, 'Who are the best-looking men in New York?' I said, 'The New York pimps.' So she made me drive her around Harlem in the back of a car looking at these guys, and she said, 'I see what you mean.' For the editor of *Vogue* to come to Harlem with us and drive around looking for blokes . . . I used to take her to the gay clubs, the ones with the leather queens in the Meatpacking District, like The Mineshaft. They didn't like women at all; Vreeland was the only one they allowed in there. I once took her to the Café Flore and everyone thought she was a film star from the silent days of movies. Once I went with her and Cecil to see the film *Elvira Madigan*, a sentimental Swedish film, and she was crying. When Cecil, Vreeland and I arrived at the cinema, which was below Bloomingdales, on 56th Street, we saw a long queue.

'Go and tell them who we are,' she said.

'I don't think it will do any good!' I said.

'Tell them who you are.'

'Nobody knows who the fuck I am!' I said, but I went and was told, 'Get to the fucking end of the queue.' You know – New York. I came back and said, 'No luck.'

'Leave it to me,' she said and the next thing I knew she's whistling at us: 'Come.' We had our seats straight away. She had a sort of power.

I think Vreeland's husband was always drunk. We used to

look out the window of Fifth Avenue and see him walking unsteadily down the street and she'd say, 'Oh, Vreeland's a bit sick today.' He was old-fashioned American, always wore a silk scarf tucked in. Kind of elegant, tall. And then he died. Vreeland loved getting stoned. I remember once driving with her and Jack Nicholson and Anjelica Huston to her old house in Regent's Park, where she lived before the war. She was stoned and crying over her memories at 3.30 in the morning, and she wanted us to steal the knocker from the front door. The women were sitting in the limousine while Jack and I were trying to steal this fucking knocker shaped like a lion's head, but we couldn't get it done.

She was great. There were some classic Vreeland moments, I remember. The best was: 'Pink is the navy blue of India. I wouldn't be seen dead in it.' She'd say things like, 'Oh Cleopatra, she's the daughter of the sun.' She said my studio was like a nightclub and Penn's was like a cathedral. She once told me, 'Bailey, go to Venice and get a thousand gondolas.' I thought, 'Shit, I better phone Liberman,' because he was sort of in charge of money. I said, 'Alex, she wants a thousand gondolas.' He knew who I was talking about. He said, 'Ten will do.' He was right, by the way. You can't see a thousand, but you can see ten. She ordered cushions to be sent to India when we were shooting there with Penelope Tree. You get cushions everywhere in India, you didn't have to send them from America!

One day she said to me, 'Bailey, we've got to stop spending so much money.' I said, 'Oh, all right.' The next day she called me up and said, 'Can you go to India to photograph the white tiger?' And I went. The tiger was in a zoo. And that was saving money. But that's where Vreeland was incredible: 'Go to India and photograph the white tiger.' A gaggle of assistants used

to run around after her, copying her, saying things like, 'It's divine, dear.' Her make-up was Vaseline, which she'd put on her cheeks up to and over her ears. Looking back, it must have been uncomfortable, those greasy ears. She was extraordinary, Vreeland, you couldn't mistake her for anybody else.

It was Babe Paley who got me interested in the fur ban. She was a friend of Vreeland, a wealthy socialite married to Bill Paley. One evening Babe turned up for the Thursday dinner in a fur coat that was black panther.

'You're wearing half the fucking panthers that are left on earth on your back,' I said.

'We should do something about it,' Vreeland said.

'Yes, we should refuse to photograph any endangered cats.'

'Quite right,' Vreeland said.

So we stuck with that. I told Bea Miller and she said, 'Oh, it will interfere with our advertising.' But Vreeland didn't give a shit. And then I made that commercial later for Greenpeace and won prizes, which launched me as a maker of commercials.

Vreeland used to tell me to charge more to *Vogue*.

'They won't pay any more,' I said.

'They will because I'll insist on using you.'

So she wasn't on their side, and in 1971 she was finally fired, I think for overspending. She used to say, 'The English don't understand that if you want to make money, you have to spend money.' But she began to get the ratio wrong by overspending.

That was almost the best Vreeland story. She told me, 'Some lawyer fired me!' Her arms were flying all over the place – you had to duck when she was talking. 'So I phoned Alex and said, "I don't want a lawyer to fire me. You hired me, you come and fire me."' He came up and she said, 'Alex, stop looking in profile, I've looked at your profile for ten years. Look me in

the eyes for once! Am I fired? I've met White Russians, I've met Red Russians, but you're the first Yellow Russian I've ever met.' Even after she'd left *Vogue*, she'd say, 'Get me a ticket to Paris,' and you never asked her for the money, you just did it. She was so used to *Vogue* doing it for her she'd think *Vogue* had paid. She was expensive, but I loved her.

Chapter 11

Breaking Up

Looking back, by 1964 the Sixties only had a couple of years to run before it became pastiche and tourism and a kind of parody. That was the year the Ad Lib club opened, in Leicester Place, London, and ran for two heady years. I always thought the Sixties was a small group of people, maybe not more than 150 at the outside, maybe as few as fifteen when it started up, a lot of whom wanted to get to know each other and hang out together. My *Box of Pin-Ups* reflected this – they were mostly my mates, and many of them were or became famous for what they did. The Ad Lib was considered to be the centre of that Sixties moment, and maybe it was. Nobody could get in really except us. It was a big party all the time. I had a joint with John Lennon there one night and he said, 'I guess I've made it. Here I am on the roof of the Ad Lib smoking a joint with David Bailey.' He asked me, 'How much do you work?' And I said, 'Eight days a week.' I don't know if the song came from that. I wasn't particularly friends with John, but out of all the Beatles he was the only one I liked.

I went to the Ad Lib there one night with Mark and Arabella Boxer and Jean, and I got into a punch-up, and Mark disappeared pretty quickly.

DAVID BAILEY

JEAN SHRIMPTON: They were arguing about who was
backing into somebody else. I remember Bailey sort of fell
over the barrels they had and he did have a bad bang on
the calf. He did get into scraps from time to time. If the
taxman came he'd push him up against the wall and tell
him to go away. He was an East End thug, wasn't he? That
was his attraction, in a way. If you're with somebody like
that you feel pretty safe because you know he'll punch for
you. And when you're young you find that more attractive
than when you're older.

I remember teaching Nureyev to do the twist at the Ad Lib.
I was quite friendly with him, though I didn't actually like
him. I can't remember how it came about. Everyone was a
bit pissed or stoned. I just showed him how to do the knees. I
think I taught Mark Boxer how to do the twist too – a dubi-
ous achievement! But Nureyev was so like a woman really. He
gave me all the pictures Avedon had taken of him, because he
wanted to get into my trousers. I gave them away, stupidly. I
think I gave some to Pat Booth, now dead, the model from the
East End who turned into a sexy thriller writer and married
Frank Lowe, the ad man. (Pat had a wealth of material to write
from – her first husband was a psychiatrist in LA, so she had
ready-made plots. He wrote a book called *The Myth of Neu-
rosis* and committed suicide soon after.)

Nureyev was a real star, the genius dancer escapee from
Russia. Him and the bullfighter El Cordobés, who fought bulls
in a lounge suit, were probably the most famous people in
the world then. I knew him too. He was also the highest-paid
showman in the world at that point. I went to Spain to photo-
graph him and he said, 'Come to lunch, I'm asking a few people

Jean in Primrose Hill.

around on Sunday.' I went to lunch and it was 500 people, all laid out with table places.

I'd see Princess Margaret a lot at the Ad Lib too, usually with the McEwen family. David McEwen was a bit of a drinker. The Beatles, the Stones, Nureyev, Mr Fish the shirtmaker, Celia Hammond, Polanski – not such a big gang either. It was a bit rough, the Ad Lib. They wouldn't let people in; it was quite a small place.

Jean didn't like dancing at the Ad Lib. She wasn't any good at it, so she used to just sit there with her knitting. Maybe I should have noticed this was a warning sign because that year, 1964, she left me. She flew to New York, telling me it was over, and I came after her. When I got there she ran off to stay with Nan, who married Bruce Weber, and I was left in New York by myself. I was in love with Jean. It was especially painful because I'd see her every day on the fucking buses. Her picture was everywhere in New York in a famous Van Heusen ad, wearing a loose shirt, with the slogan 'It looks even better on a man'. Hitchcock had just brought out *The Birds* so every poster was either 'The Birds are Coming' or a photograph of Jean Shrimpton. I had the whole of New York to compete with, whereas in London I didn't have anyone to compete with, really. Donovan maybe. And it was like losing a perfect camera and losing my perfect muse. So when she left, I wasn't just losing somebody I fucked, it was also losing somebody I'd based my career on, almost. Then she didn't do any good pictures until Avedon started to use her.

But I had been getting fed up as well. Jean was getting more ambitious and I was jealous. We'd worked together every day for about two and a half years and then Jean became more important than me, in a way. Advertisers and magazines didn't worry about the photographer, they worried about getting Jean

Shrimpton. We used to have arguments where they'd say, 'But she's £300 a day!' I'd say, 'Yeah, but a fucking Rolls-Royce is £5,000. If you want the best you're going to have to pay for it.'

What broke us up really, in the end, was pressure from Eileen Ford of the model agency and her husband, Gerard Ford. They'd jumped on her as soon as we arrived in New York and signed her up. They were always asking Jean to dinners and things with Charlie Feldman and people like that. They didn't ask me. They thought Charlie or one of those playboys would hit on Jean and I was in the way. They didn't want any influence on Jean except themselves.

We were, out of necessity, working together again after six months and it was fine by then. I was still in love with her. Or maybe I was in love with the image of her. And by that time she had taken up with Terence Stamp, whose career was taking off with *Billy Budd* in which he gets crucified in the end like Jesus Christ. It was a perfect part for him. I'd seen him around the dance halls when I was younger – he was a 'face' around the East End – but I only got to know him later when he was living with Michael Caine in a house behind Buckingham Palace. And I'd been so nice to him. I used to give him a lift and Jean would sit on his lap in the Morgan. It's a classic.

That's the only time it's happened, allowing a woman to break my fucking heart. Wasn't going to happen again. It made me much tougher.

JEAN SHRIMPTON: What happened really was his divorce had properly come through and, having got divorced, my parents and everyone thought if I got married I'd put it right. And I suddenly thought, 'I can't get married. I don't

want this to be my future. It's not right for me.' I didn't want to be married at all. I got married very late, I didn't want children – I had children very late – because none of it means anything and yet I'm very serious if I take the action. I've been married to Michael for forty-odd years now but it felt very funny getting married. And I'm a good mother yet I'm not interested in that either, but I am a good mother. It was quite difficult, and I just knew I couldn't. So I said, 'I'm going to New York for two weeks on my own.' I do remember saying, 'I've got no existence. My whole existence is your existence. You can keep going on; I don't want to keep being a model, and I can't. I haven't got many years left and what's my life going to be?'

I can't stay with somebody once I know it's not going to work. I'm quite callous when it comes to it. So I went to New York for two weeks and then Bailey came over. And I said, 'I don't want to be married.' I think he flew home and went straight from Heathrow to my mum, they're about twenty minutes away. But my parents then rang me up and said, 'What have you done? Bailey's very unhappy.' It was all prepared. They thought once the divorce came through I was duty-bound in a way, having caused the trouble, to get married.

Poor old Bailey. I don't think I've made it up. He was very upset. I couldn't do anything about it. I was gone, that was it. Also it's true that I was getting more ambitious. Before I always just did what Bailey did, my life was prescribed by that. And I suppose at the point when we broke up, I was getting a lot of attention. Once you go and work for Penn or Avedon, who was considered superior to him in the photographic world, I think that

would be true he would be a little jealous. I was a bit looking at other people too. He was always looking at other people. I was terribly jealous. I would have suffered dreadfully from jealousy. But it was like when he wasn't nice in the studio when we were working – I still knew he adored me. And though I knew he was seeing other people sometimes, it was never much, a quick one in the studio probably. I think I knew he loved me.

I didn't leave him for Stamp or anything. It was just later on that Stamp rang up to speak to Bailey and I said, 'He's back in England, we've sort of split up.' I didn't go after Stamp, though I was attracted to him. He was so bloody beautiful. He didn't really want me. He went after me as a conquest. But once he's got the conquest you're just a conquest – he doesn't want your mascara in the bathroom, doesn't want you living there, making a mess. I was a bit afraid of him.

I came back from America and Stamp didn't want me living at his place. So I had nowhere to live and I was at the Boxers' one evening and I met Geoffrey Bennison, the antique dealer, and he said I could stay at his Trebovir Road hotel. So I was there for a little while, feeling very, very lonely. You just don't understand how lonely being famous is. Eventually I shared a flat with somebody called Penny Bird. I had one little tiny room up near Hampstead, Eton Villas. And I was so famous. This is what's so ridiculous.

I've always been isolated anyway. I'm not very good at friendship, I didn't have many friends. So I was very lonely. And that's why I spent so much time in Geoffrey Bennison's shop. He was like my mum. He and his gang of drag queens loved all my dramas and miseries.

Chapter 12

Shrimpton and Bailey

JAMES FOX: *Jean Shrimpton lives with her husband, Michael Cox, in a spacious wooden clapboard house, Long Island style, with a wide veranda, in Cornwall. It sits in an area of wild grasses, fenced off from a farm. It feels quite remote, which may have been its intention when they chose the plot and built the house a few years ago – to match the feelings of isolation Shrimpton has always found familiar, outside of her happy forty-year marriage. David and Catherine Bailey have a house on Dartmoor and have picked me up from Tavistock where I have spent the night. Bailey hasn't seen Shrimpton for many years. She opens the door. She is tall, and her blue eyes are still remarkably translucent.*

JEAN SHRIMPTON: Hello, Bail. How are you?

DAVID BAILEY: Divine.

SHRIMPTON: Well, you always were divine.

The Baileys have brought Mortimer, a large, black and puffed-up chow-chow, who walks behind them. Shrimpton has two dachshunds. We discuss dog arrangements for the interview; the dachshunds, who want to guard Shrimpton, are removed and we sit down.

BAILEY: He's no trouble at all, Mortimer. He's not really very big. He's the nicest dog I've ever met, he just doesn't like me. He looks big because he's got so much fur.

SHRIMPTON: We had lots of dogs, you and me, when we lived in that flat in Princess Road. You bought me a Yorkshire terrier for my birthday and I didn't really like Yorkshires.

BAILEY: You're right. They're horrible.

SHRIMPTON: It's just not my sort of dog. The butcher across the road had him. He said it was a Yorkshire terrier. It was quite a big mongrel, it wasn't a terrier, and we called him Mongey because my names have always been original, and he was sweet. When we split up, Mum had him for a while and then she had to find a home for him and he won an obedience contest in Slough.

BAILEY: What, the butcher's dog?

SHRIMPTON: Well, he became our dog and he was called Mongey.

BAILEY: I don't remember. Why didn't we end up with him?

SHRIMPTON: I think our lives went separate ways.

BAILEY: Oh, did they? Yeah. Oh, you left me?

SHRIMPTON: Possibly.

BAILEY: It's all right. It don't matter, shit happens.

SHRIMPTON: Well, you've done very well.

BAILEY: Yes, I did, really well.

SHRIMPTON: You wouldn't want to live with me.

BAILEY: Well, I did at the time. I was a bit upset when you left but I deserved it, I suppose.

SHRIMPTON: You didn't deserve it; it's just I wouldn't have fitted into the picture. I couldn't live that life, I didn't like it.

BAILEY: What life?

SHRIMPTON: I hated being famous and all that, and I didn't respect the modelling world.

BAILEY: I know, I didn't either, but you didn't have to worry about being famous. It's other people who are famous; you're not famous.

SHRIMPTON: Well, I was famous enough.

BAILEY: You're the most famous that's ever been on that level.

SHRIMPTON: I was saying to James I have this image of you that you won't remember, coming across a bridge, and you had a bunch of flowers for me, and people didn't hold flowers like this. It was straight out of over the rainbow, it was very Judy Garland, who you used to like.

BAILEY: I still like her. 'You don't bring me flowers any more.' I tried to get you some flowers today but there's no fucking flower shops.

SHRIMPTON: I've got all my roses, as you can see, I'm a rose freak. But men didn't carry flowers without feeling embarrassed and you've never been embarrassed of being – what other people would say as gay – but you've never been embarrassed, you'd be more embarrassed by four men in a car than you would be giving someone flowers.

BAILEY: Four men in a car going to a football match, I can't think of anything worse.

I liked your mum.

SHRIMPTON: Everyone liked her.

BAILEY: But I really liked her and I don't like many people.

SHRIMPTON: I know you did.

JAMES FOX: Did she like Bailey too?

SHRIMPTON: Yes, she did like Bailey. My mum was very easy; it was Dad who was difficult. But my mum was popular, she was easy to like.

BAILEY: She was just a nice person, she didn't judge people, or she didn't with me.

SHRIMPTON: She was like her mother – my granny had nothing, an outside toilet, no bath, and she used to say, 'Oh, it's the best little spot in the world, the library van comes once a week, it couldn't be better,' and she was that contented.

SHRIMPTON: James showed me a picture of your cousin.

BAILEY: Maureen? She's eighty-six.

SHRIMPTON: She's fantastic. She's got your spirit, you can just see it.

BAILEY: I always fancied her when I was kid.

SHRIMPTON: Well, you fancied anything that moved so that doesn't surprise me.

BAILEY: More or less, yes, as long as it's frilly. I didn't like ugly girls much.

SHRIMPTON: Why are you writing this book? Is it because you want to stay famous?

BAILEY: No, I don't want to be famous.

SHRIMPTON: So why are you doing it?

BAILEY: Well, it's something to do. I do lots of things, I still work every day.

FOX: I think this is something of a historic moment. Have you ever done an interview together?

BAILEY: Not that I can remember, can you, Jean?

SHRIMPTON: Not really.

FOX: You were attracted to Bailey immediately he put his head round the door?

BAILEY: It was the way I hold flowers.

SHRIMPTON: Everyone was attracted to you but you put your hand on Clare Rendlesham's leg and things.

FOX: Clare Rendlesham, really?

SHRIMPTON: Didn't you? He was terrible but he'd get away with it. He could come on strong, a bit, at times. Bailey didn't sit you on a stool for nothing, because then he can press against your knee when he's taking the meter reading. He'd be in trouble today. But nobody objected. He was very fancied by everybody. John French fancied him. He was immensely appealing. Youth can be very appealing. He was pretty, I don't know how to describe it. Women were always receptive.

BAILEY: No, I didn't rub myself against your knee. I'd push your skirt up and *Vogue* used to airbrush it down.

SHRIMPTON: You'd be in trouble today.

BAILEY: No, I wouldn't because there was no deal. To be in trouble you have to make a deal. You have to say, 'You do this otherwise you won't be on the cover of *Vogue*,' and I'd never have done that because it wouldn't have been sensible. You'd end up with shitty *Vogue* covers if you did that. So you'd never work for *Vogue*. It would be a pointless exercise. Anyway, I didn't have to say, 'Sleep with me.' I don't know why you said that because it couldn't be less true.

SHRIMPTON: All right, I retract.

BAILEY: Do you agree it's not true?

SHRIMPTON: Possibly. Maybe it's wishful thinking. Maybe you didn't.

BAILEY: I didn't have to do that.

SHRIMPTON: No, you didn't.

BAILEY: You probably rubbed your knee up against mine, bitch.

SHRIMPTON: No, I'm too tall to do that.

BAILEY: It's funny a short-arse like me made it with all those girls.

JAMES FOX: *That topic came up, inevitably, in conversations I had with John Swannell, his studio assistant in the late Sixties, and Gilly Hawes, his PA from 1966. John said, 'I don't know how he did it. When he was young he lived for it, there was no question about it. Whatever trip he was on he went for the model and 99 per cent of the time he was bonking them.' Gilly added, 'It was a different climate in the Sixties but he didn't take advantage. There was nothing inappropriate sexually. He didn't put himself unwanted onto anybody. I was there a lot of the time with models in the evenings, there was never anything that wasn't consensual. And they would have come out of the woodwork.'*

FOX: You'd only seen Jean briefly through the door. What more did you see when you first took a picture of her? Was there something else you saw?

BAILEY: I thought she was very sexy.

SHRIMPTON: I wasn't sexy.

BAILEY: Well, you were to me.

SHRIMPTON: Possibly.

BAILEY: I hated the obvious sex. I didn't like Marilyn Monroe, that sexy thing! I liked her as an actress but not as a woman. I liked women that were skinny that looked like boys really.

SHRIMPTON: But it's funny you weren't gay at all. There are aspects of your personality that you would presume meant you were gay, but you've never been remotely gay.

BAILEY: I think you have to be a bit gay to do fashion photography because all the good ones are gay. I mean, Avedon didn't know what he was, Penn didn't really do fashion, Penn's fashion were like still lives.

FOX: What I find moving about this story, this young couple more or less on the run, eloping, nowhere to live together, meeting in parks and you find yourselves transforming the fashion world, turning overnight into the biggest icons of the Sixties. It's fairy gold.

SHRIMPTON: We do sort of love each other.

BAILEY: I loved you, I loved you so much.

SHRIMPTON: I'm not capable of loving that much. I was too damaged, darling.

BAILEY: Damaged? Why were you damaged?

SHRIMPTON: Oh, that's a long story. If you're born during the war, we were quite near Bomber Command, all these people getting on the buses to go up in their planes and there is this feeling of stress even if you are very young. The men came out of the war really screwed up. You didn't know them when they came back. Dad got pushed out of the war because he was always fainting. He was neurotic. He had it very severely. He was on Librium for forty years. He was self-made, left school at fourteen, became very successful – he made an awful lot of money building boring houses on estates. When he was away at the war I lived with Mum and my granny – ordinary, just

nice women. Of course I was spoiled to death. And then my sister, Chrissie, was born when I was two and a half and suddenly, from being idolized, we were moved to a house that my dad had built and my sister came along and I was very shocked. I became a rather distant child and everyone adored Chrissy who was much more smiley. But I think, for me, I never trusted anything really after that and then I was sent to a convent, which is enough to finish it off.

BAILEY: All dirty bitches go to convents!

SHRIMPTON: Yes, they do. Then you see Christ on the cross. That's why I bought Egon Schiele paintings, it's just very weird.

BAILEY: I didn't realize you had all these problems.

SHRIMPTON: You just want to please all the time. Fear of rejection.

BAILEY: You didn't want to please me particularly.

SHRIMPTON: Yes, I did.

BAILEY: Oh did you . . . ?

SHRIMPTON: You want to please all the time and that is very good for becoming a needy model and then you understand what you are.

BAILEY: Well, it worked. It made you the best model in the world. It did.

SHRIMPTON: No, I wasn't! That's not my opinion. It's outside of me. I'm so self-conscious, I can't move, I can't dance, I hate being looked at, and yet I could do it if it were necessary. I hated working on location because people looked at you. It was an alter ego for me.

BAILEY: No, you never knew it; beautiful girls never think they are beautiful. They look in the mirror and they don't

like it. That's why you always had your hair over your face and you were always picking your hair – do you remember that?

SHRIMPTON: Now it all falls out. No, I'm fine now. I'm very reasoned now.

FOX: You said several times, Bailey, 'The two magic models for me were Jean Shrimpton and Kate Moss.'

SHRIMPTON: I was ordinary. It's what Francis Wyndham said I was: ordinary. Kate has that ordinary quality.

BAILEY: Kate is like you, she's democratic, everyone likes her – gays, dogs, everything.

SHRIMPTON: It's a kind of ordinariness.

BAILEY: She's available but she's not available – the girl who doesn't live next door.

FOX: You didn't want to be a model. You didn't think you had it. You said, 'I've got no eyes.'

BAILEY: She had beautiful eyes.

SHRIMPTON: I didn't, I had all these bags. I needed false eyelashes, top and bottom. Twiggy had it more than me, I didn't have them often on the bottom. But I've got no eyes, as Bailey was very fond of telling me. But I have this sort of hooded quality and it's very easy to put the make-up in the hood of the lid. So without make-up I just look like a pig in the snow. But I can put make-up in there, and then I've got the bags underneath.

BAILEY: I know, you always wanted them removed. I said to keep them because they're nice. It was like Jeanne Moreau, she had bags.

SHRIMPTON: Well, luckily Jeanne Moreau preceded me; otherwise me and the bags wouldn't have happened. I remember when you photographed her.

DAVID BAILEY

BAILEY: I love what Dietrich said about you. When we went
to a party and Cecil said, 'This is Jean Shrimpton,' and she
said, 'What's all the fuss about?' Bitch.

SHRIMPTON: We were in America and we met bloody Yul
Brynner and he was also sort of dismissive.

BAILEY: He liked me.

SHRIMPTON: Did he?

BAILEY: I became good friends with him, he thought I was
his fucking long-lost gypsy brother.

SHRIMPTON: He was quite dismissive when you first met
him.

BAILEY: No, he was all right with me. I used to have dinner
with the Duke and Duchess of Windsor with him in
Paris and that writer Lesley Blanch who died aged 102.
She wrote the thing about Imam Shamyl, the Russian
revolutionary in the Balkans, *The Sabres of Paradise*.

FOX: Anyway, it took a while for you to seduce Jean.

BAILEY: Took me three months roughly to get my leg across.

SHRIMPTON: Well, only because I was so middle class and
having an affair with a married man. Dad wouldn't speak
to me for a year.

BAILEY: He had a shotgun after me, didn't he?

SHRIMPTON: Don't know about that. The trouble was he
liked you when he met you, because you made money.
Same with Mick. Mick could start a car with a hair pin
or something, the kind of thing Dad liked. And talk about
money. There he was, Mick and you and me making all
this money, poor Dad. He said, 'You just piss it up against
the wall,' which I did. He couldn't believe it. He did get to

like you because he liked people who made money. I didn't
see Mick much because Chrissie and I didn't go around
together.

FOX: But your mum found him?

SHRIMPTON: Found them in bed. Chrissie had gone into my
bed and Mick went into Chrissie's and my mum went in in
the morning because it was quite late and there was Mick
in a bed. But Mum was very able to take it.

FOX: But didn't she make everybody breakfast?

SHRIMPTON: Yes. When Dad told you and Charlie to 'get
out', she was making you and Charlie breakfast.

BAILEY: But I didn't shag you then, did I?

SHRIMPTON: No, I don't remember the date particularly.

BAILEY: What would you have done if you were me? Either
be with Jean Shrimpton or fucking be the best man at that
wedding?

SHRIMPTON: I would be the best man.

BAILEY: You see, you've got no passion.

SHRIMPTON: I've got honour.

BAILEY: Fuck off, love! It's nothing to do with honour. I'd be
a fool not to go with my emotion.

SHRIMPTON: All right, one for you and one for me.

FOX: Can I go back to the moment that didn't happen in the
haystack, but happened – at last, after rare resistance –
somewhere else?

SHRIMPTON: Oh, Littleworth Common.

FOX: Is that correct?

SHRIMPTON: That's right.

BAILEY: I think it was, because I saw a frog.

SHRIMPTON: You were turning into a prince, darling.

BAILEY: I saw a frog jumping. I thought, 'Fucking hell, that's symbolic!' This fucking frog is getting away.

FOX: Because there was nowhere else because he was married? You couldn't be at home.

SHRIMPTON: Yes, I had nowhere. We used to go to Wimbledon Common sometimes too. Then occasionally I stayed in the Strand Palace Hotel. Do you remember Eric Swayne's flat in Hampstead?

BAILEY: He was horrible, wasn't he?

SHRIMPTON: We stayed with him. He had a wife called Janine. It was quite basic. There was a single bed and you had to sleep on the floor. I remember washing my feet in the basin and the basin came away from the wall. That was very early days. You had these silly rhymes: 'Brian Duffy, bald and scruffy. David Bailey makes love daily. Richard Dormer, arsehole performer. Norman Eales, sheer appeals . . .'

BAILEY: 'John French, comely Wench.' I couldn't get one for Donovan. I couldn't say Terry Donovan because nothing would rhyme with Donovan.

SHRIMPTON: We stayed with Glad once or twice on our expeditions to the East End. We used to drive through Brick Lane on the way home, which was considered dangerous, and we'd put the windows up. I liked going there, to the East End. We used to go and see these drag queens, Rogers and Starr. Bailey paid the local ruffians or whatever you want to call them – the lads – we paid them money so they didn't scratch the car. Glad didn't like me. Bert was easy but he wasn't there very much. But Ethel or whatever she was called, Stamp's mother, really liked me.

BAILEY: Glad thought you were one of those – posh.

SHRIMPTON: I don't think Glad was a happy woman.

BAILEY: No, you couldn't say that! She's probably the most unhappy woman I've ever met. No, she was really miserable.

SHRIMPTON: You remember when I was hiding behind the dustbins and we had a row and I walked out?

BAILEY: We had a fight?

SHRIMPTON: Yes. I hid behind some dustbins up the road to worry him and Bailey went absolutely mad and got really quite worried where I was. Obviously he was more fond of me than I realized. And when I did surface back, Glad was furious at me: 'Don't you do that to my boy!'

BAILEY: The house was always cold. Those houses were draughty. I remember Jean came to stay once with Glad. Glad got very uptight because Jean asked where the other sheet was. You only had a sheet on the bottom back then. Glad said 'Who does she think she is?'

[Bailey leaves the room to make a cup of tea]

SHRIMPTON: Bert was a tailor, wasn't he? It's like Alexander McQueen, they look at clothes in a different way. It's why he's good. Very few people would come through with that. He was terribly good with clothes, Bailey. He understood them. This is what is so funny because he wasn't gay at all, but he had that ability. He liked clothes. Cecil Beaton and all these people, Nureyev, they all loved Bailey.

FOX: Did you get on with them?

SHRIMPTON: I don't think they found me very interesting; they liked Bailey more. This is what I found all the time – Cecil Beaton, it wasn't me he wanted to talk to. Cecil Beaton thought I was common. I was!

FOX: He must have thought Bailey was common as well.

SHRIMPTON: Yeah, but they don't mind rough trade common.

[Bailey re-enters]

BAILEY: Remember that day when we first went to see Vreeland together in New York, when she'd just been made editor of *Vogue*? We went in the pouring rain together, we were staying in Charlton Heston's flat.

SHRIMPTON: No, we only visited that.

BAILEY: We stayed there, David Hurn let us stay there because he had it, and we walked in the downpour and you said, 'I can't see her.' I said, 'It's better to see her wet,' because we couldn't get a taxi so I said, 'We'll fucking walk,' and that made you cry even more.

SHRIMPTON: I don't cry easily.

BAILEY: You did, you cried. Your tears and all your fucking make-up was running. You were fucking pissed off with me for making you see Vreeland and I said, 'No, we should see her. It's better to turn up than not turn up.' This was the fucking goddess of fashion.

SHRIMPTON: But I didn't care.

BAILEY: No, I did though. I was thinking of my fucking self as well.

SHRIMPTON: What a surprise.

BAILEY: I didn't want to leave you alone so I dragged you along, and when we walked in and Vreeland said 'Stop, stop . . .' In this fucking magic cave of her office with scarlet-red walls and a tiger carpet, she said, 'Stop! The English have arrived!' And then you burst more into tears and she was fantastic.

SHRIMPTON: No, I didn't.

BAILEY: You did. I remember the make-up looked kind of good the way it was all running.

SHRIMPTON: I must have looked very wet in every sense.

BAILEY: Yeah, you were soaking. You looked like an old drowned rat.

SHRIMPTON: An old drowned rat?

BAILEY: Yeah, old. All the make-up was running and I thought it was great and it made an impression. So I was right to do it, wasn't I?

SHRIMPTON: Yes.

BAILEY: If you had arrived with all make-up and everything you'd have just been another model.

FOX: You were definitely in tears, though, at the shoot in New York the year before when it was freezing cold. Your first trip with Bailey, with the street photographs.

SHRIMPTON: Yes, I was then. I accept that one.

BAILEY: My hand stuck to the camera.

SHRIMPTON: It was totally stupid. I was on Brooklyn Bridge. It was a camel outfit with a green silk blouse and it was February. It was so cold and I sort of began to cry. I just was so cold – I'm very stoic, I don't make a fuss. And the other time it was freezing it was in Paris in Versailles, and that was in the winter and I was out in one of these evening dresses and god it was cold. I don't think many people would've gone on as long as I did, it just hurt so much. But I wanted to get the picture as well because I . . . It's not that I lack ambition – if I do something I want to do it well – but I haven't got any talent so I don't do very much.

FOX: Did you have to shoot in sub-zero conditions?

SHRIMPTON: I don't know. God knows, it wasn't anything to do with me. It was unbelievable. I'm a bit of a fainter

anyway. But that's why I got employed quite a lot because I would do it. I have a need to please, a fear of rejection is a huge motivator. And also I'd gone in hook, line and sinker with Bailey. We had nowhere to live.

FOX: Bailey, why did you have to shoot in such difficult circumstances?

BAILEY: I wanted to do the bridge, Brooklyn Bridge. And, you know, it was cold so . . . We always used to shoot in the cold anyway.

SHRIMPTON: You do survive it.

FOX: Would you do it now?

SHRIMPTON: No.

BAILEY: Of course you wouldn't do it. It's not the same passion that it used to be then. It was all about getting a great picture. Now it's just about getting the picture. It's all gone. It's all changed now. I'm not old and bitter, things change.

FOX: The following year was Vreeland in the rain. Then you started to drift apart? It's such an odd story that Eileen Ford – as you said, Bailey – was trying to manipulate your separation.

BAILEY: Yes, Eileen she hated us being together. She wanted to whore Jean out. They were always trying to get you out with Warren Beatty or Charlie Feldman and people like that.

SHRIMPTON: Eileen Ford told me to get my bags done and my teeth straightened. I said, 'I'm not going to do any of it.' They just want you to look like a plastic doll.

BAILEY: Horrible. They didn't like me as a boyfriend. They didn't want anyone who had influence on Jean. They wanted to be the influence on Jean.

SHRIMPTON: They were creepy, don't you think?

BAILEY: They were creepy, they were like pimps.

FOX: There was a moment when you liked the glamour, the fame. In your book you said it was rather nice getting dressed up, knowing Stamp looked so marvellous that when you went out together it was a bit of a buzz to be seen.

SHRIMPTON: Well, initially, I think.

BAILEY: Well, superficially. You did like the glamour with Stamp because you wrote me a poncey letter – I'll show it to you – saying, 'We make such a beautiful couple.' You know what, I had a vision of you on a wedding cake with Stamp and his fucking tails and bow tie and you in a wedding dress.

SHRIMPTON: That is a dreadful thing but I must have said it. Superficially I was rather keen on him. But I was being led, I wasn't taking any decisions. Stamp took me to John Heyman as an agency so I could make some money, and I was told, 'You must get a house,' and I bought this terrible little house in Montpelier Place.

BAILEY: Stamp took 10 per cent off you, didn't he?

SHRIMPTON: Yes, he did.

BAILEY: There you go. I didn't take a penny off you.

FOX: You worked together not so long afterwards? Six months later?

BAILEY: We did great pictures afterwards. We did great pictures in Hawaii and things like that. I've got some swimsuit pictures of you in the mid-Seventies that are really sexy.

SHRIMPTON: Also we went to Egypt because Penelope came to Egypt.

BAILEY: We went everywhere, we were in lots of places.

FOX: So this time you were sort of over it?

BAILEY: Yes. I still loved her, I've always loved Jean. Jean and Penelope and Catherine – they're the three great loves of my life, I suppose. I mean, obviously some of the others were nice.

FOX: But in fact, Jean, you went on after Bailey to do quite a lot of work with people like Avedon, even though you didn't like the business of modelling.

BAILEY: She did fantastic pictures with Avedon.

FOX: You had an ambition, still, to work with the greats?

SHRIMPTON: Yes, I did have ambition to work because you adored Penn and Avedon so much. Bailey revered these people so much that I actually did want to work for them, and it was fascinating to work with them because of the people coming through the studio. And they were intelligent, they were interesting to work for.

BAILEY: I must have drove Avedon mad because he worked with her a lot, Deneuve a lot and Penelope a lot and they were all with me.

SHRIMPTON: He wasn't attracted to us.

BAILEY: No, he was annoyed—

SHRIMPTON: Because you got there first.

BAILEY: Yeah, because he photographed you but I fucked you all!

SHRIMPTON: Bailey!

FOX: Boys will be boys.

SHRIMPTON: Especially old ones.

BAILEY: I was young then. It's nice seeing you. It's funny, if you hadn't fucked off and left me for Terence Stamp we'd still be together.

SHRIMPTON: No, we wouldn't be.

BAILEY: No, we wouldn't but we might've been.

SHRIMPTON: In your dreams.

BAILEY: No, not in my dreams, in another life. I don't have dreams, dreams are for fucking romantics. I don't even have wet dreams so I'm deprived in a way.

SHRIMPTON: I don't think I could have continued in that world really. I got into a terrible mess in my life with people like Heathcote [Williams] and that. I don't see how I would have gone on, because I didn't have any money as such. I didn't have friends and I was a mess. And the thing was Michael saved me, there's no doubt about it. I would either be dead or down a lane with endless animals. I really do think that.

BAILEY: We got on well today, best we've got on since fucking sixty years. You're usually a bit offish with me.

SHRIMPTON: I am possibly a bit offish.

BAILEY: Because I'm a nice bloke.

SHRIMPTON: Yes, Bailey.

BAILEY: Easy-going.

SHRIMPTON: Yes, you are easy-going.

FOX: It must have been difficult, though, what with 'David Bailey makes love daily'?

BAILEY: Well, as Grace Coddington said, they'd all been warned.

SHRIMPTON: Well, actually it was quite difficult because he was always in the studio with beautiful girls. But, as I said, I knew he loved me somewhere. I was the jealous type but I sort of did know he loved me.

FOX: Did that help with the jealousy?

SHRIMPTON: It must've done.

BAILEY: I was a bad boy, I couldn't resist. Better than being the best man at a wedding.

SHRIMPTON: The two aren't parallel.

FOX: You said you wouldn't be famous without Jean.

SHRIMPTON: Oh, you would, Bailey.

BAILEY: No, what I did say is Jean and I wouldn't have made it without each other. We did it together.

SHRIMPTON: I wouldn't have made it without you, Bailey, no. Nobody wanted to use me much at *Vogue*. I was a scruffy mess and I would not have made it at all if it hadn't been for Bailey.

BAILEY: It's sweet you say that. I'm very flattered, but I think we wouldn't have made it without each other, in a funny sort of way. I'll tell you what, we wouldn't have made it so easy.

SHRIMPTON: OK.

BAILEY: OK. Is that a good compromise?

SHRIMPTON: Yes.

Chapter 13

Pin-Ups

'When Bailey took the album picture of the Stones' *Out of Our Heads* he was a star; I was intimidated by him – he was already there, in the swimming pool, we were just getting our swimming trunks together. He was the upright charming yob and king of Hanover Square. Not unlike in cinema, Dennis Hopper in '69 and Tarantino now, that's what the likes of Bailey, Donovan and Duffy were in the world of fashion. It really was the first pop business that got young talents abroad, to New York. Way before The Beatles. When I'd lunch with Bailey in the early days in New York he was already home. Bailey also differed from the previous lot (John French, etc.) and his peers (Duffy and Donovan) in that he dressed navvy/ worker (same t-vest worn in *Raging Bull*. Wife beater). Both Duffy and Donovan allowed for Bond Street and Knightsbridge and donned the clobber. Bailey did not.'

– ANDREW OLDHAM,
ROLLING STONES MANAGER, 1963–67

Francis Wyndham was the only writer I was really good friends with. He was also one of the most interesting journalists I ever

met. He was senior editor on the *Sunday Times Magazine* and, along with Mark Boxer, he was responsible for one of the great moments – if not the greatest – in magazine journalism. Through Francis's support and promotion of a new gang of young photographers, which included myself, the magazine became known for its glamour and style, the best photojournalism and the writing that went with it. Francis was like someone born aged fifty. He looked old when I first met him, and remained the same, but he understood how style and image underpinned the Sixties, and particularly how the image came first in the magazine stories, the words second – a reverse of the usual rule that the picture illustrated the story. A writer didn't have a chance of getting his story in the magazine if the photographs didn't carry it. Before this, journalists used to call the photographer the monkey. 'Got to take a monkey along.' They'd tell the photographer how to take the picture: 'I want it from that angle.' Not with me or the other photographers Francis and Mark used, like Don McCullin, Donovan, Duffy. This reversal only happened because of the photographic talent that was drawn to the magazine for its great layouts and exposure of their work, with big spreads of photographs bled to the edge of the page. Francis got everything right, from Bette Davis to the Krays. He'd match the photographers with writers, some of whom had never written for magazines before, like Bruce Chatwin. He commissioned his literary friends like Gore Vidal and V.S. Naipaul. The weekly appearance of the *Sunday Times Magazine* was an event. I used to go on Saturday night to Leicester Square to get a copy around 1.30 a.m. – everyone was so excited to see which new things they'd done, what the photographs were, what the story was.

Francis wrote a story in the magazine in 1964 that was a

kind of a landmark in the culture of the Sixties, mostly because of what it led to. It was called 'The Model Makers' and it was the first time Donovan, Duffy and myself had been linked together publicly as a story. It was a silly title – sounded like we're a bunch of fucking model aeroplane makers, though I can see why they used it. Unless I'd seen a picture I wouldn't have read it. But Francis was up to his tricks again; so many people read that piece and talked about it. It didn't really make much different to me what people said about me – whether Francis had been nice or nasty wouldn't have mattered. In fact, Francis could write nasty about you and you sort of accepted it. He wrote:

> The London idea of style in the 1960s has been adjusted to a certain way of looking, which is to some extent the creation of three young men, all from the East End. These are the fashion photographers Brian Duffy, Terence Dono-van, David Bailey. Between them, they make more than £100,000 a year, and they are usually accompanied by some of the most beautiful models in the world! They appear to lead enviable lives. They have little in common with the pre-1960 conception of fashion photographers; it is their straightforwardly sexual interest in women, combined with an unbroken attachment to their East End origins, which has enabled them to interpret the mixture of toughness and chic peculiar to their time. 'We try and make the model look like a bird we'd go out with.' Very often, the model and the bird are the same girl.

He quoted Donovan on our new 'status':

'The fact that we can walk into the most expensive hotel in New York,' said Terry Donovan, 'and have a chat and be completely relaxed, and the next minute go and have a meal at Joe's, and the curious thing of being able to wander around and earn a great deal of gold like this, and meet Mr Macmillan, and the next minute be talking to some fisherman: is it a thing that exists only because of photography?'

Avedon and Penn turned out to be the two photographers I was up against, in a way – they were the best in the world for the stuff I was interested in. Penn was a fantastic photographer, not so brilliant at fashion; Avedon's the greatest fashion photographer that's ever been. Donovan and Duffy – I didn't like either of their fashion pictures, though I'm talking on a very high level there. But one advantage I had on Penn and Avedon was that they didn't have any sex in their pictures. If you asked Deneuve or Jean, they always say, 'Well, Bailey got something out of me that they didn't get.' Some rapport. It's like white men can't dance, can they? And I can dance. Some people can wear jeans; others look fucking ridiculous in them.

I wasn't really aware that I did it but the girls in my photographs always looked desirable. Not like Duffy and Donovan, where there's something nice about their girls; their mothers would like them, or their boyfriends wouldn't get jealous. What I do is just something some photographers have. With Duffy and Donovan's photographs, the women looked like you could fuck them. I made them desirable rather than fuckable. Donovan and Duffy didn't realize that. I think it's key to being a fashion photographer really. Who else has it? Patrick Demarchelier has it, so does David LaChapelle. Penn's fashion pictures are sort of sexless; there's no sex, they're like still lives.

And now still lives are easier to take than they've ever been because people can do it on their iPhone.

I like to take away everything – gradually take it away. Take away that stupid bag or whatever it was, and get closer and closer until you just have the essence of the girl. In fashion pictures it's nothing about the clothes that makes it great, it's what comes across from the girl. If the girl didn't like the dress, I'd say, 'I don't think we should do this.' If the girl likes it you're halfway there. It's not like it was anyway, it's all changed. Now the average photographer and average art director just want things *not* to look well done, they just want a snap. If a commercial's well done, they don't like it. It doesn't look 'instant' enough. They want it like it's on the internet. They want the director to do nothing, and that's what customers respond to – they just want information. 'This is a comb that Boots make for three and six.' That's all you need to say and you'll sell millions of combs. The aesthetic makes it pretentious, it can get in the way. It's only the aspirational that sells. All advertising is based on looking upwards, it's based on the perception of things being better than they are. It's always upwards, personal improvement. You always have to make it seem better than it is. Aesthetics don't sell any more.

But I wanted to make the models look the best I could. Since that first image of my mother twirling in that dress, it's been a passion for me. It was nothing to do with sleeping with them. If that became an existential part of it then that was OK, but it wasn't the aim. There were girls I made look good who I never even fancied, like Marisa Berenson. I just liked the way she looked. I didn't have to say, 'Oh darling, I think you're fucking fabulous, I'd like to get my leg across you.' That's awful. Eric Swayne was a bit of a cunt like that. I was with him one

day because I used to rent his studio in Camden Town. And he was looking at this girl's portfolio, saying, 'Oh darling, that's good.' He was talking the way he thought I did – that cockney banter that was more Donovan and Duffy than me. He said, 'Do you fuck?'

'Yes,' she said.

And he got all excited. 'Really?'

'Yes,' she said, 'but not for cunts like you.'

I don't remember who she was now.

The only mistake Francis made in his article was that Duffy didn't come from the East End – he was from Kilburn, where most of the Irish were from, and was a bit of an intellectual, unlike me and Donovan. He'd had a troubled childhood in and out of schools for delinquent kids, brought up by the Catholics, but he'd ended up at Saint Martin's School of Art. He was clever, Duffy, but he was vicious.

I was never political, but Duffy was. He was a Marxist. I used to wind him up and say, 'Marks & Spencer, you mean?' He didn't like it. He could see the funny side of it, but he always thought I was superficial. Duffy was the intellectual, he was always telling me how to take pictures. In fact, Norman Parkinson said, 'Duffy should have the ideas and let Bailey shoot it.'

I'm pretty sure he'd been in the IRA. He was banned from America. The story was that his father killed a British sergeant and a private during the Irish war of independence in the 1920s and went to prison. He never spoke much about him and he was never in his life. Duffy would never be photographed when I first knew him. He was the most violent man I knew. He didn't argue, he just hit people.

We used to go to restaurants a lot in those days, like the 'Tratt', the Terrazza on Romilly Street in Soho owned by Mario

Cassandro and Franco Lagattollo that had changed the look of London's upmarket restaurants. Alvaro Maccioni and Enzo Apicella, who designed many of these restaurants, owned the Club dell'Aretusa on the King's Road where we went – you had to be a member to get in, it was a real Sixties show-off place, like the Ad Lib. I stopped Duffy breaking someone's neck in the Aretusa one night. They had railings outside with points on, and Duffy had this bloke on the railings. I said to Duffy, 'What are you fucking doing?' I thought he was going to break his back. He was completely in the wrong – he was screwing the bloke's wife!

Duffy was like a surgeon when he went to bed. He used to lay out his knotted string and everything. I used to think of him as a sexual surgeon. There was no joy in it. He used to lay out the gadgets on a handkerchief. Jean saw him laying it all out one day and she said to me, 'We'd better warn the girl.'

'No, it's up to her,' I said. 'Just fucking stay out of it.'

I always thought he was inadequate because he needed some help. It was a performance not a fuck. Duffy once knocked me out in the Aretusa. A waiter came up to me and said, 'Your mate Duffy is in a bit of trouble upstairs. There's three gorillas picking on him.' So I went up to see if I could help, and the next thing I knew I was out cold on the floor and Duffy had knocked me out! 'What was that for?' I said when I'd come round. He said, 'Well, if they think I can do that to my friends, what are they going to think I can do to them?'

The Aretusa did something to Duffy's temper, irritated his Marxist sensibilities or something – I even had to stop him being sausage and mash [flash] around Ron and Reg there once. I said, 'Keep your fucking mouth shut, you cunt. You'll end up in concrete in the M4.'

I loved Duffy, I thought he was great. I loved Doo-daa as well, Donovan. Everyone loved Donovan, he was irresistible, so funny. But Duffy was still the Fifties crowd, as we used to call them, a bit Fifties. He was about five or six years older than me and he had all those pre-Sixties ideas. It was harder for him to adapt than me. Terry Donovan was more like me. He had an aunt Dolly too, although everyone had an aunt Dolly in the East End. He wasn't my best mate like Duffy was. In a way he was more interesting than anybody else at the time. Definitely my most interesting mate. Duffy was more calculated, more intellectual, whereas Donovan was a bit rough and ready, like me. In fact he was rougher than me, much more cockney than I am. He was manly, Donovan. He'd hit people. I didn't like hitting people because they hit me back harder. Some Teddy boys stopped us once and Donovan said, 'I'll have the big one, you have the other three.' It didn't seem like a good idea to me.

'Yeah,' he said, 'if I punch the tough one, all the others will back down.'

And that's what happened. He didn't fuck about, he just hit them, like the Krays. He was into judo and he used to just slap them round the head and they'd go down. He didn't have any neck, Donovan, just a face and shoulders. He was the funniest man ever, and like a lot of very funny people he suffered from depression, which did him in in the end. He was an alcoholic and he had all that electric-shock treatment.

We used to have breakfast with the taxi drivers in their hut in Paddington station. We'd meet there, take a bottle of champagne and drink with the taxi drivers at breakfast at eight o'clock in the morning.

We both had Rolls-Royces – not really to make a point, but

Andrew Loog Oldham from my Box of Pin-Ups.

it did make a point. Donovan just loved driving his through the English country lanes. Once when he was broke – he'd overspent making a film – he borrowed some money off me.

'I can't let them know I haven't got any money,' he said. So I lent him some money and he got a new Rolls-Royce.

'Why did you do that?' I said. 'You haven't got any money!'

'No, but people will think I have.'

He was full of that East End logic. I got stopped in my Rolls-Royce more than once by the police, asking if I owned the car. They didn't believe it was mine. I got stopped twice in Hanover Square near *Vogue* when I was carrying a Hasselblad camera. 'Oi oi, what've you got there?' Once I got stopped in the Rolls after doing a shoot with Jean for *Vogue* with a python. I knew the bloke from the zoo quite well because I often used snakes. He brought it over to the studio, but after a while the shoot was getting late. He said, 'Listen, the zoo's closing at five,' and I said, 'Well, I'm not finished.' He said, 'Can you bring it to the zoo in the morning?' and I said, 'All right, yeah.' He said, 'You know about snakes; pythons don't bite.'

I finished the shoot with Jean and the snake and put the fucking thing in the boot of my Rolls-Royce in a grip, and forgot it was there. I was coming out of the Ad Lib when I was stopped by a policeman. He said, 'What's in the boot of the car?' I said, 'A snake.' He said, 'What do you mean, a snake?' I said, 'A fifteen-foot python.' He said, 'Are you stoned or something? Open up the fucking boot.'

I opened it up and unzipped the grip. He said, 'Fuck me, you're telling the truth.' I said, 'I told you.' He said, 'Are you in show business?' I said, 'It's something like that,' and he said, 'All right, fuck off.' Then about two weeks later he stopped me in the middle of Soho.

'Oh, you again. What you got in your boot today?'

He was funny, that policeman, at least he had a sense of humour.

I was working on what would become *The Box of Pin-Ups* – my first big book of portraits, thirty-six prints published not as a book but put loosely in a box. It was Mark Boxer's idea to do pin-ups in a box. He'd approached George Weidenfeld, head of Weidenfeld & Nicolson, who he knew quite well, to publish it. I wasn't mad about the idea. I wanted a book, I wanted to be like Avedon. Instead I ended up with a box of fucking postcards. Now I see that it was a good idea. And on the back of each picture, which few people have seen since, as the pictures stayed in their box, was a caption written by Francis Wyndham – each of which is a gem of its kind because of Francis being a brilliant writer, and each recaptures what these people represented at the time. It was certainly a collection of the cultural mood of the mid-Sixties – what Francis called, in fact describing Michael Caine's performance in *The Ipcress File*, 'triumphant classlessness'. It was described as a kind of manifesto, and maybe it was to the extent that these were interesting people, without particular status or class. Apart from one or two obvious ones, like The Beatles or Mick Jagger, they weren't celebrities. They were intelligent, or oddities, or performers of some kind. They were my friends, people I hung out with. You couldn't call someone like Kenneth Tynan, the theatre critic, a celebrity – but he was brilliant and he'd shaken up the cultural world, created outrage with his reviews and attacks on the old established theatre. He was a sado-masochist and quite open about it. He was the first man I saw with a mirror above his

bed. I thought, 'That's a fucking good idea. Might as well see what you're doing.' I think it's very civilized. Now you'd use a video camera.

Francis wrote about Brian Morris, who owned and managed the Ad Lib: 'for a time the most successful night club in the world.' 'At its best,' he wrote, 'the Ad Lib was not so much a nightclub, more a happening: an unselfconscious, spontaneous celebration of the new classless affluence. Then (according to David Bailey) the crimpers moved in: next came the chinless wonders, and soon the starers outnumbered the stared-at, who began to look for somewhere else . . . Even in daylight, Morris is surrounded by a pale glow of nocturnal health – a semi-physical attribute known in the East End as "moontan".'

He wrote about Michael Caine, in his thick black glasses, 'my voice is like my life – flat'. And about Lord Snowdon, 'Responding intensely to the look and feel of things, he is superficial and sensual in the literal and honourable meanings of these words. Lord Snowdon needs constant reassurance and hates criticism. He likes people who like him, but only if they do so for the right reason – himself.' Snowdrop stopped the book being sold in America because he said he objected to sharing a book with the Krays – but this caption might have been the real reason. He and Francis were good friends, but the flattery was mixed. It included the line 'his considerable talent has nothing to do with the intellect (he seldom reads a book).'

I got on great with Princess Margaret. Snowdon used to get angry because she used to write me letters. She was a big fan of my photography and not of Snowdon's, and he used to get angry. I liked her wit. When she was introduced to Twiggy, Twiggy said, 'My real name's Miss Hornby but people call me Twiggy.' And Princess Margaret said, 'Oh, how unfortunate.'

She sent me a nice letter when I got a CBE: 'and if anyone deserves it, it's you.' She carried on liking me after she and Snowdon broke up. I used to photograph them together sometimes. I've got some nice photos of them.

Andrew Oldham was in there, of course. He was fantastic. Andrew was a real rebel. He was the brains behind it all in the beginning. We're still writing to each other, he from Bogotá in Colombia, which seemed to me like his *Heart of Darkness* retreat after the mayhem he generated. Francis wrote of him, 'His epicene figure, pretty weasel's face and affected mannerisms conceal a nature both calculating and tough . . . A contradictory, decadent, impatient personality, he could only flourish in the peculiar climate of English pop today.' Andrew really put the Rolling Stones on the map, like Brian Epstein put The Beatles on the map, except I think Brian Epstein also put The Beatles back years. He turned them into a boy band. They were so corny when they came out. Silly haircuts and stupid suits. Everybody that knew anything thought they were ridiculous. The Beatles never recovered really until they made the *White Album*. The Stones were much more original.

George Melly called my collection of subjects 'The Popocracy'. In *Revolt into Style* he gave me a mixed mid-term report, calling me 'uneducated but sophisticated, charming and louche, elegant but a bit grubby; the Pygmalion of the walking talking dolly; foul-mouthed but sensitive; arbitrary yet rigid; the only sardonic historian of his time elevating a narrow circle of his own friends and acquaintances into a chic but deliberately frivolous pantheon.' A lot of words. I liked George a lot, he was a good mate. He knew all about Surrealism, he understood what I did more than anybody I knew at the time. He

understood these weren't passport pictures, which was what most people thought – fucking expensive passport pictures.

I'd had quite a good run up until now, on the whole favourable press coverage, but the *Pin-Ups* produced a lot of indignation. Malcolm Muggeridge, the journalist – who used to rant like an Old Testament prophet and was full of bile and scorn and hatred – ranted against the 'religion of narcissism' he detected in the book. He hated me. He called me the evil eye of the twentieth century. *The Box of Pin-Ups*, he said, was a coffin and all the people in it deserved to be there. Four years later he was quite happy to be in *Goodbye Baby & Amen*.

There was great outrage about the pin-up photograph of P.J. Proby, the singer from Texas, in imitation of a crucified Christ, like a religious painting though without a cross. Now it seems so innocent, but this was a time of moral panic in England when archbishops and editors publicly interrogated Mick Jagger to find out what was going on. Francis's hilarious mini-profile of Proby, as a caption to my picture, shows how he'd stoked the flames. 'His first TV appearance as P.J. Proby,' wrote Francis, 'set a pattern of disaster that has recurred throughout his career: he was drunk, and fell into a swimming-pool in the middle of a number . . . Older, taller and tougher than the British pop singers, he decided to go further than they dared. "My whole act is made up from different girls I've been with": the tittup, the mince, the pout, the voluptuous massaging of buttocks and groin, combined with his rich, emotional baritone drive his audience of young girls into a sexual frenzy.' It was too much for the archbishops. When his trousers split on stage for the second time, at Luton, it was over – banned forever by the BBC and ABC television for being 'disgusting and obscene'. They were awful the BBC.

I never really had a 'style'. The pictures I take are simple and direct and about the person I'm photographing. I spend more time talking to the person than I do taking pictures. The intensity comes from concentrating on them, nothing else. There's nothing else in the picture. They become the main thing; you impose your personality on them, I suppose. For me it's common sense, but other people ask, 'How do you do it?' You sort of advance on somebody and get closer and closer until they fill the frame. Not close in on the camera, but close in on them, until they fill the picture. You know when you've got the picture. I never photographed anyone with a guitar or any other prop to show what they were, no matter how many complaints I got. 'If you're doing Eric Clapton, you've got to have a guitar in it.' No, I haven't! It isn't what a person does that makes them interesting, it is who they are. The picture of Warhol was taken with a 50mm lens on a Hasselblad, I think. It was quite distorted. I felt that it could take it. But you have to do it from the right angle – in this case, from above. It wasn't a wide-angle lens, I just tilted the camera. Sometimes I took a lot of pictures. But usually not. I used to get it very quick.

I fall in love with people when I photograph them for that fifteen minutes or half-hour; they become the whole centre of the universe. On a superficial level. They get up and leave after that. I've spoken to photographers who say they never talk to anybody when they take their picture. They actually say that. I think they're fucking mad. It must be so hard to take the picture if you never talk to the person. It's easy to get people to say things they wouldn't say normally. I included the Krays – Reg, Ron and Charlie – in *Pin-Ups*, after Francis Wyndham introduced me to them. Since I was a teenager, they'd become the top villains in the East End, with a string of restaurants,

gambling clubs and nightclubs from Bethnal Green to Chelsea. They loved being photographed with celebrities. They were looking for legitimacy, but they were as violent and dangerous as ever.

Francis described them in the *Box of Pin-Ups*:

The Krays' headquarters are still at their mother's humble house in Vallance Road, Bethnal Green, which is now done up in Harrods style with oil paintings of Spanish dancers and guitar-shaped mirrors . . . Ron is heavy (like the gold ring he wears) and taciturn, with occasional flashes of disconcerting humour. Reg speaks softly and has a slightly worried expression; he seems anxious to please. Both can be overwhelmingly hospitable. To be with them is to enter the atmosphere (laconic, lavish, dangerous) of an early Bogart movie, where life is reduced to its simplest terms and yet remains ambiguous.

I didn't know when I first met them that it was Reggie who had put the scar on my dad's face. I only discovered it several years afterwards, when my aunt Peggy told me about it. Francis met them when they asked him to write their biography. They chose him, said Francis, because they'd heard he was related to the Queen. Francis had some grand ancestors and relations but she wasn't one of them. It turned out to be a fatal characteristic of the Krays to believe that grand friends and connections could somehow protect them, bestow respectability on them and get them immunity. At their trial, one of the brothers told the court, 'I could be having tea now with Judy Garland.' Instead Francis interviewed them, though his interview wasn't published then. In the meantime he became friendly with their mother, Violet

Kray – and fascinated, he said, by the way that she had made her sons feel 'special'. He'd go to tea with Mrs Kray in her house on Vallance Road, as I did later, when I got to know them. It was like being in my mum's front room. They were all the same – bit sparse, no pictures on the wall. Cold. If someone gave you flowers you kept them in the front room because it was cold and they lasted longer, so you never saw them.

Francis used to do a brilliant imitation of Violet visiting Parkhurst as if she was the Queen Mother, graciously asking the screws if they'd enjoyed their holidays. 'Yes, I went to Monte Carlo. I have Reg to thank for that.' She was all right. She was like my granny really, a cockney old woman who loved her boys. Her boys couldn't do wrong. But most East End mothers were like that. Like Jewish mothers. Any evidence against her sons was a bunch of lies, just brushed aside. 'It's nothing to do with me.' They had huge respect for her. They were very polite, the Krays. They wouldn't swear in front of women.

Whenever they make a film about them, they always leave out the mother. The mother to me is the most important thing in the Krays' life. But they never mention her; she gets a pass. Both films I saw of the Krays were silly. It wasn't like that at all. They made them into Robin Hood. Robin Hood was an arsehole; the Krays were arseholes, there's no question. But you have to understand the time and place. The post-war East End of the Fifties and Sixties was really poor. It's difficult to judge people if you're not there. People can sit back in Islington and say, 'Isn't it awful,' but it was the way it was. You didn't have too many choices in life.

I was never afraid of the Kray twins. I was wary of Ron, but Reg I was quite good friends with. I liked Reg, in fact. He slashed my father but it was nothing personal. Reg would look

after me but Ron was fucking nuts. You had to watch him.
You never knew which way he was going to turn. I saw him do
somebody one night. That was bad, but that's for later.

After the *Pin-Ups* session, Reggie asked me to do his wed-
ding pictures. He got married to Frances Shea – her father
Frank Shea ran a gambling club in Stoke Newington. The first
priest they asked to marry them refused on the grounds he
thought they'd do each other serious harm. In the end, the mar-
riage lasted three months and Frances died from an overdose
of barbiturates two years later. I've only done two weddings in
my life: the Krays and Murdoch. They both rang me up and
made me offers I couldn't refuse. It was obvious why I couldn't
refuse to photograph the Kray wedding. You don't say no
to the Krays. It was in St James the Great church in Bethnal
Green. I was the only photographer allowed in; the press hated
me. After that we went to a hotel in Finsbury Park. I spent the
whole day with them. I had Ron making a pass at me and the
bride-to-be making a pass at me as well. She was all kind of
gooey-eyed. So I was being very butch with him and very gay to
her. Talk about being between a hard place and a rock. Francis
was always all right because he appeared to be bent. I'm the
one who was going to get a right-hander or worse.

I remember we couldn't sell *Pin-Ups*. It was a flop. They
used to sell the prints separately in Carnaby Street for two and
six each. A tosheroon!

Chapter 14

Deneuve

I met the model Sue Murray not long after Jean left me. I think I was having an affair or a romantic moment with Tania Mallet, who played Tilly Masterson, the Bond girl in *Goldfinger*. I remember going to the premiere with Tania. They said that was the end of her career, because everyone who was a James Bond girl never did anything else in the movies. It was true in Tania's case; she never made another film. Her father was a car salesman, I think. I did a trip for French *Vogue* with her and Sue Murray. We were staying at a pub in the Cotswolds and I ended up with Sue Murray somehow. Tania deliberately backed into my Jaguar E-type during the night. Smashed it.

'I'm sorry, it was an accident,' she said.

Sue didn't really know what was going on. She was a sweet girl, a really nice girl. Catherine Deneuve said she was always cheerful, 'like a bird'. She was a bit short – five foot eight – for a model in those days, but she was a very good model, especially after I'd finished with her. She was in the first commercial film I ever made, which got banned and was never shown. It was the first one of those ads for Cadbury. All that putting the chocolate down the model's throat, which was my idea. Everyone knew what they were suggesting, unless they're an idiot.

The agency banned it. They didn't even show it to the client, they thought it was too outrageous. And then five years later Cadbury were doing it themselves.

I loved Sue Murray. She was like an angel. She gave me a cake once without telling me it had stuff in it. Afterwards I remember trying to park the Rolls-Royce. I said, 'I can't park.' It was an empty road. 'There's something wrong with the bonnet, it keeps melting.'

Another time I was in Venice, on a gondola, after someone had given me acid. I was with that famous jewellery designer, Ken Lane, who made very expensive junk jewellery. I thought Venice was moving and I was sitting still. It doesn't hit you. It's sort of slow, the effect.

I nearly got busted with another model once, who had a supply of hash, also coming back from Venice. She'd slipped me her drugs without telling me. I didn't do drugs. I used to drink a lot. I felt stoned most of the time anyway, so they didn't do much for me, to be honest.

'Shit, I'm glad we're through customs,' she said.

'Why?' I said.

'I put a lump of hash in your raincoat pocket.'

'What do you mean?' I said. 'They searched my raincoat pocket.'

So I looked in there and it had fallen into the lining. I said, 'You silly bitch.'

Sue became a transcendental meditation teacher. She was into Buddhism and all that. Once we were in North Africa, on our way to New Zealand, and we all got stoned one night – I got drunk maybe – and there were all these girls in robes and I followed the wrong girl and ended up sleeping with the fashion editor and Sue got upset. We were stuck with each other. We got

to New Zealand together and then India, and finally in India she forgave me. We were together, on and off, for quite a while; she went to New York. Then she read in a newspaper about me getting married to Catherine Deneuve, which must have surprised her. It was a bit of a surprise for me and Catherine Deneuve as well – it happened only about a month after we met.

Sue sent me a letter I wrote her when she went to New York. It must be one of the few letters I've ever written. Although I can't imagine me writing 'David':

Dear Sue, I wish you all the luck in the world. I know that you will be a 'wow'. Take the letter to Vreeland, phone and tell them that you want to see her, that you have a letter from me for her. The money for Friday is coming, but the one for Yardleys you can get in NY, ring TH at this number, and he will pay you, make sure it is £1000. The address is [. . .] Don't give [a friend of ours] any money, he has his own and don't let him use you. Maybe you could give me your address in NY. If you need or want anything just phone. Ask Derek to get your sunglasses for you. Tell him they are on the kitchen table. Also give Jane a ring, she is very nice and could be helpful. All my love, David.

I first saw Catherine at the Ad Lib club. Roman Polanski had just finished making *Repulsion* with her, one of his most brilliant films and his first English-speaking picture. I saw Catherine dancing with a famous French or Italian actor there – can't remember his name– and Polanski said, 'That woman's made for you.'

'No, she's not,' I said. 'I don't even know her and she's too short, bit on the fat side for me as well.'

He drove me mad about this little short girl. I said, 'She's too short for me. I don't go out with short girls, I only go out with great big Giacomettis. If they're too short I feel uncomfortable.'

I'd always been with girls that were at least five foot eight, preferably five foot ten and up, and were skinny – I don't like big udders. Catherine didn't have those. She's got nice tits, that was all right, but she was short. Polanski wanted me to photograph her for *Playboy*, to promote *Repulsion*. And Catherine didn't want to be photographed for *Playboy*. I had sort of refused too. I didn't like the idea of *Playboy*. The only thing they did great were the interviews; the girls with tits and all that were a bit silly. It was an American idea of what sex was.

Roman is very persistent. He eats away, he's like a Jack Russell. He wasn't helped by one of his publicity people on the film, some idiot man who said, 'Oh, it would be great if we could arrange for you and Deneuve to be on the back of a lorry in bed together, driving around London.' I said, 'In your fucking dreams, mate.' That's the kind of thing you're up against. It wasn't even mad enough, it wasn't surreal, it was just stupid.

Roman persuaded Catherine – she could choose the pictures. If she didn't like anything she could throw them out. I did them as a favour to Polanski really. I went to Paris and saw Catherine again. It was a long photographic session, an afternoon. It was in her flat. It was nice. She was nice. She's funny. Out of all the French people I've ever known, she was one of the few who had a sense of humour. She sort of got English humour as well. I think her father was an actor and her mother was an actress. He collected porn books, her father. He took me to this shop in Paris that sold them. I've still got two of them. They're bound volumes, very academic-looking, with pictures of cunts and stuff. All in French but it didn't matter, the pictures were great.

Catherine and I had an instant attraction. At some point during this session – at the end of it, I think – the earth moved, like in a Hemingway book. I've still got the pictures. They're all right, they're not awful but they're glamour pictures. Because of them our lives were changed from this moment, for a short time – a happy, eventful and then a sad time. It was already the summer of 1965. Catherine came to visit me in London as soon as she could. She had a small child with Roger Vadim, Christian, who was barely three. She went back to France almost immediately to shoot a film in Normandy called *A Matter of Resistance* by Jean-Paul Rappeneau.

It was Duffy who started the idea of getting married. I've never been a fan of marriage. It's stupid, I think. You just sign a bit of paper. If you don't like someone, leave 'em. Seems pointless. I learned that from the East End: all those people stuck with each other and hating each other. Madness. And they couldn't do anything about it. All right for the rich, but if you're poor you couldn't get divorced. But in this case Duffy and I had a bet.

'I bet she wouldn't marry you,' he said. Duffy was being evil as usual, trying to get me married.

I said, 'I bet she will.'

'I bet you ten bob she wouldn't,' he said.

'All right, I'll ask her.'

We drove, me and Duffy, to Normandy to the set where she was filming. She made a film about every week, she was always making a film in France. It was so cheap. Anyway, she came running across this cornfield when she saw us and I said, 'Will you marry me?' And she said yes. We were married within a couple of weeks in August that year. It was all quick, it was all fun.

I don't know what Catherine saw in me. I think she said it

was serendipity or something. 'Bailey lets things happen,' she said, 'he's easy-going.' Which I think I am, though not all my partners have thought so. We got married in the registry office at King's Cross. I always got married there. Got married there three times. Should have got a discount. Mick came in my Mini Moke. He was the best man. Catherine's only relation was her older sister, Françoise Dorléac, who I really liked, who was having her own successful film career. She'd made two big films in 1964 – *That Man from Rio*, playing opposite Belmondo, and *La Peau Douce*, directed by Truffaut.

I think Catherine found it a bit of a shock coming to London. My new house in Primrose Hill was basically in a slum. It had cost me £18,000. I didn't have lots of servants and things like that. She had people who were there full-time in Paris: maids and assistants and PRs and all that crap. I didn't have anything really. On the other hand, we spent a lot of time in Paris.

Soon after our wedding, I went to visit the set of Polanski's film, *Cul-de-Sac*, on Holy Island in Northumberland where Françoise was acting with Donald Pleasance. I took a picture of Polanski beside a lake, which I used for my next book – a picture that he says is his favourite portrait of himself. I got to know Françoise a little better and became very fond of her. She was more lively than Catherine, more vivacious. She used to impersonate Rita Hayworth, pull her hair up and do that dance, wiggle her backside like Gilda. She was always in love and crying. Not with me, I was just very good friends with her, never slept with her or anything. People used to think we did because we were so friendly. Catherine and Françoise really got on well together; I never saw any competition or jealousy on either side.

Catherine's world in Paris was mostly centred round directors, producers, actors, people in the movies. Eric Rohmer asked

me to be in a film of his playing a Swedish poet. I thought, 'You're fucking mad.' He was in Catherine's crowd with Truffaut and Christian Marquand and Christian's brother Serge. Christian had become known after playing opposite Bardot in the film that made her, *And God Created Woman*. The film was directed by his friend Roger Vadim, Catherine's ex. Christian was a sub-star of the New Wave, and had become a big friend of Marlon Brando. Once you were in, it was quite a small world. He'd worked with Visconti, played opposite Jean Seberg. He was a bit like a fake hippy, partly a playboy. He never paid for anything either. Used to stay with me sometimes and use my phone to call Marlon Brando for three hours, the cunt. Probably showing off. He'd taken recently to directing, with disastrous consequences. I helped him get hold of Ringo Starr to play in *Candy*, the film of Terry Southern's book, directed by Marquand in London with a big star line-up including Brando and Richard Burton, Anita Pallenberg, John Huston, James Coburn; screenplay by Buck Henry. Even with them it was terrible, described by one critic as 'pseudo pornography.' So Christian Marquand went back to acting.

I met Godard that year and photographed him on the set of *Pierrot le Fou* – where Anna Karina played opposite Belmondo. It was a portrait of him beside a camera, more of a snap. I never did that thing that Terry O'Neill did, I never went on film sets. I thought it was cheating, because the photograph looks real and you find out it's done on a film set so it's not real at all. It's actually second-hand reality. I didn't really like Godard. He didn't have much charm. He came across as a boring Swiss bank manager. I didn't like any of those French directors. Catherine liked Truffaut. François Truffle, I used to call him. She'd kept friendly with that horrible Vadim as well. He was

the biggest liar I ever met. If it was raining he'd come in and say, 'It's really sunny outside.' He just had to lie, it was like a lying disease, like *One Hundred Years of Solitude*.

Maybe it was just that I'd never liked the French. I always thought they didn't like me, then I realized they don't like each other. At least it's not personal. They just say no all the time, which is difficult to work with. '*Non.*' They want you to adapt to the way they think, which doesn't go down well with an Englishman. I think Catherine thought my attitude was an East End exaggeration. I obviously made no attempt to speak or learn French, for example. Catherine was bemused that I was crazy about Clint Eastwood. I liked that there was no pretence to his acting, how he seemed to get it right in one take – though I'm sure he didn't. I thought he got better and better and more sophisticated until he ended up with *Unforgiven*, one of the greatest cowboy movies ever made. I liked Elvis too. She'd say, 'You're so camp, Bailey, you like all these unsophisticated people!' I did like Serge Gainsbourg. He didn't seem like a Frenchman. He was funny. He used to stop cars and get into them like a taxi. He was so famous in France, it was like being with Frank Sinatra in Hollywood. He used to put out his hand and a car would stop and he'd get in. Once he did that and the car skidded and knocked me over. I used to go to black clubs with him. I used to feel a bit uncomfortable; all these West Africans about six foot six – and me and Serge, we're both fucking midgets even by European standards. I used to see Serge in Paris all the time and we went on a trip to Tokyo together. I got to know him really well. He was Catherine's friend and I think she really liked him. She liked bad boys, in a way.

I did like some of the French New Wave in the beginning – particularly Truffaut – but I was never mad about French

films. I liked Buñuel but he wasn't French, just part of that crowd, and I gravitated towards Fellini and Visconti. Fellini suffocated me with bad taste. He was the king of vulgarity. And Visconti suffocated me with good taste. He was a genius and Mastroianni always looked like he had crepe-soled shoes on. He always moved so silently. (He started seeing Catherine after we parted. They had a baby together. Cunt.)

My big influence was Cocteau. My first film was about Surrealism; I copied, among other of his works, Cocteau's *Beauty and the Beast*. It's called *G.G. Passion*. It was based on Saint Sebastian because he was killed by arrows, and I thought pop singers got killed by the points of pens, by signing autographs. The fame drives them mad. It ended with him being machine-gunned and all the blood turned into a rose, so really like Cocteau's *Blood of a Poet*. Very pretentious. It was the sixth of the sixth in '66 when I made this film. I thought, 'Shit, I've got the devil on my side.' The whole thing was surreal in a way, not intentionally. I didn't really know much about Surrealism, it just made uncommon sense. He was incredible, Cocteau, but he did too much, in a way. He did it so easily. If you do things too easily people think it's superficial. He just did everything. Quite a good draftsman. I learned to draw like him. I used to do my scripts like that. I've never been mad about drawing but I loved the way Cocteau just did it with lines. I used to draw my storyboards for commercials like Cocteau and Picasso and people liked my storyboards more than the commercials. People used to collect them.

I was very into Cocteau then. I used to go to funny little fleapits, as these small arthouse cinemas were called. There was one in Leytonstone where I saw *Ivan the Terrible*. I was very impressed with it. The first thing I ever bought was a Cocteau, a

picture of a man's head. It's a limited edition silkscreen, I think. The second thing I ever bought was a Hans Arp silkscreen. Still got that, as well. I must have had some money to afford it. It was about 1965.

I was good friends with Gérard Brach, who wrote the screenplays with Roman Polanski; Gérard Brach worked on the script with me for *G.G. Passion*. Originally we wanted Mick to play the lead but we couldn't get the money. Andrew Oldham wanted more than the entire budget of the film. So we got Eric Swayne instead. And in fact Roman paid for the film – or his company did: he was partners with a Hungarian producer called Gene Gutowski. It ran for six months in the West End, in an arthouse cinema on Tottenham Court Road, with a Japanese film called *Women in the Dunes*. It's a cult film now. It wasn't then, it was a fucking mess!

In Paris we used to go to La Coupole when they still had paper tablecloths for the artists to draw on. We used to go to Lipp. I didn't like it much – too much beef and I was a vegetarian. Catherine used to have a little restaurant whose main feature was a sausage dog that used to sing. There was an English restaurant along the Right Bank we used to go to. Can't remember the name. I liked it because they spoke English.

What was so different between Catherine's world and its equivalent in London was the fluidity – the easy mixing of politics and art and social life without many barriers, like class barriers. We used to go and have lunch with Pompidou on the weekend – quite informal lunches in his garden. The kind of thing that would never happen in England. I was even quite shocked that Pompidou, the President, drove himself about in a Porsche, when all French politicians normally had those black Citroëns. It was often the same crowd mixed up. Françoise

Sagan, whose famous book *Bonjour Tristesse* was written in 1955, was around all the time. I was quite good friends with her, not that her English was that great. So was Yves Saint Laurent and his business partner Pierre Bergé. I liked Pierre Bergé. Once during the collections he told all the paparazzi to take their cameras off the catwalk. He made three announcements and in the end he walked down the catwalk and kicked them all off. And they went on strike! They said, 'We won't photograph the collections.' So he had to go and apologize to them all. I thought he was great for doing it, but the fact he had to apologize spoilt it in a way. He was right, they were wrong, because a girl will trip on that, fall off the runway, break her fucking neck – all because some idiot photographer put his fucking camera on there.

I knew Saint Laurent was great when I saw his first collection. I thought, 'This guy's got something the others haven't got.' I also knew who the worst was: Cardin. He was tasteless: he built a village with little flying saucer houses in the South of France; he dressed his models in big bubbles of foam in white boots and silly sunglasses, sort of like Noddy in spacesuits. I hated those white boots, I never went out with a girl who wore white boots. Especially with those sunglasses that made them look like insects. Never have glasses that cover your eyebrows because you look like a bug. Catherine was dressed by the designer Real, who was Bardot's designer. Real did little dresses that looked like fucking lampshades. I said, 'You can't do Real, Brigitte Bardot looks silly in it. She looks better with her clothes off than she does with her clothes on.' That's when I persuaded her that she had to go with this new guy, Saint Laurent. I told Yves and Pierre that Catherine was going to come to them, and that's how she started at Saint Laurent. And from then on Pierre Bergé loved me. I did their advertising for about fifteen years.

It was Pierre Bergé really who got it. And Yves and I always got on well, as Bea Miller found out. On one shoot in Paris, I'd removed a length of white chiffon from around the waist of a dress and wanted to tie it round the model's head. Bea Miller said, 'You can't do it, Yves would be upset.' I said, 'Yeah, I can,' and we were fighting about it until in the end I said, 'Well, let's call him.' So we called Yves at the office and he said, 'Tell Miss Miller or whatever her name is that Bailey can do whatever he likes.' That was really a put-down to Bea Miller.

He was fantastic. Balenciaga used to sew, Saint Laurent used to do all the beading on his dresses, but that's the icing on the cake. The basic cut has got to be perfect on a dress. Everything about it – including the way it moved when the model walked or put their arms up – looked good. If you can have a genius in dress design it was probably Saint Laurent.

He was great and he was dizzy, Saint Laurent. He should have been a blonde girl, a dizzy blonde. He used to laugh about things that weren't particularly funny. Black chocolates were called the farts of nuns or something. Silly. He thought it was hilarious. He was a nice guy. He was a bit stoned most of the time, on smack.

In the spring and summer of 1966 Catherine was shooting *Les Demoiselles de Rochefort*, the musical by Jacques Demy in which she played and danced with her sister Françoise. She spent a long spell in London, where the choreographer was based. There is a picture of the sisters waiting to shoot a dance scene, dressed in identical sequined outfits, published in *Goodbye Baby & Amen*. I had to leave the set after taking the picture. I left my white convertible Mercedes there and Jacques Demy

Françoise Dorléac and Catherine while filming
Les Demoiselles de Rochefort.

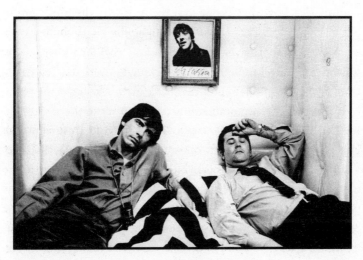

With the cameraman on the set of G.G. Passion.

used it in the film. I think Jacques Demy was more interesting when he did those early movies like *Bay of Angels*. He made some terrible films – he made a film with David Puttnam with elves and things, called *Donkey Skin*. I remember one scene where someone spits and it comes out and turns into a frog.

I was more friends with Agnès Varda, who was Jacques Demy's wife. I liked her very much and she used to call me 'The King'. She thought I was the king of photography. I think she was probably a lesbian but I don't know. She certainly looked like one. Agnès Varda did strange films like *The Creatures*, a bit surrealistic, I guess. I always found her more interesting. That was a busy year. I shot *G.G. Passion* in June in the East End and in Hampstead. Antonioni's *Blow-Up* came out around the same time in London, while Catherine was with me – the era-defining film, as it's now labelled, about a photographer and Swinging London, supposedly based partly on me. In fact, it was full of details about me and my life that puzzled me – I had no idea how they'd got into the script. In the film I put a big aeroplane propeller that I'd bought for £8 in the back of my Rolls-Royce. I never understood how they knew I paid £8 for the propeller. I thought, 'Who fucking knew that?' Ten years later Francis Wyndham confessed that these details came from him. Antonioni had commissioned him to write the treatment for the film, based on his article about me and Donovan and Duffy in the *Sunday Times Magazine*. He said to me, 'I've got a confession to make.' I said, 'No, I expected it, you're a fuck-ing journalist.' Francis had sort of discovered me, in a funny way, and promoted me. Carlo Ponti, the producer, asked me to play the part. I said, 'I can't remember a telephone number let alone a script.' Also Antonioni thought I was trying to get in the knickers of Monica Vitti, who was Antonioni's big new

star. I did a cover of *Vogue* with her. It wasn't me that was trying to get in her pants, it was Terry Stamp, because every time I photographed her he said, 'Can I come round?' I think Antonioni got a whiff of that because Stamp was dropped two weeks before the shooting, for David Hemmings.

Catherine and I queued to see the film like everyone else. I just thought it was a bit silly. I didn't like all the symbolism, and intellectually I didn't think it was a very smart movie. The portrayal of women was as much an Italian view as anything to do with London. Also strangely naïve – pot parties and orgies and that scene where the photographer twirls around the model, snapping away. Everyone thought I acted like that. He was so square, David Hemmings. It would have been better to have Terence Stamp. They turned the East End photographer character into a sort of Chelsea photographer, John Cowan or somebody. It made an impression, of an enviable lifestyle. It sold thousands of Nikons and Pentaxes, and had people twirling around taking snaps.

Roman Polanski told me that Antonioni had never seen anything like London, or rock-and-roll antics like Pete Townshend of The Who smashing his guitar on stage. Nothing like that was happening in Italy – it was far behind things, still in the grip of the Catholic church – or in France even, said Roman. They were still in the dark ages, though France was beginning to feel the new zeitgeist and sense of rebellion. Americans especially were flocking to London, and the French just discovering it. It was two years before May '68.

But 1966 was also the year Catherine shot *Belle de Jour* with Buñuel, probably the most surreal film ever made – surreal without being surreal. It just is surreal as if lifted from some other plane. I hate the word favourite, as if you're talking

about something you have when you're six – you shouldn't use it when you're eighty-two. But I'd have to say that's one of my ten favourite films.

Buñuel was incredible. I think he was a great director. I spent a lot of time with him when Catherine was shooting *Belle de Jour*. It's not only the best film Catherine made but it's one of the best films ever made. It was shot in the South of France and in Paris, where we didn't have to go anywhere; we stayed at home. I took a few snaps – I went along because Catherine was in it but also I was curious about Buñuel. He wasn't unknown; I'd seen his film with the sliced eye – *Un Chien Andalou* – and his work with Dalí and all that shit. In fact, my film *G.G. Passion* was loosely based on it, as well as on Cocteau's work.

I liked him because he was so ordinary. He was just a bloke. Liked a joke. And yet this film, and his later films, were the most radical of anything ever made in the cinema. Catherine was very tense about the film. I think it had an effect on her, because of the role she was playing – the middle-class housewife playing out her sexual fantasies as a whore, some of which were quite extreme. She said in an interview that there were moments when she felt used, when she was very unhappy. But she also said she thought it was a masterpiece, which is just like Catherine's clear-mindedness or toughness. I always liked Catherine because she never seemed to do anything when she was acting. She never seemed to act, she just seemed to be there. I thought that was interesting.

I remember some journalist from *Vogue* said to me, 'Do you get upset when you see someone caressing your wife's tits?' I said, 'Not really, because they're tit doubles.' She always had tit doubles. I recognize my wife's tits when I see them. She never showed her tits. She could have, because there was nothing

wrong with them. But I think it was that middle-class thing. I used to argue with her about it.

'One day,' I said, 'actresses will do this and it will be normal.'

'No, it will never happen,' she said.

'One day Marks & Spencer will sell all that gear,' I said, 'all that sexy underwear.'

'No, they won't,' she said.

And now they do. I was right. She was a bit square, a bit French in that way. They're supposed to be the great lovers. They're not. I think the men worried more about how women tied their scarves.

During the #MeToo campaign in 2018 *Belle de Jour* was suddenly being described as a rape apologist film; there were demands to have it banned from cinemas, along with other films and works of art that had come under the new censorship. Catherine is admirable. She doesn't give a shit. It's not the first time she's spoken out. She signed a letter with a hundred other French women, protesting that the Hollywood #MeToo campaign had crossed a line into anti-feminism and censorship. And it got her the usual backlash.

Catherine not only got attacked for her part in this letter, with the same intolerance that she was complaining about. She also found the trolls and alt-righters trying to use her, via the letter, for their bandwagon. She made a public statement: 'I'm a free woman and I will remain one. I fraternally salute all women victims of odious acts who might have felt assaulted by the letter in *Le Monde*. It is to them, and them alone, that I apologize.'

Belle de Jour was released in May 1967. In June, in the South of France, Françoise Dorléac was killed when her car left the motorway, collided with a pylon and caught fire. The rescuers

came too late to save her. I was in Ireland, working, when it happened. It was on the news. 'Would David Bailey please call the police station, there's been an accident.' And I thought, 'Oh fuck, something's happened to Catherine.' And it was Françoise. It was my hired car she crashed in. When I was leaving she said, 'Can I keep the car?' I said, 'Yeah, sure.' So that was the car she died in. I remember flying down from Paris, and the air hostess said something like '*Courage, mon brave.*' I thought only in France could you say something like that. I had wanted to accompany the coffin back to Paris – something I could do for Catherine. A long drive, with the coffin beside me. It was very odd. And boring. The driver, Françoise's agent and me, all unable to speak to each other, the coffin between us.

Catherine changed a lot after Françoise's death. It was a catastrophe for her. We were together for three years, but now after Françoise died I rarely saw her. There was no obvious break; we were friends, but we lived in different countries. Catherine went on working immediately after Françoise died, as a way of dealing with her grief, I suppose. Sometimes we were in New York at the same time, in separate hotels, and I tried to ring her but I couldn't talk to her. She wasn't taking any calls because she was filming and getting up at five every morning. But we went on working together – the only time we'd meet. I photographed her for American and Italian *Vogue*, British *Vogue* as well. So I just carried on. We got a divorce finally in 1972. She rang me up and told me it was done. She said, 'Now we can be lovers.' I remember one thing Catherine said that was uncanny: she saw a picture of Penelope Tree in American *Vogue*, before I'd ever met Penelope, and said to me, 'You're going to go off with this girl.'

Chapter 15

No Regrets

JAMES FOX: *I met Catherine Deneuve in a Paris hotel one sunny March morning in 2020 near the Place St Sulpice on the Left Bank. It was a small hotel popular with the film business, with directors and producers. As I sat waiting in the small lobby for her to arrive, hidden from the door, I watched with amazement this great French actress stop on the short cobbled entrance way, take out a mirror, adjust her make-up, presuming herself invisible, and then proceed, with a dog, into the hotel to meet me. One striking thing about Deneuve, evident right from the beginning of our meeting, is her openness and impeccable manners, her friendliness – there is no trace about her of the effect of her great fame. After some generalities, I asked her about their first photographic session, for* Playboy *magazine, fifty-four years earlier, and what it led to.*

DENEUVE: What Roman [Polanski] says is true. We did
 meet in a nightclub in London. It was Bailey's eyes
 that struck me first. That's the first thing that made me
 look at him. I didn't even know he was a photographer
 when I saw him the first time in that club. I noticed him
 because of his eyes. Avedon had eyes, not as good-looking

as Bailey, but they struck you like that. I was attracted to Bailey, it's true. *Playboy* was not really something I was keen on, to be in *Playboy*, but Roman convinced me. I think I accepted because it was Bailey who was going to do the photos. I knew it wasn't going to be something too cheap, it would be all right. I don't regret meeting Bailey, but I have always regretted doing those photos. It's rare that I ever regret doing something – what is done is done, I'm quite fatalistic – but I do regret to have done those photos, because of the nudity. It changed the look of the film. The film had nothing to do with that, so I thought it was not interesting and not necessary for the film.

FOX: If you don't mind me asking, the first kiss according to Bailey was during the photographic session.

DENEUVE: I suppose so, yes. At the end, yes.

FOX: That was very romantic, and so like a *Blow-Up* story of the Sixties.

DENEUVE: It's true.

FOX: What was he like?

DENEUVE: He was very passionate about everything he was doing. He was shy and he talked a lot. He talked to me about his life, his travels, his passion for birds. Actually I didn't really believe this passion went to the point of having sixty parrots in the house, as I discovered when I got there.

I was attracted to Bailey. To me he was not like an Englishman in the way he moved and talked and the way he did things – he was always very passionate and enthusiastic. Bailey was very jealous, which is not very English for me as a man. Also he is very romantic. What attracted me was his eye; that he saw things in a way that

other people don't see; he is very lucky to have such an eye. He has an ability to be astonished by simple things that he sees as beautiful. He always pretended to be more cynical than he is. Always giggling. Now he can't say three words without giggling and laughing. It's a way of taking away the seriousness of things. It's a defence that he had for a long time.

We'd known each other for maybe two months after that photo session when I was shooting a film by Jean-Paul Rappeneau, *A Matter of Resistance*, in Normandy, a long way from Paris. He came to see me with Duffy. He said, 'Come on, we're going to get married. I'll take you to the city hall.' I said, 'What are you talking about?' I was so taken by his enthusiasm that I didn't say, 'No, what are you doing? You're crazy.' We didn't go to the city hall because you can't get married just like that. But I didn't say no. I thought it was very romantic to get married, and David is very romantic. So we got married a little later in London. I didn't have my family with me except my sister.

[We look at photographs I have retrieved from Paris Match *of this period, taken of them both]*

DENEUVE: How sweet he looks. It was so nice. Always a cigarette in his hand. He smoked a lot. You can see his eyes are gentle. He was so thin, I used to wear his jeans. I still have a pair of jeans of his that I kept.

For the wedding I had two dresses made, one white if the sun shined and one black for rain. It did rain, so I put on the black dress. Always, when I look at the photo, I'm also holding a cigarette. *Mon dieu, c'est pas possible.* Bailey was working so hard, all the time. He had little time

the day we were married. He was working the next day. I
thought it was a joke when he said that, but no. We didn't
have a honeymoon or even a special weekend. So of course
I was very upset.

FOX: I said to Bailey, 'Did she have a boyfriend she had
to get rid of?' He said, 'Oh yes, she just dropped him, I
suppose.'

DENEUVE: You see? That's the way he can talk, I mean he's
incredible. No, no, I was not with a boyfriend at the time.

FOX: I asked Bailey whether he'd had trouble with that
boyfriend, or was it ex-boyfriend. He said, 'Yes, but I
saved his life once. We were in the Boscolo Hotel in Nice.
You know you can climb outside the balcony and get in
somebody else's room, and she said he was in there and
he might be killing himself. So I climbed around outside the
balcony and he was in the room and he was just drunk.'

DENEUVE: Most of the men I've been with were heavy
drinkers.

FOX: Bailey was a heavy drinker?

DENEUVE: Yes, but so was the father of my son. So was the
father of my daughter.

FOX: Vadim was a drinker? I didn't know that.

DENEUVE: Yes, yes.

FOX: And Mastroianni. Did it affect your relationship?

DENEUVE: Yes, because it's all right during the day, but at
night they become like Dr Jekyll and Mr Hyde. There is no
end to the night and if you don't drink yourself – I used
to drink very little, a little – you cannot follow if you're
not in the same mood. So it was a little difficult. If you are
sober you cannot spend the end of the night with a man

who drinks, no. There is no sense, you don't speak the
same language.

FOX: Did he have any other girlfriends?

DENEUVE: Not when I was there. I'm sure there must
have been, which I never thought about because for me to be
loyal was part of being with the man you love. But I'm sure
when he went away to do photos, reportage, I'm sure things
must have happened but I didn't think of it at the time
because for me it was not part of my vision of life.

After we got married, when I arrived in David's house
in Primrose Hill in London, I heard a loud shrieking noise.
I said 'What is it?' He said, 'It's the nursery.' The bottom
of the house was filled with parrot cages. Very often he
let the parrots out and they were on the stairs and you
didn't feel like crossing them. It was difficult to live in that
house because of the birds. They were the residents; I was
definitely the guest. I remember one day the parrots were
in the stairs, huge beautiful parrots, and I called Bailey and
said, 'I can't get to the room. They're on the stairs. They
won't let me go past.' Parrots are really strong. They can
be quite menacing.

On Sunday we used to go to Portobello, to the market
where one day he bought me a lovely little owl, which I
loved – very small, so pretty, called 'Pooh' like Winnie-
the-Pooh. I remember the phone number of Primrose Hill.
724-1141, I've remembered it for so long. Even last week
I thought of it. Bailey liked Primrose Hill because of Bill
Brandt, whose pictures he used to love; he did photos
like Bill Brandt there. But Primrose Hill where we lived
was not really nice. It was deserted and it was very poor.

It was like Bastille fifteen or twenty years ago, not well arranged, not very clean. So I was not too keen on that.

I suppose the longest I stayed with him in London was when I was rehearsing for the film I did with Jacques Demy with my sister, *Les Demoiselles de Rochefort*, because the choreographer was English. But other times in London when I was between films I didn't have much to do. He was always involved with work and friends of people he worked with, so I was sometimes quite lonely. We went out to the clubs and restaurants a lot because I'd been by myself all day surrounded by the birds that scared me, so I wasn't going to prepare dinner for him and me. So we'd go out with his friends, often with Donovan and Duffy. He was very close to Duffy. They were like two boys, not two men, in their relationship, the way they spoke. They reminded me of boys.

We moved between London and Paris. He was working all the time. I was not working all the time like him, but I was working. I had a little boy that was going to school in Paris. My son was four at the time. So I couldn't spend two weeks away. I brought him to London for holidays. I remember when David did his room up. He bought – which is very typical of him – a lovely little carpet for him with Bambi on it. I remember going into his room and seeing it each time. We used to go to Brittany on trips by car, the two of us. He loved Brittany. It was very wild, on the coast. I had a friend who lent me a little house down on the rocks, at Loguivy. Then Bailey would come very often for the weekend in Paris but it was increasingly difficult for him. He didn't make much effort to speak French and that was a big problem in the end. He became

quite aggressive about it, turned things into confrontations almost. He would say, 'If they don't speak English don't speak to them.'

He'd use the coming from the East End; that was always up front. That way of talking can be very rude in a way, brash. At first I couldn't see the difference of whether it was serious or not. But when I spoke better English I understood it better. But it was claiming to be special so you can say what you want. If he was working with people who were quite sophisticated and he wasn't part of them, he would exaggerate his East End side.

In June that summer of 1967 when my sister died I had rented a house in the South of France where she'd come to join me, and Bailey was there too. It was from there that my sister set off for the airport on her fatal journey. When she died, Bailey came back to Paris by a special car with her, in the coffin. He did all the travel from Cannes to Paris with her, 900 kilometres. I didn't ask him to do it. He proposed it. I suppose he did it for me and because he liked her very much. She was buried outside of Paris where my parents have a little house in the country, but that trip must have been very hard for Bailey.

I had already started a new film, *Mayerling*, with Omar Sharif, when she died. I came back to Paris a few days after she died and just went on shooting. People were very nice to me because I was very much on medications. I did the film but I was not really myself, it was very strange. It was very difficult to act but I had that medicine to help me so I was floating a little.

We went also to the South of France after I finished the film and after my sister's death and we stayed there for a

week. I have photos of that period, it was in the autumn. Bailey didn't speak much, you know, certainly not of himself. He can speak of work or life but he never spoke really of himself when I was alone with him.

It was not a very long marriage but it was a very nice relationship. Nothing was complicated. We were married; I had my son, but we didn't have children, so there was no family life. It was still very much like young people who have a relationship like that without being tied down. We did think about having children together but I had a miscarriage when I was married to him.

We divorced eventually because we couldn't work it out enough for it to be called a marriage. We didn't get divorced for a long time, until 1972. I couldn't accept the idea that I wouldn't be able to speak with someone who had known my sister because Bailey had known her. He had really been with her and they were friends and he liked her very much.

FOX: Were you able to talk to Bailey about your sister?

DENEUVE: Not much, no. Bailey is not really open. He can't really talk.

FOX: That was difficult?

DENEUVE: Very difficult for me.

FOX: Were there other people who knew your sister well? That you were intimate with that you could talk to? Bailey was special in this way?

DENEUVE: No, that's the problem. I didn't speak with anyone. And I suppose the fact I was shooting didn't allow me to mourn her death; it was something that got postponed. And this led to a major depression in 1970 as

a result. My sister's death was really a disaster. A lot of things changed for me. And Bailey and I drifted apart.

I still have a photograph of David from that period. It's very strange because it's a very small photo that he gave me a long, long time ago in a little silver frame. It's so delicate but it survived all the travelling and changing house and all that without any accident. It's still on my chimney in the country. It's always been there on the chimney. It's a very small photograph of him as a baby, it's so cute, with little shorts. He must be three or something like that, and I always kept that photo of him on my chimney, I don't know why. I know I like to be reminded of him sometimes when I look at it.

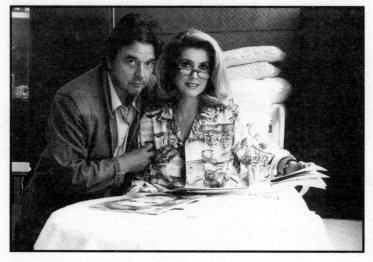

With Deneuve some years after our split.

Chapter 16

Reg and Ron

In 1968 Mark Boxer had the idea of doing a *Sunday Times Magazine* feature on the East End, which meant, in Boxer's judgement, spending a couple of weeks with the Krays and seeing how they ran gangster land. The twins were at the height of their fame and they were being hunted down by two detectives from the Yard called Gerard and Reid who badly wanted to put them away – to the point of hiding in dustbins to collect evidence. (They weren't getting it anywhere else from the East End – the Krays had that sewn up.) As ever, the Krays thought they had immunity through their famous acquaintances, who they had themselves photographed with whenever possible, which was increasingly upsetting the authorities. So their relationship with me wasn't helping them at all. But that didn't stop the twins from thinking they had me and Francis Wyndham in their pockets – especially after trying to use Francis to be the intermediary with Frank 'the Mad Axeman' Mitchell. They'd broken Mitchell out of prison a couple of years earlier, then didn't know what to do with him. He was out of control and threatening them so they had him killed.

I couldn't get an assistant from *Vogue* to come down with me and Francis on the night we'd arranged to meet the Krays

at the Old Horns pub in Whitechapel. They were too scared. I'd asked loads of people. Then John Swannell, the youngest of the assistants, volunteered. John was still officially too young to be an assistant at nineteen. He was obsessed with photography and his main ambition, for some time, had been to work with me. He knew everything about me. He'd wormed his way into the *Vogue* building by answering an ad for a job in the storeroom, which was on the same floor as the studios. He knew everything about cameras too – how to load, how to change them – he'd worked it all out. We came from similar backgrounds; he was a working-class boy who'd left school at sixteen, grown up on an overcrowded estate. He'd recently become one of the six assistants at *Vogue* just by persisting until they relented. But the first day I'd used him his nerves got the better of him and he thought he'd blown his big break.

JOHN SWANNELL: There was a new mechanism you screwed on top of the tripod – it was a twin lens Rolleiflex, a planar lens – you flicked the button down and slid the camera on and off instead of screwing it on, which takes about twenty seconds; this way it goes on in three or four seconds. And I wasn't used to this thing; it was quite a new little gadget. I was introduced to Bailey; he just grunted at me, and I slid the camera on; it was loaded. Bailey shot the picture. I went over, Bailey stood back, I flipped this thing down, nervous as hell, so fast the camera shot off at 100 miles an hour, onto the floor, smashed into bits. I thought, 'Fuck, I've got this far and I've blown it, my career's on the floor.' Bailey looked at the camera and said to me, 'What's all that about?' I said, 'I'm really sorry, when I flicked the camera down, it shot off too fast.' He

said, 'OK, pick the bits up and take them downstairs and tell *Vogue* they owe me a camera.' I had to take these bits down in a bag. It was £173. They took it out of my wages every week. I thought, 'Oh well, I've buggered it.' Bailey went on a trip, and three weeks later he came back, and I looked on the board to see who I was working with that day, and under 'David Bailey' there was my name. I said to the manager, 'You know what happened last time. How come I'm working with him today?' He said, 'Well, I asked him who he wanted, and he said, "I'll have that dickhead that broke my camera."'

Enthusiasm is worth more than anything. It's obvious, isn't it? That was the beginning of a long association. But John had no idea what kind of initiation he was in for that day when he volunteered to meet the Krays.

I wasn't going to take any chances with either of them. You had to watch Ron. He was nutty as a fucking fruitcake. You never knew which way he was going to turn. I moved around with them a lot and I didn't want to be nailed to the floor and buggered. You couldn't mention the word 'gay' in front of Ron, he'd chop your head off. So you had to be very careful what you said to him. I spent two weeks with them on this story for the *Sunday Times*. I didn't sleep well. Then one night it got horrible.

After John had said, 'I'll come, I'm not scared,' I'd explained that they were gangsters and so on, and I think he thought it would be chandeliers, something like The Fontainebleau in Miami, instead of a seedy pub in the East End. He had long hair then, he's quite small, and when Ron came over and started stroking his hair and saying, 'I'm going to take him home tonight,' he fucking shit himself. I remember Francis Wyndham saying

to Ron, 'Oh, don't be silly, he's just a stupid heterosexual. He's working with David Bailey tonight.' And Ron kept on stroking and saying, 'No, no, I'll take him home tonight with me.'

John had extra reason to be scared. He told me later that, before the twins arrived in the pub, the barman had said he'd known Ronnie since they were five years old, grown up together, been in the Army together. He'd told him, 'I'll tell you how close we were: I used to hold the soldiers down while he buggered them.' John was waiting for him to smile, and there was no smile. Deadpan.

Next thing I started taking pictures, the pub was full of people and this little bloke came over and started in at me. Little Scouser, nasty, aggressive, going on about me coming down to the East End in a Rolls-Royce. He just kept on, in my face. I had my back to a mirror, standing in front of a fireplace, and I saw Reggie coming over, looking at the guy's face in the mirror. He just turned the Scouser, whacked him in the face and kneed him in the bollocks. He landed on the floor, blood everywhere. Then Ronnie came over and grabbed him and dragged him over to the piano and banged his head against the side of the piano – *bang, bang* – and said to the pianist, 'Else, play my favourite song, the one about when I leave the world behind.'

The twins dragged the Scouser out of the pub. Then the cooks came out with mops. It was all blokes cleaning up with brooms and mops. John was so scared, his knees went and he dropped the 104 Nikon lens he was carrying. Reg came back and he had blood on the sleeve of his white shirt.

'I didn't like him, Dave,' he said. 'He was niggling you, wasn't he? Soon as he came in here, he ordered a great big plate of corned-beef sandwiches and put them on the bar and he didn't offer them to anybody. I had my eye on him all night.'

John told me that, as shocked as he was, he could see I was shocked too and that when I saw the blood on his cuff I said, insanely, 'Did you hurt your hand, Reg?'

Francis Wyndham was white as a sheet. I'm pretty sure they killed the bloke. It was awful because, though I was anti-capital punishment (still am – it's a horrendous thing), I sort of hoped he was dead. I hoped they killed him, so he wouldn't come back and get me, take his revenge. I felt guilty for hoping he was dead. And then, as if that wasn't enough, we had to go on that night around the East End to these other seedy clubs the Krays ran, this time with two bodyguards with us.

JOHN REMEMBERS: 'We went into one gambling club and there was this black guy, we only saw the back of him, he was bald. It was a great picture, the back of his head. Bailey took it, the guy stood up, turned round and grabbed hold of Bailey and said, 'I don't want any fucking pictures taken of me, mate.' And these two bodyguards, who were half his size – and they were big – said, 'George, sit down and shut up.' And the guy sat down like a lamb and said, 'OK, carry on.' Bailey said, 'It's OK, I've got my picture.' We didn't get home till four in the morning, and the next Saturday Bailey phoned me again and said, 'We've got to go back to do some more pictures.' I said, 'Bailey, I'm not going. I want this job more than anything in the world, but I don't want to go back there again.' And he didn't hold it against me.'

So I had to go back by myself, just using a hand flash. I took the picture of Ron and Reg in their sharp suits, each holding a python – they'd named the snakes Gerard and Reid. The

picture appeared in the *Sunday Times Magazine* and it was one of the last pictures of the Krays at liberty. Gerard and Reid secured their conviction soon afterwards – life sentences for murder. That didn't end the twins' reach, of course. I may have had another of their victims on my conscience some time later. There was some dodgy East End geezer known as Dennis the Painter who came to see me, claiming to work for the Krays. He was after my original negatives of them. And he threatened me. I would be slashed by fucking Dennis the Painter if I didn't deliver. I got a message to Reg in prison, 'This guy's giving me trouble.' He told Francis Wyndham, who'd visited him in Parkhurst, 'Tell Bailey he'll never hear from him again.' I never did. He's probably in the M4. I didn't know they were going to kill him. I'd said to Reg, 'Just tell him to stop coming round to see me.'

Reg actually said the nicest thing to me once. We were in a club in Hackney, just me and him, and everything was a secret in the East End so you'd lean right over even to say good morning. He said, leaning into my ear, 'Dave, I got to tell you something, mate.'

'What's that, Reg?'

'I wish I could have done it legit like you.'

I thought that was such a sweet thing for him to say. I thought that was kind of touching – if that's the word – for a fucking killer. He was always sending me movie scripts from Parkhurst, Reggie. A bit like the kind Faulkner and Hemingway used to write for Hollywood, those film noir things, 1930s Warner Brothers movies. Like *White Heat* or one of those films. There was a mother, the vicar. There was always a vicar in the stories who used to come to dinner. There was no romance in these stories. There was always violence, of course.

John started to work exclusively as my assistant, away from *Vogue*, at Gloucester Avenue after the Kray shoot, almost the same day in April 1968 that Penelope Tree came to live with me there, soon after her eighteenth birthday. Penelope was there for that shoot, over several days, though she missed the beating. She had, in fact, just run away from home in New York to live with me – or maybe I'd abducted her. It depends who you spoke to.

I'd first met her the year before, in 1967, when she had come to London for a summer job. She had already been photographed by Avedon when she was sixteen, got the attention of Diana Vreeland. But I'd never heard of her when Bea Miller, *Vogue*'s editor in London, called me in one day and said, 'I want you to photograph this girl, she's a society girl, her father's very important and I don't want any of your hanky-panky, so leave her alone.' It was about the worst thing she could have said to me. I wouldn't have even looked at her but that made me interested, the silly bitch. That first shoot I did with Penelope for *Vogue*, there was something instant between us; it was obvious to us both. I realized that I had fallen in love with her pretty quickly. But nothing could happen and nothing was said. I was with Sue Murray. I was still technically married to Catherine Deneuve.

In looks and style she was way ahead of everyone, Penelope. She was a complete original. She was like a mixture of an Egyptian Jiminy Cricket, and Bambi. Her legs went up to her neck. Her knickers were longer than her skirt. She had a belt made of some kind of animal tail – raccoon tails, I think. She was extraordinary, the way she looked. In fact, she wasn't like a 'model' at all – she was too much herself. I preferred personalities rather than perfect models – Penelope was like Anjelica

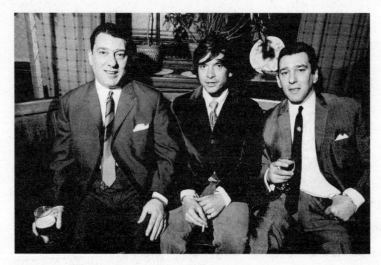

Me, Ron (on the left) and Reg at one of their pubs.

Huston in that way. They had a personality that I could use in the pictures, strong and present. That's one of the great things about the still camera, it captures the only moment we ever have in life, because we only have that second or nanosecond and then it's history and before that it's the future, so photography has that great knack.

Her father was Ronnie Tree, a Conservative MP, friend of Winston Churchill, though his roots were in America – he was the grandson of Marshall Field, the Chicago department store millionaire. Her mother, Marietta, was a New York socialite and political activist with powerful contacts in politics. She became US representative to the UN Commission on Human Rights. She was also, as I discovered, the biggest bitch. Truly horrible. By the time I met Penelope, she'd returned to New York with her parents where she was mostly left to her own devices. They lived in one of the biggest private houses in New York, 123 East 79th Street. Ronnie had also built a large house at Heron Bay in Barbados in 1947 and lived between the two places.

The first published photograph of Penelope was taken by Diane Arbus, shooting a feature on children of smart New Yorkers, trying to make Penelope look like a stranded little rich girl. In 1966, aged sixteen, she went to Truman Capote's Black and White Ball at the Plaza Hotel, the biggest splash of the decade with its guest list of Truman's 580 close friends of that moment – everyone from Lynda Bird Johnson to Albert Maysles – most of whom he lost afterwards when he turned nasty, in person and in print. Avedon was there and noticed Penelope; so did the paparazzi. She was all over the papers the next day, all picked up by Diana Vreeland, who was then editor of *Harper's Bazaar*. That was the beginning of her career, the launchpad, at sixteen.

Penelope had gone back to New York to go to Sarah Lawrence College. I came over to New York late that year of 1967 and met up with her, took her to a nightclub. There was the first kiss – that was all. In January 1968, when she was just eighteen, she came to Paris for the collections and that's where our affair started, in the house of Albert Koski, who was my photographic agent in France and who was Françoise Dorléac's last boyfriend (which also broke up Koski's engagement to Grace Coddington). I was already deeply in love with Penelope. But we couldn't take off together. I had to end not only my affair with Sue Murray – which was going on when I was married to Deneuve – but also my work with her, which took me to India, and New Zealand for several weeks. In April I went to New York to get Penelope and bring her back to live with me in Primrose Hill. This had been the plan between us for the last three months, while I was travelling with Sue. By this time Penelope had told her mother of our plans and also Avedon, and neither of them liked them.

Avedon was very jealous. He walked Penelope around the block, she told me, and said she was crazy to go over to England to be with me; she was making the biggest mistake of her life; she should stay and do her studies; he would continue to photograph her. That caused a rift for a while between Penelope and Avedon. They became friends in later years but she never worked with him again. She had her mind set on coming over to me. Nothing was going to stop her.

I thought Avedon's were the best pictures ever taken of Penelope, just incredible, much better than mine. I think he's the best fashion photographer that's ever been. Him and Steven Meisel. Of course, Avedon had that American production behind him when he took a picture, with thirty people working

on it. When I first worked with Penelope, it was me and her. I never reached the level Avedon was at. Maybe I had the advantage because they were a bit naive, my pictures, so in a way more charming than all that production, which sometimes takes over. Also he thought there was no sex in photography. I think photography is all sex. He never fucked anyone, Avedon. I think he was non-sexual. I was with three girls he really liked, including Penelope, and I'd slept with all of them. I don't say I slept with them like it's a conquest; it's just that's what happens if you're close to somebody – you end up in bed with them. Unless you're asexual like Avedon.

When I came to the door of 123 East 79th Street to get Penelope and rang the bell, Marietta opened it, saw me and immediately tried to slam it shut. I jammed my foot in and said to her, 'Don't worry, it could be worse. It could be a Rolling Stone.' I got on well with Ronnie, her dad, later but he wanted Penelope to marry Lord Lichfield, Patrick – a photographer with an earldom.

Almost as soon as Penelope arrived at Gloucester Avenue we went to the East End to photograph the Krays. She was shunted upstairs with the women. There was strict segregation of the sexes in those pubs then in the East End; ladies not allowed in the men's section. Penelope couldn't believe it; for her it must have been like walking into a Carry On movie, with everybody talking like Barbara Windsor – if she even knew what that sounded like. The purpose was that it didn't cause any fights. And I think the women liked it. No punch-ups. And there was always a fight every weekend in the East End. If Penelope had been an English girl from her background, she wouldn't have lasted five minutes. But she was all right because she didn't speak posh, she was American. And she looked like nobody else.

When Penelope and John arrived, my long-time PA Gilly Hawes had been working in Gloucester Avenue for two years, since 1966 – I'd also brought her from *Vogue*. She ran everything there for the next six years. So Bea Miller knew her and she hauled Penelope and Gilly into her office at *Vogue* and told them off about smoking dope because she felt responsible for Penelope, having introduced us. Bea had promised Marietta she'd make sure she was all right – and then she ran off with me. Marietta really didn't like me.

Penelope's initiation into London, in Gloucester Avenue at least, was the shooting of *Goodbye Baby & Amen*, which involved, over many weeks, 160 or so of the people who more or less made up the Sixties coming to Gloucester Avenue to be photographed and usually staying for a drink or we'd go out for dinner with them. If the Sixties was basically just a small group of people who knew each other, which is how I saw it, they all collected in Gloucester Avenue over this period. This was now late on into '68 and many of them were more famous than they were at the time of *Pin-Ups* four years earlier. The world had changed and hardened since then, lost some innocence. The Vietnam War was at its worst, there were riots everywhere. Daniel Cohn-Bendit, the Paris student leader, was one of those I photographed. John Lennon, Christine Keeler, now out of prison and a little down on her luck, Ravi Shankar, whose music you could hear all over the house, Peter Ustinov, Jim Dine, Brigitte Bardot, Bill Brandt – to take a random choice of opposites. Because I often had to leave after the shoot for some other work, Penelope began to resemble a hostess at a permanent Truman Capote ball. But she too was a player with the others who gathered in our house. Jim Dine and Rory McEwen made an early rap prototype record with the lines 'And I hope you

all agree, Penelope Tree' and what might have been an epitaph for the Sixties by itself: 'You and me and Penelope Tree'. John Lennon was asked to describe Penelope in three words. He said, 'Hot, hot, hot; smart, smart, smart.'

Our life at Primrose Hill was assisted by César. Penelope had found him. She described him as the butler, as some kind of ironic memory of her father's staff at East 79th Street. He used to say himself that he was the butler and sometimes he behaved like one; then he'd bring someone a drink and sit down next to them. He was a general helper – he did everything, and nothing. He was the most racist man I've ever met. He was from Brazil, and he was black and if someone from the West Indies came to the door he used to slam it in their face, saying, 'Ooh, he's a black man, I don't want to talk to him.' I used to say, 'Your hair's a bit curly, César.' He'd been an 'exotic' dancer in Paris. He was exactly like something out of *La Cage aux Folles*. In fact, if I think about it, César didn't do anything. He just seemed to take the dogs for a walk. He never cleared up or anything. One day he said to Penelope, 'You treat me like a servant,' and she said, unable to resist it, 'But, César, you are.'

I once asked him to bring the *Financial Times* in the morning and he said he wasn't going to carry a pink newspaper on the Tube and be queer-bashed. He was great, César. He said, 'If I could afford a Hasselblad I could take pictures as good as you.' He actually thought it was the Hasselblad that took the pictures and that made them good. I said he should open a restaurant and call it Cesar's Palace. In the end he went to work for Odin's, Peter Langan's restaurant, and then he died.

One of César's tasks was to feed the parrots. I don't know why I had sixty of them. You become a sort of collector, in a way. I had cockatoos, lovebirds, finches, rosellas, hyacinth

macaws, the most beautiful of all. Gilly, my assistant, who loved the parrots, brought back two galahs, Australian cockatoos, pink and grey, which I'd bought there. She pretended they were her own pets, since she had a resident's licence from living in Australia to bring pets back. I had a sulphur-crested cockatoo, pure white, just outside the office on a perch, free to move around, who may have been one of the parrots that intimidated Catherine Deneuve. Parrots have a spot behind their ears and under their wings, and if you stroke and tickle them there they close their eyes and put their head on the side, which is what Catherine should have done to get to her room, but she was much too scared to approach them.

I caught psittacosis in the mid-seventies – something very rare – off two Brazilian brown parrots. Both of them died. I had to tell the doctor what it was; he thought I had pneumonia. I said, 'No, I think you'll find it's psittacosis.' He said, 'What's psittacosis?' Nobody knew about it back then. You can get it off chickens, off the pigeons in Trafalgar Square, in which case it's called ornithosis. It's only called psittacosis if it's from a parrot. It makes my breathing shallow, it wheezes a bit. But it never bothered me at all.

One night around that time in late '68, I think, my father suddenly appeared at the door in Gloucester Avenue. It was out of the blue. I had been out of contact with him for a long time, for many years. He was kind of pathetic – he looked gaunt and ill, and like some figure out of Dickens. He was a broken man and he'd come to ask for money. That night I gave him some money and told him to go away. I didn't know – because he didn't say – what his condition was. I was very affected by his appearance, really upset for a few days, a bit haunted. He'd married again, right at the end, and his wife called me and said,

'He's dying. You've got to put him in some kind of hospital.' Turned out he had cancer. I paid for him to die. I put him in the London Clinic. Fucking fortune, the London Clinic. It wasn't even a regular hospital where you get treatment. It's cheaper to stay in the Savoy! They phoned me and said, 'We need the money now or we're going to turn him out.' It wasn't like I was trying to cheat them. Turn him out?

He was in there for a long while. I remember getting back from Barbados and that's when he died. I knew he was dying and I went to visit him in hospital. He asked me if I wanted to see his bedsores and I said no I didn't want to see them. My father treated me awful anyway. The only person that liked him was Duffy. That awful wife he married thought she was going to get a lot. She didn't get anything apart from the most expensive funeral, which I paid for and she arranged it. Fucking fancy cards with black and gold on them. He didn't know about it – he was dead. It was just for her.

Was I upset? It's upsetting if anyone dies. If the dog died I'd be very upset. I'd be more upset about that than my dad. I never liked the cunt anyway. Horrible bloke.

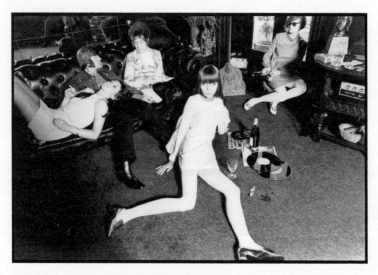

Penelope at my house in Primrose Hill.

Chapter 17

Penelope

The five years with Penelope were almost the most intense period of work in my career. There were many trips and locations – some without Penelope; I made documentaries, many commercials, published books of my pictures (*Goodbye Baby & Amen* and *Beady Minces*) and worked with *Vogue*. I never stopped working. John Swannell told me that he'd never had a single day off all the time he was working for me. He said, 'You're working me to death. I need some time off.' I've never had a day off in my life. According to John, I replied, 'That's fine, we're going to Rome next week – you can have some time off on the plane.' I'm sure I never said that. I was very nice to John. I cancelled a whole shoot in Rome once because he wanted to go home.

Before John I had Patrick Hunt as my assistant. He was great. He made John look awful he was so good. He was fantastic. He'd cut his leg off so he'd get to work. We fell out a bit over his girlfriend, who was a model I used. It was about her tits. I used her for English *Vogue*, for the Paris collections. I photographed Yves Saint Laurent's collection with her, which had see-through blouses, which was normal – every girl wore them. Patrick said, 'You ruined her career.' I said, 'What do you

mean? I fucking made her career, you cunt. She'll be known as the girl who wore the Yves Saint Laurent see-through tit dress.' He was furious. He said, 'She'll never work again.' Didn't talk to me for about six months.

I travelled with Penelope across Europe to fashion shoots in my dark-blue Ferrari 275; to Paris, to Rome, to Florence, to Milan. They were great trips. One of the bosses at Ferrari told me that it was one of only ninety in production and it was the best Ferrari ever made. One of its distinguishing features, apart from its sharp nose, was that we had to get hotel staff to push-start it in the morning. Otherwise it was fine. We'd stay at the Colombe d'Or in the South of France. Miles Davis's *Sketches of Spain* was music I remember playing in the car, going to dinner at Paul Bocuse, the posh Michelin-star restaurant in Lyon, in the centre of France, on the day of the moon landing, in July 1969. I remember coming out of the restaurant, looking up at the sky and thinking, 'There's people walking on the moon.' We stayed in out-of-the-way places that weren't known – little inns, villages. It was wonderful.

I wrote a script for Penelope called *Galaxy Cry*, a character born out of cosmic sadness. I was going to make the film and that was the beginning of it. Born in the universe of lilies; the lilies had dew on them that dripped to earth and in the drip was an egg that produced Galaxy Cry. I had other plans for Penelope and films were written but they never got made. We had too much else to do. We were always travelling – in 1969 to Kathmandu, Kashmir, India.

JOHN SWANNELL: 'She was already six foot tall, but when we'd go on trips she'd wear these heels as well, her hair would be up high, so she'd be seven foot tall walking

through the airport. Everybody turned their heads. She was like a Mongolian or Peruvian princess. She'd wear these long coats with tassels on and these big eyelashes she used to stick on every morning; it took her about an hour to put them on. But she looked like a goddess, absolutely stunning, breathtaking, in fact. And she was such good fun as well, such a lovely lady on these trips. They were magical times.'

John was five foot six and he used to wear Penelope's clothes, or some of them. He wasn't a transvestite. I think he was just fascinated by her look. He wore her shoes, her pearls under his shirt, everything. They were Mikimoto pearls. I was there in Japan when she got them. He even wore her high-heeled boots sometimes. I'd say, 'John, you've got Penelope's shoes on.' He'd say, 'Don't tell her.'

Stylists are great, when they're good. Grace Coddington was the best stylist I ever worked with. Probably one of the best women I've ever worked with as well. I'd had a romantic affair with her when she was a model. In 1969 Bea Miller gave her a job as junior fashion editor. I loved working with Grace. I respected her. I thought her whole way of looking at the world was fantastic. Once on a shoot in Tunisia, she brought along a broom to sweep the sand dunes, to make sure they were perfect.

Before Grace came along, we'd had some editors who made the work so much more difficult. Worst of all was Melanie Miller. I got on all right with Melanie in the end, and got to quite like her. And I should say this because it didn't start well. She was Vreeland's secretary before she was an editor, and moved to British *Vogue* after her husband, who was a chef, got a job in the US embassy. She was always difficult. So American. She'd

never been out of America all her life. She had her face painted white always, with high, marked eyebrows, like Dietrich or something. She wore a lot of light-coloured Pucci dresses. She took her own toilet seat on a couple of trips, like the plastic one you'd use for a child. The clothes she brought were always terrible. She liked floaty chiffony gowns, the kind you'd see in Henry Clarke photographs. He was the worst. Give him an evening dress with lots of chiffon and he'd come. These trips – and we did many trips with Melanie – were a nightmare. John says I was horrible to her, that I used to wind her up, but I felt like it was the only way to stop her trying to order me around. Penelope remembers that I was always threatening to push her over a cliff; she said I once let the handbrake off when Melanie was sitting in a car.

Melanie said, 'I'm going to tell my husband about you' because I called her a cunt. I said, 'Tell the brigade of guards, for all I care.' So she told him and he said, 'Well, call him a cunt back.' One day at breakfast, after she'd again threatened me with her husband, I said, 'I don't give a fuck what you tell your husband. He's probably got some young girl, you're away so much. She's probably putting toothpaste on his toothbrush right now,' and she burst into tears.

Inevitably, one day on a shoot in India she said, 'I'm going to leave.' So I said, 'Leave.' She said, 'I'm going to tell the police you were smoking dope.' I said, 'That's all right.' She said, 'Why?' I said, 'Because I'm going to tell them you sold it to me.'

But it's better if John Swannell tells what it was like, in case I'm exaggerating. I don't think I am. I don't know how we got anything published working with Melanie; it was a real struggle.

JOHN SWANNELL: 'We went to Kathmandu, Bailey, Penelope and me, with Melanie in 1969. Bailey didn't like her very much. They never got on. In fact, he really hated her and he used to wind her up. He was always on the phone to Beatrix, the editor of *Vogue*, saying, 'I can't work with this woman any more.' She always got him awful clothes to photograph. They were old-fashioned, horrible, long silky things, and you had these young girls, eighteen, nineteen, wearing this stuff an old woman would wear to a cocktail party. So some of the pictures could have been better and it wasn't fair, he was struggling with this stuff. One day Bailey said, 'Why don't we live on a houseboat for a week?' And Melanie said, 'I'm not sure about that.' There weren't that many available, because it was short notice. You hired it for a week and got a cook and everything. The only one we could find was sinking, it wasn't that great, it was very primitive, but it was so romantic. We all moved in and Melanie wasn't happy about it at all. Every night she was moaning and groaning about the food. The chef would say, 'How do you like your food?' Bailey said, 'I want Indian food every night, and I want it as hot as you can do it, we're not tourists. I want to taste it.' So the chef was really delighted, but Melanie said, 'No, no, I'm not sure about that.' But he just ignored her and this curry every night was unbelievable, I've never tasted anything like it in my life. Anyway, she was moaning like crazy and eventually Bailey was a real bastard – when he doesn't like somebody, he's got it in for them. She was complaining about the bath, the sanitation, this and that, and Bailey went into the bathroom and he found a rat in the bathroom. He got some rat shit and put some on her

pillow. We were all smoking a bit of dope and stuff, we were heady but not out of it, and in came Melanie with this bit of white paper with this rat shit on it. And she said, 'Bailey, what is this?' He said, 'Well, it's obvious what it is, Melanie. It's rat shit. Where did you find it?' She screamed and threw it in the air, and she said, 'I'm moving out, I've had enough.' And she went back to the hotel that night.

Soon after that we went to Turkey with another fashion editor called Marit Allen. And that trip changed everything. Marit Allen was one of the young fashion editors, one of the best they've ever had in fact – apart from Grace Coddington, of course. And we went to Turkey and the clothes were fantastic, the girl was fantastic, an American girl, and Bailey suddenly came back with pictures nobody had seen before. They were saying, 'God, is it some kind of revival?' It was nothing to do with a revival, it was that he had good clothes to photograph for a change, instead of this awful rubbish Melanie Miller used to give him. And after that I think he just refused to work with her any more, that was the end of it. I think he realized he had to work with these younger editors. From then on, all the pictures in *Vogue* were fantastic.'

Melanie was the wrong person to be working at *Vogue* – she should have been in a bank. I saw her years later when I was making a beer commercial in New York. I had a whole road blocked off, the crew waiting for me to start, and suddenly Melanie was there. She said, 'Can you come and have a coffee?' I said, 'Not right now.' I didn't say, 'I can't right now, you silly bitch. I've got forty-eight people in the crew to start with.' By that time I felt sorry for her. She was sweet but dumb. When

I eventually got sick of fashion photography – in the late Seventies – it was partly from working with people like Melanie and the fights it involved, the people who so often took me to that point. There was a lightbulb moment in Rome in 1979 when I saw Norman Parkinson choosing shoes for a shoot and he was about sixty-five. And I thought, 'Shit, I don't want to be doing that when I'm sixty, sitting in a studio looking at fucking shoes.' But it continued to take me to extraordinary places, where I could take my own photographs.

I went on a trip to Peru with Grace Coddington in 1971 – this time without Penelope. We took, instead, the Danish model Annie Schaufuss. I took many photographs outside my work that turned out to be good enough to be published separately in *Peru*. It was, by accident really, the most poetic and abstract book I've ever done, though I only realized that two or three years before I started writing this book when I republished the pictures. The landscape, the people were like *One Hundred Years of Solitude* – a man with a tuba, for example, walking down an empty street. They're not really pictures, they're not like reportage, they're just pictures of people. There was no story to them, they didn't need to be in any sequence, they're just there like smoke that gets blown away.

In the Sixties and Seventies I could get to places before they were ruined, before there were sixty Germans or Italians taking iPhone pictures. The iPhone's put me out of work. Machu Picchu, then, was magical the first time I saw it. You took a train journey from Cusco, a rickety two-hour ride on a narrow-gauge track, up steep gradients, then the rest of the way in the back of a lorry. It was 10,000 feet above sea level, and Grace and John got altitude sickness. They were all vomiting. All except me. Nothing I could do for them.

I was making a film for the Wool Board at the same time, a seventeen-minute documentary. I had that to do as well as stills. I didn't have a cameraman – I did it all myself. John was quite good with a movie camera as well, but he was Tom and Dick. I could manage, but otherwise I just had to wait until they were better. And keep on the move, which was pretty gruelling for them. We drove to Lake Titicaca, which was even more extraordinary than Machu Picchu to me, with its village floating on reeds. We saw the emerald-green Salt Lake at Arequipa, with unbelievably massive flocks of pink flamingos as far as the eye could see.

We were in a truck one day coming back from that emerald lake, with a driver and an interpreter, when we saw this parade of local people coming down the street, dressed in their Sunday best, loud. I slowed the driver down and we followed them down into this little village; there was music playing, people drinking. We set up quickly. Grace got the girl dressed, and we went into the village and I started taking pictures with her and all these people. None of them could speak English and we began to realize they weren't very friendly, and they were drinking this white stuff and all getting a bit pissed. So we had a drink of it as well and we were saying cheers to them, trying to get them to cheer up. I remember saying, 'My god, they're miserable, these people.' And eventually our interpreter came running down and said, 'Come on, let's get out of here. This isn't a wedding, this is a funeral.' Somebody was burying his mother and we were laughing and joking. So we started to walk back to the truck and they started walking after us because they were a bit pissed by this time. And suddenly a bottle came flying across our heads. Then another. Then a hail of objects. They were really drunk. I shouted to get the girls in

the car. I always kept a pocket full of change when I went to places like India and Peru. If we annoyed the locals, I'd throw the change and they'd all go after it and we'd scamper the other way. But not this time. The bottles were flying, and they were going to kill us. John and I were the last two running up to the truck while the truck was moving off. It was like something out of *Indiana Jones*.

Annie Schaufuss was really nice. We did some pictures in those same mountains on a ranch the size of Wales. Everywhere the view was so magnificent that you had to take pictures straight away because you'd get used to it. The owner of this ranch, who later had it all taken away from him by the communists, owned thousands of llamas. Annie had taken a great liking to a little one that was tied up outside the hacienda. She was a vegetarian and so am I, and she said to me the next morning, 'What happened to that little llama?' And I said, 'They had it for fucking dinner last night.' It was true, they did! And she burst into tears. It ruined the day. I was upset too, but I wasn't going to fucking cry. Most of the world's eating meat; you can't do anything about it.

There was a shoot in Goa that was really hard work, and everybody was really depressed and missing home. We had three days left in the middle of this jungle and I needed to do something to just get them through this last bit. We were booked into this strange colonial mansion hidden behind some big gates, in a clearing in the middle of a forest, covered in geckos. There were no mosquito nets – we were told the nets were coming tomorrow and the manager said, 'Don't worry about the mosquitos. The geckos will eat them.' So everyone was sitting around at dinner, looking dejected, not speaking, and I said, 'You know who's arriving tomorrow, don't you?

Elizabeth Taylor and Richard Burton. They've been touring India and they're coming here for the last couple of days, to this hotel.'

Taylor and Burton were the most famous couple in the world at the time. John Swannell said, 'You know them, don't you, you've photographed them?' I said, 'Yeah, I know Liz really well. We'll all have dinner with them tomorrow night.'

Actually I'd spent a week with them once, Elizabeth Taylor and Burton. The director Peter Glenville was acting as my helper. I didn't take one picture, she was pissed all the time. And she stole my camera. She just said, 'I like this camera,' and stole it. I had no choice; she was drunk. She had kleptomania, she had two bodyguards when she went into shops, walking around after her, paying for anything. Anyway, they were so drunk we ended up on Onassis's yacht in Venice for some reason. A great big yacht, a minesweeper that had been converted to a yacht.

So I told them this good news and it got their spirits up, and the next night they all came down to dinner looking forward to meeting Burton and Elizabeth Taylor. John found me in the bar where I was having a drink.

'What time are they coming?' he asked.

'I've just spoken to them,' I said, 'and they're late. They're not getting in until tomorrow morning now. But don't worry, we'll have dinner with them tomorrow night.'

We shot the next day OK, but in the bar the second night I had to say, 'Look, their truck's broken down; they're on the outskirts of town. They won't be able to make it tonight. They're stopping off at another hotel, but they'll be here tomorrow.' And I kept their spirits up for three days until I finally broke the news that Burton and Taylor weren't going to make

it. I only told John much later that I was lying. It's amazing that it worked. Celebrity fuckers – they were cheered up.

In the meantime I'd fallen in with Lew Grade, at ATV, to make documentaries. I ended up doing three of them for ATV – on Cecil Beaton, Luchino Visconti and Andy Warhol. Lou had to make ten cultural documentaries a year to keep his contract with ITV. He told me he'd give me 40 per cent of what he got for my documentaries, and I thought that was great. Then I found out he was charging ITV £10 each for them! He'd agreed £200,000 for a Tom Jones documentary and threw mine in as part of a job lot.

He was great, Lew, nevertheless. I got on with him so well. All three documentaries were just mapped out on a small bit of paper, which I showed to Lew: 'That's what I want to do,' and he said, 'Great, make it.' I found out later Lew thought my Cecil Beaton film was about Mrs Beeton's cookbook. One of his best lines was, 'Dave, don't give me any animosity. I get it from driving by bus queues in the back of my Rolls-Royce.' Later he said, 'I don't get animosity any more, I've got a Ford.' But he was like one of the guys I knew from the East End, a regular cockney. He was really nice.

I'd started working on the Cecil Beaton documentary in 1969. There's a sequence of Penelope dancing around his garden in a long black dress on his orders, as he photographed her on the move. 'This is marvellous, Penelope. Let's bare the fangs? Let's have a smile. Let's see the gums, the molars! Where are the molars?' There's a duet filmed in The Ritz of Beaton and Cyril Connolly, who had been at boarding school together, singing 'If You Were the Only Girl in the World'; his extraordinary sisters talking away like elderly duchesses; Cecil being his languid self. He didn't really like me, Cecil Beaton, but I thought he was a

good photographer, a good designer, good at everything. If he hadn't been such a snob he'd be fantastic. He's the snobbiest man I ever met, I think – proper snobbery: he was basically middle class and always wanted to be posh. His way of talking was definitely gay, but almost like a headmaster. He ordered you rather than talked to you. He told you what to think; his opinion was what counted really. I never saw him have a soft moment. Beaton described his day with us in his diaries, *The Unexpurgated Beaton,* edited by Hugo Vickers. '[Penelope] is so subtle, sensitive and highly intelligent. He so cocky Cockney bright and completely uneducated. It seems that during the intervals of "takes" she was standing between his legs as he sat on the kitchen table. Giving her a whack on the rump, he asked Ray [a Beaton servant], "What do you think of this old bag? She's just a home-loving old trout, really." Penelope seemed to love such treatment . . . I find them both very strange but then I do not often realize when others are "high" on "pot". Seeing me clear up some cigarette ashes, P. asked, "Are you a neat freak? Oh, David and I are terrible. We make the most awful mess."'

On the subject of motels, a Beaton hate, Tree said, 'Oh, Bailey and I love it. We want to have our home just like a motel, with tuna fish sandwiches in cellophane wrappings for breakfast.' Beaton, again: 'God what a shock this ménage must be to the Tree parents. I really feel acutely sorry for them.'

At this time the unions had a strong hold on filming, as I had discovered when I started making commercials in about 1963. I didn't really want to do them, but it was extra money – I made a lot more money from them over the years than from photography – and they were easy. Good for a dyslexic. They gave you a script and a storyboard, but I could visualize them, and that's why I was good at them. Being dyslexic wasn't very

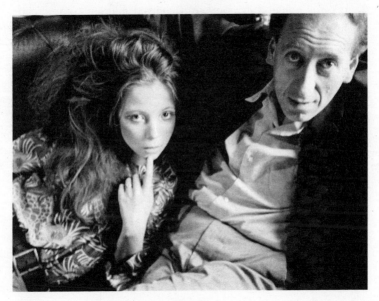

Penelope and Francis Wyndham in 1968.

good for going to meetings where people wanted me to explain things and I wasn't very good at it. They'd talk a lot of rubbish. They'd say, 'Where are you going to put the camera?' I'd say, 'I don't know, I'll work it out when I'm there.'

I was approached by Jim Garrett – Gentlemen Jim, as they called him – who ran the largest commercial production company in the UK. He took me to lunch at that fish restaurant, Scott's, for our first meeting and I started making commercials for him – mostly hairspray, perfume, cosmetics, not a lot of dialogue or action. Mostly voiceover. I did my second commercial for Tame hairspray with Tania Mallet, who led a live cheetah down the steps at St Pancras station. I didn't worry about Tania cuddling the cheetah, until later that evening I heard a scream and the cheetah had bitten his trainer.

At first, union rules meant I wasn't allowed to be called a director, I was a technical adviser; then I got my union ticket, but only for directing commercials and feature films. While I was shooting the Beaton documentary the union blacklisted me. They literally came on the set and pulled the lights. They said my union ticket didn't cover documentaries, it only covered features and commercials. The local union guy wore a cap and white scarf, he was like Peter Sellers in *I'm All Right Jack*. Actually what he really wanted was for me to have feature-film crew numbers on the documentary, which would have been an extra eight people or so, minimum. It turned me against unions, working-class people fucking up working-class people. I'm a working-class bloke like them; they're blacklisting me so I couldn't work for two years! Fucking arseholes. The union guy said, 'We'll have to have lunch.' I said, 'Where do you want to go?' I knew he'd choose the most expensive restaurant in London. I was paying, of course. I think he wanted

a backhander as well but I was determined not to give him one. There was no way Lou was going to pay for eight extra people, so the union said, 'You can't use your name under the director's credit.' We called the documentary 'Beaton by Bailey' and for the director's credit Lew put the name of the channel's current religious adviser. (He was making all those Jesus films at the time and the big joke was Lew saying, 'I want Jesus in by Easter.') And then the union bosses eventually wrote to me and apologized. They said it was a mistake and their man had been wrong. With all this going on, it was about two and a half years before I could finish the Beaton film.

My documentary on Luchino Visconti, made in 1972 when he was filming *Ludwig of Bavaria* with Helmut Berger, was a nightmare. I thought an older man, Visconti, making a film about a young boy, his lover, would make an interesting documentary. But as Visconti was sick and Helmut was constantly drunk and arguing, nothing came together. And since they were filming too it was difficult to get time with them. It was an uphill battle. When things go wrong with a documentary there's nothing you can do because the crew's booked for a certain number of days and that's it.

Then the documentary I did for Grade on Warhol hit the last wave of outraged British censorship – of the kind that had caused the storm over *Lady Chatterley's Lover* – and it was banned just hours before they put it out. In a classic, almost Carry On muddle of Law Lords and moral vigilantes, it turned out that nobody who complained and none of the judges had actually seen it before they banned it. In those days characters like Mary Whitehouse, twitching her curtains, were on the prowl for 'filthy plays' and sex in any form on television – and she had broadcasters nervous of her accusations of 'indecency'.

For good reason. She could put a spanner in the works, as could another one called Ross McWhirter, a kind of Empire loyalist who did the *Guinness Book of Records*, who was always bringing cases against trade unions and the CND – a real right-wing nutter.

We'd had a press screening of *Warhol*, which included a scene of one of his superstars Brigid Polk doing a 'tit print', pressing paint on the canvas with her bare breast. Otherwise the film shows a few of Warhol's freaks and Factory members in dialogue being filmed by Paul Morrissey and an interview between Warhol and me in bed together. It was my first selfie. Andy said he wouldn't do the film with me unless I went to bed with him, so I said, 'All right, we do all the interviews in bed.' Which we did. It was hardly a sex scene.

The tabloids went for the film: 'shocking . . . revolting . . . offensive.' McWhirter took out an injunction against the IBA (Independent Broadcasting Authority, the ITV watchdog) not having seen the film either, just based on the reviews. It got to the Appeal Court, where Lord Denning said he hadn't seen it either but the reviews showed it was certainly offensive. He said the viewers of Britain were to be shown pictures of a fat lady doing something that sounded to him very much like a breach of the Vagrancy Act. It was pure Joe Orton. They voted to ban it – none of the three judges still having seen it. The *Mirror* quoted me as saying, 'I'm more angry than disappointed. How can anyone damn something they haven't seen? Hitler used to burn books he hadn't read. I've spent nearly a year of my life working on the film so I'm not going to let it rest here. The decision to ban it is one giant step in the wrong direction for British TV and freedom of expression.' Lofty words. Warhol said, 'Gee, how can they still think like this? Honestly,

I didn't know it was possible to get anything banned on television.' Asked about McWhirter, I said, 'Who is he anyway? If he wants to make a name for himself, why doesn't he protest against Vietnam or the napalming of babies – or free bus rides for pensioners?'

The arch establishment figure Lord Shawcross, chairman of Thames Television, got a pie in the face when he said he was delighted by the verdict, that Thames TV shouldn't broadcast undignified stuff like this (without him having seen it) – at which point 200 of his Thames TV programme makers signed a petition disassociating themselves from his remarks. He muttered something about welcoming robust debate and shifted his ground. It was a real mess. In the end the Appeal Court reversed its judgment. Denning, outvoted, said the court had no right to interfere. Ross McWhirter was made to pay half the costs. Finally the film was shown in May 1973, though it stayed banned in so many countries. The last word came from Mary Whitehouse's Viewers' Association, who reported the case of a young 'well-balanced woman who had nightmares after watching the show with her husband. She felt ill and disturbed for several days and was afraid to go to sleep, so vivid and lasting had the monstrosities been.' And on the other channel Barry Norman the film critic was showing clips – including the sodomy scene with Maria Schneider and Marlon Brando – from *Last Tango in Paris*, which nobody seemed bothered by.

Around 1971, after we'd been together for about three years, Penelope's luck changed. As a model, Penelope could be as big as Jean editorially but not commercially. She didn't appeal to the masses, so she wouldn't be booked by Revlon like

Jean was. Her look, which was so distinctive, was no longer required; fashion had moved on. I was told I couldn't use her so much. And she had other problems. She had started to get fat. I remember Vreeland pulling me in and saying, 'What are we going to do about Penelope?' Because we were going to do pictures of her and Jean in Hawaii. Vreeland was great. She said, 'I'm really worried about Penelope, she's getting very big.' She said, 'Do your best, Bailey, and try and shoot from other angles.' We did the pictures, but she does look fat. That was a beginning of the end of her career as a model because you had to be really thin.

To make things a lot worse, she developed a skin disease that marked her face very badly. It was all mental; she didn't catch anything. But it was awful, awful. In 1971, when I was in Peru with Grace Coddington, Penelope went to New York to have painful operations to remove the scarring. That was one of our many separations at the time. Her modelling career was over and there was nothing I could do about it, or any of it. I didn't know what to do with her. She didn't want to go out. She didn't want to do anything. We were drifting apart anyway. She'd got involved with a bunch of hippy friends I didn't like. She had the worst kind of friends, as far as I was concerned. The only one I liked was Hercules Bellville, Polanski's friend. In 1972 she was busted for possession of cocaine with these other scumbag friends living in a squat. They might have been nice people, but I thought they were scumbags. Penelope had never bought cocaine before and the police were going for the dealer, who ratted on all his friends. I didn't know anything about it; Penelope did that without telling me. I probably got the blame for it from her mother. I wasn't into drugs.

I never bought a drug in my life. I never buy drugs now, smoke one joint at night-time sometimes. Drugs don't do much for me.

I went to court with her. All the papers said I looked like Karl Marx when I came out of the courtroom, because I had my hair combed back. She got a conditional discharge. Then after that she started working for Release, the drugs charity. I couldn't see the point of that. Not long after that, one night Penelope walked out. She left me, but I had left her too. She knew it had come to the end. I was having an affair with the wife of a friend of mine, who came after me with a baseball bat. At the time Penelope's mother was driving me mad. She was awful and she made Penelope sort of unpleasant, and my friend's wife was just very attentive. I went off to Paris with her, which caused all kinds of havoc. That was the trigger that made Penelope go. It was sad. I was madly in love with Penelope when she left, but it's no good hanging on to something that's not working. I did try to get her back but she'd gone too fast. I couldn't find out where she was. I gave up.

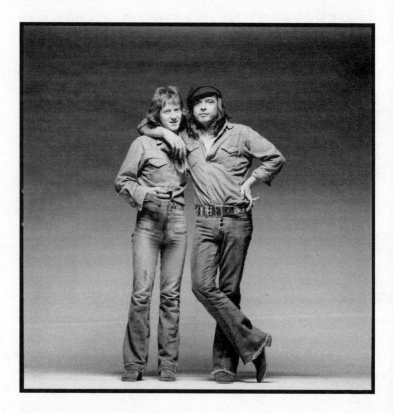

Me and John Swannell.

Chapter 18

Fifty Years Later

JAMES FOX: *It has taken some persuasion for Penelope Tree – one of Bailey's most famous models and girlfriends, and inspiration of Sixties London – to agree to sit down with Bailey for a lunch of reminiscence. They are friendly, even loving, though they rarely meet, but there are likely to be some radically different versions of events, or events possibly better left under their protective compost. It wasn't all plain sailing being Bailey's girlfriend. I have been able to persuade Penelope to come because we know each other well. I first knew her – before Bailey met her when we shared a memorably silent taxi ride – either of us too shy to converse – when she was barely fifteen and I was twenty. Perhaps it was the silence that made an impression on us both. One might be forgiven for being tongue-tied in the presence of such an unusually striking and original-looking beauty. Later we became close friends when our paths crossed several times, sometimes by the oddest coincidence and some because we have family ties in common. Bailey has said that Jean Shrimpton, Penelope and his present wife, Catherine, are the three great loves of his life.*

On this day of the lunch with Bailey, Penelope and I met beforehand to exchange briefs at a cafe across the street from

241

the restaurant. Penelope at one point appeared to be looking for something she had dropped under the table. In fact she was changing her shoes. 'I need to be wearing heels for this,' she said, 'I need to tower above him.' When they first met at the photo shoot for Vogue, she said, some months before their first embrace, 'We knew it was all going to happen. I was going to end up with him. He did too. There was a frisson. Maybe he does that with all the girls.' On their very first date, in New York, some weeks after that frisson, she said, Bailey had told her the story of the scorpion and the frog – how the frog asks the scorpion why he has stung him halfway across the river, imminently drowning them both, and the scorpion says he can't help it; it's his nature. 'I couldn't believe I listened to that story and didn't think "I'm outta here,"' she said, laughing. In Gloucester Avenue, 'the centrepiece was a shrine in his living room, photographs of all his past girlfriends, all in little gold frames, all the same size – the focal point of the room. It was like notching up kills on the side of Air Force planes. He's incredibly competitive.' He is fascinated by women, she said, 'he wants to plunder their mystery, to steal their baraka – their spiritual essence.'

'How was it in the beginning?' I asked. 'The first love of your life?'

'It all went very well for a couple of years. Two or three years, we were really close,' she said. 'I remember I didn't need a winter coat when I was first with Bailey that January because I was so hot from the whole thing, passion, excitement and happiness. I lost my winter coat somewhere, as you do when you're in a complete state of undoing, and I never got another one until the following winter. The problem was he had constant women falling over themselves to sleep with him and he

was very up for that. And that was very difficult because I was very, very, very jealous. Which you weren't supposed to be in those days. I was eaten from inside out with jealousy. At the same time, I was hopelessly dependent and I had so little confidence. He had all the power. In relationships it happens all the time. And it's deadly.'

Then came a recurring depression, when she was twenty-one, anorexia that swapped over with bulimia in cycles, when her career with Bailey had started drying up for lack of bookings.

'The bulimia and anorexia stuff he didn't know about. That wasn't his fault. When the skin problems happened, for a model that's pretty devastating. I went from being sought after to being shunned because no one could bear to talk about the way I looked. I cannot remember what Bailey was up to while I was going through all that. How he was. Really strange. He just completely zoned out and lived his life, and for me that was like my own parents. I just accepted that was how people are because I'd never had another relationship.

'It was the end of our relationship but I couldn't deal with it at all. So I was just living like my mother and father used to live. I should have known it before but I didn't. I even had this dream every night that I couldn't leave, I'd fall apart. Then I woke up in the middle of the night and I knew that he had gone off with Jane. Jane's husband didn't know until I told him. I packed my bags and that was it. I realize now that I left two dogs, Merlin and a briard called Stokely Carmichael. I left them behind when I fled Gloucester Avenue and never saw them again. I can't believe I did that, but that's how cut up I was. Or cut off.

'It burst the bubble and that was a good thing, because we were in such a bubble of not understanding anything, really anything else deeply about anybody. And I think Bailey's

*always remained in that bubble, that narcissism that completely
denies the reality basically of anybody else's existence.*

'I think I did survive,' says Penelope, 'although it took me a
*very long time to come out from under it, but there are other
people who didn't survive very well. I think I was just ridicu-
lously dependent. Because I went from home, which didn't
have a lot of love . . . well, I had an affectionate father, but I
transferred everything onto Bailey, like he was going to be my
saviour and the love that was going to completely change my
life . . . well, it did, not for the best, but it was my own psych-
ology that did that. I'm not a victim. There were a few years
when I really didn't want to see too much of him. But we're
pretty close, the bond is still very strong. I can stand up to him
now. It would have been useful to have mastered that earlier.'*

*We get up from the cafe table and head across the road.
Sheekey's is noisy with lunchers arriving. Bailey is waiting. We
have to shout occasionally to hear each other. Then it calms to
a buzz and we start a three-way conversation – not to set the
record straight but to launch it on a winding trajectory between
memory, truth and fiction.*

FOX: So you're on speaking terms, then?

BAILEY: Of course we are, I love Penelope.

FOX: A joke.

BAILEY: It was a joke? Oh. Let us know when you make a
joke so we can politely laugh.

FOX: I take it back. It wasn't a joke.

BAILEY: *[to Tree]* I'm pleased to see you.

TREE: It's been a while.

BAILEY: I know, I'm always so busy. I've just done a sumo.

TREE: A wrestler?

BAILEY: No, a book, a giant book of my pictures.

TREE: For Taschen?

BAILEY: Yeah. Benedikt Taschen, nicest man in the world, definitely the nicest publisher. You can't say that in here because everyone's a publisher.

You look good! How old are you?

TREE: Thank you. Sixty-nine.

BAILEY: Fucking hell. It goes quick, doesn't it? I'm eighty-one. Mind you, I don't look as bad as him and he's ten years younger.

FOX: Don't you? Have you looked at yourself in the mirror recently?

TREE: The wonderful thing about this place is that it shoots you full of pink.

FOX: Like Harry's Bar in Venice, if it's still pink. What were your main restaurants in those days when you first lived with Penelope?

TREE: There weren't any restaurants in Primrose Hill. There wasn't one.

BAILEY: We used to go to the Casserole on the King's Road.

TREE: The Aretusa, every night. The Terrazza. Meridiana. Apicella. And lunches, too. I remember one dinner at the Aretusa with Reggie Kray. Reggie had a bodyguard called Albert the Rock and I was sitting next to him and Bailey. No waiter would come to our table; they were too afraid to serve us. We sat around, Reggie was getting drunk. Finally Enzo Apicella arrived, had to take the order himself. Albert the Rock, I read months later, had kneecapped and killed someone. And he and I could for some reason only talk about blood, knives, killing. I was asking him questions, and everything went back to murder

and eventually, because we talked of murder, I asked him, 'You can't really be telling me you've killed people?' And he said, 'If somebody gets in your way and nobody knows, why not?'

BAILEY: The lunches we had weren't lunch, they were fucking all day. We worked all the time as well. Duffy liked lunches, he liked talking more than he liked taking pictures. He could bend your ear off. He didn't repeat his stories, though, he wasn't like Lichfield – I've heard that story of his for forty-five years, the funny one about the Queen. The Aretusa was where Duffy knocked me out. Penelope hated Duffy.

TREE: Absolutely hated him.

BAILEY: He threatened to put a billiard ball down her mouth. Very uncomfortable.

TREE: He was nasty.

BAILEY: He was Irish.

TREE: He hated me.

BAILEY: I don't think he hated you. He was a bit jealous of you.

TREE: He was in love with Bailey.

BAILEY: I don't know about that.

TREE: He was. You said you agreed.

BAILEY: Well, only when you told me. I didn't think about it before.

TREE: He was in love with Bailey and he was also kind of competitive at the same time. We used to get into the car and he'd go, 'Birds in the back.' And I was like, 'Excuse me?' He was married to this poor woman with four children who spent the whole time in the kitchen while he went out gallivanting, basically.

FOX: Did he have lots of girlfriends?

TREE: Well, he wasn't very attractive, so I don't know how many he had.

BAILEY: A lot.

TREE: Once we were in the Bar des Théâtres in Paris, and he invited me outside to have a punch-up. Do you remember the Bar des Théâtres? It didn't have anything particularly going for it, but everybody went. I don't know why. It was near [Albert] Koski's, that's why we went, I think.

FOX: Did you have a Paris life?

BAILEY: Yes, we did. That's where she seduced me. I remember the ceiling where we did it, looking up and a piece of the ceiling had come off and it was spinning.

TREE: I don't remember that.

BAILEY: Like during the war I remember, in the cellar. It looked like it was snowing when the bombs came down; this was a bit of flake that had got stuck. I remember thinking, 'That's odd.'

TREE: We were in the attic in Koski's weird house in the 16th arrondissement.

BAILEY: All the bombs were going off, do you remember? It reminded me of the war.

TREE: That was another time.

BAILEY: No, it was the first time.

TREE: It was not. That was months later, and we were having a row from New Jimmy's back to the Crillon, and we drove through what I thought were firecrackers or a celebration, and it was May '68. I remember thinking I'd missed the Paris revolution because we were fighting.

BAILEY: That was the first time we did it.

TREE: I swear to god it was not, I have a better memory than you. I'm younger than you. I'll tell you why, because we got together that January 1968 in Paris during the winter collections and Vreeland was there.

BAILEY: Oh yeah, we kissed but we didn't do it.

TREE: Yes, we did.

BAILEY: You've got me mixed up with that other geezer. I remember the situation because of the thing on the ceiling and then the bombs going off and you being a virgin, or you told me you were a virgin.

TREE: Well, there was evidence of it actually, which was very humiliating because Koski came in the room and the evidence was there and he was making all these jokes. It was rather embarrassing to be in this situation where everybody knew I was a virgin. There was this woman who had long fingernails which she was constantly buffing. She wore short shorts with a bib and a crossover thing in linen, and high heels and lots of make-up. She was Koski's assistant – she was Diane von Furstenberg! So funny. But it was January 1968, I promise.

BAILEY: Maybe it was January. That was our first fuck?

TREE: Yes. It wasn't when the bombs were going off; that was six months later. We were having a row—

BAILEY: We never rowed. We were just new together.

TREE: —because you propositioned somebody in New Jimmy's in my hearing. I know that girl too; her name was Ika Hindley.

BAILEY: Yeah, she worked with Saint Laurent, his PA or whatever.

TREE: No, that's another one.

BAILEY: I didn't do her.

TREE: I'm not talking about Marina Schiano.

BAILEY: No, I remember our first time very well; it was very important to me. There's only three girls I've ever loved and Penelope's one of them.

TREE: Aww.

FOX: Where did you first meet? It was a long time before the first kiss, no?

BAILEY: At *Vogue*. That was when Bea Miller warned me against hanky-panky because her father was rather important. I was completely, suddenly interested. Why were you in London?

TREE: I had a summer job working for Rupert Hart-Davis, the publisher. And guess who was my boss? Sonny Mehta [later Chairman of Knopf Doubleday Publishing Group in New York. He died in December 2019]. I was a reader in a publishing house. So I'd read these books with big eyelashes down to here, totally made up, mini skirt to here. I would read the book, eat a lot of biscuits, and then Sonny Mehta would come in the room and say, 'So what did you think of X?' And I had so much nerve, I'd say, 'Well, I don't think it's a really very good use of the English language . . .' I mean, I hate to think what I said about these poor writers. I had no idea what I was talking about. And he used to just stand, and you know how Sonny said nothing really eloquently? He'd stand and look at me and I'd shrink into the wall and then we'd do it again a couple of days later.

So I did this sitting with Bailey after a meeting in Bea's office in London. It was really good actually, and there was a kind of frisson going on, wasn't there? I remember when we met something happened. But you were with

Sue Murray then, and of course you were still officially married to Catherine Deneuve. Then we had this rather fraught lunch at the Terrazza, round the corner from my office in Golden Square with David McEwen.

BAILEY: I loved David. Bad boy. Were you seventeen?

TREE: Yes.

BAILEY: But going on thirty.

TREE: I don't think I was that sophisticated actually. It was just that I'd been brought up with a lot of grown-ups, but I wasn't that grown-up myself.

BAILEY: There were not many girls you'd meet and one of their best mates was Truman Capote. Bad choice of mate, by the way, horrible man.

TREE: No, he was all right when he was young, but he kind of blew it.

BAILEY: He was a vicious little queen.

TREE: He was horrible after the Black and White Ball.

BAILEY: He was always nice to me, but I just didn't like him.

TREE: I would have loved to have met him when he was twenty-five.

BAILEY: You got a lot of press because of the Truman ball, it was all about you.

FOX: How did you look?

BAILEY: Absolutely ridiculous.

TREE: I wore a dress that I had designed with Betsey Johnson. It was based on dancers, like ballet clothes, modern ballet. It had spaghetti straps that crossed at the back. It had panels of black jersey very form-fitting to below the bust, and then it had slits all the way up the waist and tights underneath so it was perfectly decent. It was a really good dress.

BAILEY: And you had already done some great pictures with Avedon and with Guy Bourdin for *Glamour* magazine.

TREE: So I went back to New York after my summer job in London and I started at Sarah Lawrence College, which was a big joke. And I was working and going to university, I was completely exhausted. And I think before Christmas, Bailey pitched up in New York and that's when we went to a nightclub, scene of the first kiss.

BAILEY: I think Bowie's wife was there, Iman, or was that later?

TREE: I don't remember who was with us because I was just completely gaga in love. Then the next time I saw you was when I was doing the winter collections with Avedon – in Paris, January 1968.

BAILEY: He loved me, Avedon.

TREE: Not! You were still with Sue Murray. You went on a trip to India with her, for a long time.

BAILEY: Oh yes. Morocco, New Zealand and India on the way back. Had we done it together then?

TREE: Yes, we had. Then you came to New York to get me, three months later in April 1968, to take me back to London. And you came to my parents' house. And that's when Marietta, my mother, opened the door, which was weird because she never opened the door. The butler opened the door.

BAILEY: I said, 'I've come to pick up Penelope,' and she tried to shut the door on me but I put my foot there. I said to her, 'Come on. It could be worse. I could be a Rolling Stone.' Then she laughed or smiled and then she sort of said, 'All right.' I think she invited me in. She was quite

tough, Marietta. I think she'd been around the block a few hundred times.

TREE: Do you think she was a goer?

BAILEY: She always had a lover with her, you didn't know.

TREE: I did know. Adlai Stevenson, for one.

FOX: Why was she trying to bar Bailey from the building?

TREE: Well, she knew I was going to go off with him. I was seventeen. He was twelve years older than me. She wanted me to finish university.

BAILEY: She wanted her to marry Patrick Lichfield. She'd get her ladyship. She was a right fucking snob, Marietta.

TREE: No, my father wanted me to marry Patrick Lichfield.

BAILEY: I thought he was on my side, your father.

TREE: He was, but this was before you. So you came to stay in Heron Bay a few times.

BAILEY: Lots of times. I always got a Christmas present from Penelope's mother that was a present from somebody else last year. She was very good at recycling.

TREE: You weren't the only one. Bailey used to come to Heron Bay, which was heaven. Suddenly we'd come from grey skies and rain, and it was so bright and so clement and gentle. And Bailey would spend his entire time in a darkroom, painting Mickey Mouses, only to emerge at dinner.

BAILEY: I met Duke Ellington twice at Marietta Tree's. He came to play there in their house. It was one of the biggest houses in New York. I counted thirty-two servants altogether if you count all the chauffeurs, gardeners, maids around the world. Barbados, Italy, New York at 123 East 79th Street, which is now the Brazilian Embassy. Duke Ellington used to play in their front room. Imagine that.

Fucking fantastic. For me one of the great geniuses of the
twentieth century. I watched Paul Gonsalves, Ellington's
sax player, making a pass at Marietta Tree. I was standing
at the top of the stairs; she didn't know I was there. I
thought she was a horrible, hateful woman. Oh, she was
a bitch. She disinherited Penelope out of pure spite. I
made her cry twice, I was very pleased. Told her she was a
bitch. And I didn't feel a bit guilty. But your father, Ronnie
Tree, was like my best mate. He said, 'We're so much
alike because we're so different. Your background and my
background are so far apart that we're almost the same.'
He was great, Ronnie. But I don't know what sort of
childhood you had.

TREE: Well, you do, actually.

BAILEY: I wouldn't want to be brought up by your mother.

TREE: She was a crap mother, unfortunately. We had a tough
time relating to each other. I lived in the nursery; I didn't
see much of my mother as she was always at work or
socializing. I often wondered what it would be like to have
a loving mother. Or even a mother. On the other hand, I
wouldn't want to be brought up by your mother! I don't
think I would have survived very long.

BAILEY: Did she like you?

TREE: No.

BAILEY: You were 'one of those', as she called them – posh.

TREE: Who did she like?

BAILEY: Jean. She was one of those as well.

TREE: Well, maybe your mother just got exhausted by the
progression of girls. So then we went back to Primrose
Hill. It was 1968. Lots was happening everywhere, except
in Regent's Park Road, the nearest main road. It had a

fish and chip shop, a junk shop, a garage, very little else.
Catherine Deneuve had done a good recent job of interior
decoration. It was the black walls and mirror globes and
everything, but she had decorated it with wonderful South
of France material.

BAILEY: The poet – the famous one, Ted Hughes – lived at
the back of me, married to Sylvia Plath.

TREE: That's where she put her head in the gas oven, right
behind the house.

BAILEY: I really liked her, did her picture for *Vogue*. He
wasn't so nice.

TREE: The first year I was with Bailey it was not only
the Krays, but he was doing this book *Goodbye Baby
& Amen*. Every night after work, more people would
come over for drinks, people from Donovan and Duffy,
advertising people. And often Bailey wasn't there that
much – you were always working – so I was like Elsa
Maxwell or something, the hostess.

BAILEY: Peter Ustinov.

TREE: Laurence Harvey, Christine Keeler . . .

BAILEY: He was nice, Laurence Harvey. He used to buy
dinner for tramps. He saw a tramp and he'd go out and
get them dinner and bring the tray back to the waiter.

We had a big sheepdog called Merlin. (The other dog
was called Stokely – named by Penelope after Stokely
Carmichael.) We were photographing Morecambe and
Wise and it was lying on the floor next to Eric, and
the dog got up to move and he said, 'Jesus Christ, your
carpet's moving.' They were really, naturally funny. They
were the only funny comedians I've ever met. They were
funny all the time. They weren't like Peter Sellers, who

was a fucking bore. They were always miserable cunts, comedians. But Morecambe and Wise, everything was a joke. Must have been a nightmare to live with them.

TREE: We did some great trips. Trips to Europe, visiting all the films being made at the moment. One was a David Hemmings film in Ireland. Bailey and he got incredibly pissed and dared Hemmings to climb this very old skeleton of a tower and he fell – and we watched him fall. It delayed shooting for three months.

BAILEY: No, he wanted to have a bet with me I couldn't climb around a castle wall. I said, 'I'm not going to fucking do it.' He said, 'Well, I'll do it,' and he fucking fell.

TREE: And then later going to Kathmandu; to Kashmir, to Egypt with Jean: an amazing trip. Jean is a good rider and we got horses and we galloped from the pyramids in Giza to the pyramids in the middle of the desert.

BAILEY: Lucky I could ride, to follow you both across the sand, these two loves of my life, on those Arab horses. I'm quite a good rider, I taught myself; just keep your knees in.

TREE: Going to India meant spending ten hours in customs because you needed every single receipt for every camera in those days.

BAILEY: When you came in and you had to count the rolls of film and you had to count them again when you left, there was always something that had fallen in the river or something.

TREE: You did quite a lot of maharajas. You covered lots of movie sets.

BAILEY: I didn't shoot over people's shoulders, though. I got
 them separately, the actors. I didn't do them on set.

TREE: No, we'd visit the sets and then you'd do the actors.
 We did *Death in Venice*, do you remember?

BAILEY: That was great. I only had a little half-frame camera.
 It was exactly a real-life version of the Olympus ads I did
 later, where Arthur Daley sneers at my camera, 'Who do you
 think you are, David Bailey?' I remember the photographers
 were all covered in cameras and I just had a little half-
 frame . . . 'Look at that guy with a half-frame camera
 running along the beach.' I had Rock Hudson complain
 about me once to American *Vogue*. I took a picture of him
 and Julie Andrews with a half-frame camera for a double-
 page spread. He said, 'He's not taking us seriously.'

TREE: Do you remember Dirk Bogarde?

BAILEY: They used to call them the aunties, him and his
 boyfriend. Did you come to his house in the South
 of France with me? They lived near Lartigue, the
 photographer.

TREE: Yes. We knew them quite well. We saw him on various
 occasions. He was absolutely lovely. Then we visited him
 on the *Death in Venice* set, when Visconti had completely
 redone the whole of the Hôtel des Bains on the Lido,
 which was just absolutely extraordinary. It wasn't just sets;
 he had redone the whole hotel. Then Dirk Bogarde had
 become the character, Aschenbach, who becomes unhinged
 by his love for the boy in the hotel. He became the part
 so much, he went through a huge nervous breakdown
 afterwards.

BAILEY: He used to get hysterical. Do you remember that actress, Capucine? That was Bogarde's great friend. He said it was the nearest he got to marrying a woman.

FOX: What sort of things did you wear?

TREE: What a lot of people do now: put a lot of things together that didn't really go.

FOX: Nobody else was really doing that?

BAILEY: Nobody, nobody.

TREE: Op shops, you know, charity shops. Chelsea antique market, everywhere . . . Just odd things.

FOX: You liked dressing up?

TREE: Yeah, I liked the dress-up part, not the 'making myself beautiful' kind of thing.

I don't think Bailey really liked working with me, but that's OK. You were a bit cantankerous towards the end, to work with. I think you thought that I was trying to create something, whereas you prefer models who are just directed.

BAILEY: Probably, yeah.

TREE: Really. I didn't expect you to back down so quickly.

BAILEY: With you?

TREE: To agree with me.

BAILEY: It was lots of pressure from the magazines: 'You can't keep using Penelope Tree all the time.' Things like that. It was ridiculous she was a model. I never think of you as a model.

TREE: I don't think I was a very good model.

BAILEY: Because she was Penelope, she couldn't be nobody; a model is someone you put in anything . . . She had to wear the clothes the editors picked. She was difficult to

style because when you made her look ordinary, it wasn't Penelope any more.

TREE: Most of the clothes you got for British *Vogue* and most magazines were really boring. You can't imagine. It was just like the most conventional, terrible clothes.

BAILEY: The thing I really hated was fucking culottes because you always had to put the leg up. 'Can you just put the leg up somewhere?' 'I'll stick the fucking leg up your fucking arse.' You couldn't see they were culottes unless the model put their leg up; they look like a skirt with the legs down. They were really exceptional or really no good, there was no in between.

TREE: The shoots depended on the editor. There was one great editor called Anna Piaggi; we did a lot of work for her and Italian *Vogue*, which got huge amounts of advertising and was outside the normal controls of Condé Nast. Anna Piaggi was absolutely unbelievable, incredible-looking, bright red hair and little hats. Her double-page spreads were legendary at that time. Anna Piaggi, then Vreeland. Vreeland had the most incredible imagination in the world. She had this vision. When she brought teams together, she brought them together to do something that hadn't been seen before. Whereas so many magazines at the time were actually very conventional.

BAILEY: She was great, Anna Piaggi. A bit too much for me. Dressed a bit strange herself. She was a bit like a caricature, but it was nothing to do with fashion. I quite liked that Penelope was nothing to do with fashion either. She was her own fashion. I wanted to work with Penelope all the time, if I could. Italian *Vogue* offered her the job of editor at nineteen.

TREE: I thought it was a joke.

BAILEY: It wasn't a joke, but I wasn't keen on the idea because it meant you had to live in Milan most of the time.

FOX: Had you always had this fascination with clothes early on?

TREE: Very early on.

BAILEY: The only clothes I ever noticed was Saint Laurent because of the cut. Penelope was more interesting to me than the clothes. I always said I didn't do fashion pictures. I did pictures of girls in clothes. The girl was always first. If the girl didn't look good, the pictures were a waste of time. I made the clothes look good because that's what I was paid to do, but I wasn't interested in them. Eventually I lost interest in fashion photography altogether. I got fed up with it. I got trapped into fashion by *Vogue*. The reason I did fashion photography was it was the only possibility – in that early period – of doing something creative that you got vaguely paid for. I always tried to use the same girls – it was always a fight. Penelope doesn't know this story. On a trip to Zambia once, *Vogue* wouldn't take her, so I paid myself. I was broke, I paid her airfare. It came to £650, I think. Made me broke, I didn't have anything in the bank. It was my last £650 because I wanted her to come.

TREE: But you ended up taking photographs of me that were published.

BAILEY: I know, because you were there, *Vogue* didn't mind because they didn't have to pay you. You know *Vogue*, they're so cheap.

TREE: But also I had my moment of attention and then it was on to the next. With *Vogue* you're just eaten up and spat out. I think my popularity was like a couple of years and

that was about it. In 1970 everything changed. It became
these athletic, blonde, very clean-cut American looks.

BAILEY: We even had struggles with Vreeland but on a level
different to anyone else. Penelope and I spent a day or
two days on a shoot and I showed her the pictures and
she said, 'Bailey, they are wonderful, beautiful pictures.'
Penelope was there and I said, 'I'm glad you like them.'
She said, 'They are wonderful but I can't use them.' I said,
'What do you mean, you can't use them? You just said
they were wonderful.' She said, 'Bailey, look at the lips!'
I said, 'What's wrong with the lips?' She said, 'There's no
languor in the lips.' Fucking hell, what am I up against
here? No languor in the lips! I can't use these pictures!
There were a lot of things like that with Vreeland. I
realized she couldn't see, and once I said, 'You're a fucking
blind old bat.' She said, 'Bailey, don't be cruel.'

[the subject turns to the death of Bailey's father]

BAILEY: It's awful having a father you don't want to be like.
You wouldn't mind being like your father, would you? I
liked your father, Ronnie Tree. He had a boyfriend, did
you know that?

TREE: Yes, well, I've only known that since I was about forty.

BAILEY: I really liked Ronnie, you know that. I thought he
was great, I remember leaving Barbados one day, one of
the saddest moments in my life watching you cry as you
were saying goodbye to him and you probably wouldn't
see him again. Not that he knew you wouldn't see him
again, but it was that time. It was one of the saddest things
I've ever seen, tears in your eyes.

TREE: In the last ten years before he died, when I was aged
fifteen to twenty-five, he always cried whenever I left.

BAILEY: No, you were crying, not him. He was left in the house with all his servants.

TREE: He was a goodie.

BAILEY: What was he? About seventy-one?

TREE: Seventy-eight or seventy-nine.

BAILEY: Lady Anne Tree. I fell in love with her. Your sister-in-law. She's one of my favourite women. She's the one who used to say to me, 'When you grope my tits, I want you to know they're real.' She was great. She used to breed Japanese butterflies in her bedroom, and she'd walked across the Himalayas with Louis Vuitton trunks. She was really a great kind of old-fashioned adventurer, and fearless. She wrote to the Home Office about her prison charity, getting people to stitch embroidery in their cells: 'No wonder the country's going to the dogs, with cunts like you in charge.' Her and Vreeland were the most extraordinary women I've ever met.

FOX: Around 1973, things weren't going so well for you two?

BAILEY: Yes, they were. Well, we had our arguments like anyone. We got on great, didn't we?

TREE: Erm . . .

BAILEY: I did anyway.

FOX: So at Primrose Hill you say there were a lot of freeloaders there at your house? Did that add some tension?

BAILEY: Only her friends.

TREE: No, you had a lot of freeloaders yourself.

BAILEY: There was one guy who stayed for a week. I said, 'When's your friend leaving?' She said, 'He's not my friend. He's your friend.' I said, 'I don't fucking know him.' It turns out he was a journalist from *Rolling Stone*. All your

friends were hippies. I remember driving in the Rolls-Royce to dinner with half a dozen of them in the back seat and picking up the bill for £300. All these hippies saying, 'Love and peace, man. We should all be together and share everything.' Share everything – fuck, they're drinking my champagne when they're back home. They were her friends.

They were sitting in my Rolls-Royce, taking the drugs that I paid for – one of the assistants bought it for Penelope or whoever came – and telling me I'm a capitalist pig.

FOX: Is that true?

TREE: Yes.

BAILEY: It is true, I couldn't make that up!

TREE: It's just you resented me working for Release.

BAILEY: I thought it was all silly.

TREE: But I had a traumatic bust, in this squat in Elvaston Place. I went there to visit friends. I spent a lot of time with them. This was when we were breaking apart, you and me.

BAILEY: Were we? Because you were hanging out with those hippies.

TREE: Possibly, but I did have something I had to escape from at that point.

BAILEY: Well, you didn't have to escape, *you* seduced *me* . . . *[pointing to a man sitting against the far wall]* See that light above his head? Do you think he sits there on purpose? It's like a halo, look.

TREE: This is your book. We are going to have to be honest, no?

BAILEY: Have you ever known me to be dishonest?

TREE: Well, I've known you to change the subject.

FOX: So you were spending some time in this squat?

TREE: Things were unravelling. There was a dealer there, American, right out of *Superfly*, with those big platform boots and everything. He opened his bag and he had countless, countless, countless little grams of pre-packaged coke. I had never bought coke in my life. I'd had it, but I hadn't bought it ever. And I happened to have twenty quid on me so I bought it and from that moment on I felt unbelievably paranoid. I went out onto the balcony and I was looking up and down the street . . . and one of my friends was saying, 'No, it's just the first time you've ever bought any. Don't worry about it.' She had a baby and her mother from Harlem who was there at the time. I came back into the room, we were looking at the baby and suddenly eight plain-clothes policeman, eight! I mean, a lot, came bursting through the room, and my friend got up and started kicking them in the shins.

At the trial Bailey completely disassociated from me and it was my father who came. My mother hid as well. Made herself extremely scarce. She went to America. They were in England for the summer. So my father went to the trial. Which was terribly sweet of him because there were a million paps outside. It was very unpleasant. All this stuff came out about my skin. Because that was one of the defences one of my lawyers made: 'She had this attack of acne and she's a model and it must have affected her judgement.' I would never have gone for that humiliation.

I got a conditional discharge because the dealer, who did a deal with the police, only got a six-month suspended sentence and they could hardly give me a worse sentence than him.

FOX: Does that go on your record?

TREE: Not conditional discharge, but every single place I tried to go I was strip-searched for years. Then I did have to hire a really good lawyer to get me off the computer. It was on for ten years at least, it was such a pain in the arse.

FOX: Anyway, so that was sad when you broke up? You had another girlfriend, Penelope walked out?

BAILEY: Yes, life is sad. That's what John Lennon didn't say: 'Life is what happens to you while you're busy making other plans.'

TREE: Or, in your case, when you're busy making love with somebody else.

BAILEY: Well, that as well. It's difficult to say no.

TREE: I packed two suitcases containing clothes and books and left.

BAILEY: I couldn't find you, you went to Barbados. Then you were off somewhere in the Far East.

TREE: No, first I went to live in a valet's room on the top storey of the Ritz. Which sounds fun but it wasn't.

BAILEY: I tried to get you back.

TREE: How come I didn't know about it, then?

Chapter 19

The Shoot

My fling with my friend's wife didn't last very long, about three months. It was a completely sexual thing with her. I'd first gone away to Paris with her, which was a nightmare. Paris is so awful anyway – not the place to go if you're unhappy, and I wasn't happy leaving Penelope back in London. After Penelope disappeared, the affair just faded away. She was a really sweet girl, one of the sweetest people I've ever met. She was almost too sweet. People took advantage of her – me included, I guess. Accidents happen. You don't really want them to happen or don't think about them, they just happen. It's like a plant: it gets big or it dies. If you don't water love affairs, the relationship dies. It needs repotting sometimes as well.

Around that time, early summer of 1973, *Vogue* asked me to shoot Penelope's friend Anjelica Huston, who was in London. Anjelica had become a top model in New York, long before she started making serious movies, but she'd broken up with her boyfriend and gone to LA. She'd also just taken up with Jack Nicholson, who was in London as well, about to shoot Antonioni's *The Passenger*. I'd known Anjelica a bit – I'd first met her with her friend Joan Buck, who became editor of French *Vogue*, when they were teenagers, giggling in the corner when I

went round to Eaton Square with Catherine Deneuve to see her father. Anjelica remembers it in her memoirs. John Huston was one of my heroes. I always thought he was a genius. *The African Queen, The Maltese Falcon*, I loved all those films. John's producing partner, Jules Buck, father of Joan, was also a partner with Peter O'Toole. They were going to make a film about a photographer, long before *Blow-Up*. That's why Jules Buck was interested in me. I'd also photographed John Huston in Ireland for *Pin-Ups* and I'd photographed Anjelica aged sixteen, when she made her film debut with her father in *A Walk with Love and Death* in 1969. Terrible film.

When she came over this time we did shoots in Paris, in Yves Saint Laurent's house, in Milan and the South of France that summer. I liked Anjelica. She was special and I used her a lot that year. *Vogue* having pushed us together, there was then a lot of resistance from the magazines because she didn't look like a model. I said, 'Well, that makes her even better.' As I've said, I liked using the same girls all the time because you get a code together, just a nod of the head and it's all right. That's why Ingmar Bergman was great, he used the same people for fifty years, the same lighting man, same cameraman . . . Just a nod and a wink and it's done; they know what you want. I hated working with new young models. I waited a couple of years and then I used them. If you used them straight away you'd have to teach them everything, it would be a nightmare. In August we were in Nice and Corsica, with Manolo Blahnik, who had only recently opened his first shoe boutique and was already designing for top fashion houses, and Grace Coddington, in what turned out to be a famous fashion shoot. Trips in those days were two or three weeks sometimes. Now it's a fucking weekend in the hotel grounds if you're lucky. Mind you,

there wasn't anybody with us; often there was no hairdresser or make-up, we just did it ourselves. It was much more fun in those days and it looked just as good.

Grace Coddington remembered this trip, in her memoirs, as the one where she nearly died laughing. And it was just one of those trips where everything was magic. Manolo was always hysterical, gesticulating and screaming. At that time I didn't realize how funny he is. I can't think of many people as naturally funny as Manolo – Donovan was funny. Manolo is the most positive man, and one of the most wonderful men I've met. Anjelica was a great mimic. She could do anybody you wanted – Lauren Bacall, anybody. She has a great sense of humour. They were hysterically funny together. She was good at everything, Anjelica. She would go on to make *Prizzi's Honor* with Jack, she was so good in that; and *The Grifters* with John Cusack; and *The Dead*, directed by her father, played in an Irish accent that was native to her.

I decided to rope in two friends who lived in the Nice area, David Hamilton and Helmut Newton. A picture of our gang, with Grace sitting on Helmut's knee and Anjelica standing in a dress worn the wrong way round, has become quite famous; Helmut's hand, around Grace's shoulder is clicking on the cable release. In Corsica, Manolo wouldn't do anything you asked him. You used to have to do it before he did it. I wanted to bury him up to his head in sand, just for a funny picture. Grace remembered that we did it to shut him up.

'I can't do that.'

'I can.'

'Well, you do it then.'

'If I do it, will you do it?'

'Yes.'

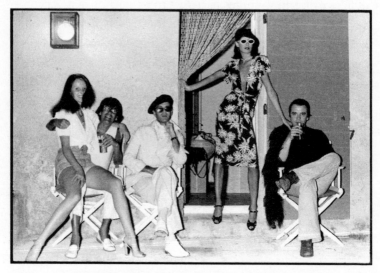

The famous picture of Grace, Helmut Newton, Manolo Blahnik, Anjelica (wearing her dress back to front) and me.

I never have an idea about how I'm going to shoot before I go to a place; it's when you get there that you see it. I put Grace in the clothes and had her and Anjelica walk down a pier with Manolo in the middle, photographed from behind. Anjelica, tall, looking through a tourist telescope, Manolo leaning out to sea like Buster Keaton. It was a gift. The *Vogue* cover that came from the shoot – a picture of Anjelica and Manolo embracing in the sunset – broke with the traditional standard full-face shot of every *Vogue* cover up until then. Grace Coddington wrote that it's an image 'every fashion enthusiast remembers with awe.'

It was helped, possibly, by the fact that Anjelica and I were having a romantic episode, despite Jack, which reached an intensity during this shoot. She was partly paying him back – she said so in her book – for being too casual with her and straying with other girls after they'd got together a few weeks earlier. She wasn't sure how much he liked her and she wasn't going to wait around. I think she saw us – her and me – like I did, as an episode. It wasn't serious, we knew it was passing. I liked her very much and she liked me and we had fun together; it was like that really. She was great, Anjelica.

Her ploy worked. Jack phoned me and said, 'Are you in love with Anjelica?' I said, 'No, I like her but I wouldn't call it love.' He said, 'Well, I am.' So I said, 'OK, but whatever you do, don't buy her flowers because if you spoil her she'll be difficult to handle because she's a fucking handful. She'll know she's got you under the thumb.' She was very tough, Anjelica. They were together after that, on and off, for a few years. I made a book of photographs of Anjelica, mostly from that intense year of 1973. It's called *Is That So Kid*. It's what her father used to say

whenever anyone tried to say something to him. It just stopped you in your tracks.

I got Manolo and Grace to come to my studio to be photographed in 2019 when I started taking pictures for a new version of *Pin-Ups*, with some slightly younger survivors of that period, like Andrew Oldham. Grace and Manolo were schoolkids when *Pin-Ups* came out. In recent times Grace had starred accidentally in the documentary about *Vogue* called *The September Issue*. She had been the magazine's artistic director of brilliance for many years. Her autobiography *Grace, A Memoir* included descriptions of our adventures in far-off places, in the late Sixties to the Eighties, on the fashion shoots that had started her reputation as the world's top stylist. Manolo, since our shoot in 1973, had become one of the world's greatest shoe designers. He arrived to have his picture taken, two days after Grace, driven by his chauffeur and dressed in a lilac double-breasted suit, very well cut. He had been recuperating in hospital from an operation, from which he had fully recovered.

BAILEY: You have a car with you?

BLAHNIK: A man. A gentleman who does us.

BAILEY: I remember you used to run all the time. I used to call you the white rabbit.

You used to run everywhere, just like the white rabbit in *Alice in Wonderland*.

I remember sitting in the Café de Flore, and watching you run along the Boulevard St Germain. You were always running, always white plimsolls and no socks.

BLAHNIK: I don't know why, because I was missing something. I love to run.

BAILEY: Not now. You're fucking crook now.

BLAHNIK: I still run but it hurts. I am the white rabbit still but now with a broken knee – look!

BAILEY: God, you old guys are all fucking Tom and Dick.

BLAHNIK: I'm a man in pieces. Look at this, that is terrible. *[pointing to his knee]* This is horrible, that hurts.

BAILEY: I'm surrounded by old farts.

[Bailey sets up the camera for Manolo's pin-up portrait]

BAILEY: You haven't fucking changed since you were in the South of France with me in 1973. Do you remember the South of France?

BLAHNIK: I have no idea, Bailey. It was a long time ago.

BAILEY: You got the pictures, Fen? *[asking Fenton Bailey to get them]*

BLAHNIK: Oh no, don't show those pictures, I'm nude. We had coffins on the plane. Do you remember? It was nuns, dead nuns inside of the plane. Then we heard a huge *brooom* and the plane was going down. I thought we were going to die.

BAILEY: Your nose started bleeding and you asked for Tampax.

BLAHNIK: 'Has anyone got Tampax for my nose?' OK, let's go. I'm ready.

BAILEY: *[holding* Is That So Kid*]* There you are in the book. Can you believe how wonderful you looked?

BLAHNIK: I even had my hat. I was absolutely prepared.

BAILEY: You look like Buster Keaton.

BLAHNIK: But you have a nude. I want to see the nude one. I had an umbrella stuck into my genitals or whatever you call it.

BAILEY: There you are. And Anjelica – look, two old queens.

BLAHNIK: Anjelica was fabulous; you can't compete with Anjelica, come on. I love Anjelica, one person I'd love to see if I could see her all the time. I've got the book of her pictures, what's it called? *Is That So Kid*.

BAILEY: I called it that after John Huston, her dad, because he always used to say to me, after I'd said something, 'Is that so, kid?' Made you feel like a right cunt.

BLAHNIK: And he had a smell, always a cigar.

BAILEY: Yeah. He used to say that and make you feel stupid. Because, no matter what you said, if someone says, 'Is that so, kid?' what do you say? You can't say anything.

BLAHNIK: Let's go. Are you going to photograph me?

BAILEY: Yeah. That's what you came for.

BLAHNIK: I love that picture, quite famous, of the shoot in Corsica we did together because it's everybody I love. Helmut [Newton] was wonderful, we got on well. He was very tough in pictures. I had this model called Willy van Rooy and Helmut made her cry. She told me this story the other day in Madrid. He'd said to her, 'Honey, you look like a slut. I want you to be more slutty, I want more slut in you.' She was very beautiful. Bailey can be tough too, but he's tough-human; Helmut was tough-Germanic.

FOX: Manolo, did you go to any of these shoots in far-off lands? Africa, Australia, anywhere with Bailey?

BAILEY: He went to Corsica with me.

BLAHNIK: Corsica is next door.

BAILEY: That was enough, fucking hell. It was a fucking
nightmare. Travelling with him, can you imagine?

BLAHNIK: It's a nightmare, I'm not easy. I could be a pain.

BAILEY: I learned very quickly, whatever he wanted I said
the opposite, because if I said, 'I want you to wear a black
suit,' he would say, 'I want to wear white.'

BLAHNIK: I bought three bags of shit.

BAILEY: I know. He was more difficult than Anjelica, and I
used to laugh at him. He was more difficult than the girls.

BLAHNIK: I had an idea what I really wanted to be like, like
in one of your young pictures, and I was very wrong. I was
a pain in the arse actually.

BAILEY: Yes. A pain in the arse.

BLAHNIK: OK. I can imagine that somebody would tell me
that, it's because I want things the way I want them. My
factories hate me because I want it like that and this is the
way I want it. And people don't like that. I'm sorry,
this is the way I am. They run away from me actually.
When I come in the morning you can see their faces . . .
the eyes.

FOX: Manolo, tell me about Anjelica. Was she very special?

BLAHNIK: I adore her. I knew her from London, like in
parties and things like that. Then we became such good
friends on this trip with Bailey, and then all my life we've
been friends. She's mad, she's totally mad. We did a
competition of who does the best Peggy Lee or whatever.
She does 'oh fever, fever in the morning' imitations, she
was in ecstasy or something like that. So on that trip,
working with Bailey, I wouldn't call it work; it was fun,
total fun. It was having that wonderful time with Grace

and Angelica screaming all the time, singing. It was
fabulous.

FOX: It's interesting that she suddenly became such a great
actress, rather late, from modelling. She'd done a bit of
cinema, not much.

BLAHNIK: Her father had already put her in that dreadful
movie – her first movie, with an Israeli boy. What is the
name of Anjelica's first movie?

FOX: *A Walk with Love and Death*, with Assi Dayan, made
in 1969.

BLAHNIK: Yes. He was the son of the minister and army
chief, Moshe Dayan.

BAILEY: Yeah, I remember him. I remember him well. I
became good friends with him.

FOX: Manolo, when did you first become conscious of
Bailey's pictures? You were brought up in the Canary
Islands, no?

BLAHNIK: I was in Geneva, I was still in school when I saw
the picture of Jean Shrimpton and him in New York,
and it was absolutely a revelation to me. On my trips to
Montreux in the summer I used to get *Vogue* all the time.
But I'd never seen pictures like that before. My mother had
a house in the Canary Islands where there were always
Vogues; everything was marvellous pictures, Mrs Vreeland,
but it was everybody in a hierarchy, everybody posing in
extraordinary positions. And Bailey had taken pictures
of – I won't say the ordinary girl – the beautiful street girl,
and he was really lucky to have those clothes to go with it,
and it was the first time I'd seen women treated like that –
modern. You really knew what you were seeing. I said,
'Finally this is happening.' It was a directness. Beautiful in

a very simple Mary Quant dress or whatever it is – one of
those dresses of the time – but Bailey got this extra thing
that he provoked people to: 'I'm going to buy, I'd love
to look like that,' which was stopped completely in the
Forties and Fifties because everybody was like movie stars
and different kind of girls then. Between Montreux and
Geneva, it was like a revelation. I mean, I saw something,
I was transfixed. It was a new period. And the *Pin-Ups*
around that time, it was almost like a before and after that
book because it was so powerful. He'd captured totally the
culture. He went through the minds of these people; they
didn't have any connection with each other. He captured
it – the time, the period – more than any books or other
things at the time, and it's never been *de moda*, never
been out of fashion. It's fantastic and this is what a great
photographer should do.

FOX: I meant to ask Grace yesterday about having her
boyfriend, Albert Koski, Bailey's agent then, stolen by
Françoise Dorléac. But I think it was very painful at the
time.

BLAHNIK: You touched on someone that I really adore.
When I was young with Gerard Sylvie and Thierry Mugler
dancing with Françoise Dorléac at Castell's, it was one of
the most beautiful nights of my life. She was dancing, a
woman so beautiful, I've never seen a woman so beautiful,
she danced like she was in the air. She was a beautiful
girl and you photographed them both, she and her sister.
Françoise was very natural, very nice. And she saw that I
was really the most extraordinary dancer, I did have my
own movements and things like that, I was a mess. But she

knew that I could do it so we danced together. It was an incredible time.

BAILEY: She was my sister-in-law.

BLAHNIK: I know, dear, yes, I know! But this was before she was.

BAILEY: She used to pull her hair up like that, film star like.

BLAHNIK: She was beautiful and I was transfixed. I was in love with her. It was a period. I'm not nostalgic but I did have a good time. I was dancing all the time. I realized that I was dancing and then doing shoes here in London. That's all I did, and having fun. We didn't have those kind of structures of machines, it was contact with people, telephone, real, have lunch, it was all the time something happening. So sometimes I just have to sit down and say, 'God, did all this happen?' All the excitement, it doesn't exist any more maybe because I'm old.

BAILEY: It's not because you're old. It doesn't exist.

Chapter 20

Marie

I started travelling outside Europe in 1974 on trips that were nothing to do with *Vogue* and fashion, to do books, to find a new look outside the East End or Mayfair. My first trip – and the hardest one in a way – was to the remotest part of the earth I could find to get photographs: to New Guinea, travelling by myself, with no assistant, for about five weeks. The SX70 Land camera had just come out and Barry Taylor, the head of Polaroid in the UK who was a friend of mine, introduced me to the head of Polaroid in Europe, a bloke called Eelco Wolf who was running a programme that Polaroid had started during the war with photographers like Ansel Adams and Dorothea Lange. Now it was called The Artists' Support Programme, where they got artists and photographers to collaborate with scientists and engineers to develop the film and the cameras. Wolf, who was Barry's boss, said to me, 'I want you to shoot the SX70 film on anything you like.' I said, 'Well, let's do it on the most primitive people.' So I went up the Amazon, with a driver and an interpreter and met these tribes and they were all wearing fucking Levi's. I said, 'We can't do it there, forget it.'

I thought we should try New Guinea, so they arranged it. Of course, Irving Penn's photographs from Dahomey and New

DAVID BAILEY

Guinea, three years earlier – especially that famous one of the
Three Asaro Mud Men – had had an impact on me. There was
also a schoolboy dream I'd had of exploring frontiers where
you might meet someone who had never seen a Caucasian. The
explorers whose names I had romanticized – Younghusband,
Burton, Lawrence, Byron – had never been to New Guinea. I'd
mostly read them in the Air Force. There were so many geeks
in the Air Force. I had so much time. Those books were just
lying around. I even read novels, which I don't normally read.
I only read history books.

The locals weren't that pleased to see me. They were a
sullen bunch: the men were aggressive and the women were
very shy. They were still wearing bones through their noses.
Even the politicians on the local aeroplane from Mount Hagen
to Port Moresby had bones through their noses. No one in
New Guinea dressed up for me – it was how they were always
dressed, how their faces were always painted; they weren't in
their Sunday best. In Mount Hagen, around there, the Abo-
rigine men didn't live with the women, they slept in long houses
and if they wanted to bunk up they used to do it in the daytime.
They were big, the houses where they slept, three times bigger
than my big studio.

It was probably much more dangerous than I thought at the
time, because they still used to eat people there. It used to be
payback – now it was waste not want not. When they played
violent war games in which nobody was supposed to get hurt,
if one of them did die, there would be some sharing of the body
parts. There was a lack of protein on the island. The women
used to breastfeed the piglets. There was no real communica-
tion between us. We had no itinerary; we just had to wing it,
find someone to translate. The trouble is all the languages and

dialects were different up there, so it wasn't much help having a translator around. They thought the Polaroid I showed them was a useless or broken mirror – which it approximately was. They looked at it and then threw it away, thinking this fucking mirror's broken because I'm looking into it and the image isn't changing.

It was rough; it was a tough trip. I wouldn't see anybody for days and the locals didn't always like having their picture taken. I was with one guy, an Australian, when one of the locals threatened me with an axe, and I said, 'Shoot your pistol in the air,' wanting to scare them off. He said, 'I can't do that.' And it turned out I'd been in New Guinea longer than he had. The Australians I met were a nice bunch, working in the island's radio stations and weather stations. Up in Mount Hagen, where I found a guest house to stay one night, there was this Australian radio technician who was working on masts. I was hungry from living on Mars bars and tinned fruit and was so happy when this guy cooked me egg and chips. Until suddenly I felt his hand on my thigh. I thought, 'Fucking hell, the middle of fucking New Guinea and someone is trying to get into my pants.' In Mount Markham it happened to me again. I said, 'I'm not like that, mate.' It happened to me once with a Polish guy in India, who was working in the coal business. I was by myself in India too. He was the saddest guy I've ever met, I think. Started putting his hand on my knee. I have been knee-gated by every fucking gay from John French onwards.

I've still got the Polaroids from New Guinea. I did a book from them: *Another Image, Papua New Guinea* – Polaroid were great, provided the film and had no further claim on the project. They just wanted me to take pictures and say they were Polaroid. I loved using Polaroid, too. This was brand-new film,

the SX70. Polaroid is good because it gives you the unexpected; you never really knew what you'd get; the humidity and temperature always had a dodgy effect on the film. You take your chance. I lost a lot; some got stolen while I was asleep one night.

When I left New Guinea I went to Australia to join Grace Coddington and to be reunited with a new romance in my life. Grace had been raving about the part-Japanese, part-Danish, part-Hawaiian model Marie Helvin. I'd seen pictures of her; she'd been working with a few different photographers, and Grace had made her popular with *Vogue*. I resisted working with her at first, mainly because Grace was pushing her onto me. Then I changed my mind. She certainly stood out, Marie. She would be the first oriental model to be on a *Vogue* cover. My photo. In fact, I'd first met her on an aeroplane coming back from Acapulco, with Patrick Lichfield – we'd been at this famous party, the Patino ball in Acapulco, and we were both hungover. Patrick and I argued over who should sit next to her, and I managed to win.

We didn't talk much. I just remember her liking my two-tone black and white shoes.

When Bea Miller asked me to photograph her in 1974 she had been working for a couple of years, which is why I was interested in shooting her. The models who had been working for a while – say, one or two years – were easier to work with. I thought she was exotic; she looked mysterious, she looked like Shanghai Lady in those vintage Chinese fashion posters. She had a fantastic body, one of the best bodies I ever saw; she was almost perfect. The hairdressers always loved her hair, too. The first shoot I did of her was for English *Vogue* in 1974. At my suggestion, I went to Brazil to shoot the landscapes I wanted to use and then later on added in the models, who I

-portrait in Kenya.

Self-portrait with a cheetah.

Early picture of Mick Jagger.

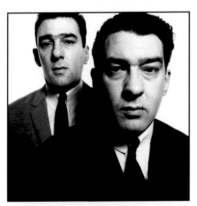

The Krays for the Sunday Times.

East End pub.

The Dagenham Idol.

Manolo Blahnik.

Carl the flower man.

Naomi Campbell.

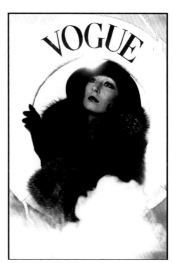

Anjelica Huston for Vogue.

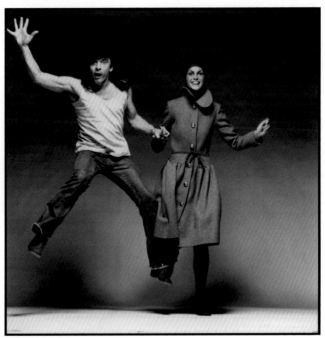

Me and Jean.

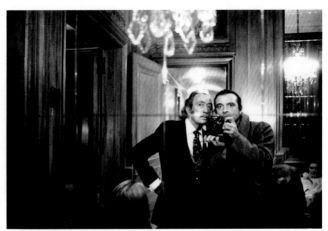

Me and Dalí in New York.

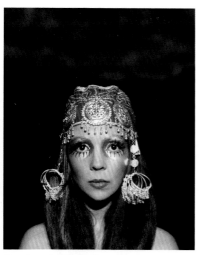

Penelope in Kashmir.

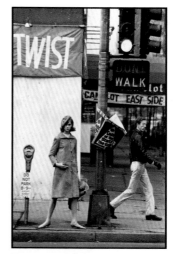

Jean on our first trip to New York for Vogue.

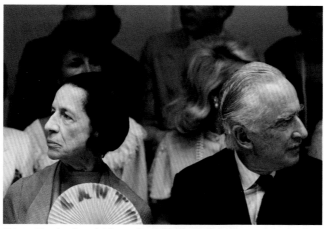

Diana Vreeland and Alexander Liberman. I've always thought this picture sums up the tension in their relationship.

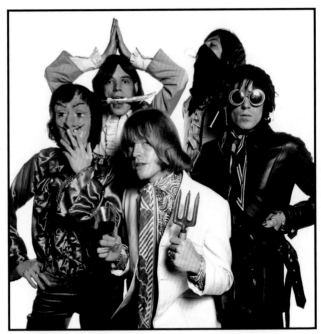

The Rolling Stones.

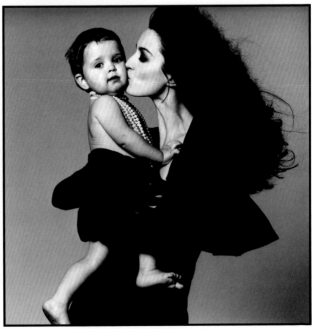

Fenton and Catherine shot for Valentino.

Marie Helvin and Jerry Hall.

Kate Moss.

Her Majesty The Queen.

shot in London using front projection. Everyone asked Marie if she'd had a good time in Brazil. She had no idea. She'd never been there.

Grace had planned a *Vogue* shoot with Marie in Australia, at the Great Barrier Reef in Queensland. I would join them from New Guinea. At first there was a problem with Bea Miller – something to do with Australian sensibilities about Asians, their war memories of the Japanese. Also there were still racist immigration laws in place in Australia, and visa restrictions for Asians and Pacific Islanders. I told Bea Miller I was taking Marie and she had to get her a visa and that anyway she's not Japanese, she's Eurasian; she has a Japanese mother and she has a European father. People didn't know what mixed race was in those days. In Japan they called her 'hafu', a half-person; in Hawaii she was called 'hapa haole', meaning half shark bait because white people there are called shark bait.

Condé Nast had always been bad with this race thing, frightened of offending advertisers, especially with black models – if they were ever used – in the US. When I did the first black cover, in 1966, Liberman said, 'If you ever do pictures like that again, you'll never work for Condé Nast.' I thought it was because the pictures inside were a bit lesbian, girls with girls, but afterwards I realized it was because I used a black girl, Donyale Luna. I thought she was great looking, she was this creature, about six feet one. It's become famous now – they wrote a book about it, just about this cover.

Luna had a six-page feature shot by Avedon in *Vogue*'s April 1965 issue; advertisers in the southern states of America had pulled pages, some readers had cancelled subscriptions and the magazine never showed her again. Avedon was warned by Condé Nast, too, not to shoot black models. So Luna came

to London, which is where I shot her. Liberman's veto hadn't reached British *Vogue*. It was to be nine years before *Vogue* attempted it again with their cover of the American model Beverly Johnson in 1974.

Bea Miller retreated, in Marie's case, and the shoot in Australia went ahead. Marie and Grace arrived at Cairns on the Great Barrier Reef from Honolulu, where they had been visiting Marie's mother. By the time I arrived soon afterwards they had rented a small apartment by the beach. I was pleased to see Marie – we were very keen on each other by then – and take a hot shower after many weeks in the jungle of New Guinea.

The shoot took place on the wildest beaches of Australia's east coast and on a place called Dunk Island. Very few clothes – Marie was almost naked, just a bikini – but big blow-up dolls, children's beach toys, which made it almost surreal. The *Vogue* cover was memorable for having Marie, upside down – a first for the magazine – on a tiny purple towel.

Marie was self-sufficient, which suited me well. On the second day of our first shoot the make-up artist couldn't turn up so I asked her to copy the make-up from the Polaroids we'd taken the day before and she did it and it was perfect. She was good at learning to do everything herself. Not to rely on other people. She had to learn everything because she'd been spoilt by a lot of Japanese people buzzing around her like flies. Also I'd taken to banning all the advertising agency people, editors and stylists into another room. I hated all that production that gets in the way of things. Hair is a nightmare. Some hairdressers are all right but most of them feel if they don't spend a long time they haven't done their job. I think it's part of the act. Often hair and make-up takes two hours, by which time you get nothing because the girl's so exhausted when she gets

on the set, she's bored to death, worried about getting home to see her boyfriend. Hair is the most difficult, that's why I always pulled it back whenever I could, back on the forehead, but for that you've got to have a strong face like Catherine or Jean. The only full-time hairdresser I used was for Italian *Vogue*, a friend of mine called Aldo Coppola. He was great; he could do anything. I try to do like Ingmar Bergman – always work with the same people, same hairdressers, same make-up. Every time I do Deneuve, she insists on those two old fucking cronies that do her all the time and it's always a disaster. She has terrible people she uses for movies and you can't use movies for stills.

Eventually I just got rid of all the people fiddling with the clothes and the models. I'd pin up the dress myself. Even now I keep a powder puff in my pocket. If you ask the make-up artists or stylist to do it they stop you shooting for ten minutes, whereas I can do it in two seconds. For me, it's all about making a girl look how she deserves to look; to show her beauty. My theory was that you couldn't take a picture of a girl if she was unhappy about the way she looked. If I saw her looking uncomfortable I'd say, 'What's wrong with you?' She would say, 'I don't like the dress.' I'd say, 'Let's change it.' And then the make-up person would have a fit and the stylist would fling herself out of the fucking studio window. I just want them to look good. I don't care about 'the look'. Marit Allen was the one I always had arguments with; she was all about the latest look and all that crap.

So I started working with Marie regularly and often. I took another picture of her for the cover of English *Vogue*, reclining on my wooden four-poster bed in Gloucester Avenue, on black satin sheets, skirt pulled up to show her suspenders above black stockings and patent leather stilettos. She did have that

Shanghai Lady poster look, which I liked about her; wavy hair, oriental distance, incredible elegance. Grace had helped to style it, and it was shocking and risqué for English *Vogue*, which was always fuddy-duddy compared to French or Italian *Vogue*. Helmut Newton wouldn't work for them in the end.

Marie would soon permanently occupy the bed on which she'd posed. César had loved Penelope, who discovered him, but he didn't take very kindly to Marie when she arrived. Brian Clarke told me that Marie had asked César to do something without a 'please' and when he went off to do it he passed Brian and hissed at him in her hearing, 'Got to run, Queen of Sheba calls.' He once served Marie a breakfast of Neapolitan ice cream, Ribena and cheese on toast – a breakfast remembered in her autobiography. Once he brought Brian Clarke some toast but he'd forgotten to toast it and it was just a piece of bread. César said, 'Is one slice of toast enough?' and Brian said, 'Yeah, just one will do, if you can bring me one?'

Marie collected a menagerie – some terrapins and several rabbits that ran wild in the house, shitting everywhere. A famous actor who had a contract with the studio never to talk about such things, and so can't be named, lost his hash in the house. After scrambling around he said, 'I've found it,' and I said, 'Don't be so certain. I think that's rabbit shit.' And he said, 'Let's not make any hasty decisions until I've smoked it.'

One interesting thing I soon noticed about Marie: she never walked anywhere if she could take a taxi. It was a joke. I had an agent called Robbie Montgomery around that time. He said to me, 'I saw Marie today.' I said, 'Where did you see her?' He said, 'Walking through Regent's Park.' I said, 'No, it wasn't Marie.' He said, 'What do you mean?' I said, 'You know Marie

Grace Coddington (left) and Marie Helvin.

With Lartigue in the South of France.

never walks anywhere. The furthest she walks is from the house to the taxi.'

I not only loved working with her, I loved being with Marie. She read a lot of books. She has an incredible memory. She could tell you who said what on page so-and-so in *Of Human Bondage*. She had a photographic memory when she read a novel; all her books were novels. I sort of read for knowledge really and she read for pleasure. I liked her more when she was exotic-looking. When she started to curl her hair I thought she'd lost it a bit. She began to look like Joan Collins rather than someone from the mysterious East.

Marie changed my style of taking pictures – it changes every time you use a woman as a muse. Jean changed my style, Sue Murray changed my style, Penelope – all women change your style because you change for them. They make you change in a way. In Marie's case, apart from her look, which was obviously completely different to any English models I'd photographed, I began experimenting with nudes, with the body. She'd worked in Japan, where nude photography is a big tradition. She'd lived naked most of her life – in Hawaii it was so natural being naked, they run about topless on the beach. It was easy for her to have these pictures taken. It wasn't like saying, 'Let's do some nudes.' If a girl's got great tits she doesn't mind showing them. If a girl's got dodgy tits she says, 'Oh, I don't do nudes.' It's basically down to that.

After a while Marie began to have trouble getting in and out of England. She didn't have a visa and she was always getting through on her library card from high school in Hawaii, hoping they wouldn't look too carefully at the dates. She came in as a student but she couldn't get a work permit. They were horrible to her at immigration. Treated her very badly, strip-searched

her when she tried to come in. Coming back from a working trip to Paris, the officer said to her, 'You know what the penalty is if we discover that you're lying?' 'No sir,' said Marie. And he said, 'Death by hanging.' That totally rattled Marie – for a moment or two.

In the end we decided to get married because then she'd have no trouble getting in and out of the country. St Pancras Registry Office, 3 November 1975 and dinner at Mr Chows. Michael and Tina Chow and Michael Roberts (then a fashion journalist on the *Sunday Times Magazine*, later Tina Brown's style director on *Vanity Fair*) were witnesses. We spent a whole month on our honeymoon in Hawaii. The most boring place on earth. I don't know what I did there. I really wasn't happy. I can't believe I stayed in Hawaii a month. Two weeks is enough. Two hours. Nobody does anything there. I remember gentle rain showers at six in the evening as it gets dark; it always gets dark at the same time because it's more or less on the equator. Then it dries out and everything's warm and you have a beautiful night. Always the perfect temperature. It's the perfect place to go just to exist. I can't see being a writer or a painter there. You don't get any inspiration from anywhere.

But we travelled the globe in the next two or three years together, until Marie got tired of some of the rougher locations. (She wrote in her memoirs, 'Increasingly I decided I wouldn't spend all my holidays trailing after Bailey in sweaty, inhospitable climes.') We went to Paris, to New York, to LA where we lived for a few weeks in the Chateau Marmont. We went to Japan, to Haiti to photograph Baby Doc. We went to Rome, to Milan.

I was expanding my book photography subjects far from fashion, some of them harrowing ones for charity, like the Vietnamese boat people; I brought back images of them crowded

into a hangar in Hong Kong – mostly middle class, educated people: doctors, lawyers and their children, in pens like cattle trucks – which seemed more shocking in a way, as a scene of human degradation. I stayed with them for about a week in 1979. We went to India a few times: Delhi, Bombay and Calcutta, where I had first struck up with Mother Teresa in 1974 – that busy year when I was also in New Guinea. She was a tough old bitch, Mother Teresa. She was a bit like Glad. Perhaps that's why I got on with her. I did a little booklet for her on her hospice. That was a cheerful job. She could have stayed where she was born, Skopje in North Macedonia, and done more. I don't know why she went to India. Every time I saw her she hit me up for $100 or $500. I'd say, 'I gave it you yesterday,' and she'd say, 'I want it again today.' I had an Indian girlfriend – Reita Faria Powell, very beautiful, who had been Miss India, then Miss World in 1966 (the first Asian to win the title) – who took over the charity from Mother Teresa when she died. Reita was still running it while I was writing this. Elton John bought ambulances for it. Reita kept Teresa's same set-up but it's run mostly for whores. I still speak to her, and I see her every time I go to India.

One of my mates around this time, by contrast, was Helmut Berger. 'The most beautiful man in the world', he was called. We went to stay in his house sometimes in Rome when Visconti, his boyfriend, was away. Helmut was outrageous. I photographed him with Marisa Berenson, the first time a man has been on the cover of *Vogue*. He was having a surprising affair with Marisa, which didn't stop Helmut chasing me around Visconti's house. Nureyev chased me a lot too. I feel I've missed something, looking back. I think, shit, I might have had a go. But I didn't.

★

Jerry Hall had come to London in 1975 to live with Bryan Ferry, who she was going to marry. She became Marie's best friend, and the two of them became the great showgirl duo of the late Seventies and early Eighties on the catwalk. I had shot Jerry's first feature for the *Sunday Times* in London when she was seventeen in 1973; it was Marie who introduced me to her at a fashion show for Kenzo in Paris. At that point she'd done a poster for a gas station and the cover of a knitting magazine. Her career wasn't flying. I brought her over to London to shoot a magazine feature called 'The Girl Who Came In From the Cows'. She was fantastic. She knew exactly what she was doing. I knew she could do it the first day I worked with her. And in the two years since then she'd become a big star. We did a lot of live-action ads together for people like L'Oréal. I helped her make a lot of money.

I did a portrait Jerry liked of her and Brian Ferry in 1975, but I didn't like Brian – I don't think he liked me very much – and I didn't think it would last. Two years later, in 1977 she dumped him for Mick Jagger, my mate, and we used to go around a lot together, me and Marie, Mick and Jerry. Jerry, it turned out, could speak quite good French. There was proof of this one night at La Coupole restaurant in Paris when I saw Françoise Sagan and Jean-Paul Sartre, the literary royals of Paris, sitting on a banquette. Jerry wanted to say hello and they waved us to the table in front of them, so we sat with them and had coffee, but Jerry was the only one of us who could converse with them, in French, at least. She said she'd learned it at high school in Mesquite, Texas. Jerry was a real broad, as I called her. Mae West was the ultimate broad; so, in her different way, was Lauren Bacall, who wasn't physically like Jerry but with the same attitude. Hard to define a broad, but bold and funny.

The last time I saw Jerry, she gave me this little plastic gherkin pickle with a button that you push, and the gherkin sticks out like a penis and it's a Mae West joke voice saying, 'Is that a pickle in your pocket or are you glad to see me?' I've got fantastic pictures of Jerry and Marie together. Sad they fell out. I think it was Marie's fault. Jerry will just say they drifted apart when Jerry started having babies.

I was making a commercial – a short film – for Barry Taylor at Polaroid when he said his boss had offered him a big raise in his salary not to go to Olympus, who were trying to poach him to be their managing director. Olympus were about to make a big push to rebrand themselves – a big advertising campaign. He said what did I think, and I said, 'If it's a choice, go for Olympus because it's the future, it's digital. That Polaroid thing is finished.' He thanked me for suggesting that. He became the boss of Olympus in Europe, or certainly in Great Britain, which was their biggest market, and brought me in as an adviser. I started filming commercials for them. Things started to take off with Olympus; they raised their profile and I helped them change. I did well out of them, too, a couple of hundred thousand a year. And they did well out of me.

When I came along, Olympus were going through the ad agency Collett Dickenson Pearce who would use advertising photographers to shoot their campaigns. They didn't know any others. So I said, 'You've got the wrong photographers. You need the photographers that I know.' Barry was great. He didn't really twig about photography. He might as well have been selling ball bearings, but he was very good at that. So I brought in Helmut Newton and Lartigue, which was a

complete turnaround for Olympus. And later they added Don McCullin, Patrick Lichfield, and my recently departed assistant, John Swannell. I tried to get them Cecil but they thought he was a poof. I remember they were shocked that we would be doing a Bruce Weber show in their gallery. It was very homophobic in those days.

In 1977, the agency, CDP, made the first of the TV commercials for their Trip 35 camera, some shot by Alan Parker, with different actors in each: Eric Idle mistakes James Hunt for me in one; in another, George Cole is a professional taunting me for my little Olympus camera. The catchline was 'Who do you think you are? David Bailey?' They were funny and they were brilliant and they put the Olympus brand so far ahead in the market. It was a long-running campaign and went well into the Eighties. A photojournalist and photography writer, Peter Dench, who was born in 1972, described being a kid and everyone using the phrase whenever someone pointed a camera. It really caught on. He wrote:

> I don't remember the adverts for Pentax cameras; I remember the adverts for Olympus cameras, the ones with photographer David Bailey. I wanted to be Bailey. Part of me still does. He was cool and hung out with rock stars, models and gangsters. The television commercials from the late 1970s and '80s, screened during the soap opera *Coronation Street* and sporting spectacles such as the FA Cup Final, reached millions, turning Bailey into a household name and Olympus into a household brand – except in my house. 'Who do you think you are? David Bailey?' would be levelled at anyone pointing a camera at a birthday party, wedding, in a pub, street, office, park or playground.

What *Blow-Up* had done to sell Pentaxes and Nikons, this did for Olympus cameras, and I became a household name for people who had no idea of the Sixties or didn't know anything about photography. I would be walking down the street and people would say, 'Who do you think you are? David Bailey?' They didn't think that you'd heard it three times that day already and from every taxi driver.

Olympus spent a fortune on this campaign. In 1977 they sent all the photographers on a junket to the Hotel du Cap in Antibes. Don McCullin, Helmut, me, everybody went. They did a couple of those, it was ridiculous. I had two fucking bodyguards. Why would you need bodyguards in the South of France? I was in a restaurant and I think Helmut said, 'What shall we feed the two bodyguards?' I said, 'Just throw them a bone.' Dennis Hopper was there as well. They rented a yacht for us to go on, at immense cost, and none of us went on it except for Marie and John Swannell – it was just sat there.

A self-portrait in 1975 with my cockatoo – one of my sixty parrots.

Chapter 21

Ritz

I started *Ritz* magazine with David Litchfield in December 1976. He used to edit a graphic arts and photography magazine called *The Image*. One day he phoned me up and said, 'Do you like my magazine?' I said, 'Yes, I think it's great.' And later I proposed to him that we make a newspaper-magazine together. I was always arguing with *Vogue* and I hated the way they treated photographers. I wanted to start a magazine to be nice to photographers. Won't pay them, but be nice. The original idea was to be a stylish fashion and photography magazine. I wanted to evoke the style of Fred Astaire – elegance and sophistication. (I photographed Astaire for *Ritz* two years later, aged seventy-nine, looking just like that, the attitude unchanged.) We knew it wouldn't work financially as a photography magazine. Instead I wanted *Ritz*, which came out fortnightly, to be more immediate like a newspaper. David Litchfield and I both put money in. We got some sponsorship from Olympus in terms of them taking ads in every issue, and we printed it on newsprint instead of glossy, with a large format for pictures. We called it Bailey and Litchfield's *Ritz Newspaper*. It looked instant. We'd get it out quick as well. *Vogue* worked three months ahead; at *Ritz* we worked about three hours ahead. It became a wider

mix of Warhol's *Interview* and *Rolling Stone*, with interviews and writing and gossip, but an English version, less New York cynical than Warhol's. We ran it on a shoestring. We were cheap; we never made any money. Almost no one got paid.

Litchfield was very good. Good at editing, getting people to be interviewed. I had to watch him because I was responsible. I was the one who would get sued, because I had more money than he did. He could be rude about people. Litchfield had it in for everybody really. Peter Sellers wanted to sue me once because he didn't like a picture of his nose. I said I wasn't responsible, God was responsible, so he was suing the wrong person. He was so unfunny, Peter Sellers. Marie always begged me not to put her next to him at dinner. Litchfield was good at getting really clever people, like Frances Lynn, who wrote the 'Bitch' column and who took the gossip column to a different level. Barry Fantoni, the *Private Eye* writer and cartoonist, wrote about 'Ritzy Lynn' in the *Evening News*:

> Frances Lynn (Franny to the few friends she has left) wins my accolade as the bitchiest gossip writer in town. As high-priestess of the single-entendre, she has assassinated everybody who is anybody in her two-page column in the bi-monthly magazine, *Ritz*. Her list of victims includes people like Elkie Brooks, Roman Polanski, Diana Rigg, Yves St Laurent, Elton John and The Eagles. I would like to give some examples of her killing technique – but I can't in case I get into trouble. Asked if she had, in fact, received any writs lately she replied demurely: 'Of course not.' In a more familiar vein, she added: 'If I had, I wouldn't tell you, dahling.'

Thanks partly to Frances, *Ritz* became the first gossip magazine, long before *Hello!* This wasn't for posh people, like *Tatler*, it was gossip for the working class really, like everyone connected with the fashion business. Art students loved it.

I already knew Brian Clarke, who had become famous very young as a painter, printmaker, stained-glass artist. He was still living in Oldham and I got him to fund a section of the magazine – he had a bit of money – called 'Inside Art', which was meant to sound like 'Inside out' in cockney (for someone with a wooden ear). It was four pages in each issue.

With *Ritz* I brought paparazzi coverage to London for the first time from Italy and I got Richard Young in to do it. He was the first – working for *Ritz*. We used the whole gamut of photography from rebel types to poncey art. But I'd seen these streetwise, edgy pictures under Richard Young's by-line first in the *Evening Standard* then for the *Express*. He was the only photographer at the time who was standing out on the street photographing people coming out of restaurants. There were only really two restaurants at the time where the celebs went – the San Lorenzo in Beauchamp Place and Langan's Brasserie in Marylebone. We hired him to take pictures at parties too, which was already a breakthrough. He had the pitch to himself for a while. We'd have four pages of pictures, snaps of parties. They'd all buy it for their aunts and uncles to show them that they're in the newspaper.

Richard was taking pictures for the William Hickey column on the *Daily Express* and for us – and we had the entrées through *Ritz* more than they did; we were linked into the social network. The *Express* couldn't work out where his inside information came from; they thought he was the wonderboy who knew everything about cafe society. And he got the *Express*

to develop all the pictures he took for us, so the *Express* was financing us to an extent. Richard's secret was to eat at the restaurants – never to be accepting freebies from them – then he'd saunter across and ask if he could take a picture. Richard was fantastic. He was really charming. That was the point – as well as being a good photographer. People didn't mind him taking their pictures because he was so charming when he did it. He wasn't elbowing someone out of the way and getting pictures. He was originally hired to do the occasional party picture but became so good that he did all the paparazzi pictures in the magazine.

We not only started the paparazzi business in the UK, through Richard, we kick-started the whole celebrity culture – but it began in *Ritz* with promoting talent, not being negative or stitching people up, apart from when Frances Lynn did it as a joke. It started a whole new magazine culture – *i-D*, *The Face* and *Blitz* came afterwards. I made the rule that all the interviews were done in Q&A format. A journalist can't lie with Q&A because it's the actual interviewee speaking, not the writer making assumptions. I hate people who make assumptions, as they're wrong half the time.

The Seventies was like the Sixties in that we were still one big small world; everyone knew everyone else. What had started with that Ad Lib scene was bigger now; a couple of thousand privileged people living in London; fashion was tied in to society – the rich and middle class – much more than it is now. In East Ham not many people could afford a dress that was in *Vogue*. Mary Quant was the most popular designer, but someone from East Ham couldn't afford to go up to Chelsea to go to Mary Quant to buy a dress. I hoped it would spread from there, so people could afford it in Barking and the East End. We

had access to a very large network of key cultural figures from *Pin-Ups* days onwards. There were no exposés; people weren't scared; they were keen to be interviewed. We had great writers, like Clive James or Peter York. We interviewed Frank Sinatra, Gore Vidal, who wrote for us too, George Michael, Marlon Brando, John Travolta, Tony Curtis; there was Bianca Jagger, Manolo – we had unrivalled access for interviews.

Ritz was also the launchpad of Nicky Haslam as a writer, interviewer, memoirist – yet another of his many careers and talents. He had the style that I admire. I don't think he's always right but he has style, so I asked him to write for us, even though he'd never had anything published before. He was our other 'Bitch' gossip columnist, under the name Paul Parsons. His interviews mostly concentrated on 'our glamorous and eccentric past'. As he said in his memoirs: 'They asked me to write for *Ritz*. I was both elated and nervous, but can still remember pulling over my car to read, again and again, incredulous at seeing my words in print, the first interview I'd done.' The interview was with Norman Hartnell, 'the couturier who had dressed all the three English queens of my lifetime for many decades.' Nicky wrote that he was amazed, as I was, how many people thought to be highbrow or reclusive were eager to be questioned by such a flippant publication. Nicky interviewed Sir Harold Acton – the aesthete and model for a character from *Brideshead Revisited* – who described Virginia Woolf to him as 'so hideous, with that maddening overdone enthusiasm for the slightest thing.' 'Paul Parsons' was the Louella Parsons, whose name he took, of Chelsea.

One day Nicky, Marie and I went to interview Stephen Tennant, decadent and socialite, last of the 'Bright Young Things' – a contemporary of Cecil Beaton, the Sitwells, the Mitfords, by now

a cult figure and a recluse, with long purple hair, living in a house called Wilsford that was falling to bits, like him and his garden and all his possessions. He quickly agreed, like everybody else, to be interviewed. A butler called Skull – his real name – opened the door. Stephen came halfway down the stairs and sat there in his pyjamas. Later he got dressed and he had brown khaki shorts on and no socks, just shoes. He looked like a street sweeper really. But everything was clean and he was charming. I went up to his bathroom and it was full of seashells, it looked like a fairy story. I mean it was really full – tons of seashells, cockles and things. In the bath. You couldn't get in it. Such an oddball, he was. I loved it, but then I like chaos. He was what I expected of an eccentric Englishman. He was completely eccentric.

Nicky recorded a very funny interview – full of Stephen's pronouncements, followed by a question. 'What pretty names. You both look as if you had a touch of the East about you. Have you, Mr Bailey? Perhaps the East End too? So much more mysterious. Oh, you were born in India – how exciting – the Orient. And you, dear Mrs Bailey? Hawaiian and Japanese? Too thrilling.' Maybe because he said, 'Are you from the east?' I made a joke about East India. They didn't think of the East End, that Chelsea lot. If you said 'east' they automatically thought of Singapore or Malaya, not east London. I went along with him. I knew he was a wind-up merchant but I was used to that with Duffy. I knew it wasn't serious.

Ritz was very popular. We found out the advertisers were taking the sales figures of *Ritz* from one bookshop in Sloane Square, so we'd go down there and buy it up and make it more popular. At its peak in 1981 it was reported as selling 25,000 copies a month.

★

JAMES FOX: *A conversation between Bailey and the artist Brian Clarke in Bailey's house in Archway, London, on a Sunday in early 2020, just before the onset of the coronavirus.*

Brian Clarke was born in Oldham, Lancashire, in 1953, fifteen years after Bailey. He was still living in the North, in Preston, Lancashire, when they first met in the early Seventies. Brian was in his early twenties and already achieving fame. They have been friends ever since. The advantage of having a third person (myself) to convene the conversation between Bailey and Clarke, was that they could talk about each other in the third person as if the other wasn't there, which often seemed convenient or necessary. However, there were certain things that Clarke wanted to establish before Bailey joined us.

CLARKE: In the Eighties Bailey had a big comeback, everybody knew him, every age group, and the Olympus ads were part of it; he made the Olympus ads slightly seditious . . . I remember him saying to me, 'That'll confuse the art photographers, won't it?' i.e. 'I'll do a commercial and I'm still better than you.' It's always been his charm, that. He actually liked the way he couldn't be pigeonholed. There was a considerable distance between the photographers who worked as artists and were basically living hand to mouth where the only sustaining thing they had was genius, like Harry Callahan and Bill Brandt, and then there were commercial guys like Cecil Beaton and Bailey. And there was almost universal dismissal of a photographer who didn't describe himself as an artist, and yet they were struggling. There are different kinds of categories of what photographers are supposed to be and he didn't acknowledge any of those categories – he

Andy Warhol reading a copy of Ritz.

was just a photographer – and in that way he may have done himself a lot of damage.

People always talk about the Sixties; I don't know about the Sixties, I was a kid in the Sixties, but in the Eighties Bailey was one of the most exciting people in London because he was stirring everything up. There was a centrifugal force operating around him. I think *Ritz* magazine played a big part in it, a whole society developed around *Ritz* and it was so audacious, a bit like Andy's 'if you don't like it, don't put it in the magazine'. Be positive. Everybody wanted to see *Ritz* because that's where you saw the latest interesting photographer.

As to Bailey and friendship, the usual politenesses that exist between friends don't pertain to Bailey. He's honest, especially when it's also an opportunity to be rude. You can say anything to Bailey as a friend because he can take it, and it's understood that he can say anything to you. Martin Harrison is a close friend. Watching Bailey with Martin, who is a brilliant art historian, it reminds me of Francis Bacon and Denis Wirth-Miller fist-fighting and punching each other in the face when they were in their eighties in Soho. They are vile with each other. And they love each other. I entirely trust Bailey and I entirely love him. And I think he entirely loves me, but I'm not sure he trusts me.

CLARKE: I worked with Bailey on *Trouble and Strife* in 1980 when I was in my twenties – Bailey's book of nudes of Marie; I wrote the introduction.

BAILEY: Worst book I've ever done.

CLARKE: I was a kid, and I remember thinking at the time, Bailey was so old that he was almost dead. The

introduction says 'Bailey who is now 42'! I don't know
how old I was, twenty-six or twenty-seven. I remember
thinking when I first met Martin Harrison – who's written
more about you than anybody – how unusual it was for
somebody that old to be interesting. And he was in his
thirties. We met at Mr Chows and Martin introduced us,
but I think I was still living in Derbyshire. It was the late
Seventies. I'd got involved with *Ritz*. You'd done those
Olympus commercials. There was a big buzz, a big new
appetite for photography at this moment.

BAILEY: It was already there. The Olympus commercials were
just feeding it.

CLARKE: From the outside it looked like Olympus were
really turned on because they were dealing with the best
photographers in the world. So when *Ritz* came along,
Bailey was on everybody's lips. Metaphorically.

BAILEY: And physically.

FOX: Modesty speaks.

BAILEY: Nothing to be modest about. No need to be modest.

CLARKE: *Ritz* had a real buzz about it. It was like a very
English version of *Interview*. It had its own character.
There was a time in the late Seventies and early Eighties
when I wouldn't hardly dream of going to an exhibition
of paintings if there was an exhibition of photography to
see, it was so fucking exciting . . . People had suddenly
realized that photography was art; painting was all
wrapped up in politics and conceptualism and it just didn't
excite me. I started getting interested in photography
when I was living in New York and I met Harry Callahan,
Aaron Siskind and Ralph Gibson and a lot of American
photographers. I think at that time photography was

really where the action was – until they started being represented by Castelli Gallery and took on the worst pretensions of the art world – but Bailey wasn't like anyone else. He was positioned outside of those things, not a fashion photographer, not an art photographer. All the photographers I knew were very—

BAILEY: Arty.

CLARKE: Arty and—

BAILEY: Farty.

CLARKE: Sort of very self-conscious about being artists because maybe at that time photography hadn't been acknowledged as an art yet in any serious way. I mean, the Victoria and Albert Museum didn't collect photography then; the Tate certainly didn't until very recently. I was used to that very serious intellectual photography, and Bailey didn't care about any of that but was clearly doing pictures that fell squarely within what they would call the remit or responsibility of art photographers. But there was no fuss surrounding it, there was no self-consciousness surrounding it. In an odd sort of way it was purer because it was less self-conscious.

BAILEY: The great thing about *Ritz* was that we could use big images; we had big pages, bigger than *Vogue*. That was our advantage. It was easy to get people to appear, to be interviewed and photographed – it looked so good. The photographs looked great.

CLARKE: David Litchfield asked me to do an interview with Francis Bacon for *Ritz*. I said, 'It's not going to happen.' And he's saying, 'It would be great, we'll put him on the cover,' all this. I waited until some moment when Francis was legless and said, 'Would you do an interview for *Ritz*

magazine?' 'No. Never heard of it.' I saw a lot of Francis Bacon in those days. They were nothing alike, but Bailey used to remind me of being with Francis because there was only honesty allowed, because you're not allowed to get away with anything else. There's something incredibly freeing about it.

BAILEY: That's the nicest thing you've ever said about me, Brian.

CLARKE: No, but it frees you up. If you are in the company of somebody who is only interested in who you are, not in any game you play, then automatically you step into your own shoes.

FOX: You used to drink together quite a lot.

CLARKE: We were heavy drinkers.

BAILEY: I sort of remember stopping drinking. I stopped drinking and stopped smoking at the same time in two weeks, I was thirty, thirty-two.

CLARKE: No. I didn't know you when you were thirty-two and we used to drink like fish. We used to get pissed together all the time. But you stopped before me. I stopped drinking thirty-one years ago and Bailey stopped before me.

BAILEY: No, you thought we were getting pissed together but you were getting pissed by yourself!

CLARKE: I think not.

FOX: Marie remembers coming downstairs in the morning and you were still at it?

BAILEY: Still at what?

CLARKE: Drinking.

FOX: Barry Taylor, you, Bailey, John Swannell . . . bottle of scotch, bottle of brandy, champagne. Piled-up ashtrays.

BAILEY: I was with Francis Wyndham, a lot of them.

FOX: And then Barry still in his suit would go straight to Olympus, and you'd go downstairs to work.

CLARKE: That did happen quite often.

FOX: How did you do that? Do you remember working straight through and not going to bed?

BAILEY: Yeah. I just fell asleep after we'd finished, I guess. It wasn't like it was every night. I had one of those giant coffee machines. George Melly wrote really nice things about me. And he was a big drinker. They used to say, 'Who's going to die first, George or Bailey?' Because I used to drink in those days. A bottle of whisky a day easily. I drank mostly brandy and whisky in that period. Before that it was wine. And before that it was stout and mild. In the East End you start drinking when you're fourteen, they'd let you go in pubs. I've never really been to pubs since. I never liked them. Standing around, talking to men about football was not my thing. In the Air Force I would drink eight pints. In the early Sixties I drank a bottle of scotch in a sitting. That's one of the reasons I stopped. I think I was probably an alcoholic. Everyone was in those days. The writers were the worst. It's hard to take a picture if you're drunk.

CLARKE: You drank a lot but didn't get drunk. Of course, some people when they drink become really grumpy and unpleasant, but you couldn't tell the difference with Bailey because he was like that all the time! It just morphed in.

BAILEY: I didn't stagger or anything. It didn't bother me. I felt much the same when I drank. That's what worried me. I got bored with it. I had to stop because I had started making more and more commercials – it was my main source of income. I was working too much and when

you have to be up at six o'clock at the studio doing
commercials, you don't want to turn up there when you've
got a budget of sometimes up to $3 million in America
and have a hangover, with people waiting for you to
make decisions and make an idiot of yourself. I just said,
'I've got to stop.' So I stopped drinking and smoking the
same week. I remember for two weeks it was dodgy and
afterwards I couldn't give a monkeys, I didn't care. I ate
a lot of lollipops, like Kojak. I never drank or smoked
again – maybe the odd smoke.

I liked the collections when we'd shoot into the early
hours of the morning, for several days. I used to give
the girls a saccharine because they were tired when we
were shooting all night. I used to wrap up a little white
saccharine pill in silver paper and say, 'Take this, it'll keep
you awake.' They thought it was great. I felt great because
they were working. I just kept on drinking coffee. The
best thing always was to keep your calm. I sometimes
had six models on shifts, different hairdressers. It was
like a factory. We never got finished before four, five in
the morning. But then we'd go and have breakfast in Les
Halles, the marketplace. I sometimes had five assistants,
working all night and they used to gradually drop off like
flies. Even John. He was great, John, he was always the
last one standing, worked all the time. Most people are
wimps, aren't they? Especially during the collections it was
really difficult. But it was great. It's not really work.

FOX: You don't call it work?

BAILEY: It's like having fun really. I figure I never really
worked in my life except during that period from fifteen
until I went in the Air Force. No, it's a passion. Not

many people have it. John's got passion. John can work like that. Duffy always got distracted. Avedon could do it. I fall in love with people when I photograph them for that fifteen minutes or half-hour; they become the whole centre of the universe. It's always the same picture. It's not about photography really, it's about getting something out of people. I used to fight with Tina Brown all the time. She'd say, 'He's arrogant, make him look arrogant,' and I'd say, 'No, he'll come out like he is.' If you have some preconceived idea of what you want to do, I don't see any artistic thing to it, it's just a professional job, it's a stitch-up job.

CLARKE: That's why he doesn't like anybody trying to 'style' the picture – the editors. I remember one occasion, he became my hero that day, I've forgotten who she was, a really self-important woman from some magazine. Every time he pressed the shutter she said, 'I think we should do this . . . And do this.' There was a restaurant called Odette's nearby, and this woman was some big American stylist or editor – and he'd obviously had enough of it and he said, 'Do you want to go to have something to eat, Brian?' And we just walked out and left her there and she said, 'Where are you going?' He said, 'You take them. You seem to know what you want.' I've often wondered how she explained that to her boss.

BAILEY: I've enjoyed Brian, he's great, he's entertaining. I'm surprised he understands photography like he does. I'm not being condescending, but usually only really good photographers understand. He doesn't take pictures, that's what's odd.

CLARKE: I don't need to. They say every great portrait is actually as much a portrait of the artist as of the subject, but in Bailey's pictures I think that isn't the case. You recognize the language but you're much more aware of the subject than you are of anything else. Considering he is one of the most opinionated people on earth, there is a tremendous modesty that comes into play when you do those portraits. It's kind of touching in a way for such a grumpy bastard to be so modest.

BAILEY: Makes a change from cunt.

Chapter 22

Trouble and Strife

I was away a lot shooting commercials when I was with Marie, often in America where the money and the budgets were, and travelling to some rough places that she didn't always want to come to. But we were together in Gloucester Avenue one day in 1978 when she got a telephone call to say her sister Suzon had died in an accident in Jamaica. That was really awful – devastating to Marie, who was very close to her sister. For me it was the second time my wife had lost her sister in an accident. Also I knew Suzon quite well; she'd stayed with us for a while. Pretty girl. She'd gone to live in a hippy colony in Negril, Jamaica with her boyfriend. She was riding her bike and apparently skidded over a cliff and dropped fifteen feet. She was dead before they could get her to Montego Bay hospital. Apart from Marie's grief, she had the problem of getting around Jamaican red tape – first of being unable to get her sister's body to Honolulu and having to cremate her in Jamaica, then of getting her family from Honolulu to Jamaica. She got help dealing with the officialdom from John Pringle, the kind of roving ambassador for Jamaica, a friend of mine, a relation of Chris Blackwell of Island Records.

I didn't go to the cremation. I don't go to funerals, and Marie agreed that me sitting around for days with her relations

wouldn't have been OK. She was hurt I wasn't there, but she was relieved too. In her grief, which almost deranged her, Marie naturally took it out on me. I was away shooting a Mary Quant ad at the time of the cremation and she blamed me for not supporting her enough, not coming home to Hawaii with her, despite what we had agreed. After the cremation we met in LA and flew to Mexico and drove the long journey from Mérida through the desert, to Yucatán. Marie was angry, grieving, silent as we drove through arid landscape, past seedy hotels. I couldn't placate her – she focused on my absence from the funeral, and I took that. I did what always works – I worked with Marie on a shoot there for *Harper's & Queen*, which took Marie's mind off it for a moment. We got some rest and quiet in Chichén Itzá, climbing Mayan temples. But the extended grieving took its toll on our relationship, as it had with Catherine. It changed them both. By 1980 Marie and I were drifting apart anyway. We weren't getting on well. She began to wander off a bit. I was having affairs. Whatever happened, we went on working, even though I was often away. There was some more – and, for Marie, unexpected – fame and notoriety to come from the book we did together and published in 1980: *Trouble and Strife*, a book of nudes I'd taken of her since we first met. Nothing like it had been published in the UK. It was a book of very intimate nude portraits of Marie, taken over all the time we'd known each other. It was a very big success. I was partly influenced by Bill Brandt, although I didn't go to extremes like him with wide angles. The one picture that caused more of a stir than the others was what looked like a bondage picture of Marie tied up, though this was more a surrealist picture, more in the tradition of the Mexican surrealist photographer Manuel Bravo, as one of many influences

on my work, than what others have supposed was a Japanese influence – like the portraits of Nobuyoshi Araki, who in fact came after me, or Kinbaku. Marie was worried, even shocked that I was going to publish the picture. Then she came round to it. As she remembers:

MARIE HELVIN: 'That's the only photograph in the book I would call exploitative, that I was bothered with. It's the last one in the book, where I'm all wrapped up with newspaper and tied up, my arms bound in rope and only my pubes exposed. I'd forgotten about it, I'd never seen the contact sheets. Now I don't care, I can laugh at it, at how silly it was and how silly I felt. But then if you think about it, that was pre the photographs of Araki, the world-renowned photographer from Japan who practises tying up women, explicit bondage pictures, which go for zillions. He's considered a great artist. Bailey did that way before him.

At the time I didn't like it, because the women's groups were so powerful; they had power to wreak havoc basically on someone's career, on someone's reputation. I was a young girl, I was really scared. But luckily, for some strange reason, I didn't get attacked in any way whatsoever. In fact, I remember Emma Soames writing a piece saying there's something about her in the nude that doesn't offend women. And I remember women that I know like Olivia Harrison came up to me and said, 'Oh, I just bought the book of nudes for George.' At the time I thought it was kind of odd, but so many women said this to me, I guess it was true, I did not offend women. I was certainly not a *Playboy* type, an archetypal big-busted

woman that you think is going to slay your husband or boyfriend. I was a scrawny model.'

It did end slowly, our marriage. Marie and I both worked all the time. I was always travelling. Marie worked a lot in Europe, in France and Italy. The biggest problem that Marie and I had was a cultural gap. I was British, an East Ender from London and she was American. Although I always think she was not sure what she was. Her father was an American GI of French and Dutch background, and her mother was Japanese. She was born in Japan, speaks Japanese and raised in Hawaii. Our relationship just dwindled. I had taken up with Catherine three years before Marie knew about it. Towards the end of a relationship that is over you don't care what the other person's doing; after a bit you're indifferent. David Litchfield used to tell me, 'You know Marie's fucking Jack Nicholson in LA?' (I found out later she wasn't, but not for lack of trying on his part.) I just said, 'It's nothing to do with me any more.'

Chapter 23

Catherine

My romance with Catherine Dyer began on Midsummer's Day, 20 June, in 1981 on the Isle of Skye, where I was doing a shoot for Italian *Vogue* and she was the model. We had known each other for a while, and worked together, but now we would be together when we could. I had met her a year earlier at the Roger Street studios. Donovan and I were there when Catherine walked by to go to work with a photographer called John Bishop, a catalogue photographer. I went into the studio to take another look under the guise of borrowing a handbag or something. I noticed her but that's all. I almost forgot about her until she lied to my protective PA Sarah Lane to say that I'd asked to see her portfolio. Sarah asked me, 'Do you want to see her?' According to Sarah I said, 'I don't know, I don't remember her.' But then she was there so I saw her and looked at her portfolio and I thought, 'Shit, she's good.' I was booked to do an Avon calendar – the scent company. That was for money. You wouldn't do Avon without a lot of money and, like Jerry, I knew straight away the first day I worked with Catherine that she could do it. I could see some things in her, like I saw in Jean, that nobody else did. It was the same thing. It's always the intelligent ones that are good. And with Catherine, I did go

back to a more Jean Shrimpton period. Catherine is a fantastic model, though she doesn't know it. After that Avon calendar I booked her for Italian *Vogue* and the ball started rolling.

Catherine was nineteen then, in 1980, a middle-class girl from Winchester; her father was an architect who worked for the British government. Catherine left home at eighteen and got a secretarial job in London. Her mother, also a secretary, had sent her to Lucie Clayton's finishing school, Jean Shrimpton's old alma mater, where you learned to get out of a car without showing your knickers. I think her parents thought she was a nice girl – until we got together, and then she was a naughty girl. They were horrified.

And we'd got together on the Isle of Skye that midsummer night for the first time. It was the most romantic beginning. It was the most magical day of my life, I think. It was a day when you can't go wrong. The sea was perfect. No great waves. There was a dead whale on the beach. I found Bill Brandt's picture of a seabird, exactly in the position he'd photographed it in, exactly the same place. Then there was a gannet that attacked me because we went near its nest, the Bill Brandt nest. I expected a fucking ship to come over the horizon. That day was so romantic. I remember the sun going down at midnight. You could see the sun set at midnight, and by two o'clock it's getting light again. We stayed in a great hotel. They said they'd never had five days of continuous sun in their lives. They called it the Bailey Week in the hotel. I've always been lucky with the weather.

Then I went off around the world to do a commercial for Löwenbräu beer for a couple of months. Sarah phoned Catherine up every so often to see how she was. Catherine had a boyfriend called Roy who was poncing off her anyway and she was thinking of ditching him. The assistant said, 'I think he

looks fucking gay to me, so I thought he's not going to be any problem.' I never saw what Roy looked like. He's dead now.

We were both away working a great deal, sometimes away together on shoots, and Marie was away a lot as well. Catherine only came to Gloucester Avenue once, when Marie was away, in the next four years. She had her own flat and that's where we spent the little time we had together between our various trips.

Our first long time together was a trip to Australia in 1983. It was a coincidence we were there at the same time. I was shooting on location and working on a book about Australia, which is only just coming out now, thirty-six years later. The film, which Ilford had supplied originally, turned out dud, and I lost any interest. But I'd shot in Polaroid as well, which I looked at again and liked. Catherine was there on a shoot for a fashion magazine on Green Island, off the coast of Cairns in Queensland. I had gone there with Brian Clarke, who wanted to see Australia. He saw more of it than he expected: I drove across Australia for at least 3,000 kilometres and took trains almost that distance, and for much of that time Brian was with me. We found ourselves in some very remote places with some people who, on one occasion particularly, hadn't seen anyone they had ever less liked the look of than us.

Somewhere in the outback in New South Wales Brian decided he wanted some lunch, as if he was in Paris, and we headed into a sheep station bar with raucous noise coming out of it. Brian was dressed in a green St Laurent suit, his hair was blonde and curly then and he had an earring in one ear. I had black leather trousers, cameras round my neck and a billabong hat. They probably thought that was taking the piss too. There were thirty or so jackaroos sitting around drinking, the

strongest guys you've ever seen. They had these great big bellies but they were strong like Scottish caber tossers. The place went dead quiet as Brian walked to the bar, sat on a stool and said, 'Can I have a black coffee?' A few jackaroos started laughing. The barman said, 'This is a bar. We've got beer.' A big bloke sat down on the stool next to Brian, grabbed hold of his ear and said, 'That's a nice earring you've got there, curly.' Brian said weakly, 'Yes. It's lapis lazuli.' They couldn't believe this. They're laughing helplessly. I said, 'Let's leave while they are still laughing because it could turn nasty.' They'd use you like a fucking tennis ball. Real rednecks. They drive Land Rovers with these bars across that they call 'roo bars' and they go driving along the road to hit kangaroos intentionally. They're like that in Sydney too. I was in a bar there with two models, Sue Murray and somebody else, and this bloke came over and said, 'What are these two beautiful girls doing with a faggot like you?' I said, 'It's probably because I'm charming,' and he said, 'Do you want a drink? and I said, 'Yeah champagne,' so he bought us champagne! I wasn't that well known in Australia. I got an award of some kind and it was presented at Peter Jones, the biggest department store in Sydney. And the presenter of the award said, 'I'm going to introduce you to my very famous friend, Bruce Bailey.' It wasn't believable. It was wonderful. It was hilarious.

I joined up with Catherine in Cairns. She had to get out of the work she was doing and disappear out of sight of her model agency to come on a road trip with me. We were on the road for many weeks. We drove from Cairns to Charters Towers and then we drove up to Alice Springs, a journey of 1,600 kilometres and from there to Darwin, another 1,500 kilometres. We got back to the south coast by taking a train from Alice

With Brian Clarke on our Australian road trip.

Springs to Port Fairy, which took sixteen hours. We travelled in real outback, coming across towns that were nowhere, full of tumbleweed, towns bypassed by the railways. We drove through bush fires, down interminable highways of unchanging landscape always hoping to find a hotel, or what passed for a hotel. You really see Australia, staying in these motels like prison cells, with water mattresses and a food hatch right next to your bed. You would hear in the morning this trapdoor open and then they'd put a tray in and the trapdoor would close again. Fried eggs shoved in by the side of the bed – accommodation so rudimentary that to get to Alice Springs and stay in a proper motel with towels and hot water was a big relief.

Brian has this story about the early stages of my romance with Catherine. I don't really like it and it's not true – he's completely made it up – but he loves telling it.

BRIAN CLARKE: Bailey was clearly in love with her, and wanted me to keep quiet about it because he was frightened of divorce. But also very proud of his new partnership. They came to stay in my house in Seville. It's kind of a big house and my bedroom is separated by a sitting room from a guest bedroom. When you walk up the rather large staircase you can be heard coming. And I'd been painting downstairs and it was about three o'clock in the morning and I came upstairs and – he couldn't resist this – his bedroom door is closed and Catherine is fast asleep. I'm sure Bailey must have heard me on the stairs because I heard him say, his voice pointing towards me to make sure I heard, 'You fucking filthy bitch, Catherine, *again*?'

When we came back from this trip to Australia, someone had tipped off Marie and she confronted me, with a question about a bill for delivery of flowers to Catherine, or some pretext or other. Marie moved into a spare room. We agreed to get a divorce but to delay it for the statutory two years so we didn't have to cite co-respondents. So we entered a kind of semi-cohabitation, which had, in a sense, been underway already for some time.

Of all the charity projects I worked on, the worst sights in terms of human suffering were the starving and dying children in the drought in Sudan and Ethiopia in 1984. I went to take photographs of the refugee camps and the feeding centres along the Sudanese–Ethiopian border and in the Red Sea Province of Sudan. It was part of Bob Geldof's Band Aid charity, which released a single that Christmas. I was asked to take part by Kevin Jenden, the director of Band Aid. I went specifically to make a book of the pictures, called *Imagine*, to help raise awareness and then raise money through Geldof's operation.

I got to Khartoum on a plane belonging to Adnan Khashoggi, the arms dealer and the uncle of Jamal Khashoggi who was murdered by the Saudis in Turkey. I didn't know him, he just said I could travel in his plane. I sat all the way to Khartoum in a Land Rover he was transporting, the plane's seats having been stripped out to make room for supplies. I was sitting with the pilot when we were flying over Egypt and a message flashed up saying, you are invading Egyptian airspace. I said, 'What are you going to do?' He said, 'Oh, their planes could never catch us, we can fly much faster than them. We'll just fly off.'

I had an assistant with me, a born-again Christian who was

always carrying his bibles. The only place we could find to sleep in the desert was under the lorries. I remember looking under the lorry and he's sitting in the middle of the desert reading his bible! Not going to do you much good in a Muslim country.

All the kids were starving and they were all dying. The nurses used to nickname the kids. I remember 'E.T.' was one. I photographed him in the morning, then went back to do it again and he was dead. That happened all the time. You don't realize how awful it is until you see it. You read about it in the papers and I'd seen it before, in India, in Brazil, but not like it was then. The flies, people completely covered in flies all the time; the smell of death, like intense shit, as if everyone farted in the world. There's nothing you can do anyway. You can't make it better. What's the most you can do? Take their picture and show other people what it's like, though you'd never capture the smell and the ravenous flies in a photograph. I was there for a week and I never stopped photographing. You've got to start directly you arrive, because after two days the place looks normal. The best pictures are taken straight away when everything is fresh in your mind.

The Swiss and French doctors weren't very nice to photographers; they didn't like photojournalists and they didn't help you at all. We were in the way. I said, 'If I didn't do things like this you wouldn't get any publicity, you wouldn't get any money.' The nurses by contrast were all Irish, and friendly and very funny. They tried their best to make it bearable. That was the worst trip really, emotionally. We're fucking idiots glorifying war. There's nothing to glorify about blowing someone's head off. But then people wouldn't go to war if the government told the truth. If it said, 'Your country needs you to blow someone's head off,' you'd think twice about going to war.

I was arrested at the airport on my way out of Sudan with my assistant. They thought I was a spy because I didn't have an entry stamp. I said, 'I came in at four o'clock in the morning,' and they said, 'Planes stop flying at four in the morning.' I said, 'It was a private plane, it was Khashoggi's,' which made it worse. They said, 'You better come with us. You could be a spy.' I said, 'If was a spy I would have an entry fucking visa, wouldn't I?' but I didn't put it like that. I was locked up in this little room for a couple of very long hours, which was a little scary because I didn't know what was going to happen. So I had to get round it by putting $100 in my passport and the passport of my assistant. That seemed to work as suddenly we weren't spies any more and we had entry stamps. In the end we missed the return flight so I had to buy more tickets. But it was an extraordinary shoot, and I'm really proud of the book.

When I got home I recognize now that I must have been a little traumatized. Catherine was pregnant with our first child. It was unplanned, accidental. Catherine had been told she could never have children. I came to the hospital to see the scans of Paloma, my daughter who was about to be born, and nearly passed out. I had to leave the room. The foetus flashed me back to the image of a starving Ethiopian child – all of them starving; the foetus looked like a starving baby.

The book was published in July 1985, the same month as the Live Aid concert – maybe the greatest pop concert ever and the biggest link-up of humanity – two billion people, a third of the world population, watching as it was transmitted live from Wembley. I'd been asked to photograph everyone, so I set up a makeshift studio and captured everyone as they came off stage. We auctioned off all the pictures afterwards. He was a funny cunt, Geldof. The whole day was mad, though

everything was strangely in place and everyone was where they were meant to be. You felt that Geldof somehow made it all happen, even if he always looked like he didn't know what the fuck he was doing. It's a long time ago and the description I gave Dylan Jones, editor of *GQ* magazine, for his book on that time is nearer to the event and more spontaneous than anything I can summon now. I told him:

> It was so unreal, it was a crazy experience. Everyone was famous, and it was like being at some sort of party that never ended. It was hectic. Everyone was great – Elton, Bowie, Paul McCartney, U2, everybody. I loved it because I was one of only four people who had the magic pass, the pass where you could go everywhere. Bob Geldof had one, Midge Ure had one, Harvey Goldsmith had one, and I had the other. It was like Willy Wonka's Golden Ticket. I could even have gone on stage if I'd wanted to. The only people who were a bit off were George Michael and Sade, who didn't want her picture taken. It was funny. Diana (Princess of Wales) was there, although I didn't see her that day. Diana was a nice, upper-class Sloaney girl, but she was no great beauty. They used to call Prince Charles handsome and dashing, too, which really is a stretch. But Geldof was very pleased they were there. Diana was all right, but she insisted on having that terrible hairdo, the one that looked like a wig. She had a terrible posture.

At one point I got a tap on my shoulder and spun round. Suddenly there was a big tongue down my throat! It was Freddie Mercury. I didn't say anything. It was a compliment, if you think about it. There aren't many people who've stuck their

tongue down my throat; all were unexpected and uninvited. There was Bob Richardson, Terry Richardson's father – a great and influential photographer in his own right. We were sitting on the floor in Primrose Hill and Penelope or Anjelica, who was in love with him, went to get some cigarettes, and he suddenly pushed me over and tried it on.

Marie and I had been living in a kind of limbo in the same house, waiting for two years to elapse so we could have a divorce without citing co-respondents. She was often away. She had a new boyfriend, Mark Shand. Then, with a week to go before Paloma was born, Marie offered to move out so that Catherine could move in. The two-year period hadn't elapsed, so we would need to cite co-respondents after all. Catherine was shocked by the disorder in Gloucester Avenue when she first moved in. I liked the way it was; I don't mind chaos, I prefer it. I knew where everything was, but she certainly didn't like it.

CATHERINE: When I moved in I did not know how anybody lived in it. The press wrote about the bohemian house, the black walls, the red gloss and disco balls on the ceiling. But it was vile, it was putrid. The only way I can describe it – Bailey says I've got something wrong with me, that I'm anally clean. There was a Mr Sheen ad back in the Seventies and Eighties, the little old lady going into a haunted house to clean with a Mr Sheen spray. Gloucester Avenue was like that. You had a basement where the darkrooms were and a kitchen, then the yard and parrots, and dogshit and dirt and everything falling apart. And

DAVID BAILEY

then you went up to the first floor where the office was
and a back room and what would have been the double
front sitting room divided by shutters, that was the studio
and then you go up to the first-floor bathroom with an
extension on it like a conservatory, full of parrots. I had no
idea that that first-floor bathroom actually had a bath in it
when I moved in there, there was so much junk piled up.
Then I went up another staircase. A sort of chipboard door
dividing the upper part of the house from the lower part
with wire meshing on it. Christ knows how Marie lived
in it. Then it went to all painted gloss red in the corridor,
went up to the main living-room area all painted gloss
black, a bedroom with a four-poster bed.

William Morris fabric on the wall but it was all hanging
off, curtains were ripped and there were piles of catshit
under the bed. It was disgusting. Then went another floor,
a spare room and his library, which had all shelves made
out of gloss chipboard where they bow. And then a spiral
staircase, a Seventies one, looked like scaffolding poles
with wooden platforms, no banister rails. A room upstairs
painted in black and a pool table up there. I moved in two
weeks before Paloma was born, and two weeks before
having a baby you go into this peculiar clean frenzy.
So I had a girlfriend help me. Most of the books I lugged
upstairs into the library – me and (unborn) Paloma – tons
of them because Bailey doesn't put anything away,
so bedroom floor-to-ceiling books, and the staircase
broken.'

Paloma was born within a week of Catherine moving in, just
before the Band Aid concert. And about a year later we got

married, much to the relief of Catherine's parents. When Catherine's mother, who is very proper middle-class from Winchester, realized that Catherine and I were a fixture, she came roaring up on the train and bearded me. 'It's all very well now,' she said, 'she's twenty-two and you're forty-eight. But what's it going to be like when she's forty and you're ninety or whatever?' I said, 'I guess I'm going to have to find a younger woman.' It was a hilarious ceremony. Catherine's mum and dad, and that was it. There was a very nervous registrar in a pearly grey suit with a shiny pink tie and a matching pocket handkerchief, a very stiff and proper council person. I didn't have any money and Catherine's dad had to give £5 to pay for the licence. Afterwards I went straight back to Shepperton for a recce and Catherine went back to Gloucester Avenue to have wedding cake with her mum and dad and Paloma.

My basic attitude to children, and to marriage, is that it's nothing to do with me. It's something other people want to do. But I've never really wanted children and I don't want children. They're all right now, but if you don't have them, you don't know they're going to be all right, so why take the gamble? They could have turned out to be Hitler and Mussolini and Eva Perón. It would be a different attitude then, wouldn't it? I joke about it, but I was determined that my life wasn't going to change because of children. I never let them get in the way. They stop you doing things. 'A pram in the hallway is the end of creativity.' Catherine thought she couldn't have children for medical reasons, which is why the first, Paloma, was an accident. I said, 'OK, I've never done it before, so why not?' She planned the next two. They were all nice kids and Catherine was a great mother, and I was working a lot. I brought presents for them when I came back. I treated them with dignity.

Fenton.

Sascha.

Paloma.

Chapter 24

Dumb Animals

The endless travelling away from home and Catherine was mostly to make commercials, which took over my life from that time, the late Eighties. I used to make a commercial every two weeks. I was with Ridley Scott's production company, RSA, for a bit, then I was with Paul Weiland and then I went on my own. It was a big period of work – twenty years from about 1980. I made so much money. All gone now, on Ferraris and art. I'd already made a lot of commercials but they were non-talking commercials, hair or beauty things, boring commercials. I'm not good at meetings with ad agencies, can't talk it up, and they didn't think I could do dialogue. It wasn't until I made my 'Dumb Animals' anti-fur commercial for Greenpeace in 1985 that my directing career took off, and they accepted me to do anything. The agency never came to the shoot; it was so unimportant to them, without any commercial angle. Then it won all the prizes including a Golden Lion at the Venice Film Festival, a gold in London at the Art Directors Club awards, and they saw me in a different light. Everything changed. It had impact because it took the message directly to the wearer of furs; it changed the perception of fur from something glamorous to something grotesque and barbaric. And it worked – in terms of

fashion, maybe not in terms of sales since – that struggle still goes on. It started as a poster I designed for Lynx, the anti-fur organization, as part of a campaign for Greenpeace. It showed a woman dragging a fur coat that has left a trail of blood behind it. The slogan was memorable and sharp: 'It takes up to forty dumb animals to make a fur coat. But only one to wear it.' And a strapline read, 'If you don't want millions of animals tortured and killed in leg-hold traps, don't buy a fur coat.' That led to Greenpeace commissioning me to do the TV commercial. All I had to go on was the copy line and the poster. I expanded it to a catwalk show, starring Susie Bick, Catherine and Debbie Brett, in which the parading models in their fur coats suddenly splash the audience with blood and leave a trail of it on the runway, to throbbing music by Vangelis. It got the media commotion it aimed for. I followed that with an anti-nuclear film for Greenpeace, showing mass graves at the end of the world, and another animal rights film that was anti fox-hunting. I got an Emmy for a film I made for Cancer of America. It was called 'Sophisticated Lady' about a beautiful girl smoking at a bar and gradually her face turns to tar and it melts, to the music of Duke Ellington. But that was much later and I never went to collect it. I won many more prizes for my commercials than I did for photography – and I earned a great deal more money.

I really gave up full-time fashion photography – I'd had enough of it – and made commercials for the next few years, many of them with big crews and big budgets. It was good fun in those days, but you could only do it in America because they had the money. My main competition was David Fincher and Tony Kaye. If I lost a commercial it was to one of those two. Ridley and Tony Scott of course were doing movies by then.

I directed about six commercials for Donald Trump, for his

Trump Shuttle airline. I got on all right with him, but then I like people who are upfront. We had a disagreement because I didn't want to put an airliner in any of the commercials. Better to spend the money, I said, on good people speaking about it. He saw my point. We were using celebrities, with unscripted dialogues because you couldn't ask these people to use someone else's words. The idea was that we'd put together two people you wouldn't expect to agree on anything but they'd both think the airline was great. We used Carol Alt – she used to be a supermodel, now does exercises on Fox – with sex therapist Dr Ruth Westheimer. Trump said, 'Can you get Carol Alt to say I love Donald Trump on film?' I said, 'Listen, mate, for what you're paying her I can get her to say anything you like.' And I said action and she said it, and he said, 'Thank you very much.'

There was one with Norman Mailer and the boxing promoter Don King, which was hard to do as he was bonkers. All the ads were hard in a way because there were no scripts. Former Secretary of State General Haig was asked, 'What do you think of John Wayne?' And Haig said, 'He's my kinda guy,' but he wouldn't have said that if it was in a script. They got big money, for those days. They got paid $75,000 dollars a day.

One day, I was in a restaurant with Liz Tilberis when Trump came over and sat down next to me. It was in Balthazar, Keith McNally's restaurant in New York. And he said, 'How do you get such classy women, Bailey?' And I said, 'You wouldn't understand, Donald. It's to do with humour.' He's all right. He might say stupid things, but he's obviously not that stupid as he's the most powerful man in the world. It's like people used to say Murdoch's stupid. I wish I was that stupid sometimes. Of course, I didn't think he would be POTUS, but in America anything's possible. I think Clint Eastwood could've been if

he'd run for office. He ended up as Mayor of Carmel, banning stilettos because it was ruining the boardwalks.

I remember a shoot for Drexel Burnham, the dodgy bank, in New Mexico around the time that Michael Milken, who headed up the high-yield bond department, had been jailed for insider trading and racketeering – later pardoned by his friend Donald Trump. I think they used to send the rushes to the open prison. They've removed it all from their archives now. It used to be on their showreel. I made about fourteen films, I think, for Drexel. By accident I flew on the same plane as the lawyers to LA. In those days on MGM flights you had armchairs and there were more stewards than there were people. So, hidden in this armchair, I could hear them talking, and I couldn't believe we were working for a company where the bosses were all still getting $8m a year, some of them in the slammer. I thought, 'This is America, this is madness!' And their biggest worry was, 'Please, Bailey, don't make the images look too gay,' because I had made a film for them with surfers in open cars and things like that. They were paranoid about looking too gay. The ad I was shooting on this trip wouldn't have looked too gay anyway because I based it all on Walker Evans' dust bowl pictures. I had something like five Panavision cameras, fantastic cameras. I needed them all working at once because I was doing different slides of the desert. They were a million dollars each then. The producer, Andrew, worked for Jay Chiat, the American advertising genius. We were in the middle of the desert, eighty crew standing around picking their noses. It was really cold in New Mexico so we had those big thermal suits on, which were awful, because if you wanted to go to the toilet you had to take them off. And if you did you got icicles on your dick. And the producer said, 'David, what are you going to do?' And I said,

'Andrew, I don't fucking know.' And he screamed. I said, 'Are you all right?' He said, 'Yeah! I'm so happy working with you, if it had been an American he'd have been full of bullshit. At least you tell the truth.' I didn't know what I was going to do, but it ended up winning a Clio so we were all right. It was like a faded town with stop frames, signs getting old and all falling down. In the end the film was taken off the air because, as the *New York Times* reported, the scenes I shot:

> were supposed to show the town of Vidalia, Louisiana, gripped in unemployment before junk bonds ('high-yield bonds,' as Drexel Burnham calls them) paved the way for a new hydroelectric plant. Never mind that the firm hardest hit by the insider-trading scandal on Wall Street was advertising its virtue and public spirit. That's not why the spot was taken off the air. It was because Vidalians were incensed; after all, they have Sears, and Burger King in their town and the women wear shorts and running shoes just like everybody else.

Madness, all those things people don't realize go on.

I did a lot with American Express, who always wanted cowboys in their commercials and always used male models. I was always shooting around places like Utah and Wyoming, great landscapes, so I ended up using real cowboys because the models looked so poncey. I think we used the wranglers, the real ones. They were always better. We had them on set because they came with the horses. One day on a shoot in Monument Valley, at six o'clock in the morning, I turned to a girl who was scheduled to ride and said, 'OK, get on your fucking horse, girl.' She burst into tears. I said, 'What's wrong with you?' She said,

'I lied in the audition, I've never been on a horse.' I said, 'Well, you've got fucking ten minutes to learn.' We had some funny moments. I did a commercial once, I think for Rover, shooting in Spain, which was a take-off of *North by Northwest*. Everything's a rip-off in commercials. I had a plane coming over, a fair-sized plane, big wingspan. And I said to the pilot before we started, 'It's a bit windy, are you sure about the wind?' He said, 'Yeah, we're all right.' I said, 'You sure? You're coming in that way, there's a lot of wind.' He insisted he'd be fine. I had three or four cameras on it, all rolling, when I saw that the plane was coming from the wrong way, from behind us instead of to the side. The wind gusted and the plane went straight through the camera car, the wings came off and the fuselage went into the back of the van, nearly killing the art director, who was thrown in a ditch. And I remember I had an assistant director, Alan Marshall, who became Alan Parker's film partner and ended up a big producer in Hollywood doing those epics like *Midnight Express*, *Bugsy Malone*, *Another Country* and others. The pilot was complaining to Alan, asking 'What's my compensation?' And Alan said, 'I'll tell you what we'll do for you, we won't sue you. That's your compensation, now fuck off.' And there was a payment of a pound extra for extras and people with small parts if you wore your own clothes and it rained. I remember him arguing with a bloke, who's soaking, rain pouring down his face, and Alan was saying, 'Rain, what rain?' He was a tough guy.

I made a lot of films with the cameraman Jan de Bont, director of *Speed* and *Twister*, cinematographer on *Basic Instinct*, *Hunt for Red October*, *Die Hard*. I really liked him. I made about forty commercials with him. He met my agency producer, Trish Reeves, on one of the films I was making for National

cars. We had to stop shooting because there was a sandstorm and I saw them walking off together and he married her. Jan had seventeen brothers and sisters. Seventeen! His mother must have been at it all her fucking life. And they all lived! He was good fun, he was Dutch, he became Ridley's cameraman. He started off making porn films in Denmark. Crews hated him because he was so strict; they used to let his tyres down.

I also used Vilmos Zsigmond, the Hungarian-American cinematographer on *Deliverance*, *The Deer Hunter*, *Close Encounters of the Third Kind*, *McCabe and Mrs Miller*. I used to make all Martha Stewart's commercials for Kmart and American Express and she said to me one day, when I was using Vilmos, 'I'm going to check on your cameraman, I'm not sure about him.' I just said, 'Sure.' She went on the internet, came back the next day and said, 'Bailey, you bastard, you could have told me he's got an Oscar.'

I was paying him about $30,000 a day. If you've got the best cameraman, you've got the best crew, because all the crew come with the cameraman in America. If you're an Englishman out there, you're fucked unless you have an American cameraman on your side, because you can't get the crew. You learn all the tricks, you make friends with the Teamsters, the trucking union, straight away. I shot mostly in the seven western states. They're much easier. The union was pretty tough in New York; it was much more relaxed when you're out of state. The union didn't exactly make trouble; they just blow the whistle and all the fucking trucks disappear. They don't really need a reason. They don't like you or something. They weren't underpaid or anything, they were the most highly paid of everyone, much more than most of the film crew. The film crew didn't like them

but nobody criticized them because they were so tough, they were like gangsters.

My list of feature films made is not distinguished: *G.G. Passion* (director, 1966); *Paperback* (director, 1977); *The Intruder* (director, 1999); *Who Dealt?* (director, 1993) starring Juliet Stevenson. I haven't had much luck with films. I'm not really a writer. I'm good at thirty seconds, I'm good at directing. I made the feature *The Intruder* with Charlotte Gainsbourg in 1999, a psychological thriller. I hated it. It was terrible, the most miserable three months of my life in Canada, 20 below. It was quite a good script, a nice idea, and I worked with some great actors – Charlotte Gainsbourg was just magic. She's probably one of the most professional people I've ever had the pleasure of working with. I got Marianne Faithfull to sing a song on it. But I had no control at all over the crew. They all spoke French Canadian and they just did what they liked, cut it behind my back. They really couldn't care less. I had the worst producers I'd ever met in my life. All they cared about was getting it onto video so they could make some money on it. Every day there was a problem. In the end I had to get the actresses to do the fucking stunts because the stunt men were so bad.

With the money I was making on commercials, I was able to buy a house on the edge of Dartmoor. I bought it for Catherine, though she says it had always been some Enid Blyton fantasy of mine to live in the West Country like the Famous Five. We had small children – my eldest son, Fenton, was born just after we bought the house in 1987. I tricked Catherine at first; she knew the house, we visited it when she was pregnant. I didn't tell her I'd bought it.

It's an old Devon farmhouse, dating visibly from the fifteenth century, or the twelfth century from the records. It's

mentioned in Pevsner's Guide as once having belonged to Sir
Francis Drake. It was the biggest farmhouse around there, with
a mill and a mill stream. It was a disused riding stable when
we first saw it, once standing on a hundred acres. I like the
house where it is, because it's on the edge of Dartmoor; you can
get on to it easily. Our nearest neighbour is half a mile away.
There's nothing on our road. In fact, the sign just says the name
of the house. My friend Damien Hirst is exactly north of me as
the crow flies, about ten minutes. It's more than an hour to get
to Damien's by road but only if you know the roads.

CATHERINE: He always wanted to have a farm in the
 West Country, probably one of those childhood dreams,
 Famous Five and all that stuff. And he did a shoot for
 Hugh Hudson for *Revolution* and we stayed with them at
 their house in Devon, just outside Tavistock, and Bailey
 asked Sue to look out for a farmhouse. And then an old
 riding stable came up for sale. Bailey told me to go and
 have a look at this house and Sue took me to see it. And I
 thought it was fantastic. It was really run-down but it was
 magical. Bailey had made some money out of commercials,
 so he bought it on the quiet and then, two weeks before
 Fenton was born, in August 1987, he said, 'Why don't we
 go down and look at the house?' I said, 'I don't want to.
 You told me it's been sold anyway. Why look at something
 you can't have?' When we did drive into the yard of the
 house it was empty, and I was furious. 'Fuckers, they sold
 it to someone else.' Bailey was evasive and then he just
 gave me the keys: 'I've bought it.' It was great. I went back
 for a big meeting with architects when Fenton was four
 days old. I drove back down with him. I must have been

mad. I was knackered and I couldn't find the place, Fenton
sitting in the seat next to me. I had to check in to a hotel.
The only way to get the house sorted was for me to move
down there, which I did in 1992 when Fenton was five,
Paloma seven. I was happy to because I was fed up with
London schools. Bailey was working all the time. When we
got together he made it very plain to me that, as he said,
'photography, parrots and pussy' were the most important
things to him. Not necessarily in that order. I always knew
I wasn't to get in the way of his work. But I was happy
down there. I got some really close girlfriends, and the kids
were at school. Bailey came down on weekends. It was
habitable: you could have central heating on at one end or
the other, not both. There were nightmares: the kerosene
leak, which meant digging up the entire inside of the
house, was the biggest – a three-year project so far.

Dogs came and went over those years, in succession: a
Roman-nosed black-and-white English bull terrier called
Spot, which we got before we lived together; Smudge, a
smooth-haired collie; Patch, a collie farm dog that came
to stay with us for a weekend and never went back to the
farmer; Otis, a Border terrier, which was Fenton's dog who
lived to fourteen; Pig the long-legged Jack Russell, a puppy
from a hunt pack, who I bought for Bailey. At the time of
writing we have a chow-chow, Mortimer, inherited from
our son Sascha.

BAILEY: Chows are not like dogs. The Chinese have been
fucking about with them for 5,000 years. He's like having
a mandarin around the place. Fierce, imposing. He's got
the best manners of any dog I've ever seen. If children
come in he goes upstairs and waits. Says hello and then

won't bother you unless you ask him to. They have black tongues. They still eat them in China. Genghis Khan had 5,000 of them. I've never met a dog like him. He doesn't like me. He's besotted with Catherine. But me, he couldn't give a monkey's about.

I set up a darkroom in Devon. I was able to print both my major 'Stardust' exhibitions there for the National Portrait Gallery. I added a barn to the farm – you'd never tell its age. It's amazing I got permission to build it; there's been nothing built on Dartmoor like that since '56 or something. And that gives me space to store my huge collection of paintings – my own paintings. I used to paint a lot. I've been painting since I was twelve. Then and even now I still do it for myself. I have no education in technique, in the same way that my photography is self-taught. Also I realized that Picasso had more or less covered painting when I was in my teens. He cut off the painting balls of every other painter. Every image had the giant shadow of his influence. I decided just to paint what I wanted to paint and in the way I wanted to do it. I had no school, no style, no pleasing a gallery. Every time I go to those tribal places, I do paintings of what I think it was like. So the paintings aren't great but they represent something I do. Call them primitive if you like, but it's still representation. It's what I think I saw, but obviously I didn't see it like that. Doesn't matter anyway. Most art is a load of cobblers. I'm a bit suspicious of all art. Flannels on Oxford Street is planning to project my paintings on their huge electronic windows, just as they showed my photographs in early 2020, which makes me happy. Maybe I'll get booed off the stage. Here's what Julian Schnabel says about my paintings.

He's having a conversation with himself. And that's a viable and valid way to make work. It doesn't have to be classified or codified by some kind of a gallery system. In fact, he's sort of a Sunday painter or he would say that in a sense, even if he wasn't. Because he's very humble about that. He's quite modest, David. I don't know if people really know that, because he's always having a go at everybody, but he's extremely humble, and super talented. And what he does is particularly personal. I think it would be nice if he painted a couple of big ones. Not so he would be like me. I just think if you want to paint, those paintings that are painted in a loose manner would lend themselves to be pretty interesting paintings. But that's a commitment he would have to make that I don't think he really feels like doing.

Years ago I brought Captain Beefheart [Don Van Vliet] to England and I introduced him to David. Unfortunately David kept calling him Captain Meathook, and Don wanted to smack him around, but I discouraged him from doing that. Don was very sensitive and really funny also, so it was great to have the two of them together, but I think they had a very different kind of sensibility and sense of humour. I told Don that David liked him quite a bit but I think he hit a wrong note when he called him Captain Meathook.

The way Bailey tells it, I didn't pay him for the first painting I bought from him. I thought I gave him $300, and he said, 'Oh, keep it.' But I think he was happy I wanted the painting and I did put it in the film *Basquiat*. It's over the couch when Benicio [del Toro] and Jeffrey Wright walk into this crummy party and they're stoned out of their minds and Benicio basically passes out on his face on the couch, and

David's painting is behind him. It's a painting of some kind of weird mutant with a sailor's hat.

Obviously he's become friends with Damien Hirst over recent years. Damien has been very supportive of David, so I don't know if Damien has bought some paintings from him or has plans to show David's paintings at all, but they could be displayed in a way if there was enough space around them, if they were hung correctly . . . if he doesn't mind taking a beating. People love to attack people who are really good at something who then do something else really good, but which doesn't fit the category they've put that artist in, or fit the idea of that artist they have fixed in their minds. If he doesn't care about that . . .

Dennis Hopper was one of my best friends. I loved Dennis, and I thought his photographs were like Cartier-Bresson. He painted and made objects; he was more like a Fluxus artist. He wasn't like Gerhard Richter, who went into the studio every day. Dennis had the show, and luckily Dennis died before the show opened. I say luckily because Christopher Knight wrote the nastiest review I ever read about an artist. He said it was the worst museum show he'd ever seen. He tore the work apart and, I have to say, this work was excellent. It may not have fit into their concept of what the format was meant to be, but I thought it was a beautiful manifestation of Dennis. Then I thought, 'OK, tell me something: what had more of an effect on American art? Was *Easy Rider* less important than, say, Jasper Johns' painting of the American flag? Do we have to pick? But aren't we lucky to have both?' So what I'm saying is, if David felt like putting the energy into showing those things, big, I'd like to see about thirty of them.

The family in Devon in 1999.

Chapter 25

Family

My long journeys abroad were punctuated in the Nineties by the odd event at home, rather than the other way around: some of them sad and difficult.

In the early Nineties Glad had a painful decline. She was living in Wanstead by then. She always wanted to move, she always thought there was something better across the road. She moved out of East Ham to be with friends in Romford. She hated Romford so Thelma bought her a house in Barking, on a mortgage. Then she didn't like Barking – she only stayed about two months, leaving Thelma with a lot of debt. So I bought her a flat in Wanstead so she could be among the taxi drivers. I saw her maybe every three or four months, but it wasn't any good. She didn't know who you were anyway. Or most of the time. When she was demented she thought she was fucking married to Patrick Lichfield. I said, 'Couldn't you at least make it Avedon? Why do you have to make it Patrick Lichfield?' I liked him but he didn't understand photography; he just took pictures. Last time I saw Glad she was all right; she had her moments of nutty clarity. She wanted me to do the garden. I said, 'I'm not going to do the fucking garden.' She said, 'It's full of weeds.' I said, 'Well, nobody goes in there, so what are you worried about?' She got

very cantankerous. She used to upset everybody. She was like an old witch really. She called me 'Da' pronounced 'day'. She'd mutter 'poor little bugger'. She was like something out of Dickens. She didn't have spiders crawling in her hair like one of my mate's grandmothers, but she'd scream and frighten the kids. It was like she was drunk all the time. She wasn't – she didn't drink – but it seemed like she'd had too much to drink and got nasty. In the end people didn't want to be around her. Even Dolly stopped coming to see Glad. She should have been in a nursing home. I said I'd pay for everything, but she was savvy enough to know what was going to happen and insisted on staying with my sister Thelma. I said to Thelma, 'She's going to ruin your life, let me put her in a home.' She said, 'No, I'll look after her.' In the end, after she had a massive heart attack, she died, slowly, in 1993 in a private room with the paint flaking off the walls in Guy's Hospital. I didn't go to her funeral. I don't do funerals. She was buried in Wanstead cemetery, among the taxi drivers.

After a gap of seven years our third child, Sascha, was born in 1994 at home in Devon at Whimington. This time I photographed the pregnancy and entire birth in great detail and put the pictures in my book of praise to Catherine, *The Lady Is a Tramp*, which came out in 1995. So I must have been around a lot at that moment.

It was the moment, the mid-Nineties, when Kate Moss appeared and took over. For me, she was the second-greatest model I had ever worked with, after Shrimpton. Both of them have a magic that is still impossible to explain. It's something the camera picks up. I know more beautiful girls but I've never met anybody more photogenic. And it had nothing to do with the waif look or 'heroin chic' or grunge. Some girls – these two girls – didn't have to do anything and still looked good. Jean was a good

mover. Catherine can move as well. Some girls can work a dress, some girls can't. Jerry works a dress. Kate just stands there and does nothing, I don't want her to do anything. She doesn't work a dress, she's just Kate. Kate is totally natural. So anything Kate does, it's Kate. You can't work it, Kate has to do it. Not many photographers know this. You have to have done a lot of fashion. They think you just get a model and they do it all. She doesn't.

Then one day in 1996 I got a telephone call from Marie, who I hadn't spoken to for a while. She said, 'Donovan's killed himself.' I said, 'So what?' She said, 'What do you mean "so what"?' I said, 'Well, I don't know him.' Because I thought she meant Donovan the singer. And it turned out it was Terence Donovan. He'd hanged himself in his studio. I knew he was an alcoholic and that he'd had electric shock treatment, but I'd seen him just before and he seemed completely normal. It was the biggest shock of my life. I was amazed. He was one of the last blokes on earth you would expect to kill himself.

JAMES FOX: *I arranged to have a three-way interview with Bailey and Catherine – something they said had never been done before – to try and illuminate some of the more opaque parts of the story from Bailey's point of view, some of the areas to do with family life and history. My plan was to start with Bailey, then invite Catherine to join us, and then Fenton and Paloma. Sascha wasn't available. We talked in Bailey's studio in Brownlow Mews, WC1, next to the Grays Inn Road, the studio he has had for many years.*

FOX *[TO BAILEY]*: This is what you wrote about Catherine when you did your book about her, *The Lady Is a Tramp*. You had been married to her for ten years.

Catherine is a woman of mystery, impossible to understand, like an unexplained far-off place, a place one wants to enter, but the danger might override the wonders.

To go there and be made a king, live in a palace where one's every wish is fulfilled, or maybe the other side of paradise put in chains in some dark hole, your only hope that when your balls are cut off you are not forced to eat them. Don't go there, stay with the magic.

Catherine has respect for the space around her; she treats it like her accomplice, breaking the space only to move through it with elegance, poise and grace.

Catherine embodies every woman I have ever known, sometimes dippy and illogical, then so insightful it is like a kick in the head, the knowledge that comes from that unknown place.

Making love with her is like being with every woman I have ever been with, and the ones I can't remember for they were in another time and space.

I am sure Helen of Troy, Cleopatra, Garbo and Hepburn are all there in her. It is as if I am making love to all women that ever walked through time, from that mysterious place.

FOX: What do you think about this now?

BAILEY: Yeah, it's good. I've said it all in that piece. There's not much more you can say, is there? I've been fucking nice about her. It's a bit Somerset Maugham-ish, but still.

FOX: Catherine effected a major change in your life.

BAILEY: Forty years of my fucking life.

FOX: Did you give up your boyish ways in order to marry Catherine?

BAILEY: Gradually, yeah.

FOX: Why? Or how?

BAILEY: I can't tell you.

FOX: Why not?

BAILEY: You can't print it.

FOX: OK, lean over and whisper, East End style.

BAILEY: My dick was wearing out.

FOX: I'm afraid I can't accept that.

BAILEY: I don't know, but it must work otherwise it wouldn't
have lasted. Once it's forty years it's forever in the end.
I suppose it's like Dietrich said in the song: 'I've grown
accustomed to your face.'

FOX: Well, that could make things more difficult, of course.

BAILEY: I don't change. She's changed more than I've
changed, I think. I don't really change.

FOX: We'll have to go in and ask her right now. She's in the
studio next door.

BAILEY: She'll contradict anything I say.

FOX: Well, that makes it interesting.

BAILEY: For her and you, not for me!

> [*Catherine Bailey enters: Bailey asks her to read the
> document he wrote about her. Apparently she has not read
> it until now.*]

BAILEY [*to Catherine*]: I said that about you.

CATHERINE [*laughing*]: You bastard. 'That the dangers might
override the wonders . . .' He's got to give you a slap in
the face. [*reading on, laughing*] Sorry, it's very nice, but . . .
'your only hope that when your balls are cut off you are
not forced to eat them.' Well, it's Bailey's summing up
of me.

BAILEY: When James gave this to me I was shocked at
what I wrote about you, because I thought it was quite

347

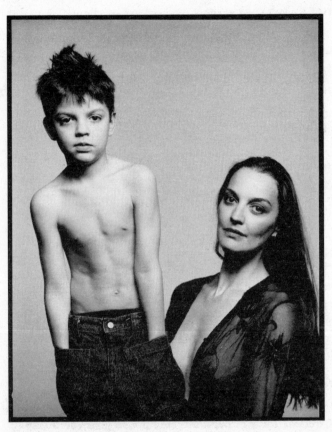

Catherine and Sascha.

good. A bit of it was bad at the end, but it was well written. I get a shock sometimes when I read things I wrote ages ago.

FOX: Catherine, I was asking him did he change, how did this last for forty years?

CATHERINE: I don't know. Bailey always said he made the decision to make it work.

FOX: Did you?

BAILEY: If she says so.

CATHERINE: Well, you always used to say that to me.

BAILEY: People get fed up with the relationship and they get into another relationship and it ends up like the old relationship, so you might as well make the relationship you've got work.

CATHERINE: I think also you always wanted a farm or a place down in Devon and you got that and I made that work for you.

BAILEY: For you as well.

CATHERINE: Yeah, but I made it work for you.

BAILEY: Yeah, I loved that, going west. I don't know why. It was a romantic idea of what it was like. I mean, a farm is fucking awful really.

CATHERINE: The reality is hard work.

BAILEY: I had an Enid Blyton idea of what a farm was like.

FOX: And were you disillusioned?

BAILEY: Well, Enid Blyton was a liar. I was always suspicious of Rupert Bear, I thought he was possibly a black bear.

CATHERINE: You liked walking along the moors and the house and the painting.

FOX: And you went to the beach?

CATHERINE: Not so much, we used to go down to the river a lot, with Sascha, a place called Double Waters, near the River Tamar.

FOX: What was he like as a kid, Sascha? Was he quite sporty?

CATHERINE: No. Barrack-room lawyer, always.

BAILEY: He used to go off and sing by himself.

CATHERINE: Always making up little operas when he was, like, three. He was a pretty little boy. He made up a lot of songs with Damien. That was when we were in Mexico, he couldn't keep up with Damien. Damien is very good with words, rhymes. 'I love Jesus, Jesus is my life. I just wish he'd stop sniffing round my wife.'

BAILEY: That was Damien, but Sascha knew it well.

CATHERINE: He loved Damien. Damien was great with him as a kid.

BAILEY: I'm no good with children. I've got nothing to say to them really.

FOX: Maybe you did, part of you, want to get married and settle down and have children? Even though you can't talk to them?

BAILEY: NO! No, I didn't want children. I didn't want a family. I didn't want to settle down either. It was more aggravation, fucking hell. I'd got enough aggravation in my life. Life's an adventure. You can't have much of an adventure living in the country with two kids and a couple of dogs.

FOX: It got easier.

BAILEY: Catherine liked children.

CATHERINE: I liked our children. But you didn't really have much to do with them.

BAILEY: No, I didn't bring them up. Catherine brought them up.

CATHERINE: You found them an inconvenience.

BAILEY: Well, they were. They are an inconvenience. Gay people seem to get more done.

CATHERINE: You've got so many fantastic pictures of them.

BAILEY: But if I hadn't got them, I wouldn't have done the pictures.

CATHERINE: But if you hadn't have gone to the Naga Hills you wouldn't have done the pictures. It's a chapter in your life.

FOX: These pictures have a lot of love about them. You felt that obviously towards them.

BAILEY: Yeah, but I'm not sentimental.

FOX: I've noticed. Blood out of a stone.

CATHERINE: At Glad's funeral Thelma made the theme Spanish. Everyone had to come in a Spanish outfit. Fenton, who was five and a half, didn't have a Spanish outfit so he just went in plus-fours and a cap. Paloma did the dutiful; she'd weep and wail whenever anyone was weeping. She didn't know Glad other than scaring the shit out of her, because when they met her she was yelling all the time. Dementia had unchained her anger; she was really gone. The vicar said, 'Now you can throw the soil onto the coffin.' I said, 'Go on, Fenton. Go on, you can do that.' I saw this fat little hand feeling the earth and I thought, 'Shit, he's found a rock in the soil.' He hurled it towards the coffin and it made a great nice thud.

[Paloma and Fenton enter]

FOX: Bailey doesn't have much to say about bringing up children, Fenton.

DAVID BAILEY

FENTON: I'm not surprised. [*to Bailey*] You weren't around much when I was young, you were doing all adverts and stuff, travelling a lot, so I'd see him once in a while and get a Gameboy game and then wouldn't see him for a while again.

BAILEY: I taught you how to play chess. And now Fenton can beat me, the cunt.

CATHERINE: Paloma was a very bright toddler. He went down to Devon with her, took her down a day before and then I came down with Fenton and the nanny. Paloma was feral. Her hair was all over the place, she was covered in muck, she'd fallen asleep on the sofa. I think that's how she slept. She had a brilliant time. And then Bailey picked her up because it was bedtime and she pissed on him.

BAILEY: Bitch.

CATHERINE: Then to cook her some baked beans she showed him how to do the microwave – when she was three and a half. Bailey put the tin in the microwave and it blew up.

BAILEY: Big explosion. The tin stuck to the roof of the microwave.

CATHERINE: He changed a nappy. He did it once.

BAILEY: I did it up with gaffer tape because it wouldn't stick.

CATHERINE: Then he stuffed her under the darkroom sinks and carried on printing. The nanny came back that evening. I was off somewhere doing a job.

FOX: So Paloma, you're nine years older than your younger brother, Sascha.

PALOMA: Yes.

FOX: How old is Fenton compared to Sascha?

PALOMA: Seven years older.

FOX: That's quite a gap, isn't it?

BAILEY: Catherine's idea.

PALOMA: What a terrible idea.

BAILEY: It's fucking Catherine being stupid. She made such a fuss about having another baby. I didn't want you in the first place!

PALOMA: I know you didn't, but I don't get the fact you finally get your life back and then have another one.

BAILEY: I don't want babies in my life. I'm too busy.

FOX: You're pleased now you've got babies in your life?

BAILEY: Yeah, now I've got them. If you don't have them, you don't know. If you've never had an ice cream you wouldn't like an ice cream.

PALOMA: I'm so used to this.

BAILEY: I'm mad about Paloma. She can paint as well. I never wanted babies.

FOX: When they come, you fall in love with them.

BAILEY: Well, 'love' is a bit of an exaggeration! When they can play chess I like them.

FOX: Was he an attentive father?

PALOMA: Yes.

BAILEY: No. No, I wasn't.

PALOMA: You were a good dad when I saw you.

BAILEY: You could do what you liked. I didn't fucking interfere with you. I had nothing to do with which school you went to, I paid for everything.

PALOMA: You provided, you never abused us.

BAILEY: I didn't abuse you.

FOX: He was nice to you?

PALOMA: Yes.

FOX: Did you grow up in the country?

PALOMA: London till I was seven and then we moved to the country and then I went to boarding school at eleven in Dorset. At sixteen, after I left boarding school, I moved back to London to live with Dad for a bit in Primrose Hill.

FOX: Did you like the house in Primrose Hill?

PALOMA: Yes, I loved that house.

FOX: Why did you sell that house?

BAILEY: Catherine wanted to sell it.

PALOMA: She thought it was too dark and she didn't like it. I thought it was a stupid idea.

BAILEY: Wasn't me. Cost me a fucking fortune, selling that house. It's worth about £6 million now. I sold it for about £450k.

FOX: When?

PALOMA: Ninety-four or ninety-five.

BAILEY: It was her fault but I'm easy-going. 'I don't want to live there.' 'Oh, all right, we'll find somewhere else.' Then we bought that flat in King's Cross, didn't we? Now we've got a house we can't go to in Devon and a flat that is rented in King's Cross. And now we live in a church in Archway.

CATHERINE: No, the reason we sold the house in Primrose Hill was that it was falling to pieces, ceilings were falling down, the staircase was coming adrift. And we had a lot of work to do on the Devon house. Builders were a problem because we weren't on site; Fenton was about to start a new school; Paloma was struggling with her school in London. It made sense for me to move down there permanently with the children, get them new schools and look after the work on the house. It wasn't Enid Blyton but it was a good decision.

Chapter 26

Travels

Donovan gave his last interview about two weeks before he died, giving no indication of his state of mind. In it he said, 'What you've got to understand about Bailey and me is, we were fantastically hard-working. Bailey and I never wanted to be successful photographers. That wasn't the plot. We weren't ambitious, ever. We just wanted to do it.'

He was very clever, Donovan. He was right. Writing this in my eighty-second year, I get a sense that there's not a great deal of time. I'm going to keep working, and pretty furiously. Some stories I never got still nag me. I failed over thirty years to photograph Castro. Tina Brown thought it a good idea, but it never happened even with the power of *Vanity Fair* behind us. He became a kind of Holy Grail. I'm glad I never got to him; it would have spoilt the quest. Even though I was one of a few photographers who went there to try it. The authorities were very strict, you weren't even allowed to take a computer in, but I took my laptop anyway. I did get a book about Havana out of it and I met Che Guevara's son. He showed me some Kodachrome 35mm slides that belonged to his father. They had mildew around the edges and the son said that he wanted to clean them up, remove the mildew, but I told him he should

leave them like that as they showed the passage of time. They were history. He didn't get it all. The other frustrated quest was Howard Hughes. Every New Year I sent a telex to him at the Inn on the Park, asking if I could take his picture, but never got an acknowledgement. I sent it for ten years.

In 2010 I went to Afghanistan, where the British troops were dug in in Camp Bastion, getting wounded, blown up, for no clear purpose. I was always being asked to contribute to or donate to charities, but this one, called Help for Heroes, appealed to me in terms of engaging and maybe helping these soldiers I really considered heroes – like all the squaddies, always so young, who always went out to fight the wars, kids mostly. Partly it was my fascination with the Great Game, wanting to go to this place where part of it was played out for 400 years. I'd followed events to the point of knowing that counterinsurgency rarely worked in this part of the world and was failing in this case against Al Qaeda and its Taliban supporters. It's my pet subject, the Great Game. I've probably read more books on the subject than anyone I know: Kipling, Peter Hopkirk, Lutz Kleveman, George MacDonald Fraser, the Younghusband expedition, the lot. It's involved everything from Russia trying to take India, the consequences of that, and the British expedition to Tibet during 1903 and 1904. And I've always loved Indian history. And I feel an affinity for the troops. I started thinking in Malaya when I was eighteen about these young boys coming back with no arms or legs. I thought of Fenton and Sascha, both at the age when they would have been called up in a war.

I wasn't prepared, when I got there, for the sheer scale of modern warfare, the miles and miles of trucks and tanks and equipment at the base at Camp Bastion. And still nobody can win. And never could. My book of the soldiers was called simply *Heroes*.

I knew in 2012 that the expedition I made to the Naga Hills in India was my last trip. It was also physically the toughest I've ever done. I was seventy-four. I went with my assistant Mark Pattenden and with Fenton, who later replaced him as my assistant and became the best I've had, along with Malak Kabbani – or 'Egypt', as I call her. I dread losing either of them. This trip pushed Fenton to his limits as well – partly, admittedly, the limits of putting up with me, along with the frustration and discomfort of those two weeks. I hadn't anticipated what we were in for.

The Naga Hills are in the north-east of India, with Myanmar (Burma) to the east, and Assam to the west. The capital Kohima is where the Japanese suffered what they think of as their greatest ever military defeat when they invaded India in 1944. They were trying to destabilize the Raj and were beaten back by British and Indian troops, taking an incredible 53,000 casualties. It is so remote and isolated that the battle is about the only thing the outside world knows of it. India runs it but with a loose grip, leaving 'vigilantes' – rebels – and bandits of every kind to bicker it out. The main band of Naga rebels don't want India ruling them, and Burma is behind their push for independence. That kind of armed lawlessness, together with its indigenous headhunting tribes, makes it an extremely dangerous place to get lost in.

I tried to look for places that had not turned into tourist attractions. You can't go anywhere now. When I first went to Lake Titicaca in Peru, it was an adventure. You went up there in a broken-down, very old lorry and you go back there ten years later and they've got hotels there and McDonald's almost. It's always like that now. Even when I went to New Guinea, the only time I got anything real was in the hills – Mount Hagen,

around there – but in most places they all dress up for the tourists, like the mud men. There was this tourist exhibition there that was like watching morris dancers in England. If you took their grass skirts off they had Calvin Klein underwear on underneath. Same in Africa, you get all those people doing dances in the hotels. It's a different form of morris dancing in a way.

Nagaland is the last romantic place. I first heard of it reading Kipling's *Kim*. It's the last place an explorer would have gone to 150 years ago and it's still that primitive there. And mountainous, and cloudy and cut off. And we did get lost, straight off. We had a driver and a guide called Kevin who fell asleep in the back, and my assistant Mark. We missed the only turn in the fucking road. We ended up with two people who were bandits. They said they were poachers but I think they were bandits, because everyone else would run away from us when we got out of the car. The girls would just scarper into the bush and wouldn't want to give us directions. Five white dudes jumping out the back of a car. We ended up in an area with the vigilantes, the insurgents, who were an irregular army of about 6,000. They had made a deal with the government not to shoot government soldiers if they wouldn't shoot the vigilantes. It was a mad situation. Plus the bandits and the tribal people who do a bit of banditing themselves. It was really dangerous.

The bandits, who we managed to photograph, were really dangerous – they were like hippies or Rastafarians but aggressive – and everyone was scared of them. These were not insurgents, they were outlaws, just someone you don't want to fuck with.

We photographed the 'kings' or leaders of the villages – identifiable because their necklaces hang with heads they've cut off. The ones with tattoos had actually taken part in headhunting

before it was banned. We found a collection of seventy-four heads in one village, miles away from anywhere. The king who appears in the book that came out of this trip, *Bailey's Naga Hills*, was loading up the opium pipe when we did an interview with him in one of the huts. We were talking to him, filming him, and he had a little bone bong, put the opium in, took a big ember, held it up with two sticks and held that in the bong and smoked it. But you only meet them up in the hills. It's one of the most interesting places I've been in a way – the clash between digital and stone age. It's there before your eyes. You've got these stone-age people, these kings smoking opium all day, with leopard-print cowboy hats on, hardly any clothes, just some dirty shorts, and the next minute you're in town with these kids trying to get the internet to work. One of the portraits in the book is of Jasmina, the local socialite who owned the only hotel, the only one you could just about stay in. The other ones were unbelievable. Jasmina's gang of kids were all on the internet – when they could get it but they can't get it all the time because the electricity keeps cutting out. We come along and charge two cameras and the whole town shuts down. You look outside and it's completely dark! 'Oh bugger.'

We saw one tourist in the two weeks we were there, a German anthropologist with her Aboriginal guide. We saw a couple of American Baptists in the town. They were nutcases. I don't think they quite knew where they were. Their ancestors had been sent to Burma fifty or sixty years ago to start a church and they'd ended up in the Naga Hills, taking the wrong turn.

It was beyond uncomfortable. The whole time. One day we drove for nine hours to see someone who was no good and then took one picture and then drove nine hours back. The first place we stayed, in the district of Mon, was really rough.

We got put in the servants' quarters, while the guide and driver were staying in the main house. We slept on wooden pallets with a mattress as thin as cardboard. There was nothing to eat at all. They gave me a chicken bone – no chicken on it, just a bone. And I'm vegetarian. Every day chicken, rice and dhal was on offer. A freshly killed chicken but with no flesh on it. They took all the good meat and gave us the shit. I think we got that place closed down because we complained.

FOX: Fenton, what other aggravations do you remember from that trip?

BAILEY: It was just discomfort, just think of the worst place to sleep.

FENTON: Bailey's tantrums weren't always that good as well. He got quite upset about quite a lot. He didn't take it very well.

BAILEY: I didn't have tantrums. He's more emotional than I am. It wasn't bad. He's exaggerating.

FENTON: I'm tougher than he thinks. I'm not really scared of him anyway. I got through it. I did consider leaving at one point. I had my passport and £100 in my pocket so I figured I could probably get back to Delhi and find my own way home. It seemed preferable at that point, but I sucked it up and got the job done.

FOX: What was the tipping point?

FENTON: Being woken up at six in the morning and being told I had mental problems because I couldn't get the internet started, which I did, but it was just intermittent. It was pretty bad.

Chapter 27

Back to Barking

Over the years I accumulated honours; they tend to attract each other when you get co-opted by the establishment or they try to co-opt you. I'm a Fellow of many societies. The Royal Photographic, the Society of Industrial Artists and Designers. And more. When my first National Portrait Gallery show was opened, Mark Hudson in the *Guardian* wrote the line 'Bailey, the embodiment of twinkly-eyed geezerdom made good – the bastard'. He means he's jumped the counter, but we love him. When Brian Clarke was first being written about for his early successes, journalists couldn't help writing his Oldham accent into the quotes, such as 'I used to go with me brother,' thinking it sounded cute or authentic or folksy or something. Brian thought that was taking the piss – and it was, but they didn't mean it. Or did they? I was rewarded for my twinkly insolence by being made a Companion of the British Empire in 2001. The British Empire, of which I have many schoolboy romantic notions, needs a good politically incorrect companion these days, so I accepted. But as Prince Charles was giving it to me, I said to him, 'I'm not joining you lot. I'm infiltrating.'

I do like the Queen. I photographed her in 2014, just in time for my second show at the National Portrait Gallery. She's

smiling broadly in the picture, almost laughing. I said to her, 'If I say anything out of order, I want you to know I've got Truth Tourette's.' That's what made her laugh. She said something about me being cheeky. She was wearing emeralds and I asked her if they were real – as a joke. I think she wasn't sure if I was joking or not. I liked working with her, she was all right. I wonder if she remembered the first time we met. I wrote about it in *Ritz*. I was at one of those fucking things when they ask you to the Palace, I never know what for, and you stand around and sometimes they put a little red badge on you, which means she's going to talk to you. If you haven't got a little red badge, you're just going to stand around. And she came around and she spoke to me. That was the first time I met her.

She asked me about the Air Force. She said, 'You were in the forces, weren't you?' I said, 'Well, I was in national service, I suppose you could say that.' I said I tried to get out of it, and she was quite shocked by that. She never shows any negativity, does she? Never looks angry or shocked or upset.

As for powerful women, I loved Margaret Thatcher. I got on great with her. I photographed her three times, I think. I wasn't attracted to her. Helmut was. Helmut wanted to fuck her. He thought she was the most powerful woman in the world. I think he wanted to fuck her power, he didn't want to fuck her. I really liked her. I'm quicker than most photographers, and she always put an hour aside. And an hour for her is really important because she knew every fucking hour what she was going to do for the next three months. I always get the pictures within twenty minutes so each time she said, 'Ooh, we've finished early again. You'll just have to talk to me for the rest of the hour.' We talked about everything – art, painting, general things. I always find something to talk about.

One of the biggest honours I've received is the big *Sumo* book of my entire life's work, published by Taschen. An enormous book that sits on a stand. They've only done six of these: Helmut Newton, Annie Leibovitz, Sebastião Salgado, Muhammad Ali, David Hockney and myself. I've published forty-five books, and no one has been easier to deal with than Benedikt Taschen. The book was done with no agent or anything; it was so straightforward and honest. Damien Hirst wrote a foreword for it, which ended with the complimentary four-letter word 'cunt'. I think Damien's great. I think he's my best friend. First time I met him he came to my office at Ridley Scott's, before he was Damien Hirst. I liked him. I thought, 'Arrogant little arsehole, but I like this guy.' We swap prints and art. I've got more pictures by Damien than anybody. There's about ten in my house. 'Dead Angel' is my favourite. I used to go to Mexico with him. I love Damien. I'm not sure I like everything he does, but I like everything he thinks. Sometimes he should think it and not do it. Lots of people I know hated Damien and now they love him; they're such hypocrites.

When I was photographing the East End in the early Sixties nothing had changed since before the war. In fact, nothing had changed much since the First World War. Also nobody moved out of the East End. Most people stayed in the same district; it was like being born in a village. The average person never went more than five miles outside of where they lived. I didn't go to the West End until I was fifteen and went to the jazz clubs.

Even if it's changed, I still feel that affinity with East Ham, that belonging. Most people from outside would think of East Ham as just another shitty borough of east London. I love the rawness of it. And the humour, which is still raw. Being taken over by all the Muslims it's even rawer. You go down to Upton

Park or somewhere on a Saturday and it's much more exotic than going to market in Delhi. It used to be Jews, Irish, Hindus, Chinese. Now it's 130 different cultures. It's great how they have transformed it and it will probably last longer there, hold out with its character.

I went back to the East End as part of the research for this book, to find its character, to see what's survived and what's new. And also to work on a book called *The Road to Barking*. I was going to do The Road to Essex, on the East End and the East End corridor where the old East End population overflowed into Essex, which is where the only real cockneys are now. But Essex is too big. I kept getting stuck in Barking, which is the last East End really, along with East Ham. Places like Stratford are all becoming very middle-class. I took photographs of the people who live on the boats on Barking Creek, the old river where the biggest fishing fleet in England used to unload its catch, of the boxing club in Dagenham and the people and places in that battered community. There is a great bar on the creek – about the only civilized thing in Barking – called The Boathouse Cafe and Bar, which is why I call it Rick's Bar, as in *Casablanca*. Like that, it's a kind of outpost of civilization. That's where I based my operations. My uncle used to work down the road a bit, on the creek, in a wood factory. Uncle Henry, I think he was called, my mum's brother. Died of a fit. The term 'barking mad' originated here because there used to be an asylum up the road; maybe the term 'up the creek' came from here as well. Barking was a bit of a dumping ground. The Gascoigne Estate beside the creek was the notorious badlands; it's where the Krays hid Axeman Mitchell when he was on the run, before they killed him.

I got a lot of help in Barking and friendliness. And I fell in with

the most interesting guy I'd met in a few years: Darren Rodwell, the leader of the Barking and Dagenham Council. Darren was born in Dagenham and still lives on the same council estate where he grew up. He could be my younger brother or something. It's like I grew up with him, though I didn't, me in East Ham and he in Dagenham. He went into politics after the British National Party won twelve seats on the council in 2006, to organize the local fight back on behalf of Labour. In 2010 Darren was elected to the council and the BNP were kicked out. He became leader in 2014. He wants to pull the community back together, as it was, a working-class community that looks after diversity. He wants, he says, to stop the working class being priced out of their community. And he's succeeding. Before lockdown he was building around 60,000 new houses as just one of his projects.

He's building a huge film studio to rival Pinewood and Shepperton, an East End arts centre and other projects to bring business to Dagenham, where land is cheap and plentiful. He's just not like any other politician I've met or even heard of. He thinks outside the box, he cuts the crap. Also he's got plans for me too. He wants to set up a foundation in my name, housing my archive, on Barking Creek, to be part of the Tate and National Portrait Gallery's project to move their archives down there. He's already earmarked the land. It's a foundation to get people supported, to get them started, to launch them out of the ghetto, to see that there's a future in creative art. That's the idea. If I can do something for Darren, I will.

We had lunch at "Rick's Bar" – me, Darren and James – before the pandemic. I wanted James to meet him and get some stories from Barking and Dagenham, the front line.

★

DAVID BAILEY

BAILEY: Whenever I can nowadays, I always try to mention Barking.

RODWELL: Yes, and you do a good job. I was at the Labour leaders' conference up in Warwick. All these leaders kept on saying to me, 'You know David Bailey?' I went, 'Yeah, right old tosser, he is. He felt sorry for me. He wanted to go back to his real roots.'

FOX: Well, it's very kind of you to come down today and talk to us.

RODWELL: My pleasure. What do you want to know?

FOX: I want to know how you run this place.

BAILEY: Be nice to him.

RODWELL: I'm always nice. My first anecdote – how we met – is probably the good one. I'm on the board, and so is Bailey, of a charity called Create London, to bring arts to east London and other places. The first time we met was in a very luxurious house that happens to be the chairman's property and I felt very out of sync with the situation. There were all these lovely antiques, there was a butler. I've never seen a butler in my life. Very uncomfortable. I just thought, 'I want to get out of here as quickly as possible,' and all of a sudden the door rang and obviously the butler went off to answer. And the chairman jumped up really quickly and he hadn't done that for anyone else. Then I heard this, 'I'm fucking here, aren't I?' That was his opening line. I think the chairman said something like, 'I wasn't sure if you were coming or not.' And I thought, 'OK, that's impressive, I wonder who that is?' As he came in, I was standing there and he looked at me and went, 'Who the fuck are you looking at?' So instinctively I said, 'Who the fucking hell are you talking

to?' and he went 'Oh, a fucking normal person.' And that
has been the bromance ever since.

Why did we connect instantly? Why were we like two
naughty schoolkids, and we are. We were at the dinner
at Christmas soon after that, same chairman, at Spencer
House. I mean, the *top* top, the cream of the cream. I'm
there – why, I don't know. I walk in and he's sitting there. I
went, 'I didn't realize this was help the aged day, what are
you doing here?' He went, 'Fuck off, you bastard.'
You should have seen people's faces, it was really funny.
What I was amazed about, and I am today, is that
Bailey can go into a room and insult everyone and be as
politically incorrect as you like, and everybody loves him
for it. Especially from the more gentry classes, and nine
times out of ten they don't realize he's actually being very
truthful; he just finds it a pain in the arse being wherever
he is.

FOX: What does that charity do?

BAILEY: Fuck knows.

RODWELL: It supports arts and culture in poor parts of
originally east London, but it's done other stuff in other
parts of the United Kingdom as well. It does a really good
job, to be frank. But it does need to be reminded that art
is not there to be 'done' to people; it has to come from the
people and they support wherever that journey takes them.
I think, between us, we very much bring a grounding, it's
fair to say, to some of the grand ideas they have every now
and then. That's fair?

BAILEY: That's fair. Stop them doing stuff like putting a
fucking swimming pool in the Tate. They want to build a

swimming pool there so they could go for a swim before
they went and got some culture.

RODWELL: You've got to be nice and clean of mind and
body.

BAILEY: So condescending. It's a middle-class idea of what
people want. To get them to go and see art. If they don't
want to see art, they don't want to see art.

FOX: What a great ally to have.

BAILEY: Him as my ally? Or am I his? He could be my
fucking younger brother. He could. Bit of a cunt. We could
have easily been gangsters because we didn't have too
much choice as kids. I always used to say it's the choice of
being a car thief or a villain.

RODWELL: That's very true. Some of my family have had
a chequered past, it's fair to say. But my old man said
two things to me growing up, and again it's very similar
to Bailey's outlook. Never conform and never work in
Ford's. Because you were told what to do on a daily basis.
What time to go to the toilet, when to take your holidays.
It was only really in the Eighties when people started
going abroad and not going to Butlins. We'd have a long
weekend in Jaywick. When I was a wee nipper, in the early
Seventies, I'll be on my dad's shoulders, outside The Ship
in Southend. If you stood that side of the street you'd
watch the Mods and the Rockers beat the crap out of each
other, until the old bill turned up and then they'd beat the
crap out of the old bill. Every bank holiday that's what
would happen. People didn't have a week away or two
weeks away; you had your bank holiday – that was your
holiday. And there was a fight, every time. But again, you
grew up with that.

Bailey is from – and I am from – a very proud working-class community and it's in the title. That ethos is so strong in the East End and it doesn't matter what generation you're from. I think that's why we connect so well. As I've said before, I'm a simple lad from Dagenham, I've lived on the same housing estate most of my life. I haven't come off that housing estate. We speak Estuary, the clever people tell me. It's a mixture of East End and Essex. And actually we had our own culture. Probably the last bastion of working-class London.

BAILEY: We're the end of the East End.

RODWELL: We are, aren't we? It's the last piece where you've proper working-class people of different backgrounds. There's over 130 different cultures in Barking and Dagenham. And it's the poorest area of London. It's the cheapest area of London. And that's put it under severe pressure. When Ford's closed down in 2002, it was a disaster; the whole culture depended on it. It was like almost overnight we had 50,000 people moved out and a huge influx of people looking for cheap housing. It led to tensions – and that's what let the BNP in because locally there wasn't an answer for it. A huge churn of population in the next decade. Underneath all this is housing – and this emphasis from Thatcher days on home ownership. That's what caused a massive rift in our old communities over the last forty years – the have and have-nots. Social housing is a derogatory term saying you are not good enough to buy your house because you're on social benefit. That's a disgrace because all of us were pretty much in that place for the last forty, fifty years. So what we're

DAVID BAILEY

trying to do is bring renting back. People should have the right to rent again because most of London did.

FOX: But there's nowhere to rent? Margaret Thatcher reduced the amount of council houses and they weren't replaced.

BAILEY: She was wrong in selling council houses, they should have kept council houses.

RODWELL: That's the point, we've lost about 48,500 council homes to the right to buy scheme. And none got built. One in 3 properties in the borough now are owned by buy to let landlords who charge four times the rent the council charges. Because the council didn't build new houses, they don't have enough properties so they have to pay private landlords. Nationally we spend billions paying for people's rents. It's a trap. So what we've done is avoid the state.

We go out to the private sector to build houses. That way we can fix rents, and let tenants buy a share in their houses. I've no problem with people bettering their lifestyle but it shouldn't be at a cost to the wider community. Because then the vulnerable become more vulnerable, they then blame other people, and there's where the hatred comes in. We've got to start building for all of us, give everyone a choice and make it a place where everyone can feel they're part of a community. We've got four hundred hectares of land to build on, we're going to build housing for all different people, ethnic and social backgrounds and incomes. People rent at different levels based on income. If they can afford it they can buy a portion of the asset. No matter where you are in our society, you need to be linked together. We don't want gated communities. Again, Bailey understands that.

370

BAILEY: It's good. I want him to be prime minister. I really fucking do. Don't muck about, just go to the fucking top.

FOX: He pretends he's not political, I think he is.

RODWELL: He's very political. That's why we get on, because he does care about his community. He cares where it's going, he doesn't do the conformist politics because there isn't just the left and the right. On a number of different issues there's an equalizer.

BAILEY: The left think I'm right and the right think I'm wrong.

RODWELL: Absolutely, that sounds like me now. When both extremes hate you, you know you're being cuddled. What you've got to do is understand where they are because no one is instinctively racist, bigoted, abusive.

FOX: Tell me about your fight with the far right.

RODWELL: It's because of that fight that things have started working here, it's how we got organized. I did a poster, it's the only bit of graphic art I've ever done. Bailey's seen it in my house actually. It shows different scenes of us fighting the far right, in 1933 in Cable Street, in 1977 in Lewisham, the black and white riots, and in 2010 when we were fighting Nick Griffin in this borough, when we were fighting the BNP here in Barking. If you know your past, you know what you stand for. If you know what you stand for you know what you fight for. If you know what you fight for, you've got aspirations to change tomorrow.

FOX: How did you turn it around?

RODWELL: Every door got knocked on three times. Me and lots of others knocked on 168,000 doors. The community turned them back.

FOX: Did you get threatened by the BNP?

DAVID BAILEY

RODWELL: Many times. The last one, I was in the john on
election night.

FOX: Where?

RODWELL: At Goresbrook Leisure Centre, having a piss and
this guy walks in, Stanley knife, puts it up to my throat.
He went, 'We're having you after this.' I went, 'I'm fucking
having a piss.' He goes, 'Don't care. We're having you after
this.' I said, 'You're big man, you are. There I am, holding
it. Once this is put away, I'm getting that knife and I'm
shoving it up your arse. Now get out of my fucking toilet.
And P.S. I've got twenty-four cousins. You won't leave the
borough before we track you down and kick the shit out
of you and if you're lucky you'll still be alive.'

BAILEY: Do you see what I mean about being a gangster?

RODWELL: He said, 'You think you're hard.' I said, 'I don't
think I'm hard, I am hard.' And he left.

BAILEY: Especially the Stanley knife. It's horrible, they all
used to have Stanley knives.

RODWELL: We had two guys trying to put a scaffold pole
through the front window of my house. So I chased them
down the road with a baseball bat.

FOX: And they ran?

RODWELL: Course they fucking ran, I was going to hit them.
I don't mess around.

FOX: They could see your intentions.

RODWELL: Oh yeah. I'm working-class, mate. I may wear a
suit and I may have to not swear these days. Bailey makes
me sound posh. I do love him for that.

BAILEY: You are quite posh. You're much more middle-class
than I am.

RODWELL: You piss off, you wanker. Get out of here.

FOX: When I first met you, you were saying – and it was chilling – that the BNP strongholds were exactly the same places as in the 1930s. Same stomping ground, same streets, as if the virus had just gone underground.

BAILEY: I find it a bit scary.

RODWELL: It can be. I don't pretend it's not and I've lived there all my life. As a youngster I've had more fights than I care to remember.

BAILEY: Not scary-scary, but scary. They've screamed at me a few times, 'Don't you fucking take pictures of my house.' I'm more scared of the women than the men.

RODWELL: So you should be, mate. One of them might be my mother.

BAILEY: Or mine.

FOX: What can you do with Bailey in the East End? Have you got projects?

RODWELL: Yeah, I think the proudest moment in my career was when I got a call from him saying, 'Come over for Sunday lunch.' I didn't realize he was fucking vegetarian, I would've said no, but my wife enjoyed it.

BAILEY: Your wife is vegetarian.

RODWELL: She is indeed. She enjoyed it.

BAILEY: She's a progressive thinker.

RODWELL: She keeps saying to me, 'When we going out again?' I go, 'Yeah, but I need to eat something!' We were sitting there and just generally talking and then he sort of said – he's getting on a bit now, he's gone just past his midlife crisis – he's working on the basis that he wants to give back. He wants young people in the East End to see that there's a future in creative art. There is a snobbery within all walks of life and one of those is in photography;

some people say that's not as important as painting or filmmaking or whatever. But, to Bailey's credit, he sees all of it in the same context; it all has its place. When he said he's looking at a foundation to get people supported in making their way in life, I think that is so important. It's important for us in the East End. I think it's important for his legacy.

BAILEY: We're the legacy. There are no cockneys left. Darren is the last cockney, me and Darren.

Acknowledgements

With thanks to everyone who either worked on the book or made time to be interviewed:

Catherine Bailey

Fenton Bailey

Paloma Bailey

Manolo Blahnik

Maureen Burrows

Brian Clarke

Grace Coddington

Ingrid Connell

Catherine Deneuve

James Fox

Jerry Hall

Nicky Haslam

Marie Helvin

Malak Kabbani

Gilly Newberry

Danny O'Connor

Andrew Oldham

Darren Rodwell

Julian Schnabel

Barbara Seymour

Jean Shrimpton

John Swannell

Penelope Tree

Richard Young